Scandinavian Design

Farrar, Straus and Giroux / New York
The American-Scandinavian Foundation / New York

SCANDINAVIAN DESIGN

Objects of a Life Style

Eileene Harrison Beer

Copyright © 1975 by The American-Scandinavian Foundation / All rights
reserved / Second printing, 1976 / Printed in the United States of America
Published simultaneousy in Canada by McGraw-Hill Ryerson Ltd., Toronto
Designed by Jane Byers Bierhorst

Library of Congress Cataloging in Publication Data

Beer, Eileene Harrison.
Scandinavian design.

Bibliography: p.
Includes index.
1. Art industries and trade—Scandinavia. 2. Design—Scandinavia.
3. Design, Industrial—Scandinavia.
I. Title.
NK979.B43 745.4'4948 75-25732

Foreword

Arts and crafts, even when industrially produced, mirror a people's way of life. This was never more true than in the case of the Scandinavians. The world has come to respect the great design originating in Finland, Denmark, Norway, Sweden, and Iceland; they have earned a reputation for aesthetic achievement and high-quality craftsmanship. The products of these nations are thoughtfully conceived and meticulously made, and then go out into the world as inanimate ambassadors, communicating to others a proud and honorable Nordic life style.

These are free lands of free thinkers who have a high standard of living. The people are pleasant, just, independent, sensible, hard-working; they have devised an enlightened living pattern which carefully protects individual rights and human dignity.

A stern climate has taught them the wisdom of making the most of available resources, both human and material. The scenic wonders of their homelands have instilled in them a passionate respect for nature, the eternally perfect art form. Quite naturally, then, these factors are reflected in their arts and crafts, which show an innate sense of artistic proportion and economy of line and color, inspired by the precious raw materials from which they are fashioned. Above all, in the past two decades Scandinavian design has become notably timeless in form, in addition to being of excellent quality. Many pieces blend comfortably with styles from other times and places, and will be among the heirlooms of the future.

In Nordic lands, art is a major obsession. Its clinical symptoms are quickly observed. One is promptly impressed by the bonanza of unhackneyed art seen everywhere—in homes, shops, restaurants, exhibits, public buildings. In the home, where most of us might hang a picture or two, the Scandinavian will group an assorted dozen—everything from Monet to Matisse, Picasso to Munch, Cézanne to Gallén-Kallela— and somehow the total effect is highly agreeable. Other walls will invariably be shelved and laden with literature. Scandinavians in all walks of life are known to acquire good paintings and books almost before chairs and beds. The names of artists and designers are well known even to children, because art and design exhibits are frequent and attended by the whole family. Creative artists are highly regarded and often subsidized by the government, producers, or arts and crafts societies. Talent and learning command more respect than wealth.

It is logical that these people, who appreciate beauty and demand practicality, should expect from their artists, artisans, and producers purity of design and flawless craftsmanship in everything from the minutiae of homemaking to the most important decorative accents. The result is that an egg cup is styled with as much finesse and charm as a sterling-silver punch ladle. A chair will offer more than masterful form, joining, finishing, and comfort; it is likely to be stackable, too. Things are created to be both noticed and used—functional but never impersonal, enchanting but not ostentatious. There is little slavery to fads or "obsession with possession," and what is retained from the past is only that which still merits a place in today's milieu. Scandinavian designers have operated for years on the knowledge recently put so succinctly into words by my favorite American interior designer, Billy Baldwin: "A chair, for God's sake, is to *sit* in."

One who dwells among the Scandinavians for an extended period discovers this very rational set of values, which for them constitutes a rewarding total existence. This is not to say that life there is an idyllic Valhalla on earth. But it is indeed less frenetic, less money-mad, and more forthright in general than elsewhere at the moment. This Northland still has air that is pure, clear, and intoxicating. The countryside abounds in fine scenery, fascinating history, and local talent. It's a soul-refreshing area to visit, though you may need to diet afterward, for you will surely have been wined and dined by a home-loving people whose hospitality is unexcelled. In other places you may be invited out to dine. The Scandinavian proudly invites you into his home, his sanctuary, the calm eye in the hurricane of his daily world. In so doing, he is inviting you into the heart of his family and the circle of their friendship.

The word "Scandinavia" implies, to a limited extent, certain things in common between the five countries—Finland, Norway, Sweden, Denmark, and Iceland—to which it is applied nowadays. Their historical backgrounds are interrelated, and their language similarities have enabled most of them to communicate well through the centuries, creating ideological togetherness. Today they have in common an almost total absence of class distinctions. They like to say, "Every man is a king here." Each and all have lots of winter, a glowing sense of humor, an inbred revulsion to dirt, a tendency to skål and eat as if there were no tomorrow, and a love for making frequent long-winded speeches and telling jokes on one another . . . all in good fun.

Of course there are differences. The unmelancholy Dane is known as the salesman among them, though certainly not the hard-sell variety. Denmark is a joyous, easygoing little country, the only hectic factor being Copenhagen traffic. Danish worries are usually scheduled for some other time, except for the suspicion that Tuborg is being made faster than they can drink it.

Norway is an island of tranquillity in a hysterical world, if you discount the wild rituals of Midsummer Night and May 17 (Independence Day). Norwegians have an unpretentious yet sophisticated charm and nary a phony bone in their bodies. They are the most psychologically self-sufficient of the Scandinavians and don't mind extended periods of solitude; in fact, they often seek it; as witness their many explorer-heroes. If there is a bit of snow anywhere on which to set a ski, nobody is ever at home. Wonderful Norway, with its majestic fjords, mountains, and lush valleys, is surely the topping on the Nordic cake.

In Sweden, one finds a more formal air, a cultured chivalry, a delicacy of social custom, a certain reserve. Behind this crisp and courtly façade lie warm hearts and welcomes, and a fair share of high spirits, so don't ever let the initial formalities deceive you. In Sweden, one finds the keen businessmen of Scandinavia and the greatest mass-production capability to go with their business acumen.

Icelandic people, whose lives are somewhat limited by island confinement and minimal local resources, are nonetheless highly inventive,

and are among the most well-read people in the entire world, engaging, knowledgeable, and creative. They are intensely interested in all art forms.

Finland, with its faint aura of the Eastern and Slavic, makes one feel at first a little alien . . . until one meets a few "friendly natives." It is difficult to vignette the indefatigable Finn and his "super-sisu" personality in just a sentence or two. He is an individualist to the core. Aesthetically he is a fountainhead. He is the most fiercely independent of all independent thinkers; thus his art concepts are daring, unique, and explorative. Too many travelers stop at Stockholm or Copenhagen and miss visiting this intriguing land of silent soothing forests and crystal lakes (and a few "kippis" at the M Club of the Hotel Marski). Those who fail to hop on a Finnair Super-Caravelle for a scenic one-hour flight to Finland—the land where happiness is a sauna—are missing something wonderful.

There is a sage saying: "Whatever it is, the Danes sell it, the Swedes manufacture it, the Norwegians ship it, and the Finns design it."

Most of the artists and producers in this book—and others who have helped me with it—are now my valued friends. Not only do I admire them professionally, but I love them personally. I like the way they act and think and work and play. I respect what they make, and want to arouse the reader's interest in studying, understanding, and learning from it, for it represents excellent taste.

This book is a digest of the works, studies, and contributions of dozens of talented people, including many journalists, critics, and historians who have chronicled the saga of Scandinavian design in the past, from one angle or another. To all of them, I am grateful.

When you go to Scandinavia (not if but when), see more than the scenery. Get acquainted with the people and study their wonderful arts and crafts. See how beauty is incorporated into their everyday living. Each country maintains at least one permanent design exhibit and the welcome mat is always out, not only there but at many studios and factories. The tourist headquarters will happily point you in the right direction.

Contents

Acknowledgments

Erik J. Friis, Donald Askey, and The American-Scandinavian Foundation, who have made this book possible

Timo and Pi Sarpaneva, Helsinki, beloved, talented friends and inspiring helpmates

Kjell Munch, Oslo, an artist with a camera

Runar Kockberg, Finnish Foreign Trade Association, Helsinki, my right arm in Suomi

Ulf-Erik Slotte, Maire Walden, Matti Tuovinnen (and my dear friend, the late Dr. Phil. Tellervo Aima) of the Finnish Foreign Ministry

Veli Virkkunen of Finnair and his charming American wife, Maggie, who have together done so much to communicate to others the wonders of Finland and its design

Arabia Oy of Finland, in the persons of Ulla Witting Haber and Marjatta Nurmi and the late, brilliant Holger Carring

Finnish Consul-General and Mrs. Per Thømte of Oslo, who can make a Finnofile of anyone

S. Helgason and Sverre Marcussen of Loftleidir (Icelandic Airlines)

Ake Tjeder and Mrs. Maire Gullichson, Artek, Helsinki

Dr. Mogens Utzon-Frank, Danish Society of Arts and Crafts

Mrs. Edith Wanscher, Den Permanente, Copenhagen

Dr. (now President) Kristjan Eldjarn and Dr. Selma Jónsdóttir, National Gallery of Iceland, Reykjavik

Einar Eliasson, GLIT Ceramics, Reykjavik

Edna Martin, Friends of Swedish Handicraft, Stockholm

Linda Meyer, Georg Jensen, New York

Maj Odelberg, Museum of National Antiquities, Stockholm, and Dr. Eva Nordensen

Rut Liedgren, Nordiska Museet, Stockholm, and Fru Hidemark

Kristofer Berg, Hadeland Glassworks, Norway

Kjell Aas, Porsgrunds Porselaensfabrik, Porsgrunn, Norway

Jan-Erik Eriksson, Orrefors, Sweden

Oivin Grimnes, Sandvika Veveri, Haslum, Norway

Prof. Dag Widman, National Museum of Stockholm

Mrs. Ulla Tarras-Wahlberg and Miss Birgitta Willén, Swedish Society of Arts and Crafts and Industrial Design, Stockholm

Ivar and Jon David-Andersen, Oslo, Norway

Connoisseurs and authors Ulf Hard, Åke Stavenow, Åke Huldt, Arne Karlsen, Anker Tiedemann, Ben Zilliacus, Erik Zahle, Alf Bøe, and others, for their expertise and earlier knowledgeable works, which have been my basic training.

Studios, museums, factories, and private collections, artists and artisans visited and herein represented, especially Kaj Franck, Kirsti Ilvessalo, Tapio Wirk-kala, Birger Kaipiainen, Annikki Hovisaari, Bjørn Weckstrom, Jane Wiberg, Tias Eckhoff, Ragnar Kjartansson, Jóhannes Jóhannesson, Berndt Bengston, Alvar Aalto, the late Ulla Procopé, Richard and Francesca Lindh, and many others, each marvelously expressive about his work.

Last, but far from least, every author owes a great deal to those around him or her every day for their patience and moral support—in my case my children and my husband, Dr. David C. Beer, whose medical training has helped him understand all women, including me. This book is dedicated, in all fairness, to my prominent author-friend, editorial coach, and egger-on, Eloise Engel Paananen, who has given me constant encouragement, and without whom my sentences would be even longer than they still are.

Tusen takk, tak så mycket, og kiitos.
Eileene Harrison Beer

Scandinavian Design

I. DESIGN FOR LIVING—SCANDINAVIAN-STYLE

The Scandinavians have a realistic philosophy of living. It is largely responsible for the abundance of beguiling objects, masterfully crafted, coming steadily from Denmark, Norway, Sweden, Iceland, and Finland, that regularly receive a disproportionately large share of world awards in arts and crafts and industrial design. The Scandinavian has a fundamental belief in enhancing his daily existence with beautiful things, both in his home and in public parks and buildings. His intimate relationship with nature is obvious in his feeling for proportion, color, and the efficient use of raw materials.

With what amounts to a passion, he expresses his personal style of religion in the open air, savoring the matchless scenery with which God has surrounded him. He will not be rushed away from the outdoors by any pressures of the business world, for his formula for living includes a healthy amount of time with nature. His creed postulates that good health and a share of the beautiful things in life are more essential to happiness than amassing funds beyond what is needed to live comfortably.

All conflicting demands upon the Scandinavian's thought processes, time, and physical energies are balanced against his basic desire to live wisely, well, and to a ripe old age. Worldly goods are acquired for personal enrichment and joy rather than status. The scramble for income is confined to its fair share of his time. There must be daily hours devoted to work, time for rest and for play—also for exercise and quiet contemplation, preferably in the fresh air, temperature notwithstanding. Above all, time must be reserved for the pleasures of family love, for companionship and hospitality, for appreciation of all things beautiful.

Back in the days when the Vikings were quaffing mead from hollowed-out horns, they found it necessary to add two metal feet to the horns, so they could be set down between skåls. These necessary appendages were soon made decorative as well. They were crafted in pewter and silver and engraved to suit individual tastes. To this day, the Scandinavian insists that purpose and function are the first considerations for the use of available material. *After* the problem of usefulness is solved, an object should be made attractive enough to please human aesthetic needs.

Writers on Scandinavian arts and crafts have always been fond of attributing existing characteristics to the area's former geographical, social, and political isolation. This is true to the extent that isolation influenced their arts and crafts centuries ago, and that a heritage of respect for economy has been handed down the generations. Long ago the variety of raw materials was extremely limited, and lack of communication with other peoples meant that creative concepts were necessarily of local origin, rather than imported. Theirs was a region without the blessings of orchard or vineyard, and with long, severe winters. The people were faced with a hard struggle for life, and had limited time, energy, and light to develop their arts and crafts except as an offshoot of necessity. In time, these factors infused into their mode of living and thinking a permanent dedication to minimizing waste.

Isolation and limited resources also influenced Scandinavians with regard to materials and design. For example, Norway, Sweden, and Finland, endowed with ample forests, came naturally to learn the best techniques of working wood. This laid the foundation for expertise with this wondrous material—an expertise that has been passed along from father to son. The spectacular scenery all around them contributed design motifs and educated them to the realization that nature's ever-changing beauty is the best and most constant source of lasting pleasure in form and color.

Defense, exploration, and aggression necessitated tools of battle. The Scandinavians' abilities in working with metal obviously grew from this need for weapons, and their need for beauty was demonstrated in the intricate craftsmanship with which they shaped and adorned them. A sword—romantically and symbolically given a name of its own, such as Falcon's Claw or Tooth of Victory—was soon transformed from a primitive design into a thing of beauty, its hilt embellished with the heads of animals, natural symbols of strength, courage, and valor in battle.

From their exploits abroad came new ideas and new materials with which to create, and these were given a personal interpretation. But first came the *need,* then the artistry. Scandinavians have instinctively been aware that one cannot create something pretty in the hope that it might also be useful, but an object made to perform a function can always be made pleasing in form. This thread of common sense has been continuous throughout Scandinavian-design history.

In Scandinavian homes today, one sees many worthy examples of both fine and applied arts. The most humble dwelling usually has good paintings on the walls, perhaps a handsome rya (spelled *ryijy* in Finland) rug or tapestry, or an old provincial cupboard, rose-carved and painted. In restaurants, where tableware must be sturdy, it will nevertheless have been designed with good line, scale, proportion, style, and color. There is little truly "ordinary" design. The dinner plates at Oslo's Najaden Restaurant (a part of a maritime museum) bear a reproduction of an ancient and fascinating Viking map. The Royal Restaurant in Helsinki is a showcase of the works of master architect-designer Alvar Aalto. The Continental Hotel in Stockholm is a working exhibit of the efforts of leading Swedish artists and artisans. So are Stockholm's subway stations. On the other hand, a little neighborhood *konditori* will have miniature coffee pots, creamers, and sugar bowls of charming shape and color, which, though produced industrially, will have been conceived first at the potter's wheel by the skilled hands of an artist.

Nowhere can the seeker find a better illustration of true art appreciation than in these countries where artists are highly respected and budding young talents are financially sponsored and encouraged in every possible way.

A Scandinavian acquires a lovely painting or weaves a small masterpiece of tapestry, not to impress his neighbor, but because it gives him personal joy to look upon it day by day. It uplifts his spirit and glorifies his home, which is the real focal point of his existence, the foundation and meaning of his life. He, like his ancestors, has been imbued with this attitude from childhood.

Such a rich heritage of devotion to arts and crafts of historic beginnings has not in the least hampered the Scandinavian's acceptance and creation of new cultural trends. In fact, where others tend to divide themselves into camps of those limiting their acquisitions to antiques only, or favoring contemporary styles, or championing a single period such as the eighteenth century, a Scandinavian has room in mind, heart, and home for the best of each, and an ingenious knack for blending them into harmonious combinations. The idea that things should "match" has never impressed him—only the concept that good things will blend and harmonize, and that each acquisition should have meaning to the family.

Thus, there is a profusion of old and new to be found in Scandinavian homes. Today's design is meant for every man, for every day. Essentially timeless, it gratifies a multitude of personal tastes. It is totally contemporary, yet complements designs from the past. Because they have great respect for what is beautiful in nature, because they are deeply practical, the Scandinavian people want to surround themselves with objects that make sense to them, are handsome, and which they can afford to own. Once their feet were set upon this path of art for use rather than merely for art's own sake, the results were inevitably good.

A study of present-day Scandinavian design is a basic lesson in sound design principles and dependable artistic taste. It has worldwide appeal, the ability to blend harmoniously with other periods and styles, and suitability for today's living. Its essence is the insistence that useful articles should be, not just sturdily constructed, but also beautifully formed.

The Scandinavian has a word for it: *brukskunst*. Its literal translation —useful art—is an understatement. In its truest sense, it embraces the thought and end product of creating articles appropriate to a need, yet with a beauty satisfying to the artistic heartbeat of a man's time.

The Scandinavian sees no valid reason for mediocrity in design or workmanship, regardless of whether an object is costly or inexpensive. He believes that food for his body should be served on tableware handsome enough to be food for his soul. The rug under his feet must feel warm and comforting; its colors must please him; furthermore, it should be made to last, to be handed down through the family.

In Nordic lands, *brukskunst* is a natural phenomenon, and has been a forceful and challenging inspiration to artists, artisans, and producers. Its fruition has become a harvest of masterful design forms for the enrichment of daily living, and purports that the search for beauty should always be more than just a sometime thing . . . that more is art than that which is hung upon walls or set upon pedestals.

Throughout history, the applied and decorative arts have given the world some of its most consummate beauty. (Since the earliest age, the potter's art has offered beauty to man, long before other forms of art were known.) Artists and designers in this field have a different perspective from that of the fine arts. They are seldom boiling pots of temperament or frustration seeking new outlets for inner seethings about the meaning of life. They are "applying" their creative talents to building something useful, with artistic form, texture, and color, from some practical material attractive to the eye.

In a sense, their challenge is greater that that of the pure brush artist, sculptor, or composer, who needs to concern himself only with creating "something." The designer of useful objects must create "something" that serves a utilitarian role. Utility + form + color + texture + durability + cost—this is the exacting formula to which he must discipline himself.

To a limited extent only will he follow any so-called "school" of art or design. To a large extent, he will reflect the milieu of his time and of his country's history, natural resources, and moral-intellectual climate. He may utilize the theories of some particular teacher from his educational background, but by and large his works are highly individual.

When Scandinavian designers and craftsmen occasionally create something born out of sheer whimsy, just for fun, it has to do with a very special Scandinavian word: *"hygge"* (pronounced roughly *hue-geh* and not specifically translatable). *Hygge* implies a very special charm, a tender and comfortable feeling. It applies to people, things, or surroundings giving a sense of joy and well-being. It is probably most closely related to "cozy," with a little "good cheer" thrown in for extra warmth. *Hygge* is created with a small, amusing object; with a fine sherry in a well-shaped glass, which feels nice when you hold it in your hand; with a colorful and tastefully set dinner table, a delightful flower arrangement, whether of hothouse roses or just three stalks of wheat, a pillow with delicately hand-embroidered little native plants; or with the relaxing companionship of a trusted, interesting, and much-loved friend. Scandinavians are definitely great exponents of *hygge.*

Industrialization came rather late to Scandinavia. Efforts to perpetuate the folk arts had already been established, so today the look of handicraftsmanship is still evident, even in mechanized production.

It is not just the designers, craftsmen, and producers who insist on this, but the people themselves. Well educated and urbane, they have a healthy and constant interest in the applied arts, and follow them closely, attending the numerous exhibits and buying knowingly and critically. In short, there is broad audience participation, which has made interior design an art for all the people, not just for a small wealthy or professional group. This has been a remarkable benefit to both giver and receiver. It has kept alive true craftsmanship as an honored, respected profession. Public and private financial support behind creative talents relieves them of being forced to come up with contrivances, too much, too fast, just to suit market schedules. They are as much respected for perfecting old forms as for bringing out new ones. The theme is not "Is it new?" but "Is it better?"

Public awareness is a tremendous inspiration to artists, craftsmen, and producers. They do everything possible to sustain and deserve it. Many pieces bear the designer's name on the back or bottom, not just the hallmark of the manufacturer. It is a sad thing in so many other countries to see a fine example of design and workmanship identified only with the producer's name, leaving the talented creator a faceless,

nameless ghost, unheralded, unidentified, and probably uninspired.

In Scandinavia, the artist is more than just a designer; he is also a craftsman. He devotes long hours to practicing with his material and never hesitates to leave his atelier to acquire more intimate knowledge of the inner dynamics and possibilities of his raw material by working with it firsthand. The very heart of Scandinavian design is this knowledge of how to work in harmony with the nature of the material. This is possible only for an artist who is also a craftsman.

The high level which Scandinavian applied arts have reached is the result of several factors:

First, the versatility and achievement of their artists and craftsmen, and the fact that their artists are *both*.

Second, the complete cooperation of industrial firms, and the encouragement and promotional support of the many Scandinavian societies of arts and crafts and industrial design.

Third, the general public's ever-growing understanding and appreciation of quality workmanship and sound design form, based on their belief that utilitarian objects should also be beautiful, from the lowliest pot holder to the finest silver candelabra.

One more element of the success of today's Scandinavian design is seldom mentioned but should be: There is no mimicry, no make-believe. All design springs from the innate characteristics of the raw material used and the function to be performed. Nobody tries to make stainless steel imitate silver, however artistic, or molded glass copy blown crystal forms. Nor are radios designed to look like telephones or antique cars.

Ulf Hård has expressed this attitude well in his book *Scandinavian Design:* "When judging the design worthiness of any object, the first consideration must be: How well has the material been used, technically and aesthetically, for the purpose to which it is being put? A bad design violates the nature of its material. And one material should not be made to look like another, even if this is technically possible, because the unique beauty of each will be lost."

The Scandinavian feels that earthen tableware can be very handsome in its own right and that it is unnecessary and foolhardy to try to make it resemble the delicate forms of porcelain. The problem with this versatile material was to find a way to make it chip less easily. It was kilned, reground, reworked, then kilned again, thus becoming harder and more durable. At the same time, its beauty was enhanced. Glazes were developed that lent infinite variety, visual and tactile. New methods were then employed to make the earthenware technically more perfect from the standpoint of usefulness, i.e., to make it ovenproof. In another, later development, aluminum was added, with the result that earthenware became flameproof.

Accenting each material for itself was an approach which early led Scandinavian designers to depart from what was labeled (poorly) "functionalism" in the revolution against embellishment and ostentation represented by the Bauhaus School and the famous Swedish design exhibition of 1930, which made "Swedish Modern" an international term. Although this break from the past served the purpose of design-awakening, the Scandinavians promptly recognized it as too unsatisfying and devoid of warmth. Ornamentation, so completely discarded by ultra-pure functionalism, was soon missed by everyone who tried to live with a style so severe and impersonal that it was contrary to human nature and to the best possibilities of the raw material. The cabinetmakers revolted against wood set in square angular shapes foreign to its nature, to the human anatomy, and to the human eye. Immediately they brought forth more rounded, softened forms, shaped and slender where exposure of grain and lightness of weight were a consideration, and curved into thickness where needed for strength and good contour. Joints were curved imperceptibly together, lending a natural look, as if growing together as a branch grows from a tree trunk. They incorporated in later designs such curvilinear shapes and restrained ornamentation as could be integral to the whole, give character and proportion to the overall form, and yet complement the function of the piece.

Good form and complete exploitation of material, combined with technical proficiency, are the fundamental underlying principles responsible for the enduring success of Scandinavian applied arts, whether handcrafted or adapted to mechanized production. It cannot be better stated than in the words of Viggo Sten Møller, director of the Copenhagen School for Arts and Crafts: "Work well done, in addition to being pleasing to its creator, commands the respect and admiration of others."

II. BEGINNINGS

Reviewing the complicated history of the Norsemen is not within the scope of this book. Yet to understand a culture in perspective, at least a capsule look at its development in the "eternal landscape of the past" is important. To this end, a few abbreviated facts on the arts of Northern Europe in earlier times are given here. The bibliography lists more extensive readings for those concerned with the antiquities.

Owing to geographical location, influences from other peoples reached the North slowly and by many-splendored routes. In a way, this was not entirely a handicap, for it gave the northern people opportunity to develop their own talents and the initiative to discover craft uses for their native raw materials. Influences reaching them from other areas were accepted, but were interpreted in their own logical way. Creativity advanced as new technical methods were evolved or imported. Luxury, elegance, and refinement in arts and crafts were highly developed in Egypt and Mediterranean environs long before they were known in the Far North, where life remained primitive until the Vikings began to sail the seas, bringing back spoils of conquest from other lands.

Ancient Times

Man hunted, fished, ate, slept, and fought in the Far North during the Ice and Stone Ages. Weapons and utensils which were buried with him in bogs or mounds have been found in Denmark. The first indication of human life in Norway and Sweden was during the Stone Age. About A.D. 100, in the Iron Age, the Finns were arriving at their chosen land, migrating north from the Baltic. It is thought they were probably in search of furs, already a negotiable trading commodity in Europe. The oldest find indicating life in Iceland is a group of three Roman coins. According to Dr. Kristjan Eldjarn (former curator of the Icelandic National Museum and now Iceland's president), mystery surrounds the coins. It may be that the Romans once landed there during their uninvited stay in Britain, or else the coins were left behind by some Celts who first journeyed to Iceland and there found a superior fishing hole. Major Icelandic settlement occurred later with Viking raids, and about A.D. 900, with the migration of some disgruntled and hardy Norwegians considerably irked by their then-ruler, Harald Hårfager.

From the Maglemosian period (7000–5000 B.C. in Scandinavia) have come objects of bone, horn, and amber which reveal early artistic ability. There were decorations of naturalistic human and animal figures, and small, well-proportioned figurines of birds and animals, interpreted to have been good-luck charms carried by hunters.

Finds from the Neolithic age (3500–2500 B.C.) in Denmark indicate a transition from hunting and nomadic living to a more settled life where agriculture and cattle raising were undertaken. Pottery making was introduced by agricultural folk, was soon mastered, and became quite elegant in line. It was decorated symmetrically with what seem to be patterns taken from intricately woven basket designs. The shapes of vessels show graceful form and good craftsmanship. Weapons of stone and flint were improvised from examples the craftsmen had seen and, lacking the metals, had crafted from materials at hand. What metals they did obtain were copper, tin, and gold, for which they bartered amber, found in the North Sea.

Metal became more available in the early Bronze Age (1500–900 B.C.), and with it ornamentation flourished. Up from the south of Europe came a spiral motif, found repeatedly on sword, ax, and various ornaments of dress. Sword blades were curved at the tip during this "spiral period" and only later became straight and pointed. The spiral craze wore itself out, but was still found occasionally in ornamentation during the ensuing ages.

The late Bronze Age (900–400 B.C.) was a zenith of artistic craftsmanship. Finds from these years yielded handsome two-horned bronze helmets, woolen tweed textiles of houndstooth pattern, belt plates and necklaces, gracefully curved lurs (trumpets), and golden rings and bracelets made with incredible neatness and precision. The rings were used in payment, and were apparently the form in which gold was imported from Central Europe. Gold foil was applied over bronze, the only form of gilding known at that time. Human figures and sun motifs were symbolic of gods and other objects of worship.

An impoverished period followed during the early Iron Age (400–0 B.C.). Celtic works of art found their way to Scandinavia during this time. Silver and bronze objects show the influence of Celtic art, especially in the flowing and curving lineal styling. Augustus's fleet touched Danish waters at the dawn of the Christian era and Rome then exerted its influence on handicrafts until A.D. 400. It was, once again, a more affluent period, especially in Denmark, and Roman silver vessels, bronze and glass objects were imported. Gradually domestic handicrafts reflected the excellence of Roman form and artistry. Classic motifs appeared, although, as always, with local interpretation of the foreign prototypes. Necklets and bracelets in bronze and gold were ornate—the gold ornaments used by citizens considered to be of noble birth, or by tribal chieftains and their wives.

In the Teutonic Iron Age (A.D. 400–800), after the fall of Rome, Northern Europeans became disenchanted with the Roman influence and again developed artistic expressions of their own. One theme in particular became dominant—the animal motif, as opposed to vine and leaf in classic forms of ornamentation. Often a stylized animal was framed in fretwork or revivals of the old spiral theme. Textiles, closer woven in the North for warmth, also grew more intricate and varied.

The Viking Era

The foregoing backdrop notwithstanding, it is with the aggressive Viking days (A.D. 800–1100) that the Scandinavians' permanent image and character took shape, beginning with a pagan, warlike society and ending with its transition into organized Christian communities. It was the dawn of distinctions between Norway, Sweden, and Denmark (Finland had always remained somewhat detached), and an era of more chief-

a
Bronze necklet ending in spirals,
exemplifying the curved and twisting
forms prevalent in the late Bronze Age.
This necklet, c. 500–400 B.C., found at
Maribo, Lolland, Denmark. [Danish
National Museum, Copenhagen]
b
Bronze necklace with sharp twistings
known as Wendel rings, c. 500–400 B.C.
Found at Røgerup, Zealand, Denmark,
from the late Bronze Age, characteristic
of the craftsmanship of that period. The
pin dates from same period, which was
the heyday of the spiral motif
c
Gold necklet, Teutonic Iron Age,
c. A.D. 500, showing development of
hinged forms. Found at Falster, Denmark
[Danish National Museum, Copen-
hagen]. Gold necklaces were a favored
ornament in this period. They became a
status symbol, indicating wealth or
position

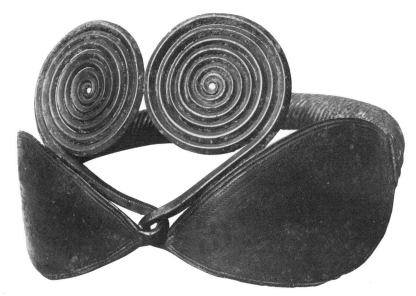

a

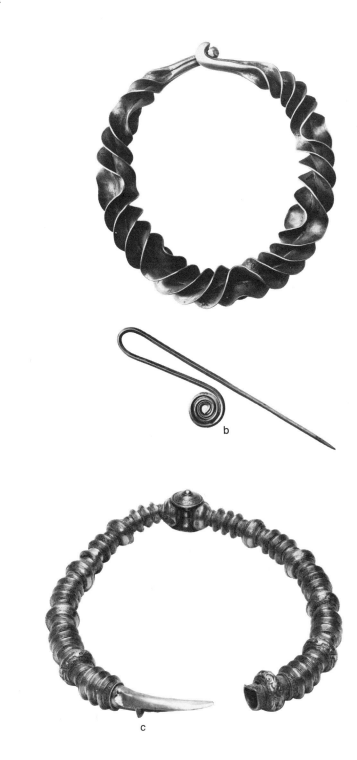

b

c

tains, kings, and shifting power plays than historians can disentangle and record without nervous exhaustion. It was a giant chess game, its joys and sorrows told and retold by the skalds (poets) and saga writers of the times. Wars gave power and wars took it away, and the Vikings in their graceful longboats explored and traded, or just helped themselves. Honey, furs, and pitch were bartered for Byzantine and Oriental luxury products and grain. "Foreign trade" became a part of Nordic life, as the Vikings conquered the seas.

The Viking favored plants, birds, and human heads in trefoil arrangements in their ornamentation. Ferocious gripping-beast designs and grotesque masks symbolizing godlike powers were popular. Metals were highly prized by the old Norsemen, and the goldsmiths of the age were masters at their craft. Burial mounds and the longboats salvaged have yielded beautifully crafted shields, necklaces, belt and breast plates, ornamental keys, and other fine jewelry of the time.

Silver was the preferred metal, though some gold was used. Necklets were worn by men, the number of circlets indicating financial or political status. Brooches were worn by the women to fasten and adorn a blouse or bodice.

Battle-axes and swords were forged and ornamented with great skill. Viking swords were masterpieces of smithery. Some were very simple, others heavily decorated. They were a slashing, cutting type of weapon, in contrast to the stabbing Roman short-swords of previous times. Upon viewing museum examples of these weapons, one marvels at how such huge implements were wielded so swiftly and expertly, for they seem a problem merely to lift.

Plundering raids on the Christian communities of Western Europe brought to the northern lands bibelots bearing figures of saints or angels. The symbolism of these objects meant nothing and they were enjoyed simply as decorative trinkets. It was not until the eleventh century, when Christianity was more or less forced with sword in hand upon these pagan folk, that other religious symbols such as the cross, serpents, and saint figures began to appear in their own handicrafts, especially in metalwork and textile weaving. The Norsemen's earliest "Christianity" was largely a business necessity, as shown in tapestries and carvings of that period, employing Christian motifs but often with pagan symbols added unobtrusively here and there. The Viking still hesitated to reject his old gods, Thor, Odin, and Freya, so he found subtle ways to assure complete coverage in regard to heavenly protection. Outwardly he acknowledged Christianity as a convenience, but inwardly he continued to believe whatever he chose.

About this time the famous *stave* churches of Norway were built. The shape and the motif of protruding beast heads on the rooflines have a definite Oriental look, a fact still unexplained, considering that little contact with the Orient had yet occurred, as far as is known. The architecture and carpentry in these structures is amazing for the time period, and now, almost nine hundred years later, they still stand solid as rocks. There were no pews or chairs; worshippers did not sit in these churches. Benches around the side walls were for the old and infirm only.

Paganism now came to an end; Christian art and the Romanesque period began a new epoch.

Medieval-Renaissance Era

In Scandinavia, as elsewhere, the Middle Ages and the Renaissance were the heyday of the stonecutters. Little more need be considered here from the standpoint of arts-and-crafts history in Scandinavia, except that it followed the trends of the rest of Europe in sophisticated design (but a little behind in time) and only peasant crafts continued to be the truly indigenous art of the area. The cross replaced the hammer of Thor as a religious symbol in carving, weaving, and metalworking, each of which techniques became more refined.

Tableware was still largely of wood and clay. Gold was used for adornment by the privileged, silver by the peasant classes. Furniture was fixed, although some movable chairs were made, including one of the early folding types. Animal heads similar to those on the *stave* churches were often carved at the top of a chair's upright supports.

Valuables were kept in chests, a custom which has continued through the generations. The more sophisticated chests had iron fittings and ornamental carvings. In more remote settlements (particularly in Norway), peasant farmers began to paint these chests, using floral motifs. This type of painting, graceful, colorful, and cheery, spread to walls, ceilings, and cupboards, even to needlework, small boxes, and the like. To this day, *rosmåling* (rose painting) is very popular and one of the most genuine and delightful of all Norwegian handicrafts.

The custom of the bridal crown and bridegroom's cross began during this period. They were made of silver of exquisite workmanship, often lent by the church or the town. The idea of the bridal crown is thought to have been borrowed from church statues of the Virgin Mary. These are still in use today. In isolated villages in the North where a silver crown is unavailable, one is made of delicately handwoven reeds.

During this period, peasant needlework grew exceedingly beautiful. Specifically in Norway, where mountains and valleys separated small settlements, each area devised an embroidered costume for the men and women of its own village, province, or valley different from all the rest. Silver jewelry and knitted sweater patterns followed this custom, too. On festive days in all Scandinavian countries, the beautiful native costumes are worn again, as much for personal joy as for the benefit of tourists. In the olden days, with multiple undergarments and the heavy embroidery in the outer clothing, some of these costumes weighed perhaps thirty pounds and involved the wearer in a couple of hours of dressing time!

Yesterday

During the seventeenth, eighteenth, and nineteenth centuries, the culture of Scandinavia continued to follow Europe's lead. Blindly it imported,

a
Runic inscription carved into a rock from Täby Parish, Uppland, Sweden. The Christian cross dates the inscription from the Viking Age, c. A.D. 800–1000. [Photo: Antikvarisk Topografiska Arkivet, Stockholm, by H. Faith-Ell]

b
Also from the Viking Age is this runic stone from Bjudby, Blacksta Parish, Södermanland, Sweden. It reads: "Torsten erected this stone to the memory of himself and his son, Hävner. To England this young warrior had gone, then he died at home. May God help their souls. Brume and Slode have cut this stone." [Photo: Antikvarisk Topografiska Arkivet, Stockholm, by H. Faith-Ell]

c
Crucifix from the twelfth century, part of a find at Gåtebo, Bredsätra Parish, Öland, Sweden. Though the style is of a Byzantine type, it is obviously Scandinavian-made, since the ornamentation is so similar to Nordic runic carvings. [Photo: Antikvarisk Topografiska Arkivet, Stockholm, by Sören Hallgren]

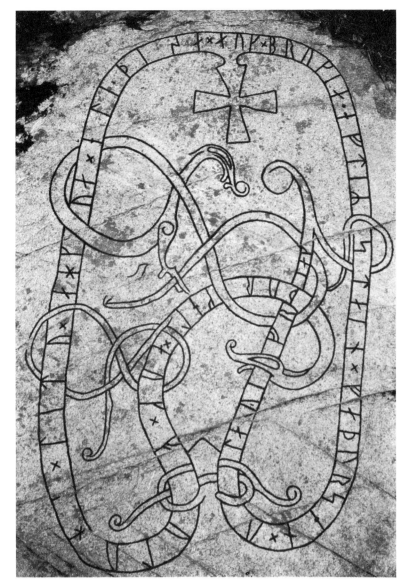

a

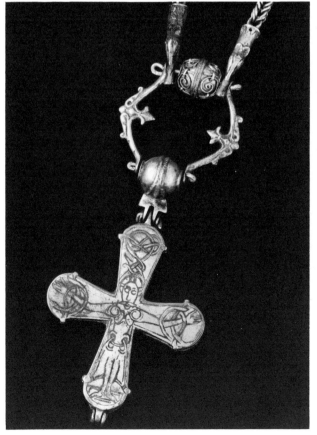

c

b

A door of carved whalebone, thought to
be from an altar, and depicting stories
from the life of Christ. Height is about
21″. Dated 1606. [Owner: National
Museum of Iceland, Reykjavik]

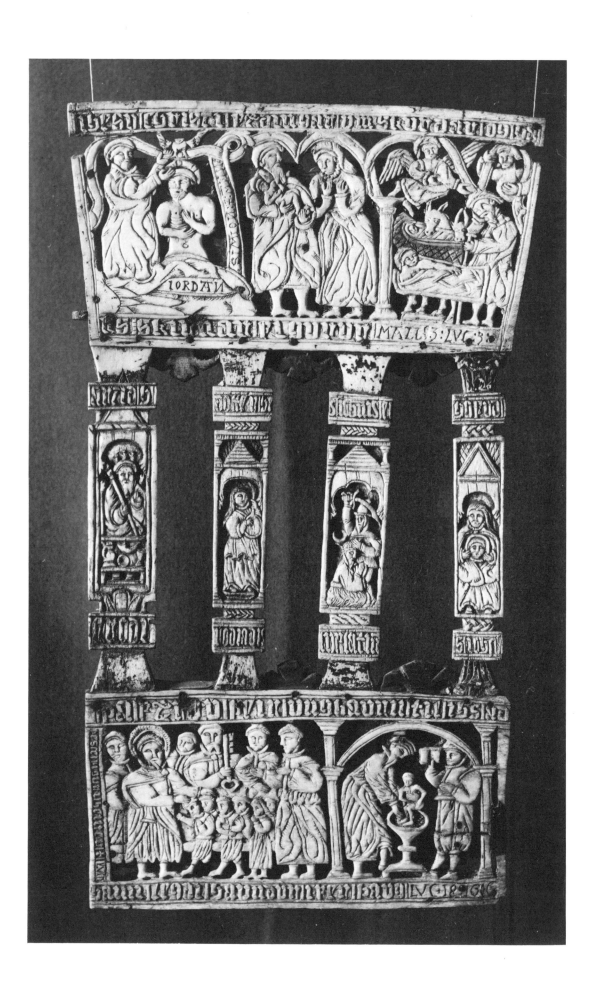

A pulpit with apostle figures, from the
early seventeenth century. [Owner:
National Museum of Iceland, Reykjavik]

copied, or revised French, Dutch, German, and English developments such as baroque, rococo, neoclassic, Biedermeier, Hepplewhite, Chippendale, Sheraton, and all the rest. "Elaborate" was in demand. Gilding, carving, engraving, embroidery, all had their fling. Some good things were made and imported, but on the whole nothing was innately Scandinavian except for minor local adaptations. What was truly Scandinavian during those years that bears on current arts and crafts?

In Sweden, there were wandering peddlers (*pedlars, knallare*) who were something special. There were hundreds of them still, in Sweden, in the late 1800's, driving carts or toting bags on their backs. Laden with home handicrafts, they traveled alone or sometimes in pairs, calling out their sales pitch with lilting musical oratory. What they carried were fabrics, ribbons, baskets, wood, tin and iron ware, earthenware, and leather. Since the *pedlar* bought his stock in one place and sold it in another, he was the instrument for transporting home handicrafts around the land. His wares were often beautiful examples of handcrafted art, and this heritage was thus nurtured through the years, and later fostered by various hard-working handicraft societies that are still active today.

Organized advancement of home industries began in the early nineteenth century, and even today a firm or shop will buy, for example, yarn, and send it out to many small outlying villages to be handwoven into textiles or knitted into the handsome sweaters for which Scandinavia is well known. Then the finished products are shipped back to the bigger towns and cities for sale. Handicraft industry is very important, especially in Norway, where many families still live in remote valleys or on mountainsides. It is still an important source of income for the isolated, as well as for the elderly people, and at the same time it perpetuates the traditional native arts.

It is no accident that designers and workers in machine-made articles in our time are no longer imported talent but almost 100 percent Scandinavian. This is a natural outgrowth of the home handicraft tradition. Both designer and worker thus have the advantage of this inherited, even intuitive familiarity with their craft, and together they are able to transmute the skill of hand-looming, hand-carving, or weaving to automated methods. Often a technician can interpret a designer's sketch into a mechanically made version without detailed break-down drawings, for most weavers, potters, cabinetmakers, and smithies have grown up in their craft. It has been their life, and they absorbed it along with readin', writin', and 'rithmetic.

Whole towns grew up around a "manufacturing estate," such as a textile or glass community. The factory was the pivotal center of life, with homes, church, school, and recreational facilities for workers and families as its satellites. Children grew older and were apprenticed in the trade. Those communities in which the plant has taken up technical advances have become larger, but the old "manufacturing estate" aura lingers, though in a modern environment.

Carl Gustafs Stad, at Eskilstuna, Sweden, is a typical example. Founded in 1650, the factory made weapons and cutting implements, needles, spoons, door and window fittings, locks and hinges, candlesticks, and even pepper mills. These were smithed in iron and steel,

though some copper and brass were used. Today the company still makes these things, plus some modern replacements such as surgical instruments instead of bleeding irons. Artistry entered the door through the hands of the craftsmen, even though mass production prevailed. Eskilstuna is still the heart of Sweden's smithy area and has been since the mid-seventeenth century. An architect named Jean de la Vallée designed in those early times a special type of building housing the forge and living quarters, with its end wall facing toward the street. It was known as a "Kronhus." The entire group, erected in a community-planned layout, is preserved today as a cultural museum.

The mid-1800's brought the great surge in industrial expansion which came with electricity, railroads, and steam engines. It opened many new fields in comparison to simple man-powered methods, but hand-work shops did not die out.

Mechanization fortunately did not entirely eliminate design excellence. Actually, good function from the standpoint of mass production still led to good design, simply because it held design to simpler, handsome forms and made maximum use of raw materials. Throughout design history, it has been shown over and over again that results are poor whenever something is created simply to be showy or snobbishly grandiose.

During this period, another precedent was set in Denmark. The Royal Furniture Store was founded there in 1777, the prototype of today's famous Danish Cabinetmakers' Guild. Cabinetmakers could exhibit there the furniture they had for sale. The quality of workmanship was carefully controlled, and encouragement was given to young craftsmen toward design excellence. Models were provided, and quality materials and tools made available for purchase. English influence on cabinetmaking was still considerable, but the interpretation was Danish. In any event, the movement started by the Royal Furniture Store led the way to further collaboration among designer, architect, craftsman, and producer, a cooperation which has been very beneficial to Scandinavian applied arts and crafts and industrial design since.

Before we leave the age of inlaid satinwood and beribboned cupids, we should note one other pioneer firm of the time. The first ceramic works was founded in St. Kongensgade, Denmark, in 1722, and became the now-famous Royal Copenhagen Porcelain Factory in 1779. It was started to compete with imports and its characteristic line at the time was white with painting in cobalt blue, still a prominent and beloved color theme in ceramics and glass throughout Scandinavia. The manufacture of true porcelain began there in 1766, using the factory hallmark of three wavy blue lines (still used today), symbolizing the three waterways dividing Denmark's land.

Today

At the turn of the century (actually beginning about 1895), following the lead of Paris, Brussels, London, and Munich, the Art Nouveau culture had a strong influence on Scandinavian design. Called Jugendstil

a
The white drawing room in the manor
house of Forsmark, in Uppland,
Sweden. Wall decoration thought to be
by Lars Bolander (1731–95). Pastel
coloring, with gilt ledges. The Continen-
tal influence at this time is obvious.
[Photo: Nordiska Museum, Stockholm]

b
Assembly room in the Swedish manor
house of Övedskloster, Scania. The
whole interior was designed by Jean
Erik Rehn (1717–93) about 1780. The
wall fabric, draperies, and upholstery
are all of red silk damask. The fine
old Swedish tiled stoves are white with
green decoration. [Photo: Nordiska
Museum, Stockholm]

c
The "Herrstuga," best parlor room in
a farmhouse from Delsbo, Hälsingland.
This has now been moved and rebuilt
at Skansen (the open-air museum of
Stockholm), along with many other old
homes from the Swedish countryside.
The wall decorations, indeed very
Swedish, were done by the brothers
Erik and Anders Andersson from
Leksand, Dalarna, in 1819. The furniture
pieces illustrate how an imported style
was interpreted in a local way (in this
case Gustavian) by provincial craftsmen.
[Photo: Nordiska Museum, Stockholm]

d
Parlor with typical old Swedish decora-
tion, in a home from the Delsbo farm-
stead, at Skansen open-air museum in
Stockholm. The interior (from the village
of Tjärnmyra, Delsbo Parish) was done
by Gustaf Reuter (1696–1783) between
1748 and 1773. [Photo: Nordiska
Museum, Stockholm]

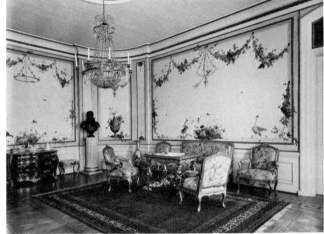

a

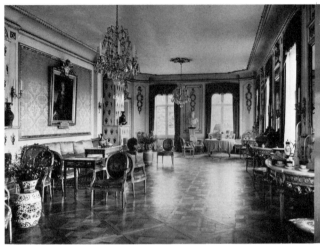

b

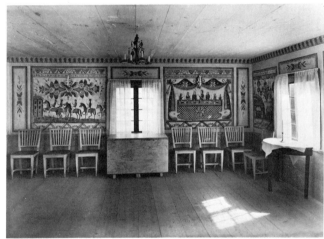

c

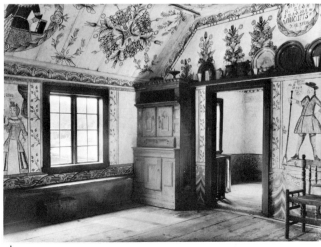

d

a
Footstool carved in pine and painted
light blue, with gilt edges. From the
town of Vadstena, Sweden, c. 1740.
[Owner: Nordiska Museum, Stockholm]
b
Counterpane from Bohuslän, Sweden.
The pattern of the weaving is character-
istic of the peasant variation of figured
double weaving in "tabby" binding.
Used in a farmhouse and probably
woven by a farmer's wife, c. 1787.
[Owner: Nordiska Museum, Stockholm]
c
Counterpane from Scania, used in a
farmhouse and probably woven by the
farmer's wife. Initials and dates woven
in border. Note it is woven in two parts
joined down the middle, due to the
limitations of loom width. [Owner:
Nordiska Museum, Stockholm]

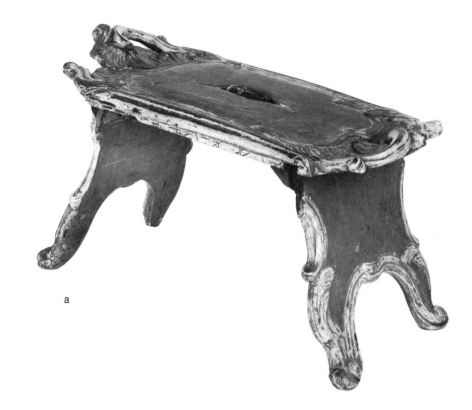

a

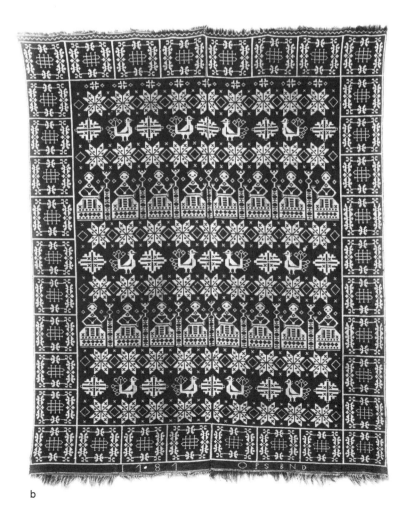

b

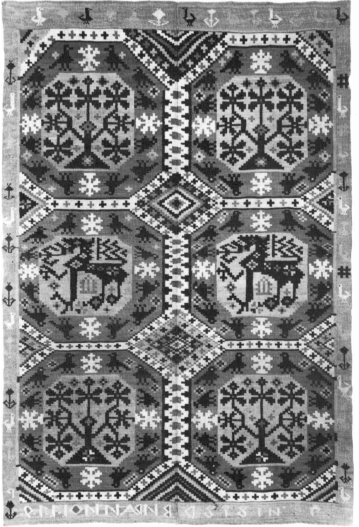

c

a
Neo-Gothic style escritoire with mahogany veneering. Made by then-journeyman Fredrik Rambach of Stockholm in 1834 to qualify for the rating of master journeyman/cabinet-maker. [Owner: Nordiska Museum, Stockholm]

b
Old wagon cushion from Skåne, hand-woven with a typical Swedish pattern. [Owner: Nordiska Museum, Stockholm]

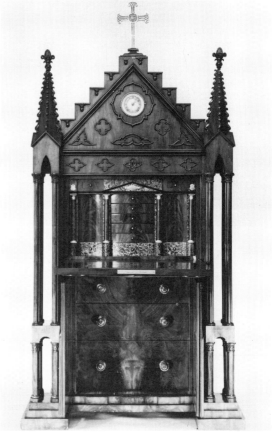

a

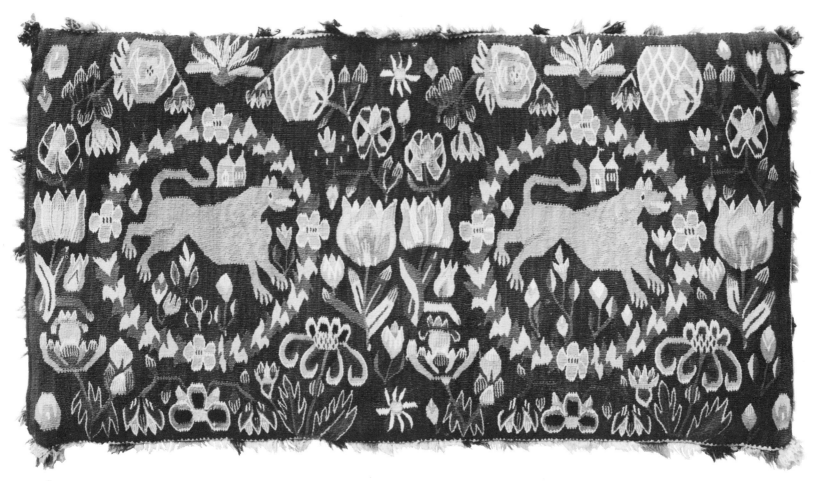

b

in this area, it held sway until World War I. Local individuality was evident in the use of native flowers, birch leaves, or pine twigs, rather than the iris and chrysanthemum used elsewhere in Europe. The style mainly pervaded ceramics and textiles, and occasionally glass and furniture. Some excellent examples of Jugendstil are illustrated in this section.

Suburban living began about 1915, and brought with it a lively new interest in home decoration, down to such minute details as door handles and coathooks. Architects, sculptors, and painters became a wellspring of fresh ideas for interior furnishings. Simultaneously, the Jugend style, although it had charm, clung to the same old shapes and overworked themes, and gradually became tiresome. The Baltic Exhibition in Malmö, Sweden, in 1914 turned out to be its swan song (except for a degree of revived popularity today).

Into this temporary design vacuum—which was international—came functionalism. The Walter Gropius Bauhaus movement, and the German Werkbund crusade—one offering pure functionalism and the other working for art in household furnishings—gave rise to a movement toward lighter types of furniture more suited to twentieth-century living.

In Scandinavia there developed a revival of interest in native handicrafts, and an appeal for "more beautiful things for everyday use." Five countries of nature-oriented people, delighted to rid themselves of copying, happily bade farewell to what they considered artificialities, such as stain and varnish on wood, a material beloved by them, which they felt was more attractive and less trouble in its natural state. Suddenly ingenuity was revived, rejuvenated, reborn.

The demand for better everyday things was not entirely aesthetic. To some extent it was the result of the man in the street's rising expectations, improving taste, and growing income. There was academic encouragement, and certainly some producers foresaw profit in the endeavor, along with being sincerely eager to encourage cultural growth. For all these reasons, enthusiasm grew for developing more attractive products which would add to the pleasure of home life and relieve the monotony of what was then available. Furthermore, there was a strong desire for a revival of real Scandinavian originality. Since this was also a time of massive industrialization, a merger of capability and aesthetic longings led to success.

Nordic applied arts first gained international attention at the Paris Exhibition in 1925. The glass impressed the critics, both for the delicately engraved pieces and everyday wares, and for the fact that the producers were as proud of their handsome everyday products as they were of their exclusive art pieces. There followed the sensational Stockholm Exposition of 1930, and then successful showings at World's Fairs in Chicago in 1933, in Paris in 1937, and in New York in 1939. Since then, Scandinavian design has been honored regularly at international exhibits, fairs, and world competitions.

The Stockholm Exposition, held at the high noon of pure functionalism, touched off a cultural feud that echoed around the globe. Devotees of tradition butted heads with advocates of bare functional form and a new way of life. There seemed to be no middle ground. The sensational

developments—good or bad—did accomplish one important thing. People in all walks of life began taking at least some degree of interest in such things once more. The pendulum soon swung back from extremism to the more satisfying humanized functionalism we know today —somewhere between the overdecoration of many old styles and the cold, uncomfortable treatment offered by pure cubism and functionalism. Design forms from Scandinavia are now graceful, uncomplicated, and decorated only where it enhances the whole. They are suitable to be the antiques of the future, mellow and welcoming to the family and its guests—things to be proud of, offering artistic warmth, comfort, and dependability.

As extreme functionalism disappeared, the great transition of the Industrial Revolution grew. The entire production of glassware, ceramics, silverware, furniture, textiles, and stainless steel shifted from handcraftsmanship to mechanized systems, or a combination of the two.

Before this phenomenal changeover, people had been in close touch with craftsmen. The things they owned were often homecrafted or else made by craftsmen specifically to order for them. Such personal contact led to recognition of and appreciation for fine workmanship, good design, pleasing proportion, and the expedient use of materials. To put it simply, having tried to make, let's say, a chair, one soon appreciates just how complicated the job is—what time, patience, and skill are required to carve and join wood correctly, to judge stress, to reveal the best grain, and to come up with a flawless finish.

With the swing to industrial manufacture came an almost total lack of appreciation for design or quality of workmanship and material. *Almost.* And that "almost" represents an ethereal entity in man which cries out for individuality and for the great joy of working with one's hands. It could not go on forever, this acquisition of routine goods, indifferently made, which meant nothing personally to the owner. The revolt against impersonality in design represented by "Swedish Modern" (which never caught on in Sweden, incidentally) and other extreme cubist or functional forms in the 1930's spread to the rest of the world. And so, many people turned to the "how-to" hobbies of woodworking, upholstering, sewing, and needlework—not to mention the joys of working at a potter's wheel, restoring antiques, china painting, and other handicrafts.

This, in turn, brought back a genuine interest in all the applied arts, and a more educated appreciation of refined form and color experiment. There is now a happy tendency toward good taste and lasting quality. We must hope that junk has had its day. The buying public expects and demands even industrialized production to present items of reasonable durability and sound design, even in the most ordinary utensils and furnishings.

All this has come about in the past thirty years, and Scandinavia has led the way. Artists, designers, and craftsmen work today separately, together, and with industry.

Some artist-craftsmen maintain their own independent atelier. Creating something new is their primary goal, and their works are largely one-of-a-kind art pieces, each handcrafted and signed. They exhibit on

Green bowl with pansies in transparent light blue, in "cased" glass. Designed by Gunnar Wennerberg at Kosta Glassworks in Sweden, about 1905, in the middle of the Jugendstil period

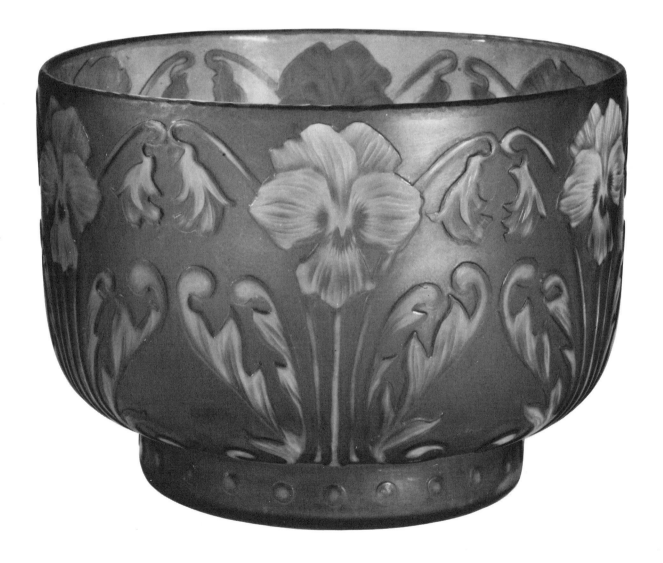

a
Typical Jugendstil (Art Nouveau) ceramics from Finland. [Arabia. Photo: Pietinen]

b
Plate of bone china, decorated in low relief. Lilies-of-the-valley design hand-painted in green and white. Designed by Gunnar Wennerberg in 1897, early Jugend style. Made at the Gustavsberg factory near Stockholm. [Owner: Nordiska Museum, Stockholm]

c
A variety of flasks from Sweden. L. to R.: (1) Perfume flask from Kosta (2) Provincial styling typical of Erik Höglund of Boda (3) Delicate stemmed bud vase by Edvin Öhrström of Orrefors, made in clear, aquamarine blue, or pale gray. (4) A cruet, an old and still timeless design in blue or clear crystal by Edvard Hald, pioneer artist of Orrefors

d
Timo Sarpaneva's thoughtfully designed casseroles and pans made by Rosenløw of Finland. The pots in black or clear red enamel on cast iron are lined in white and made for flame/oven/table/refrigerator use

a

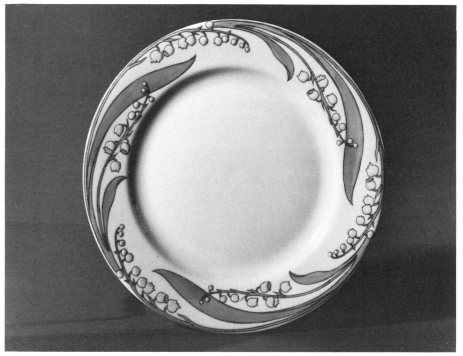

b

d

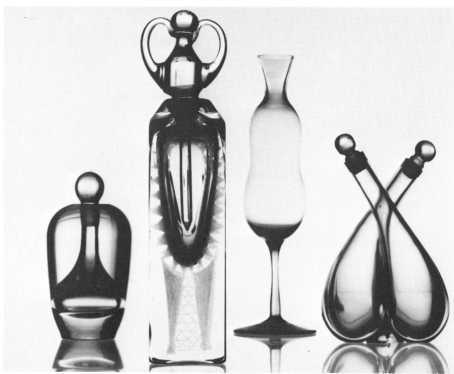

c

their own, in shows sponsored by arts and crafts organizations, occasionally in international contests such as the Milan Triennale, the Sacramento (California) exhibits, the Design Cavalcade (held each September in all the Scandinavian countries simultaneously), and in local exhibit areas. Award-winning objects are often acquired by both national museums and those specifically devoted to the applied arts and industrial design, and also by such preservers of "high culture" as the Museum of Modern Art in New York.

The artist-designer whose talents are employed in industrial design, on the other hand, works with a team. The designer and the skilled craftsman must work closely together, to solve problems above and beyond what the raw material and new production methods allow. For example, a coffee pot in the company's line may be of only average design, with perhaps a dozen small parts to be made and assembled. It will be totally redone, with more simple and elegant lines, and its parts reduced to four or five in the process. The new pot will now be more efficient, more attractive, easier to keep clean, and at the same time less expensive to the homeowner, since it is less expensive to manufacture. It will also last longer, for fewer working parts mean minimal breakdowns, repair, and replacement.

The industrial team also includes representatives of the sales and purchasing staffs, the factory engineer, the production manager, and perhaps others. It is a team of specialists, and they must coordinate all factors. The modern designer is the team leader, and with his colleagues is responsible for the appearance, utility, and salability of the final product.

The interchangeability of both these segments of artistic endeavor has been remarkable. Many work as individual creative artists who sometimes contribute to industrial design, or as industrial designers who at the same time are allowed full freedom to do something on their own in the way of an art piece if so inclined. Talent is never restricted. Furthermore, these are artists who make it a point to work firsthand with their raw materials. They never hesitate to get their hands dirty in the shop in order to explore all the possibilities and limitations of each material, and thus to find new avenues of discovery for its use.

Complementary to these artistic souls is the ample number of experienced and outstanding craftsmen who stand with them in their drive toward better products. The skilled craftsman, highly respected for his work, takes great pride in his ability to interpret what the artist has proposed. There is a wonderful sense of togetherness in accomplishment shared by the designer and the artisan who can bring his idea into being with perfect interpretation, and with the best quality built into the finished object. Often this feat is carried out largely through the experienced eye and sure hands of a man whose life has been spent in his particular craft until he can work almost by instinct.

In Sweden, about 1916, the Swedish Society for Industrial Design began its campaign for better design in everyday wares, stating that artists should not confine their efforts to one-of-a-kind exclusive pieces but apply their talents to utility goods as well. One of the first to pick up the challenge was the team of Simon Gate, Edvard Hald, and the Orrefors glass firm. Orrefors gave its designers complete control, with Hald as managing director. Now legend in Scandinavia are the words of the head of Orrefors to these two men: "Make something beautiful. Do something different. Take all the time you need."

It is said that Gate and Hald were creative, inspiring, and constructive —also personable and lovable. Under their aegis, the Orrefors community, nestled in the sylvan beauty of the Småland countryside in southeast Sweden, grew prosperous and happy. Vicke Lindstrand later joined the firm and also contributed to its success. Additional firms in this and the other Scandinavian countries promptly took up the crusade, and each has stimulated the others.

It would be difficult today to name a company making articles for the home in any of the five Nordic lands who did not base its production on models created by an artist and interpreted by a master craftsman before they are manufactured. The project for bringing artists into industrial design has spread to all manner of products. The close relationship between good design and good function has also entered into the manufacture of cars, appliances, door handles, hand tools, office equipment, and of course the enormous, ever-growing field of packaging.

Count Sigvard Bernadotte, of the Swedish royal family, designs such things as china and cutlery, but also contributes his brilliant ideas to the improvement of such mundane items as adding machines, window fans, lavatory sinks, plastic brushes, portable camping equipment, even kitchen stoves. He is typical of today's designer, who is sensitive to all objects encountered in his everyday environment, notices that something could be bettered, and is then motivated to improve it in some way.

Timo Sarpaneva of Finland is another alert and versatile artist. Such things as candles, printing methods, stationery, wrapping paper, and men's fashions struck him as having been boring and unimproved for years, whereupon he promptly did something about it. He has improved the style, form, and color of many ordinary articles, making them instead extraordinary, and in so doing has also perfected (and sometimes wisely patented) a better method of production, instrumental in cutting costs while simplifying techniques for the manufacturer. The result: more artistic wares, more simply made, more available to the person of average or modest means, more practical in use, and thus more worthwhile to own and live with.

The trend toward artistic influence in household design was also a natural outcome of architectural demands. Alvar Aalto (Finland), Poul Henningsen, Arne Jacobsen, and Kaare Klint (Denmark), for example, made exciting architectural advances in building design. When they found no furnishings, lighting fixtures, or textiles in harmony with their innovative structures, they began to create their own.

Arne Jacobsen has been not only a building architect of international renown but he has designed furniture, textiles, glass, silverware, porcelain, wallpaper, stainless-steel cutlery, and lighting fixtures. They have stemmed from a specific need for a specific building, and then been carried into general production. His designs are unrestrained, but done with architectonic simplicity and dignity. They demonstrate well an architect's feeling that furnishings and other building decor must blend

somewhat anonymously with the room or building as an architectural whole for the ultimate in eye-pleasing, soul-soothing environment.

Scandinavian furniture designers have been thorough and thoughtful in their work, and in Scandinavia are referred to by the significant term "furniture architects." Kaare Klint, Hans Wegner, and Arne Jacobsen of Denmark, Bruno Mathsson of Sweden, and Alvar Aalto of Finland, among others, have based their furniture designs on exhaustive research and computations of the human anatomy in various positions at work and in repose. Was there any reason why a chair should not be comfortable . . . a table the proper height for both eating and paper work?

Based on Kaare Klint's earlier meticulous studies of storage needs in the average household of his day, Børge Mogensen and Grethe Meyer of Denmark extended the analyses, updated them, and then designed (for Boligens Byggeskabe, Inc.) their B.B. Cabinet System of sectional storage units to meet every conceivable demand for specialized storage space. It considers storage of clothes, linens, laundry, books and magazines, writing space, drawing and painting materials, musical and sound equipment, and tableware. Thorough planning characterizes every detail. Hinges were designed that permitted the doors to be opened at right angles while the drawers were also open. The key (also a handle) is recessed to avoid catching on clothing or marring a wall or another cupboard when the door is opened. The units are painted and sold for self-assembly, which is simple and money-saving in shipment, and to the buyer, who presumably has and can use a screwdriver.

This theme of thoughtfully planned workability has advanced individual and industrial design steadily in every material. Thorbjørn Lie-Jørgensen, Norwegian painter and silversmith, was one of the first to incorporate the perhaps graceful but still troublesome spout into the main body of a silver pitcher. The firm of Høyang in Norway turned out cooking-pot covers which are flat, with a heatproof handle off to the side. A few sizes of these—about three—accommodate almost any cooking pot. Fewer pot lids and less storage space are required.

With space at a premium in modern-day small homes and apartments, the demand for stackable, foldable everything brought from designers new shapes in chairs, glassware, china, and all manner of utensils. Textile manufacturers, answering the need arising from the disappearance of servants, came up with the elimination of the drudgery of ironing, and of the risk of shrinkage and color fading.

Kaj Franck, at the Arabia ceramics factory in Finland, eschewed the limitations and waste of china sold at the time only in "sets" containing many pieces seldom used and crowding cupboard space. He began a whole new era of mix-match tableware, back in the 1940's, when mix-match was unheard of. Today we take it so much for granted, in dishes, in clothing, in furnishings, that it is easy to forget how revolutionary Franck's notion was. It was Franck who at the same time deplored the inefficiency of a wide, flat rim on plates, obviously there mainly to support a design. (The wide rims had at one time been both functional and decorative, for they permitted servants to handle plates easily and without touching the food; with the virtual disappearance of the servant class, the rims became useless.) He enlarged the center of the plate for more attractive, uncrowded serving. He angled up the rim, not only an improvement for foods with gravies and sauces but also making the plates stack more securely.

Axel Brüel, who rather late in his career turned to ceramics, created for the porcelain factory of Danmark, Inc., the tableware called "Thermodan." This is a double-walled porcelain service of graceful simplicity, slender enough to fit comfortably in the hand, with insulating space between inner and outer layers. It entirely eliminates the need for handles, which are inclined to break off in use and are a real nuisance in shipment and in cupboards.

Erik Herløw of Denmark departed from well-known styles of flatware which were largely variations of one basic form with different decorations. He created "Obelisk" in stainless steel. "Obelisk" has solid handles made to balance correctly both in the hand and on the plate. The handles are round where the fingers rest, flat at the end to avoid rolling. The knife blade is short and angles, so the entire blade is used in cutting, instead of just a small spot toward the tip. He continued the use of Kaj Bojesen's earlier development of the three-pronged fork, which picks up food better than a four-pronged one, and is less inclined to split the food in the process.

Architect Poul Henningsen pioneered functionalism in lighting fixtures. Using a petaled effect, his lamps threw light in one or more directions as needed without the bulb's rays hitting the eyes and without reflecting the rays more than once. These "PH" lamps are world-famous. Designed many years ago, they are as up-to-date as tomorrow.

The firm of Arabia in Finland, with its happily pampered stable of superb designers, has led the way in both artistic and technical progress in the ceramics field for over twenty years. Among its many accomplishments are its improvements in attractive cooking-serving utensils of clay, so treated as to go from refrigerator to open fire, or oven to table.

Most of the design leaders mentioned above were way-pavers, and they are now teachers as well. The newcomers learn from them and are encouraged by them. The ties are close.

Progress and discovery . . . beauty and convenience . . . comfort and practicality . . . economy and virtue . . . all these traits represent what has happened to Scandinavian design in the twenty years just past, which has been so beneficially contagious to other nations. The results have been happy for their own people, too: they have learned what is good, and are living with these good things in their homes. Family-and-home is still the basic way of life for the Scandinavian people, and what they introduce into it must have integrity, flexibility, and charm for them and their guests.

a
Rocking armchair of laminated birch bentwood by Alvar Aalto. [Courtesy Artek, Helsinki]

b
"Casablanca" dishes and saucepans can be stacked onto one another. [Manufactured by Hackman and Co., Finland]

c
Crystal vase designed by architect Alvar Aalto, acquired by the Museum of Modern Art, New York. [Courtesy Artek, Helsinki]

a

b

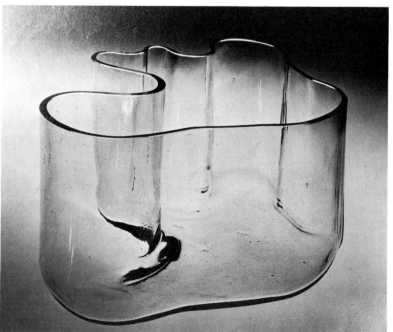

c

a
Egg cup of a cleverly designed table
service by Kristian Vedel, 1958, still
popular. Made by Torben Ørskov & Co.
of Denmark in white, red, and black
melamine. [Courtesy Den Permanente]

b
A spice cabinet to end all spice
cabinets is this one of wood and
plastic called "The Modern Pantry."
Dozens of sizes and arrangements
are available in this space-saving
Norwegian design

a

b

a
Danish architect Poul Henningsen
gained world renown with this "Arti-
choke" light fixture, architectonically
designed for diffused lighting carefully
reflected. Produced by Louis Poulsen,
Denmark. [Courtesy Den Permanente.
Photo: Strüwing]

b
Artistic and practical enamelware by
the Finel division of Wärtsilä, Finland

c
"Rustica," in clear or smoky glass,
illustrates Franck's conscious effort to
point up the innate characteristics of
the glass itself. The cylindrical, squat
form is typical of his table glasses.
[Nuutajärvi]

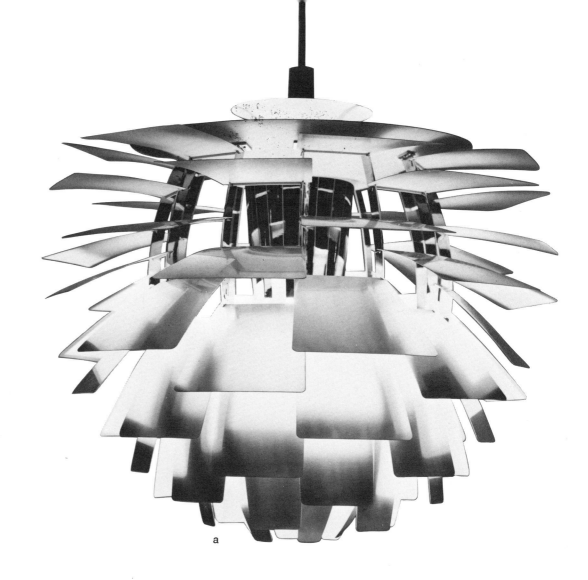

a

b

c

III. CERAMICS

Just as every one of us, as a child, played with clay, making mud pies, little coiled snakes, baskets with fruit (bananas were my specialty), tiny dishes, even Giacometti-like figures, so man has made things of clay ever since he drew breath on this planet. His history is revealed in the way his pots have become more refined through the ages, by improved techniques and superimposed decorations. The earthy nature of this primitive substance is predominant in almost anything made of it, offering a strong communion with the artist who works the soft, responsive mass into something almost alive. Even in industrialized production, clay pieces are an extension of an original model formed by the touch of human fingertips—much as always, though possibly the wheel is now power-driven. (I say possibly, because many potters today still prefer a foot-driven wheel.)

Well-designed clay objects should offer this personal appeal to the observer and arouse a longing to touch the object, not merely to look at it. Any decoration or color glaze applied should not overpower but should be in complete harmony with the basic form and the raw material. Rounded shapes are more natural and therefore more sound design in clay, simply because of their intimacy with human hand and wheel. (*Some* good artists make hand-formed, squarish shapes, but these obviously bear the imperfections that say "hand-shaped" and therefore do not lose their "personal" imprint.) Clay products made with molds may be aesthetically at odds with the raw material—somehow the intimacy is lost.

The current reaction against impersonal, industrially made objects is perhaps most obvious in the field of ceramics. Prior to the fifties, the aim was simplicity, a matte glaze, and an attempt to make everything look like porcelain. Presently, the handcrafted shapes, using coarse grains and colorful glazes, either glossy or transparent, are enjoying a deserved popularity, showing a new awareness of more primitive clay handling. High- (or hard-) fired stoneware, appealing in itself, is now often enhanced with metallic glazes added during a second firing at a lower temperature. New clay formulas, which can be lightly fired, offer multiple possibilities for newly developed ornamental glazes.

Ceramics production began in Scandinavia in 1722, when the Delfts Porcelains eller Hollandsk Steentøys Fabrique was established in Denmark. It made mostly blue-and-white faience after the Netherlands style and method. True porcelain was first made in Denmark after a local supply of kaolin was discovered on Bornholm Island in 1755, and after the formula (a soft paste type) was obtained from a Frenchman named Fournier who worked in Denmark from 1760 to 1765. With the Bornholm kaolin (and later other ingredients to refine the formula), the quality of the porcelain was much improved. In 1779, Den Kongelige Danske Porcelains Fabrik (the famous Royal Copenhagen Porcelain Factory) was officially established and taken over by the government. New artists were hired, some German, some Danish. This factory later won fame in 1889 when it devised "underglaze" decoration. The colored pattern was applied directly on the bisque ware, then the glaze applied, one of the really significant new methods developed during the nineteenth century.

During the eighteenth century, Scandinavian porcelain and pottery design was so based on borrowed ideas that nothing was very original, and finally there wasn't anything left to imitate. German design became the prototype of Danish wares, although the Danes did at least alter this influence by rejecting the Germans' gilding and rather garish colors, preferring more natural ones for flowers and scenes. Many of the eighteenth-century ceramics are in Scandinavian museums, and the influence of Meissen, Chinese, Japanese, English, and French painters and potters can be easily identified, including the Meissen "Onion" pattern and the Wedgwood "Egyptian" and "Etruscan" patterns, and a blue-and-white one called "Muschel," of obscure beginnings but probably German, which is made to this day.

At the Royal Copenhagen factory, a sudden refreshing break from the eternal copying occurred with the design of the famous "Flora Danica" dinner service. It was begun about 1789, reputedly intended as a gift to Catherine II of Russia, who died before it was completed. This service is artfully decorated with botanical paintings by Johann Cristoph Bayer. Here at last was a return to nature as an inspiration, after a century when artists had deserted the natural in favor of turning out ornate designs in accord with the consumer demands of that particularly affluent time. "Flora Danica" was a great step forward in good ceramic design: the paintings were graceful, delicate, and so botanically authentic they were scholarly. By 1797, 2,528 pieces had been painstakingly completed, with 180 still to be made. In 1802, the court ordered the work terminated, but it represented a turning point away from the eighteenth-century mimicry. The Danish royal family exhibits "Flora Danica" proudly and uses it on great state occasions. It is once again in limited production, available in the United States at Georg Jensen in New York, and highly prized by collectors.

In Sweden, a porcelain factory was begun in 1759 called Marieberg, located at Kungsholmen, Stockholm. It soon switched from porcelain to making only faience, and in 1788 it closed down. The only other prominent name in the early history of ceramics in Sweden is Rörstrand, established in 1726 with government funds to manufacture pottery in the Delft manner. This was only one of many industries nationally underwritten at the time to revive Sweden's sagging economy.

A native of Holstein, Johan Wolff (who came to Sweden via Copenhagen) was the works manager. He was followed by three others, all German, until at last a Swede named Anders Fahlström took over and the factory really blossomed, as did export business. It was, however, a man named Elias Ingman who brought the factory to real success. Under him, it went through phases of French influence, and later British. Rörstrand survived trade crises and foreign competition, and at the close of the nineteenth century this fine producer of Swedish ceramics and porcelain had about a thousand employees and it relocated at Linköping in a large modern plant, one of the best equipped in Europe today.

In the meantime, the ceramic works of Gustavsberg (which we will

"Flora Danica" represents a big step forward in ceramic design made in the eighteenth century—a totally original design departing from centuries of copying or interpreting traditional themes. Produced from 1789 to 1802, 1,500 pieces of this magnificent service are still used by the Royal Court in Denmark on special occasions. A second set was made in 1863 for the Danish Princess Alexandra's wedding to the Prince of Wales. Since then, "Flora Danica" porcelain has been in regular production and is highly coveted by collectors. [Royal Copenhagen Porcelain Factory, Denmark. Photo: Strüwing]

discuss later) was established in 1827. Both firms have flourished and become well known for their excellent products. In 1874, Rörstrand set up a Finnish subsidiary, the now world-famous Arabia firm. It passed to Finnish ownership in 1916 and is the largest of its kind in Europe. Twice later the Arabia firm fell under the control of other than the Finns, and something must be said for that old Finnish *sisu* that always when in Finnish hands the firm progressed by leaps and bounds; in the hands of others, it failed.

Sweden's ceramic industry developed in Scania on the southern tip of the peninsula. In the eighteenth century, Sweden's government, striving to develop local industries and find new sources of raw materials, sent scouts to seek out possibilities. Near Scania there were coal and fire clay. A mining company was started, making fireproof crucibles and other items of this sort, in 1737. To this day, Scania potters' wheels spin in this area, and it remains the Swedish crucible of the ceramic arts. In 1833, with the discovery of many types of clay suitable for tableware, tiles, etc., the pioneer firm, named Höganäs, converted to household earthenware. Potters and glaziers were recruited from the area, and the products were based on true Swedish-peasant traditions, a move that is never an artistic mistake. Höganäs pottery wound up its activities long afterward in 1926, having introduced to the craft the touch of the Swedish artist at last.

During Höganäs's one hundred years, potters, glaziers, and designers had grown up with the craft and the community, so they carried on the traditions on their own. For example, Karl Andersson and Sigfrid Johansson joined together in a firm that grew to over fifty employees. There was also Ville Sjöholm, who had his own kiln, and a skilled ceramic artist named Åke Holm, who is presently famous for his highly individualized stoneware with the look of sculpture. Holm has experimented with new forms and new types of glazes. Andersson and Johansson later merged with a larger firm, Nyman and Nyman's Höganäskeramick, in the belief that there was more progress to be made by joining hands than by competing. The Scania traditional community of potters continues to grow and produce new things, and it is a fascinating, enticing place to visit in Sweden.

Some of the Höganäs potters did wander off after 1900; one of them was the distinguished ceramist Berndt Friberg. He joined the firm of Gustavsberg in the 1920's and has been one of their finest artists ever since. Patrick Nordström, born and raised in Höganäs, became involved with pottery later in France. About 1900 he settled in Denmark with a furnace of his own, experimenting with glazes and stoneware with great success. In 1912 he joined the staff of the Royal Copenhagen Porcelain Factory.

In Höganäs today, in addition to the larger concerns, there are many small workshops where handcrafted pottery is still made and new techniques are developed in handling, firing, and glazing clay.

Norway

The first ceramics firm in Norway, Herrebøe, was begun near Fredrikshald in 1758 and moved to Drammen in 1762. About ten years later it failed financially, but during its brief existence under the leadership of the enterprising Peter Hofnagel, a handful of talented ceramists turned out some very nice work. Unappreciated at the time, these were later—in 1900—exhibited at Kunstindustrimuseet in Oslo, and were much admired, with some pieces bringing prices as high as $1,500.

In the town of Porsgrunn, about 1880, profitable employment was needed at a time when shipyard activities were at low ebb. There was also a need for modestly priced porcelain, and there were handy local sources of feldspar and quartz. Since ice was then shipped to England from Porsgrunn, it would be cheap to carry English china clay and coal on the way back. Labor was available and the nearest competition was in Germany, Sweden, and Denmark. Thus the Porsgrund Porcelain Factory came into being, and still dominates the field in Norway today. The kilns were first fired in 1887, staffed with foreigners, under the direction of one Carl Maria Bauer, a young German ceramist who later had a brilliant career with Rosenthal in Germany. Bauer laid out the plant and directed its beginnings before returning to Germany. The Norwegians soon began to interpret things in their own way, though they remained under other European influences until well into the 1900's, just as most firms in Scandinavia did. It was Hans Flygenring who during 1920–7 finally broke away from Art Nouveau forms with more heavily molded models somewhat Oriental in feeling. In 1927, the Norwegian Society of Arts and Crafts and Industrial Design, in a move to encourage originality, asked the artists and firms to submit objects for their 1928 exhibition in Bergen. A young student at the State School of Arts and Crafts, Nora Gulbrandsen, won wide acclaim at the exhibit, was promptly employed by Porsgrund, and had a long career with the factory. Her early style was functional in shape and color, even extreme at times, but after 1935 she favored less severe forms and softer contours.

In 1952, an outstanding talent turned up under Porsgrund's own roof in the person of a young Norwegian named Tias Eckhoff, who had been with the factory for some years. Others who have accomplished great things for Porsgrund since then are Konrad Galaaen, Anne Marie Ødegaard, Grete Rønning, Leif Larsen Enger, and the prominent designer Eystein Sandnes, who took over artistic direction when Tias Eckhoff left the firm in 1957 to work independently. (Eckhoff is still linked with the firm as a consultant.) Designs by Eckhoff and Sandnes have chalked up three gold medals and one silver at the Milan Triennale exhibits, in which Porsgrund participated in 1954, 1957, and 1960.

Tias Eckhoff is a perfectionist. His precise forms display a disciplined but individual artistic integrity and economy of line and decoration. They adapt readily to industrialized production. Eckhoff has earned many awards from Milan and other international exhibits. Besides his ceramic work for Porsgrund, he has also designed silver flatware for Georg Jensen ("Cypress' in sterling, Milan gold medal winner) and stainless-steel tableware ("Fuga" and "Opus") for Dansk Knivfabrikk, his ever popular "Maya" in stainless steel for Norsk Stålpress, and even a practical and charming teakettle in natural and colored aluminum for Halden Aluminiumsvarefabrikk in Norway.

a
"Spire" (also called "Snow China"),
designed for Porsgrund by Konrad
Galaaen, is uniquely shaped and thinly
cut to emphasize the distinctive
character of the porcelain itself
b
A carefully simple contemporary dinner
service series designed for Porsgrund
by Eystein Sandnes, and named
"Jubilee." Quietly dignified by itself,
it is also sometimes decorated

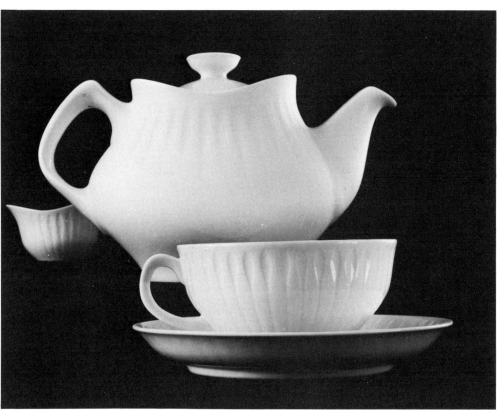

a

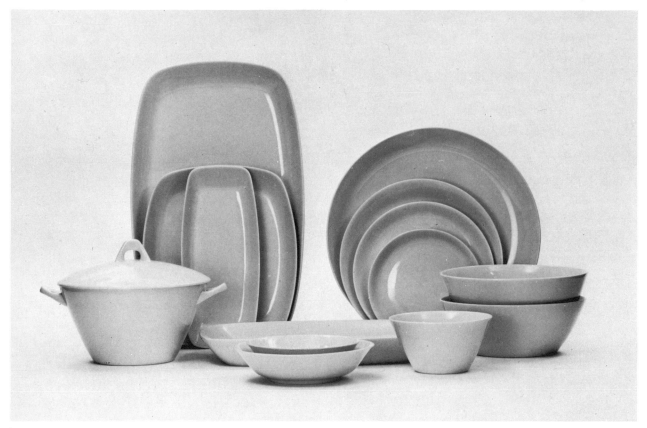

b

Tias Eckhoff, winner of many design awards, created this well-proportioned service for Porsgrund, suitable for everyday use and sturdy enough for restaurant use also. Alongside: variations in shape and size of tea or coffee servers, lidded and stackable

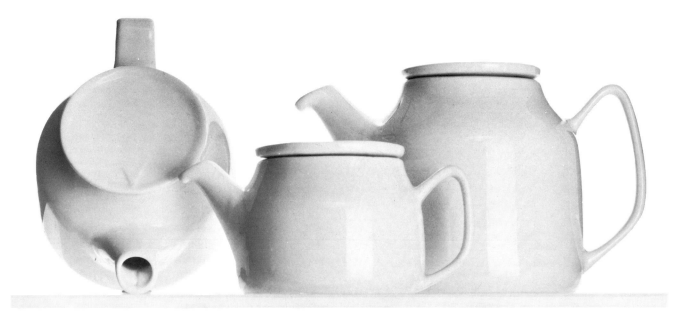

Norwegian ceramics are made mostly in independent ateliers, for large industries are still relatively few: Porsgrund-Egersund; Figgjo Faience Factory, founded in 1948: and Stavangerflint, founded in 1946. These three carry the market as far as industrialized production is concerned, and turn out interesting specialty lines, too. But Norway's small studio potters are many and excellent. They numbered over five hundred after the German occupation of World War II and did a thriving business. All other materials being next to impossible to get, ceramics made from local clay were almost the only things available to buy for small gifts. Like other Norwegian design and art, stoneware and other clay products express a feeling of good cheer. Decoration is cozy and earthy, and designs are most often related to folk art, fables, and family.

An internationally known and respected Norwegian potter is Erik Pløen, who has always worked as an individual. He established his own studio in Hedmark in 1946, just after the Occupation ended. For a while he traveled to study and from then on he was a dedicated man, full of ideas and ready to fly. He moved his family and atelier to Oslo, set up a kiln, and he hasn't stopped experimenting since. The year he devoted entirely to creative experimentation, he recalls, was one of "fiskesuppe and lapskaus" for his family, but the end result was worth it. By 1958 he had already had an exhibit of his own. The famous architect Erik Herløw included much of Pløen's work in the Paris exhibit "Formes Scandinaves" that same year. Since then Erik Pløen has acquired many honors, including the coveted Lunning Prize. In 1963–4 he was awarded a visiting professorship at the University of Chicago; during his year's residence American potters benefited from his skills and teaching, and he at the same time was able to work with new kinds of clay and to experiment with ash glazes.

Pløen specializes in individual art pieces of stoneware, and to my way of thinking his affinity for clay's ancient beginnings and primitive forms is beautifully obvious. He has innovative methods of handling clay and adding his own unique glazes created to blend intimately with the design and basic material. Many of his shapes are squared and formed freehand, as man may have done long before he figured out how a revolving wheel-table could turn his work, instead of his having to walk continually around it. Pløen does everything himself in his shop, including working, throwing, and sculpting the clay, and the firing and glazing.

The husband and wife team of Dagny and Finn Hald of Norway are well known for their ornamental plaques. They also make charming stoneware vases with whimsical owl-like faces. One of my favorites in their collection is a chess set in stoneware, with gingerbread castles, a most regal queen, a striding pompous king, and humble kneeling knights and bishops. The handcrafted figures embody all the grace and movement of any fine larger sculptural work.

A leading artist with Figgjo Faience is Hermann Bongard. For the world of ceramics he designs flameproof earthenware (called "flint" or "flintporselen" in Scandinavia) with polychrome designs. He is first and foremost a graphic artist and illustrator. Many of his works have been decorative murals and polychrome windows for public buildings, and he holds a gold and silver medal from the Milan Triennale, 1954, for his designs in glass for the firm of Hadeland in Norway. It is Hermann Bongard who designed the beautifully engraved glass mural panel for the entry to Hadeland's Christiania Glasmagasinet Art-Glass Department in Oslo. This versatile man has also created flatware in silver and stainless steel, worked with furniture, enameled trays, and turned-and-lathed woodwork—all these with the greatest success. He is also a journalist and a teacher. Hermann Bongard is represented in many museums in Europe and the United States. The Kunstindustrimuseet in Oslo displays the entire collection of his industrial art designs. He, too, is a Lunning Prize winner.

Other outstanding Norwegian ceramists include Richard Duborgh and Rolf Hansen. Duborgh is good at small items, especially in *chamotte,* which have wonderful unpretentious charm and appealing glazes, such as soft grays and blues. Rolf Hansen uses simple earthenware forms, partially decorated with white glaze, in which he scratches a delicate design, usually linear or lineal-floral. They have great tactile appeal. Sometimes he designs dishes or figures, not at all linear but, rather, full of typically Norsk humor.

Iceland

Pottery art is a newcomer to Iceland. A man from Miodal named Gudmundur Einarsson (sculptor, painter, photographer, etcher) discovered in Iceland, I am told, over one hundred different kinds of clay, more than forty of which are suitable for pottery. He started working with Icelandic clay in 1927. His factory no longer exists, but one of his students, Ragnar Kjartansson, has carried on the work. With backing from a partner, businessman, and friend, Einar Eliasson, who had strong faith in this artist's capabilities, the firm of GLIT Ceramics was created a few years ago. The studio has become successful, particularly in working with clay combined with volcanic basalt lava rock and dolomite, which Iceland has in profusion. Kjartansson studied in Göteborg, Sweden, before firing up his own kiln. The young workers in his pottery are encouraged to come up with designs and glazes of their own, and Kjartansson himself has advanced to the fine art of making enormous wall-tile murals for buildings. Everything at GLIT is hand-formed, hand-decorated, and hand-glazed. The basalt lava and clay mix, an end product of volcanic heat, is a natural for holding hot or cold foods, so covered pots of this thermal material make marvelous containers for hot soups, cold drinks, and the like.

Ragnar Kjartansson is a huge, bearded man who looks as if he might bellow a great Viking battle cry and dare to pick a fight with Thor. Yet this big man is as gentle with a clay mass as a mother with her newborn. GLIT ceramics are of a *chamotte* type, and every vase, bowl, and ashtray exudes an Icelandic moonscape feeling.

Steinun Marteinsdottir, after studying in Germany, joined the GLIT studios and is a very promising young artist. She prefers to work with imported clays, and makes mostly vases, mugs, dishes, coffee services, and

Four murals by Ragnar Kjartansson,
artist and ceramist of GLIT of
Reykjavik

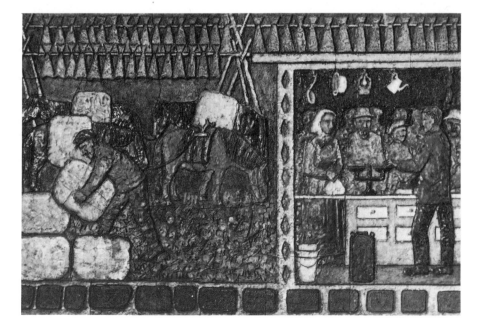

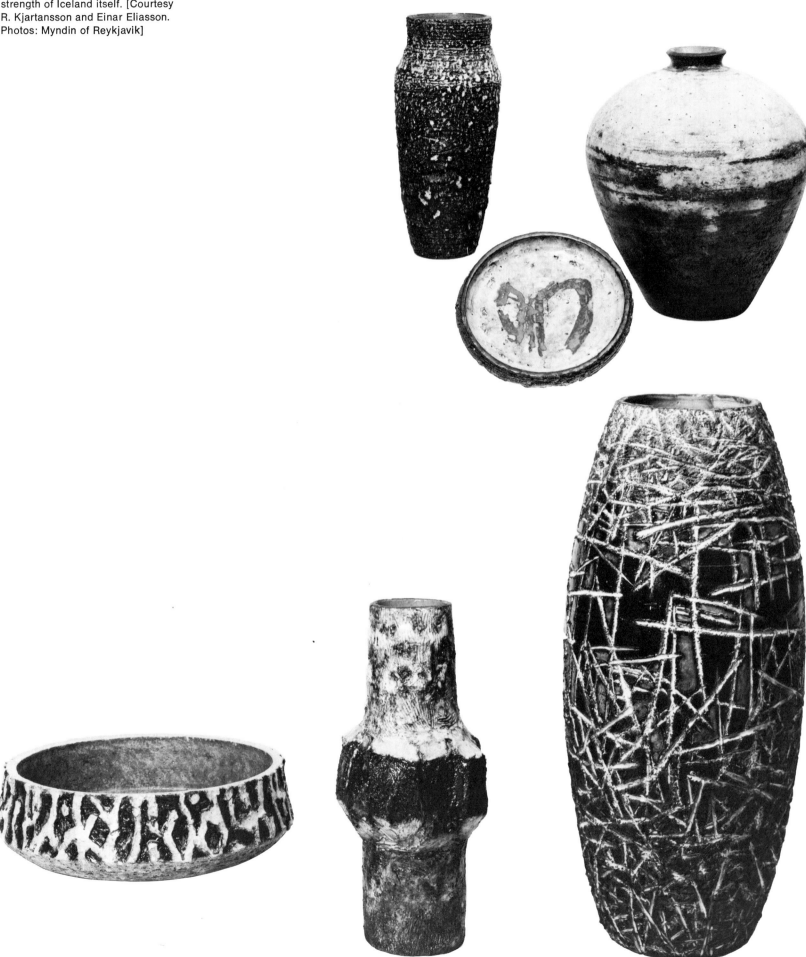

Grouped here are excellent examples of high-fired and partially glazed ceramics made by GLIT of Iceland from various clays mixed with ground basalt lava rock and imbued with the look and strength of Iceland itself. [Courtesy R. Kjartansson and Einar Eliasson. Photos: Myndin of Reykjavik]

pieces less masculine in appearance than those of Kjartansson. Incidentally, she has made a ceramic fireplace in her home. Her style in small ceramic objects is usually sculptural.

Denmark

The pottery trade has a firm foundation of ancient tradition in Denmark. If you want something just as Danish as you can get, find yourself a Jyde pot. From the Stone Age to the end of the nineteenth century, Danish women in Jutland have made what are known as "Jyde pots" by piling pieces of rolled clay, one over another, and baking them in a simple fashion. This process makes fine earthenware pots, low-fired, with a clear full glaze, and it is said that at one time the local and export demand for them reached as high as 1,500,000 a year. They are still made, in the same old way, simply because experience has proven that the design cannot be improved. Danish potters of today claim that when they feel too carried away by current trends they pause to look at the simple Jyde pot, a reminder that the plain and practical always yield the best design. Present-day ceramists allow themselves complete freedom with new forms, glazes, and firing methods, but apply this expertise only to point up the natural plasticity of clay.

The individual craftsman in Denmark shares the spotlight with small workshops and large porcelain factories. The best objects from smaller kilns are always to be found at Den Permanente, Copenhagen, which is an association of many small and larger studios dedicated to superior quality and artistic integrity. Den Permanente is a representative exhibition of the best in all forms of handicrafts in Denmark, and it also functions as an export outlet for the smaller workshops. It is unique and certainly the first place to visit in regard to seeing Danish design while "on location" in Copenhagen.

It began in 1931, when a permanent exhibition and sales headquarters was established in Copenhagen for Danish arts and crafts. Its sole purpose was, and is, to give talented newcomers and individual craftsmen equal opportunity for recognition along with more famous and well-established artists and manufacturers. Above all, Den Permanente (under the able leadership of Esbjørn Hiort) stands for quality, in regard to artistry, craftsmanship, and innovation. There is absolutely nothing to be seen in the showrooms but the finest Danish housewares and handicrafts. Den Permanente's in-shop shepherdess was for many years the knowledgeable Mrs. Edith Wanscher, a busy and lovely lady dedicated to the exhibit and all it represents. She has been succeeded by Katrine Høy, wife of a leading Danish designer of interior furnishings. New things are constantly added to this ever-changing handsomely displayed exhibit.

As mentioned earlier, if one had time to visit only one applied-arts showplace in Copenhagen, Den Permanente would be the one place. Second would surely be Illum's Bolighus, also adept at displaying the best design advantageously, and showcasing in addition the best of design from other Scandinavian countries. Not far away, too, are the

Cabinetmakers' Guild, Royal Copenhagen, Bing & Grøndahl, Georg Jensen, and many others. The area is a mini-education in arts and crafts, with everyone more than proud to explain the artistic reasons why any piece has been chosen for display. At Den Permanente, the ceramists have the major share of display space, and why not? Denmark excels in this field, and there is never a lack of new talent appearing each year to uphold this reputation.

Art ceramics have always been important in Denmark. Porcelain, holding a dominant position for some decades, nowadays has only equal status, since the focal point has turned to stoneware as a potter's material —perhaps a logical turn of events in the revived tendency toward an essence of the primitive seen in ceramic design everywhere today.

Glazing effects have had special attention in Denmark, as to both color and texture. Sometimes a piece is formed expressly for the result it will give in enabling the glaze to "flow" over protrusions or indentations, or for distinctive plays of color and light reflection. The workshop of Nathalie Krebs—Saxbo—was begun in the thirties and has always been devoted to scientific experiment in glazes. Nathalie Krebs is said to have "the touch of a chemist and the spirit of an artist." She is especially skilled at difficult refined glazes similar to those created by Chinese techniques. Working with her have been Eva Staehr-Nielsen, Edith Sonne Bruun, and Kirsten Weeke. These three form the clay while Nathalie Krebs devises the glazes, and their collaboration represents deep mutual artistic understanding.

Axel Salto is one of Denmark's foremost artists in stoneware. His shapes are bulky and often suggestive of fruit or growing plants, such as his "budding" and "germinating" vase forms. These exist as a vehicle for special color effects obtained by letting the glazes flow over and between the nodules and through the grooves of the vase's surface.

Perhaps the most internationally famous of all Danish ceramic artists is Bjørn Wiinblad. He is a freethinking pixie, totally uninfluenced by tradition. His Danish heritage shows in his expertise with clay and in the delightful sense of humor expressed, for example, in his flower girls, droll faun figurines, and perky horsemen bearing candleholders. Wiinblad's pieces are beloved by collectors. The delightful "Fru Krogh" is a Danish lady welcome in homes around the world for holding flowers. Wiinblad, like Bengt Berglund of Sweden and Birger Kaipiainen of Finland, is a blithe spirit whose merry world is full of whimsical creatures. One smiles to see them: surely this has great bearing on the longing one has to own them.

As a technician, Bjørn Wiinblad is an expert. He is also well known as a painter. His charming ballet and theater posters are much sought after. Some of these designs have now been applied to porcelain plates also meant as decorative wall accessories. He now lives part of the time in Germany, where he contributes to the Rosenthal Studio line, made up of items selected by an international "jury" from the designs of glass and ceramic artists throughout the world. Wiinblad also designs for Neiman-Marcus of Dallas, Texas. He now has a new exhibit house/shop off Strøget in Copenhagen, a Wiinblad fantasyland full of large and small delights, all designed by this great artist.

a
Tureens in engobed earthenware by
Bjørn Wiinblad

b
"Variant," in faience, designed by the
ceramist Inge-Lise Kofoed and Leif
Lautrup-Larsen (a civil engineer). The
service is efficiently stackable and
multipurpose, made with two plain
glazes: blue and gray-white. Some
pieces bear a blue decoration.
[Courtesy Royal Copenhagen, Den-
mark. Photo: Strüwing]

c
Part of a coffee service in porcelain by
Erik Magnussen, a Lunning Prize winner,
1967, for Bing & Grøndahl, Copen-
hagen. The thermal design of the stack-
ing cups eliminates the need for
handles. [Courtesy Den Permanente.
Photo: Rigmor Mydtskov and Steen
Rønne]

a

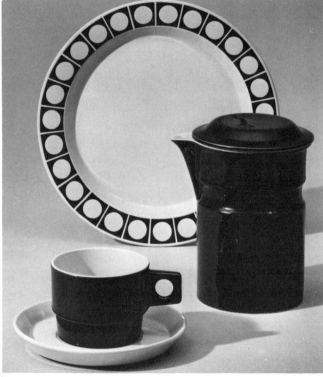

b

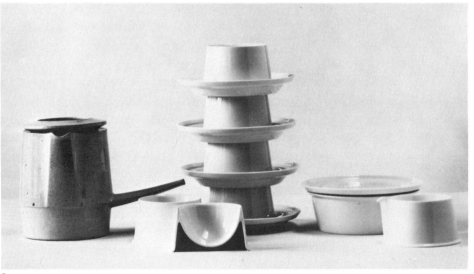

c

Sweden

The emphasis in Sweden has been on factory-produced utility wares. The firm of Gustavsberg in 1827 introduced a hard translucent china-ware containing a large amount of bone ash, and this is still a specialty with this firm and its sister factories, Upsala-Ekeby, Gefle Porcelain, and Karlskrona Porcelain. In 1920, when the Swedish Society of Industrial Design began promoting artistic participation in industry, certain artists eagerly joined in the crusade. Wilhelm Kåge went to Gustavsberg, Arthur Percy to Gefle. Edvard Hald (who later devoted his attention to glass) went to Karlskrona, and Gunnar Nylund became associated with the Rörstrand firm. Artists' studios were set up for these and subsequent designers, and like magic, everyday wares soon became handsome. Continuing this progress in the fifties (and again in 1961) was Sven-Erik Skawonius, and, after 1949, Stig Lindberg, as art director.

Gustavsberg sprawls on a Baltic inlet near Stockholm where it is easy to receive shipped-in clay from other lands, currently from Cornwall, England. Arthur Hald (poet, writer, art authority, and business-man combined—and son of Edvard Hald) is its present art director. Besides the art and utility ceramics department, Gustavsberg has a large plastics division which turns out inexpensive but artfully designed home utility wares such as bowls and pitchers. It also has one of the few ovens in Europe big enough to process porcelain enamel on steel, as used for stoves, refrigerators, and other large appliances. This department has in the past few years been infiltrated by art, too. Bengt Berglund and other artists began painting with this porcelain enamel process, creating not only wall plaques but huge sectional murals for the Stockholm Slussen subway station. This work of art was like a gigantic jigsaw puzzle forty-four meters long, and exacting to produce, for if one section came out with a faulty color tone or other flaw, it meant the correction of all surrounding sections. The painter of this huge work was Sune Fogde. The process involves first putting one coat of porcelain enamel on the steel plate. Then the design is painted with colored enamel, sometimes with the use of silk-screen stencils. The whole is then refired, during which process the colors darken somewhat. The surface can be refired several times if it is not right the first time. No glaze is applied over the design.

There aren't many places in the world with such a large, expensive oven. Gustavsberg therefore invites artists from all over who want to work with this technique. They merely pay for their materials; Eje Öberg of the Gustavsberg staff is host artist and teacher-consultant for students who come to learn and experiment. Bengt Berglund, a Gustavs-berg designer, was inspired to try his luck with this process, and did sixteen designs for wall plaques, put out in limited editions of two hundred each. He did not agree with its being dubbed by the media "enamel graphics" but preferred to call it "painting with enamel."

"A painter finds it quite a different technique," he told me, "and just has to understand and test it for himself, and then also to learn how each color will change in the firing."

In this man, Sweden, too, has its Wiinblad and Kaipiainen, for he is an imaginative artist, full of fantasy. On the shelves of his atelier at Gustavsberg when I called on him were dozens of wildly free-form "critters" which had been exhibited in Stockholm in 1964 and at the Ruska Museum in Göteborg in 1966, billed simply as "Movement in Clay."

On the subject of this collection, he remarked: "I like to use the clay simply as clay, which is the most plastic material I know. I start with a face, and then form a kind of animal. No special animal . . . just a fantasy creature or figure. These just express the way I look at and feel about clay. It is not static but flexible sculpture."

"Clay," he pointed out, "is a natural partner to color. The material is actually part of the colors, and the glaze is an organic thing in ceramics. For example, I don't necessarily need the glaze as such, but for my work I do need the rich colors it can give."

Contrast this—glaze only to give color to the form—with what was mentioned earlier regarding Axel Salto of Denmark, whose forms exist to support, or as a vehicle for, the glaze effects. Here are two opposite approaches to pottery art, both with rewarding results. In fact, there are probably as many viewpoints on ceramic art as there are artists.

Berglund works in wood sculpture at home, just for pleasure and experimentation, but something good is bound to come from this talented man who says, "Much as I love clay, it is, of course, not the only material." Plastics, however—in spite of having all facilities to work with them at Gustavsberg—have given him no great challenge as yet. "You have so small a margin for dreaming, and you still have to ask the machine too much," he states. For an artist made up almost entirely of dreams and unadulterated imagination, his feeling can be understood.

Karin Björquist is a ceramist at Gustavsberg who retains a strong connection with old traditions in pottery. She has been with the firm about twenty years, and won the Lunning Prize in 1963 for her carefully conceived olive-green table service, "Every Day" (Vardag). Arthur Hald, Swedish authority on design, has aptly called her a "ceramist, body and soul . . . she shapes quiet forms, magnificent forms, expressive forms. Her register includes the intelligent, practical woman's way of handling everyday things. She gives noble airs to a tureen, platter, flower pot, or a garden birdbath. Or she can concentrate all her feeling for material, glaze, and texture in a little ceramic ball, a charm to hold in one's hand."

Lisa Larson, in contrast to Karin Björquist's more serious works, loves to make what I call personality-animals and lighthearted things filled with gaiety and whimsy. Lately she has veered off to things of more primitive concept, but she still makes her wonderful little animals; you can see these in America at Georg Jensen in New York.

Berndt Friberg, another fine artist at Gustavsberg, is best known for his elegant stoneware, very reminiscent of Sung dynasty forms. He has kept exclusively to individually made art pieces; he does nothing for mass production. His preference is for genteel classical shapes of great elegance. Friberg is a craftsman son of a craftsman father and grand-father. He is now over seventy and semi-retired.

Another well-known designer, mentioned earlier as art director at

a
"Every Day" (Vardag), a Lunning Prize-winning table service by Karin Björquist, Gustavsberg. The color is muted dark green. [Courtesy Svenska Slöjdföreningen]

b
Unique stoneware decorative vases designed by Berndt Friberg at Gustavsberg, Sweden. Friberg prefers elegant shapes reminiscent of Oriental and/or classical forms. [Courtesy Svenska Slöjdföreningen]

c
"Bersa" series in earthenware (with wood covers) by Stig Lindberg for Gustavsberg. Lindberg prefers a modicum of delicacy in line and form, which is seen even in this gay kitchenware meant for daily use. [Courtesy Svenska Slöjdföreningen and Gustavsberg]

d
Detail of a plaque in stoneware by Bengt Berglund, a ceramic artist exuberant with imagination and fantasy in his work at Gustavsberg. He likes detail, such as this, and is freethinking in his work with clay, which he refers to as "flexible sculpture." [Courtesy Svenska Slöjdföreningen]

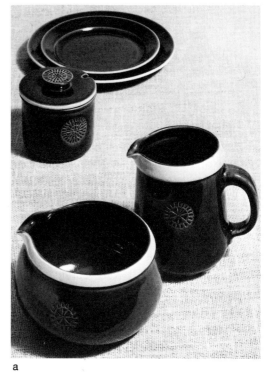
a

b

d

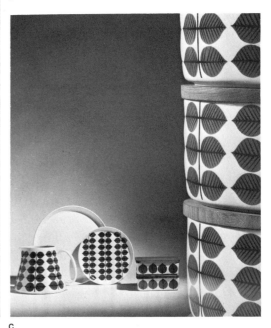
c

Gustavsberg from 1949, is Stig Lindberg. His preference is for dignified, subtle shapes with polished glazes, the effect being formal and delicate, and indeed very Swedish in its refinement. His talent for design does change direction now and then to bizarre stoneware, even to such things as pipes, playing cards, and kitchenware.

Britt-Louise Sundell-Niemer is a gifted ceramist who has been with Gustavsberg since 1954. In addition to her ceramic work, she has also designed the great iron gates of the Maria Torget subway station and some smaller ones at the Centralen subway station in Stockholm. She, too, is conscious of the problem of "keeping the original feeling when a design goes to mass production" in the stoneware she loves to make, but she has a knack for dealing with this. She likes shiny glazes containing quartz, giving a glasslike effect, and sometimes crackles them—which is accomplished with hot and cold shock to the quartz glaze.

In response to a challenge from the Swedish Society for Arts and Crafts (Svenska Slöjdföreningen) in 1967, Mrs. Sundell-Niemer created an award-winning table service meant to solve certain problems turned up in market research done by the society. Most tableware was aimed at four persons, and the demand was felt to be for sets for families of six. Although extra plates and cups could be purchased, the serving bowls and platters were then too small. In addition, soup bowls needed to be designed to be carried without dunking the thumb in the hot soup. Mrs. Sundell-Niemer came up with a suitable design. She decorated it tastefully with a mushroom pattern in a subdued black-and-brown combination on white; also an alternative color scheme of green and blue. She designed a sensible, good-looking plastic bowl in a shape similar to that of a giant half-walnut shell, which provides not only a place to grip the bowl but also a pouring spout.

Sweden's Society for Arts and Crafts and Industrial Design (mentioned above) was established in 1845 and has been the instigator of so much progress in Swedish applied arts that the foreign-trade industrial groups there must be endlessly grateful. There are about twenty people on its board of directors, representatives of four divisions: general membership and subscribers, manufacturers, designers, and the national consumers' organization. In 1967 it was reorganized slightly to include the Svensk Form Design Center in Stockholm. The fund's sources include a small grant from the government, plus occasional special research-project grants from the government, and the rest from manufacturers who like the exhibits and from subscribers to and advertisers in *Form,* the society's handsome publication. Ulla Tarras-Wahlberg and Birgitta Willén are the hard-working key personnel at the society's headquarters, and it is to be hoped an appreciative Sweden will never let this organization down, for it has done a mountainous job of real worth to Swedish applied arts, as have similar groups in the other Nordic countries.

To return to Rörstrand at Linköping, this firm is justly proud of its team of artists, among them Hertha Bengtson, Gunnar Nylund, Sylvia Leuchovius, Marianne Westman, and the very talented Carl Harry Stålhane. At one time Birger Kaipiainen was also associated with Rörstrand, before he moved to Finland. Carl Harry Stålhane, presently the leading designer at Rörstrand, leans toward the primitive in style,

with virile forms declaring the fact that the work was man-crafted. He likes to devise glazes from other clays and earth, rather than from the popular metal oxides. In the finished baked pot, this results in unusually exciting colors totally integrated with the basic pot itself.

Many artists maintain their own workshops in Sweden, too. One example is Signe Persson-Melin at Malmö, a gifted ceramist favoring rustic concepts. In contrast, there is the team of Ingrid and Erich Triller, making genteel forms that reflect Chinese influences, with which they tastefully employ delicate, refined glazes. Hertha Hillfon represents another type of ceramic art—earthenware sculpture, done in a vigorous and imaginative style. Her sculptural pieces range from stylized tree branches (shaped similarly to the way a coral tree grows under the sea) to exotic figures and masks.

Arabia of Finland

The firm of Arabia (owned by Oy Wärtsilä AB and pronounced Ah-rah'-bee-ah, not Ah-ray'-bee-ah) has the largest ceramic factory of its kind in Europe today. It is no exaggeration to say that this factory's staff and artistic contingent have made extraordinary contributions to the development of contemporary ceramic art as a whole. Its history is representative of most ceramic firms in Scandinavia up to the early twentieth century, but since the 1950's Arabia has taken the lead in the search for world recognition and showered itself with success.

Arabia was founded in 1874 as a branch of Rörstrand of Sweden and was eventually taken over by Wärtsilä in 1916. The area where the factory is located, just outside Helsinki (and an adjoining area called Canaan's Land), was officially named Arabia in the minutes of the Bench of Magistrates in 1763, in the fashion of the day to label land with exotic titles. It was probably a name bestowed by Aron Peron, a merchant who had founded a brick factory nearby. A villa named Arabia was later built upon this land, and the name stuck when a merchant named Halldin rented the fields from the city and built the original factory for Rörstrand.

For a while after Arabia came under Finnish control, Rörstrand retained 90 percent of the stock and a mother-hen affiliation. Following World War I, German financiers managed to obtain controlling shares of stock, and again the direction of the firm was lost from Finnish control. During World War II, there were additional setbacks under foreign influence. In each period that the Finns were allowed to run the factory, it made progress, and since it became Finnish once more it has forged ahead, and there seems no limit to its scope and success. Today it is enormous and has an international reputation for quality and artistry in its production.

During the forty years that Arabia was a Swedish firm, there was no independent, indigenous creative work done at the Finnish plant. The models were taken from Rörstrand and adapted to Finnish and Russian markets. The material used was faience and the decorations were copper

a
Free-form vase glazed in cobalt and
iron-mixed glaze, by Carl Harry
Stålhane for Rörstrand of Sweden. This
artist's designs are extremely masculine
and communicate a sense of strength.
[Courtesy Nordiska Kompaniet and
Svenska Slöjdföreningen]

b
Stoneware vases by Gunnar Nylund for
Rörstrand Porslinsfabriker, Linköping,
Sweden. The glazes are parchment
white, dark brown, and pearl gray.
[Courtesy Svenska Slöjdföreningen.
Photo: Sörvik, Göteborg, Sweden]

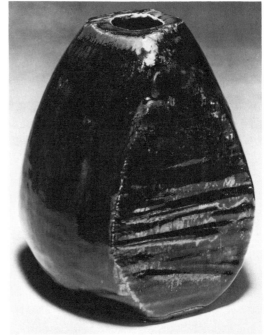

a

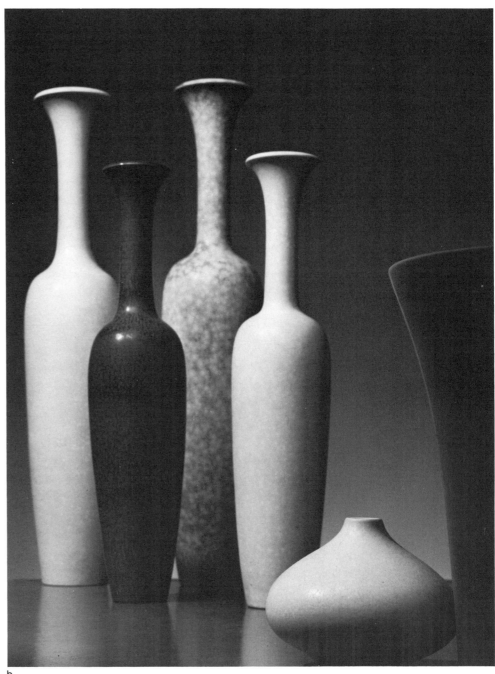

b

printing and a unit design under glaze. Much undecorated white ware, sometimes with a raised pattern, was produced. The products were dull. Toward the end of the nineteenth century, the majolica technique was predominant, and the products were glazed tile stoves, flower pedestals, urns, jugs, plant pots, figurines, and such. Looking at these today, one wonders why these somewhat tasteless things were ever popular. Actually, they were reasonably appropriate to the cluttered home decor of that time, and the people in general willingly accepted cheap imitations of styles of earlier periods. It happened everywhere—a boring, uncreative artistic era, in the main. Rococo has survived the longest (if you discount the recent Art Nouveau revival), and in the more simplified interpretations of rococo used today, it still has appeal for many people.

As public opinion in the early 1900's began to rebel against copying and clutter and a longing for true craftsmanship grew, the Art Nouveau style was developed. Some excellent examples of this theme as carried out at Arabia are illustrated in chapter two.

Kurt Ekholm was art director of Arabia from 1932 to 1948 and is responsible for organizing Arabia's outstanding ceramic museum at the plant. He is credited with developing china dinner services and for creating some interesting individual pieces in stoneware. He later moved to Sweden as head of the ceramics department at the Göteborg School of Industrial Design, and has been director of it since 1950.

People come from all over the world to visit the Arabia museum. Perhaps, if you are one of them, you will notice first the simple, clean lines of the first day's production at Arabia on October 19, 1874. Decoration is conspicuous by its absence, considering the fashion demands of the day. One pitcher does have under its lip the figure of a graceful swan affectionately tending to her brood. What might be called the in-between years of the rococo and Jugend periods are well represented with water lilies frozen in ceramics, proud old urns and pedestals. Art history is all there, each thing having been a sensation in its own time. What often entrances the visitor is Michael Schilkin's incomparable owl sculptured in *chamotte*. There is no other owl in the world as charmingly Finnish as this bulgy, determined-looking, enchanting bird made by a man who represented the budding of truly Finnish creative design. Schilkin did many marvelous animal sculptures, but this tongue-in-cheek owl looks to me like the essence of the wise, often "stony-silent," witty, and fiercely independent Finn—so often serious of countenance but bubbling with dry humor inside. With all this personality, let there be no mistake that this is a sculpture made of clay. With such intimacies between himself and his material did Michael Schilkin communicate his gentle art.

Schilkin was one of Arabia's leading artists until his death in 1962. He was Russian-born, but somehow very Finnish in his work. In addition to his famous animal figurines, he excelled at large decorative reliefs for public buildings. His work was used in the interior and exterior of Arabia's most recent building addition. The factory is now a huge, sprawling, nine-story building.

In 1946 Arabia pioneered an important move on the part of Finnish producers to introduce the touch of the artist into mechanized production. To spearhead this reformation, Kaj Franck, then only thirty-four years old, was named head of design planning. Arabia sensed in this man, already prominent in the art and design world, something more than artistic talent alone. He had shown rare insight into and keen ability for tackling a design problem and finding a sensible solution, and it was this Arabia sought. The move turned out to be a wise one, for the association of Franck and Arabia has been long, happy, and successful.

Under Franck's artistic leadership, the firm employed a whole stable of artists to work in porcelain and ceramics. They were given free rein, and excellent technicians in the craft backed them up. They work in top-floor studios at the plant, with a panoramic view of Vanhakaupunki Bay, which is as inspiring as it is unpronounceable. The results, however, have spoken clearly.

Notsjö Glasbruk, founded in 1793 and located in Urjala, is the oldest Finnish glassworks and is a sister firm to Arabia. The two concerns have a joint sales department, many of their artists work in both ceramics and glass, and both firms have blossomed under the loving care of Kaj Franck, behind whom stood a progressive and highly intelligent marketing director, Holger Carring. Carring's untimely death in 1971 was a great loss and he will never be forgotten by those who knew him. He was a most erudite and articulate thinker, writer, and spokesman for good design. As an example of clarity in expressing the motivation of Arabia, and all artists and craftsmen in the world of design, I give you a significant excerpt from one of his speeches at the opening of a Finnish exhibition held at Scandinavian Designs on Regent Street in London some years ago:

"In good design we should feel a sense of the individual things in nature . . . For instance, when we look at a glittering crystal vase, where the light shimmers full of secrets like a fountain in the wood. And when we rest our hands on the softly carved wooden arms of a chair, it should give us a pleasant feeling, a feeling of contact with nature . . . Good industrial design has a hallmark of genuineness and imports a feeling of well-being. It is created for people who have eyes to see with and hands to touch and feel with. It is most irritating to see, in a shop where design articles are sold, a notice saying 'Please do not touch.' These articles invite you to come and look at them . . . to touch and feel them. They have been created to live among people and to be handled and enjoyed."

With these wise words Holger Carring spoke for himself, his firm and its artists, his countrymen, and all design-oriented people in Scandinavia . . . and certainly for me. I spend a lot of time convincing my own friends and associates not to hesitate to pick up, or at least touch, objects if they are to appreciate fully what the artist *and* craftsman intended to convey.

Kaj Franck is still consultant to both Arabia and Notsjö, and a professor at the Institute of Arts and Crafts and Industrial Design in Helsinki. (The Arabia art directorship is now held by Richard Lindh, himself a famous ceramist.) Franck, who has been awarded a mile-long list of honors and prizes (including the exclusive Compasso d'Oro in

Milan in 1957), is a true pioneer in ceramics. He was presented with the challenge of adapting artful design to automated techniques and moderate prices, as this movement in design was meant to benefit all the people, not just those of above-average means. Franck's guiding principle was his belief that tableware should be multipurpose, mix-matchable with other existing dinnerware on hand, to allow for gradual replacement and variable table settings. It must be remembered that this was still in the days of "sets" of dishes, before anyone had yet thought of mix-match anything.

Franck had his finger on the pulse of our day in devising his still popular "Kilta" series of mix-match ceramics in the late forties. Though at first glance it seems a basically simple design, further examination and use reveal how meticulously and perceptively each piece has been conceived. "Kilta" stacks efficiently and securely. Its individual pieces are shaped in an artfully neutral way so as to be usable for many purposes quite on their own. It goes from refrigerator to oven to table and back again. It is made in five cheerful colors, each of which seems to blend well with a variety of other tableware. The plates do away with wasted flat-rim space, allowing more area to arrange food attractively. The rim is angled upward, which is better for the more liquid foods such as stews and which makes the plate attractive on its own as a fruit bowl or other accent dish. Franck's well-thought-out designs are as advanced as they are straightforward.

He has also designed furniture, toys, lighting fixtures, printed textiles, and, of course, a great deal of glass—a medium which gives him great joy. His works in glass span a wide range of objects: subtly formed decanters and pitchers, practical yet imaginative drinking glasses in which he never fails to point up the innate characteristics of the liquid glass mass itself, vases as thin as soap bubbles, and heavy multicolored art pieces, sculptural in feeling, sometimes cut to create a prismatic effect as the piece is rotated and light refracts through it, creating *color motion.*

Franck becomes lyrically expressive on the subject of the originality of Finnish colors. Finnish colors are unique, entirely different from those found in other nations' color wheels. Franck will point out that the reason they are so "subtle and elegant is that they are intimately related to nature.

"Put them next to colors from other areas," he explains, "and you will immediately be aware of the difference between the precisely natural color tones of Finland's design and the more vivid color spectrum used by most others. Normally, to place a livelier hue next to a subdued color makes the softer color look drab and lifeless. Not so with Finnish colors. They only look more rich and appealing, while the brighter tones suddenly seem garish, unreal, gaudy. It is because our colors are entirely nature-based. We feel, you see, that time has proven nature is the true source of lasting beauty. Does anyone ever tire of looking at a graceful birch or willow . . . or a beautiful sunset?"

Kaj Franck is artist, teacher, and smart businessman. He can be called a moderately earthbound angel of Finnish industrial design. He is highly respected by his colleagues, an inspiration to students, an internationally renowned designer, and an artists' artist. Finland is vastly proud of him, as it has a right to be.

Under the Arabia roof, besides Franck, there are many gifted artists. Richard Lindh, Franck's successor as art director of Arabia, and his talented wife, Francesca, are two of them. She was born and trained in Italy and he in Finland, but from there they have run a parallel course, and both have earned many coveted design awards. Lindh's work shows profound knowledge and intimacy with clay. "Clay is a capricious and living material," he explains, "which means that the artist must keep in close touch with it all the time, to remain alive to its possibilities and limitations. The same applies to colors and glazes. First you must know them thoroughly; then, and only then, can you make real progress."

Covered with design-award glory and fame is Arabia's fabulous Birger Kaipiainen. Like Bjørn Wiinblad of Denmark, Kaipiainen is a man of delightful fantasy. His penchant is for pansy faces, clocks, great sea birds, and fruits. His was the exciting ceramic pansy mural seen at Expo '67 in Montreal. It was part of the remarkable exhibit "The Creative Finns," along with Timo Sarpaneva's powerful iceberg of sculptured glass, Tapio Wirkkala's spectacular wood relief, Laila Pullinen's copper sculpture, and Uhra Simberg-Ehrström's greatest of all ryas.

Kaipiainen is the total romanticist. His material is faience. Because its firing heat is higher than most colors can stand, he hand-paints all his work. When you consider that the Montreal work was composed, in addition to the larger sections, of some two million "pearls," each hand-crafted, it becomes evident that this was a monumental project. To begin with, he was fond of pastel colors and of making human figures in the manner of old Etruscan paintings, which he had spent some time studying in Italy. Later he tended toward deeper colors, and his human figures became more fanciful, with broad faces and long thin necks. (Here again the communion with Wiinblad is noticeable.) Natural forms have little meaning for him as a rule, except in a stylized fashion. His works are filled with happy daydreams and expressive fantasy, and are often Byzantine in their intricate, beadlike effects.

Kaipiainen is a prolific artist, but never at the sacrifice of careful, meticulous detail work. He gained international fame with a giant sea bird somewhat like a tern, entirely made of tiny pearl-painted ceramic beads. He made one "for fun," and it created such a stir that orders accompanied by offers of several thousand dollars finally tempted him to make a few more. He has carried out many large-scale mural commissions, and has made many wall plaques and numbers of fanciful, huge Easter eggs, fashioned in his own idiom, such as those made for an exhibit at Georg Jensen in New York for Easter, 1967. Birger Kaipiainen is the opposite of Kaj Franck, whose works are artistic and sensible. Kaipiainen's are pure decorative phantasmagoria. He did design a table service called "Paratiisi" with some plain glazed pieces and some patterned with his beloved pansies, grapes, and leaves. The unusual factor in his fine shapes for this service is that the plates are oval rather than round. This is not a natural shape for ceramic plates; therefore, the processing requires more care and special handling, making the design

a
Michael Schilkin at Wärtsilä Arabia in Helsinki was one of the firm's first artists. Besides his contributions to the firm's industrial design, he was a fine sculptor, particularly fond of animal figures. ''Ape'' and ''Leopard'' sculptures are ceramic. The panther is *chamotte.* [Photo: Pietinen]

b
Kaj Franck, art director for Arabia ceramics and Nuutajärvi glassworks in Finland since 1946, is also a teacher and head of the art department at the Institute of Arts and Crafts and Industrial Design in Helsinki. Although he also creates unique art pieces, he is primarily known for his pioneer efforts in the introduction of art into everyday wares. He has won a Lunning Prize and a Fulbright grant, four medals at the Milan Triennale, the gold medal at Sacramento, California, and others. [Courtesy Arabia. Photo: Pietinen]

a

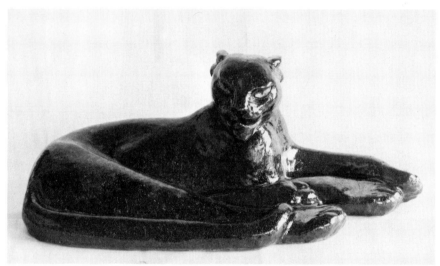
a

b

a
Richard Lindh, designer and art director
of the Arabia Design Department.
b
Lindh's matte glazed flower pots
in hard faience. The pots to the
left are made in two separate parts
(pot and stand). The rectangular con-
tainer holds water on either side of the
pot it frames. The colors in which these
are made are white and black. [Arabia]

a

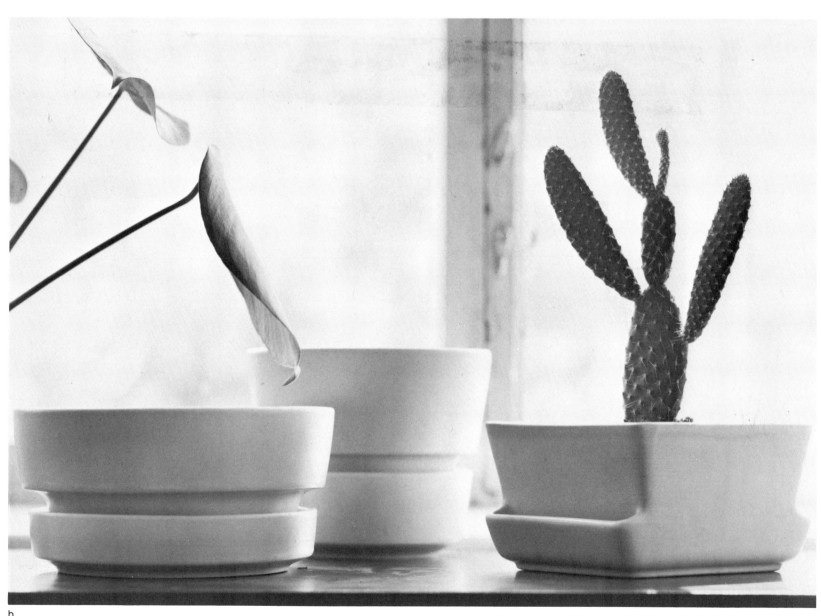

b

Hand-thrown vases of rough *chamotte* by Francesca Lindh. The exotic shape and warm colors are characteristic of this artist. Colors from left: yellow, black, turquoise, and moss green. The close-up shows in detail the rough live material. [Arabia]

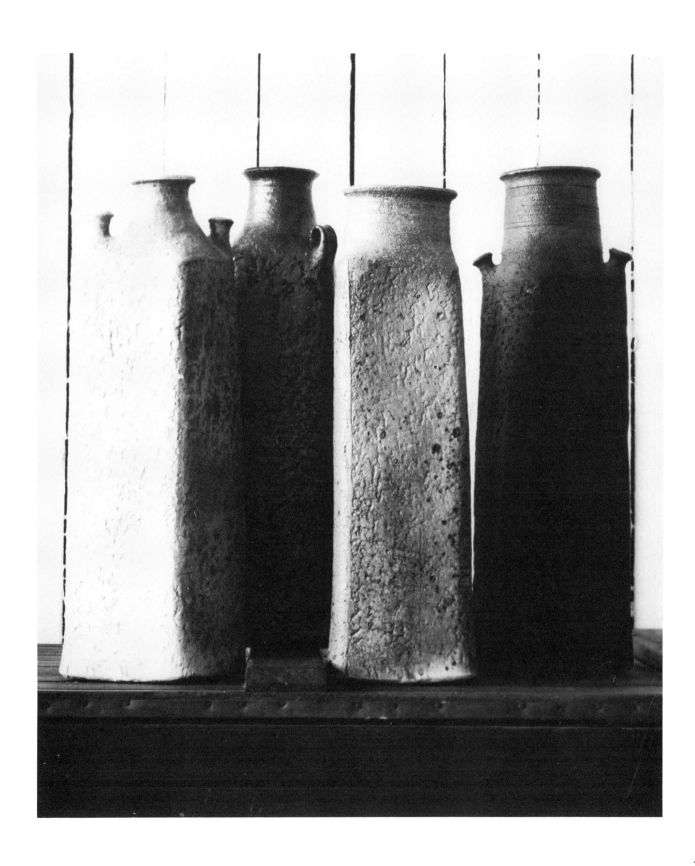

a little more costly but also more artistic and uniquely Kaipiainen.

Another important designer at Arabia was Ulla Procopé, a pretty and gentle lady much loved by all who knew her. After an extended illness, she died at Christmastime, 1968, at fifty-seven years of age. Her designs were done exclusively for mass production, and are perhaps the most handsome, practical, and popular tableware in Arabia's sparkling history. "Liekki," "Ruska," "Rosmarin," and "Anemone" are all Procopé designs, best sellers every one. Her works have been exhibited in many countries. Ulla Procopé's designs were sturdy enough to appeal to the man of the house, yet beautiful and sensible enough to be a source of pride and joy to the woman.

Rut Bryk, wife of the renowned Tapio Wirkkala, is in her own right famous, and at Arabia she loves to design wall tiles. Her favorite technique is to create the design with the outline of the drawing raised from the surface of the tile or plaque, then filling these spaces with thick layers of colored, translucent glazes. She has a vast range of themes in these designs, including larger compositions and smaller, intricately detailed studies of line and color.

Annikki Hovisaari joined the Arabia firm in 1949, and has always worked there as an artist under no one's orders but her own. She designs mostly individual pieces in *chamotte,* though occasionally she does something for mass production. She favors cylindrical forms and rough *chamotte* for her vases, dishes, bowls, and candlesticks, and excels at developing new matte glazes of copper, iron, and other metallic mixtures. Especially in this field of metallic glazes, she has a superb sense of what is in harmony with the *chamotte's* rough surface and the basic form of the vessel itself.

Another exceptional talent at Arabia is Friedl Kjellberg, Austrian by birth but associated with Arabia since 1924. Winner of many gold medals in Brussels, Milan, Paris, and Cannes, with her works represented in many museums, she developed in porcelain a rice-china series that is delicate and regal. The rice-grain process is ancient and remarkable. Rice porcelain is believed to have originated in China during the fifteenth century and reached its zenith from 1736 to 1796, the Ch'ien-lung period. As made today at Arabia, it is largely done by hand, under the guidance of Mrs. Kjellberg. Small holes of the desired shape are made in the moist porcelain and filled with glazing material. In the firing, the filled spots are thinner and more translucent than the rest of the piece. The formula for this porcelain is costly, breakage in handling during manufacture is high, and the melting of the glaze is difficult to control. Therefore, rice china is expensive, but worthy of the investment made in it.

Mrs. Kjellberg has also modeled less delicate things in clay in the form of white stoneware bowls and vases of clustered horn shapes, glazed with sang de boeuf or celadon in the ancient Chinese manner. She has also made some exquisite Negro figurines in porcelain. They are exceedingly graceful, and their flowing gowns are glazed to resemble elegant fabrics.

In 1956 a young artist named Oiva Toikka joined Arabia and Notsjö, and this young man's works have become a sensation. He had been well known previously as a designer of rya and täkänä rugs. Toikka had a ceramics exhibition in 1958 which was adjudged to be "amazing" . . . "inspired" . . . "gifted," and so on. He had always been all those things in the eyes of his teachers. Oiva Toikka's designs are courageously original, some of them wildly exuberant and unreal. After a few years in ceramics, he succumbed to the call of that old temptress glass, and this medium has held him spellbound ever since.

It seems one can go on and on about the many fine talents at Arabia, for there are more of them to mention: Liisa Larsen, Esteri Tomula, Kaarina Aho, Hilkka-Liisa Ahola, Göran Bak, Gunvor A. M. Olin, Raija Uosikkinen, and others, award winners all. Each of them is gifted in different directions, and each has been honored time and again at exhibits.

Giving the artistic team its head has brought bouquets, laurels, and glory to Arabia. The same situation exists at the Notsjö glassworks; this will be discussed in the section on glass and crystal. To top it off, there is another branch of the parent firm of Wärtsilä, named Finel, which makes porcelain enameled kitchenware of equally high merit. The factory, the artists' studios, and the fine Arabia ceramic museum are open to visitors upon arrangement and are recommended as a must for visitors to Helsinki who are interested in the world of ceramic art. In ceramics as in the other applied arts, you will find Finnish design and workmanship second to none, and highly original. It is a truism that "an American can tell you who pitches for the Giants—the Finn can tell you who designs for Arabia."

a

"Liekki," designed by Ulla Procopé, has become a world-famous service, for several reasons. The material is hard faience with a rich dark-brown matte finish, and the serving pieces have removable rattan handles. "Liekki" dishes are flameproof as well as oven-proof, and the bases are designed with the same diameter as the average hotplate of a stove. They keep foods hot (or cold) and are very easy to clean. Turned upside down the tops become dishes in their own right. Artistically, the shapes are true to the raw material and the shape and color neutral enough to blend well with other tablewares. [Arabia]

b

"Purpuri-Jenkka" is a series of hard white earthenware (named for two old country dances) with hand-painted underglaze decoration in red and green. The design has been applied on the "Valencia" shape; both design and decoration are by Ulla Procopé. [Arabia]

c

A decorative wall tile in faience by Rut Bryk. Her tiles are sometimes glazed, sometimes unglazed, sometimes partly glazed. Colors usually are strong and glowing. [Arabia]

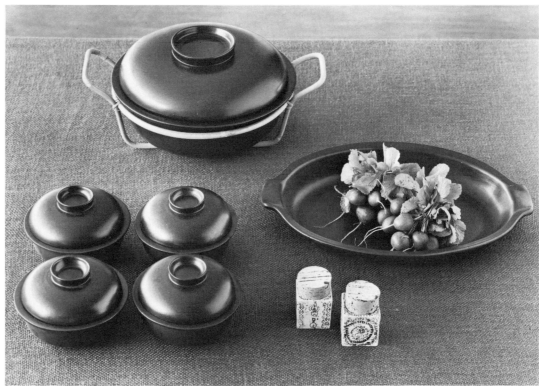

a

b

c

a
Annikki Hovisaari begins mixing the clay
in her workshop at the Arabia factory
in Helsinki. She prefers *chamotte,* with
metal oxide glazes. The clay is first
kneaded, like bread dough, with the
weight of the entire body thrown behind
the hand pressure. The clay must be
free from airholes. The clay is then truly
"thrown" with force down onto the
potter's disk, and the wheel is set into
motion

b
The wheel is now kept in motion during
the entire period of forming the clay
into a shape. The hands are kept wet,
and as they change positions in-
side and outside the gradually changing
shape, its form rises, curves, and in
general responds to the slightest
pressure from the fingers, as if it were
alive

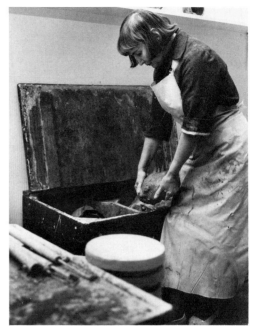

a

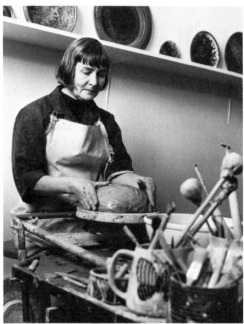

a

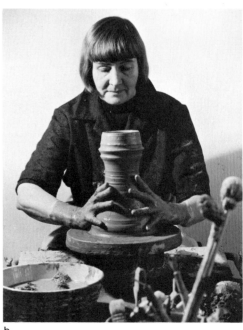

b

c
In a later stage of the shaping, the
form of the finished item can be seen.
After the throwing, the piece is allowed
to dry. The period of drying depends on
size and shape, but in general requires
three or four days. If the piece is to be
decorated with any engraving, this is
done on the first or second day of
drying, before the work is
completely dry

d
Here Miss Hovisaari's items can be
seen in the kiln. She uses smoke firing
at a high temperature for her rough
chamotte. Glaze is applied in the
artist's studio when the pieces are dry,
but prior to being kilned. The glazes
preferred by Miss Hovisaari are metal-
oxide glazes, which in the kiln under
the effect of smoke at high temperature
yield beautiful and individual colors,
such as bright rich turquoise and
brown-blacks

e
A close-up of one shelf of the tunnel
kiln-car, as it is coming out of the
kiln after the firing. The item we are
watching being made is in the upper
left corner of this picture

f
The finished vase. Hovisaari's favorite
material, rough *chamotte,* gives a
beautiful rustic surface, and her glazes
harmonize perfectly with the earthiness
of the piece

c

d

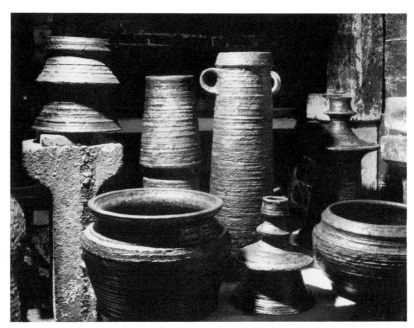

e

f

a
"Sunflower," a cheerful pattern in yellow and dark brown hand-painted by Hilkka-Liisa Ahola of Arabia's applied-art department. The glasses, designed in several colors, are by Kaj Franck. [Arabia and Nuutajärvi-Nötsjö]

b
Table setting combining a dark-green cloth with big black plates, smaller "Vegeta" plates in pale green and yellow shades, clear wineglasses with dark-green stems and a clear glass bowl with cover. "Vegeta" is designed by Esteri Tomula. [Arabia ceramics, glassware by Nuutajärvi]

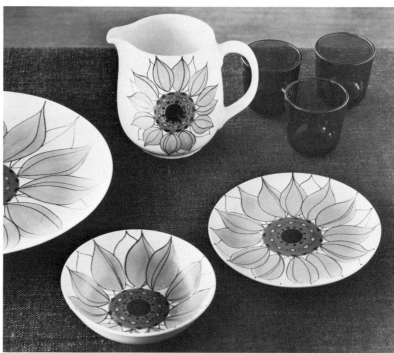

a

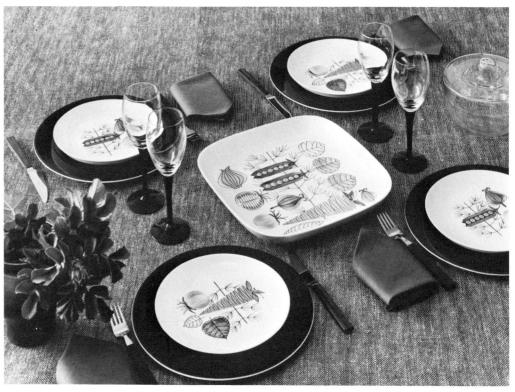

b

Rice porcelain bowls designed by
Friedl Kjellberg for Arabia. Her Finnish
technique of making rice porcelain
differs from the old Chinese method but
is inspired by it. Arabia has produced
rice porcelain since 1942. Inset: Detail
of rice porcelain

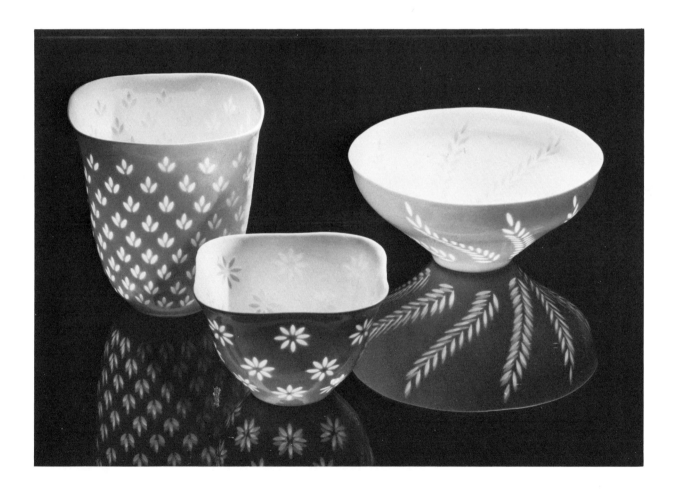

IV. WOOD AND FURNITURE

Scandinavian furniture expresses a special way of life, with the home as a center for most activities. To this end, the aim is an atmosphere of hearty welcome for guests and serenity for the family. Furniture has special meaning for such home-loving people. What they own is a firm declaration of their sense of values. Inside their homes, the impression is of neatness, comfort, and security. These are unpretentious, practical people seeking in their dwelling places a private haven from a whirligig outside world. The Nordic family places special importance on an attractive, inviting entry, and inside the house plenty of light, air, and greenery. An open fireplace is as essential as the obligatory potato in their menus.

Scandinavians select their furniture with educated discrimination and without prejudice. They are proud to own both heirlooms and new pieces. What is so charming is the way a veneration for the past is smoothly blended with today's design products to create an inviting and livable atmosphere. They keep up with artistic developments and like to know about the artist who designed the item they select. Wisely, they invest only in quality craftsmanship, because they expect their furniture to last at least one lifetime. Furniture is not for passing fancies.

In general, Scandinavian homes and apartments, which are furnished mainly with contemporary design, give a composed, uncluttered impression. The sleek lines of modern furniture are often accented, however, with old and treasured pieces handed down in the family, such as a carved hutch or a rose-painted antique chest. Some homes are furnished almost entirely with family heirlooms of peasant-craft origin, but there may be one or two contemporary pieces, which oddly enough do not seem at all out of place.

What Scandinavians seek in acquiring furniture is something which seems right for today and for the future, yet associates well with furniture from the past. They want furniture they will not tire of and will enjoy more every day they live with it. Factors considered include economy of form, graceful lines, absence of gimmicks, and good overall contour with no topheaviness or other distortion. The best workmanship and material are basic requirements.

Reverence for Wood

It is natural to expect the best from this area in all uses of wood. Norway, Sweden, and Finland have been blessed with forests on the basis of which they have created and maintained their economic structure. From wood came their homes and churches, ships, wagons, sleds, skis, fuel, utensils, containers, and implements of all kinds. From wood they built their astounding Viking longboats and their seaworthy fishing boats. It was the only resource they had with which they could trade internationally. The forests are truly the "Green Gold" they have been nicknamed.

Through the generations, these people have discovered wood's every

possible use, shape, strength, and beauty. They are now masters at handling it with a sureness and respect kept alive through decades and centuries of experimenting with its subtleties.

In earlier times, except for peasant craftsmanship, "city" furniture was made in conformance with set styles popular elsewhere, although the difference was usually apparent in meticulous wood processing, seasoning, and workmanship. Styles were also simplified and improved upon, according to local tendencies.

The Scandinavian furniture of today is quite the opposite. It employs no preconceived patterns from elsewhere, or any specific "style" at all. It has earned the esteem of the world not only for its quality but especially for this very neutrality, which allows it to be a good companion to other furniture treasures. It is straightforward, well thought out and constructed, and above all practical and suitable for the way people live now.

Wood is to the Scandinavian home as tile is to the Italian and Spanish house. In a sensible manner, materials requiring painting or replacing (such as plaster or wallpaper) are used for walls. Ceilings, which are more difficult to repaint or refinish, are often paneled with natural wood, warmly decorative and largely maintenance-free. Wooden floors with natural finish remain almost impervious to trouble and lend themselves to frequent wet-mopping for the near-surgical cleanliness demanded by the tidy Scandinavian housewife.

Such a long history with wood as a major raw material for home-crafted furniture and utensils has taught Nordic people how much beauty can be derived simply from sloping and rounding wood to show off its singular grain, how and where to carve it thick for strength and thin for grace. They have also learned how impractical it is to give this marvelous material a coat of high-gloss varnish, which only detracts, compared to its natural glow when hand rubbed, and makes the wood ill-adapted to steady hard use without damage and periodic refinishing.

Originally, the primary woods used for furniture were of necessity native ash, birch, pine, fir, and some oak. After the war years, teak—technically and aesthetically a cabinetmaker's delight—was imported from Thailand; then mahogany, rosewood (palisander), and walnut. During the fifties, teak and walnut were almost synonymous with Scandinavian furniture, particularly Danish. Birch has managed to hold its own, and now popular once again are juniper, ash, elm, spruce, and the fruitwoods. A more happily balanced choice of wood is used these days, the selection depending on suitability for each specific design and its purpose.

Whatever kind of wood is employed, the Scandinavian's respect for this material is obvious, and seldom can you enter a furniture shop or exhibit there without noting the way many people reach out to stroke the silken finish of the perfectly crafted wood, smiling appreciatively. Knud Poulson, Danish professional visitor at the 1965 annual exhibit of the Danish Cabinetmakers' Guild, made these pertinent remarks:

"Wood must not show resistance. It should submit itself to the caressing touch. It should grow under our hands, as though it were self-creating . . . A table, a chair, a cabinet, a bed, you possess them

when you touch them. They belong to you, together with their craftsmanship, or, if you like, their art."

Design Development

Today's Scandinavian furniture forms had their roots in what became world-famous as "Swedish Modern," itself inspired by the Bauhaus crusade for pure functionalism. The style caused a sensation around the world when it was introduced in the 1930's. It was called ugly, repulsive, cold, loathsome, uncomfortable-looking, and devoid of charm by people long steeped in traditional styles which were status symbols in the past. Pro-functionalists, on the other hand, sung its praises loud and clear, in an earnest revolt against excessive Victorian frills and gewgaws, and welcomed the most radical departures from elaborate ornamentation and monotonous recopying of prior styles. The publicity about the controversial development did at least serve to renew people's interest in creative interior design, a healthy development.

In furniture, as in other arts, functionalism ran to atrocious excesses of its own at that time, until a disenchantment eventually set in. It wasn't long before such utter severity lost its appeal, and tastes rebounded in the direction of honest craftsmanship and more appropriate, though still functional, form. Although architects, craftsmen, and the people themselves had rejected traditional things for the nonce, they still had a strong yearning for quiet, humanized, natural shapes, which could demonstrate more completely the qualities and beauties of each raw material. Thus emerged a most desirable blending of the practicality offered by functionalism and artistic discrimination, which for lack of a more accurate term is referred to nowadays as "contemporary."

In considering the Scandinavian furniture design of today, it is necessary to look back three decades or more. Some of the furniture created in the thirties and forties, then considered somewhat outré, has proven itself by surviving changing times, radical social reforms, an entirely new life style, and even the massive onslaught of new materials, machines, and processes. Scandinavian architects and artisans, along with the functionalists in the rest of Europe, cut away from the past, perhaps too sharply at first, but there were even then a handful of men who had the foresight to back off from the extreme and to modify their approach to functionalism with a little common sense. These architects and artisans used restraint. They retained in their clear-cut, forthright forms the important magic of the natural curve, the gently rounded corner, the warm look of expertly treated unpainted wood. Based on sound and honest principles, their furniture forms were neither drastic nor stereotyped; these moderate designs are still perfectly at home in today's milieu. The furniture of Alvar Aalto and Bruno Mathsson is as entirely appropriate in the 1970's as when it was made in the 1930's.

"Swedish Modern," functionally and scientifically designed, was a sensational best seller in the United States, appealing to the younger generation, which, then as now, sought a departure from tradition and needed furnishings scaled for small homes and apartment living. Though the designs were too extreme at first, the aims were worthy: efficiency and minimal care. Women were often employed outside the home—dusting grooves and curlicues was felt to be time- and energy-wasting—and few in those post-Depression years had domestic help. The style became adapted mainly for the big American market. The Swedes certainly didn't consider it very Swedish. The austere functional forms proved humanistically unrewarding. Gentle curves were missed and cubist shapes were felt to be alien to the nature of wood and contributing nothing much toward the look of cozy restfulness desired in homes. Promptly the Scandinavians developed the exemplary alternative which has since made them famous—furniture of logical size, natural form, and worthy materials, honestly crafted, to provide the owner with long years of faithful service and comfort.

Though Sweden led the 1930 renaissance toward functional design, Denmark has more recently received the world's accolades for its contemporary furniture. Sweden continues to present the market with outstanding designs, however, and Finland has now rocketed into the foreground with industrially produced furniture full of imagination, character, and elegance. In Norway, Denmark, and Sweden, furniture production takes place mostly in many small workshops and factories. Finland, on the other hand, has fewer manufacturers, but they employ five hundred or more men each. In Iceland, production of furniture is on a very small scale, but it is being developed. The relationship between industrial producers and craftsmen in Scandinavia is so close that expertise has been retained in all details.

Scandinavian furniture designed for public spaces, most particularly the Finnish, has gained a fine reputation around the world and is to be found in distinguished buildings at Oxford, Harvard, Yale; in the World Bank, the Chase Manhattan skyscraper, the Athens Hilton, the Kennedy Center, and dozens of other great structures around the globe, wherever only the best is desired.

The range of design is great, from free forms as exciting as the world-famous "Egg," "Swan," and "Ant" chairs by Denmark's Arne Jacobsen, to Poul Kjaerholm's equally esteemed chair of metal and woven fiber designed for industrial production, to the simple, clean lines of modern-day versions of provincial furniture. Molded plastic circle-and-curve-shaped chairs are being made which have much appeal to the younger set. There seems to be no limit to what the Scandinavian designers can come up with to suit all kinds of people seeking to create a personal atmosphere within their four walls. The common denominator is that, whatever the form, their furniture has the basic factors of being conceived and made for quality, comfort, and adaptability. Whether the piece be inexpensive or costly, humble or imposing, it will inevitably have a certain elegance of line and an international appeal which can stand the test of time and everyday use.

Parallel to the new growth of the cabinetmaking art since the thirties has been its collaboration with and influence on industrial production. The inclusion of the craftsman-designer in mechanized production has been beneficial to all. Scandinavian design's tasteful

a
Of the four most famous contemporary chairs in the world, Scandinavians have designed two, shown here. (The other two are Mies van der Rohe's Barcelona chair and the Eames lounge chair.) The armchair with caned seat designed by Hans J. Wegner in 1949 for Johannes Hansen of Denmark, is such basically sound design and craftsmanship that it became known simply as "*The* Chair."

b
The steel and cane easychair was designed by Poul Kjaerholm in 1957, and is produced by E. Kold Christensen in Denmark. Note the absence of steel cross members at the top back and front edge. [Courtesy Den Permanente]

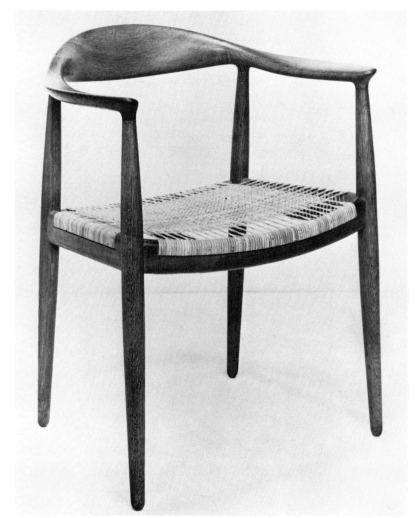

a

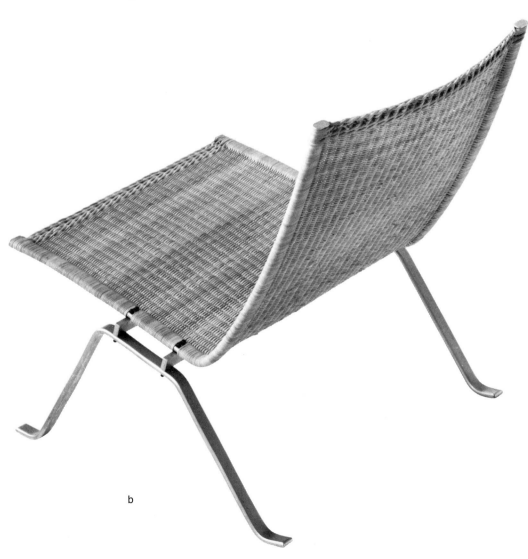

b

Equally world-renowned are the furniture designs of Arne Jacobsen of Denmark, especially his "Egg" and "Swan" chairs. The "Egg" chair swivels, and from personal experience, the author avows this cozy chair is a source of marvelous comfort and relaxation. Both of these chairs may be checked out by the visitor to Denmark in the lobby of the Royal (SAS) Hotel

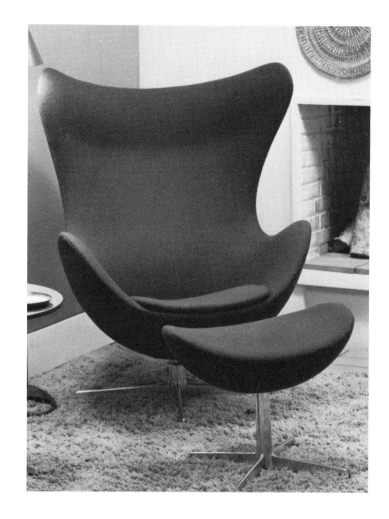

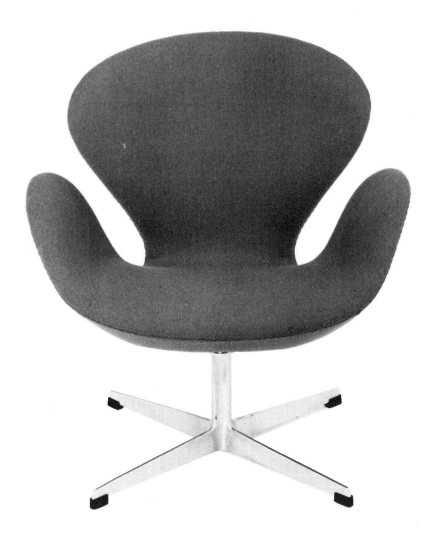

solutions for today's needs have been a welcome counterbalance to ennui and disillusion with snobbish decor.

This creativity flourishes in an atmosphere of professional serenity and encouragement, lending a placidity to design themes. Last year's good models are not discarded to make room for the next innovation. Improving an already existing form is given careful and constant attention. The goal is to perfect. Some of today's best and most popular designs were created two or three decades ago, and have actually gained ground with age. Nothing is contrived for market pressures. Experimentation is continuous, such as development of new methods of laminating and bending woods to make them more plastic, and new surface treatments to improve wood's durability in natural finishes.

The studied proportions, good material, and fine cabinetwork characteristic of *Scandinavian* furniture are to be found in products actually *made in Scandinavia.* A few designers have been exported to other countries, and other countries have sent some of their people to Scandinavia for study and training, which is all to the good, but there has meanwhile been much copying of the generalized look without the quality or proportions, and this has been misleading. Quality control in export goods is strict in Scandinavia, so there is nothing quite like the genuine article.

Furniture designed for the changing times and the trend toward smaller homes and apartments was likewise better suited to a more mobile way of life. Scandinavian designers focused upon movable, lightly scaled pieces, storage-wall components adaptable to every possible family need, yet easy to dismantle, set up, or rearrange for different dwelling spaces. Furniture was designed to be set away from walls, thus requiring attractive appearance on all sides. Everything became more versatile, collapsible, space-saving, multipurpose, compact, yet charming enough to satisfy the need to change a neutral rented cubicle into a warm, personalized place to be.

In Scandinavia there also occurred, as the century progressed, a social leveling that left a huge middle class, with few elite and few poor or destitute. Whereas before people had been housed in small cottages or opulent homes, there was now a complete change in living, with many apartment houses and smaller homes being built. Only Norway still has a considerable percentage of people living country-style in truly remote areas.

Getting designers, architects, master craftsmen, and manufacturers into collaborative production was the secret of providing mass-produced furnishings, well designed and made, at a price most consumers could afford. It was a major accomplishment.

Hytte Living

Scandinavians have long been families with two homes . . . one their daily town or city dwelling place and the other a summer-winter vacation home—on seashore or island, in valley or on mountaintop, or beside a forest-fringed lake. Here in the long winter, Nordic folk head out to ski, or just to get away from city life. In the summer they are off again to their country place, called a *hytte,* at every opportunity, which many a business visitor to Scandinavia has discovered to his chagrin. With their great love for their still-unspoiled outdoors, for sound health and vigorous exercise, and with scorn for the idiocy of rat-race schedules comes an accompanying yen to leave town . . . as often as possible. Great store is placed on these vacation retreats and what is placed inside of them. As a result, much furniture is specifically designed for *hytter.*

The *hytte* is an intimate family hideaway, and the strong Nordic feeling for the preservation of old customs and folk art is given full expression there rather than in the dressier atmosphere of townhouses. *Hytter* are always very personally furnished. There are long plank tables of fir, benches to match, and provincial chairs with woven rush seats, providing for extended happy meals (sometimes hours long) and skåling with the family and such few friends as are selectively invited to visit the country home. Antique rose-painted or carved cabinets, old pewter tankards, and heirloom china are used here with loving pride and sentiment.

Time spent in these tranquil cottages is meant for rest, recreation, exposure to precious sunshine and fresh air, meditation, and remembering . . . refreshment for mind and body before plunging back into city life again. *Hytter* are very sophisticated in construction and decor, though carefully rustic and traditional in spirit. Here hangs the treasured rya rug. Here is found the beautiful handwrought iron hearth and accessories, pewter, brass, handsomely glazed stoneware, an antique grandfather clock, or a tall stove of ceramic tile, first owned by *tip-tip-oldefar* (great-great-grandfather).

The furniture is usually robust and sturdy but may be provincial *or* contemporary in feeling. The emphasis is on natural, easily maintained woods, styled in a rustic fashion harking back to past cultures, reflecting a country atmosphere and prepared for indoor-outdoor living requirements. Leather upholstery is popular, pelts, ruggedly handsome textiles, handwoven floor runners.

Leading Designers

The most internationally famous furniture designers from Scandinavia include the Danish architects Poul Kjaerholm and Arne Jacobsen, designer-craftsman Hans J. Wegner, Finland's famed architect Alvar Aalto, and Sweden's Bruno Mathsson. Wegner's world-famous armchair is a classic, simply referred to as *The* Chair, and has been copied more than thirty times by others—which Wegner considers a compliment. An exhibit of all known copies assembled with the original was once arranged. Shown alongside the imperfect attempts at reproduction, the original chair with its flawless perfection provided an eye-opening lesson on what is meant by the word "masterpiece."

a
Ax found at Skogstorp, Södermanland,
Sweden, from early Bronze Age,
c. 1500–500 B.C. Found with fragments
of another ax. They are interpreted
as sacred articles used in connection
with religious rites. Wooden handle
and gold ornament with amber.
[Owner: National Museum, Stockholm]
b
Comb made of horn from a site at
Gullrum, Näs Parish, in Gotland,
Sweden. The ends are ornamented with
heads of a human and a horse. Late
Stone Age, c. 1700–1500 B.C. [Owner:
National Museum, Stockholm. Photo:
Sören Hallgren]
c
Drinking horns, characteristic of the
Germanic peoples since very early
times, had a kind of revival during the
thirteenth and fourteenth centuries.
Pictured is one of two medieval wooden
horns, very rare and owned by the
National Museum in Stockholm. This
one apparently received a later coat
of paint, though the original colors are
visible. About 15″ long. The other
horn found (not illustrated) has no trace
of painting. [Photo: Sören Hallgren]

a

b

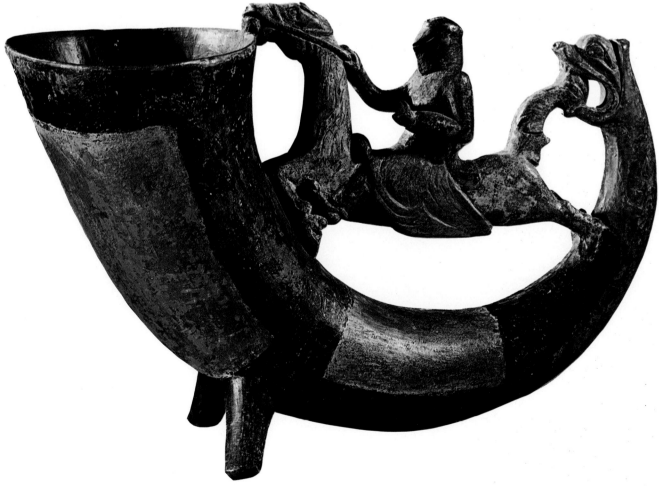

c

a

"Seljord" by Porsgrund, a Norwegian rose-painting (rosmåling) design delicately interpreted in soft blue with gold, and applied to Porsgrund's contemporary "Jubilee" shape service by designer Thorstein Rønjom

b

More of the great Bjørn Wiinblad's imaginative work. This is a hand-painted bowl of papier-mâché, typical of this artist's innovative and cheerful works. [Courtesy Bjørn Wiinblad and Den Permanente]

c

A vase by Annikki Hovisaari [Arabia]

d

Two fountain figurines delightfully christened "Mrs. Krogh" in blue on white. In the background, a handsome grill table. By Bjørn Wiinblad. [Photo: Kirsten Kyhl]

a

b

c

d

a

"Kilta" (for Arabia) in oven-proof faience, is mix-match, multipurpose, made in white, black, green, sunny yellow, and a deep rich blue. Kaj Franck and Arabia tag this versatile design with a revealing description: "To use for anything"

b

"Blue Rose" (BlåRos) design on "National-servisen" model hard-paste porcelain. Designed in 1930 by Louise Adelborg for Rörstrand of Sweden. The glass sauce dish and saucer are inexpensive *lett-krystal* (which may be translated as half crystal, half glass) made by Hadeland of Norway. The tablecloth is woven in Finland and demonstrates the Finnish gift for color subtlety

c

Chamotte vases by Francesca Lindh. [Arabia]

a

b

c

a
Birger Kaipiainen's famous "pearl"
bird, which won the Grand Prix in
Milan, 1960. [Arabia]
b
Characteristic decorative work of
Birger Kaipiainen. Glowing colors,
rich and detailed ornamental
material. [Arabia]

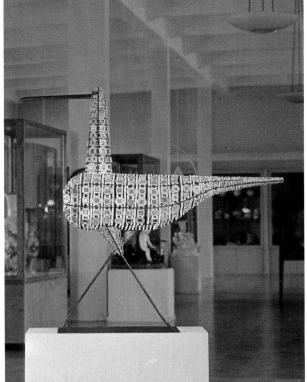

a

b

a
Ovenproof "Ruska," designed by Ulla Procopé, has all the appearance and feeling of hand-thrown ceramics, with the typical roughness, vigor, and uneven color of a handmade object carefully retained even though industrially produced. "Ruska" is a rich, deep, pumpernickel-brown stoneware, its color bringing to mind the Lapland autumn

b
Gay and practical faience stackable jars for preserves or refrigerator storage use. Design: Ulla Procopé. Decoration: Raija Uosikkinen

c
Porcelain vases with turquoise glaze by Friedl Kjellberg. [Arabia]

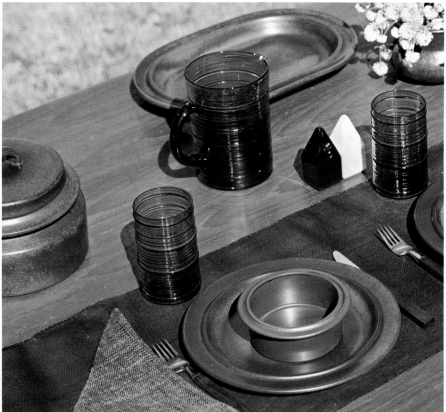

a

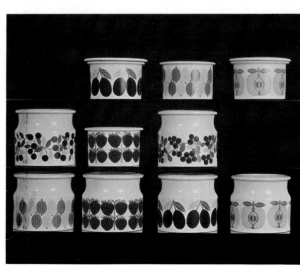

b

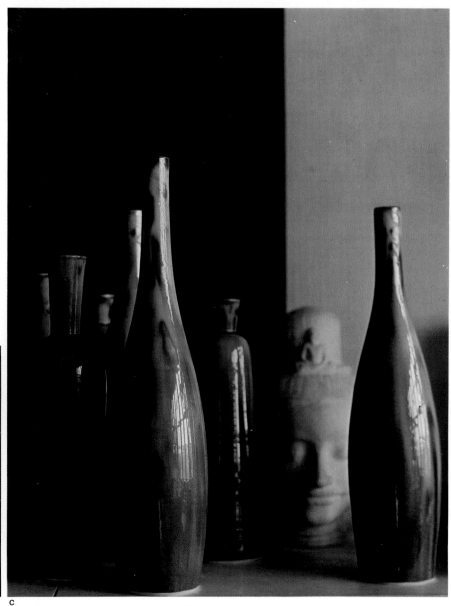

c

a
World-famous chair and table with
tension leg, important developments in
furniture design by Bruno Mathsson of
Sweden in collaboration with Piet
Hein, famous Danish mathematician and
poet. The super-ellipse table is
approximately 5½′ in diameter. The
workmanship is superb, with joinings
so perfect they are hard to spot even on
very close inspection. The tension-
principle leg, developed by Mathsson,
clips into place and is easily removable.
Mathsson designs are meticulously
executed by his cabinetmaker father's
(Karl Mathsson) firm. [Courtesy Svenska
Slöjdföreningen]
b
Children's sectional table and colorful
chairs by the Finnish architect Alvar
Aalto. [Courtesy Artek, Helsinki]
c
This chair, by Lunning Prize winner Yrjö
Kukkapuro for Haimi Oy of Finland,
could well qualify to be the most invit-
ing one of all time. The arms are
optional, and with or without them, the
chair in any number forms a sofa or row
of seats as desired. The fiberglass
pedestal base is part of a related mix-
match series of table components
designed to create tables as needed in
cocktail, occasional, bridge, or dining
sizes. There is a wide color selection
both in the fiberglass base and ten lush
leather shades, twenty vinyls, and many
fabric choices. Just how versatile can
a design be?

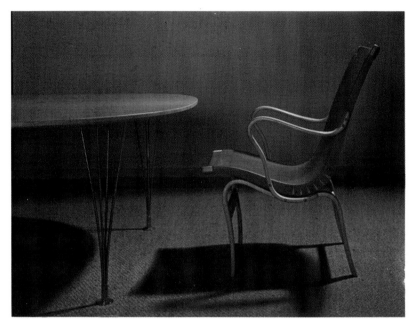

a

b

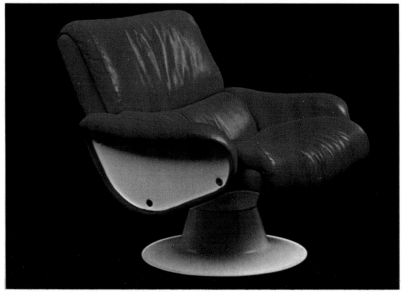

c

Extreme left and right: cobalt-blue
beer goblet and deep amber goblet,
Erik Höglund, Boda Glassworks. Rest:
Orrefors aquamarine blue goblet and
two candlesticks reflected in a lovely
Orrefors crystal vase. [Photo: Kjell
Munch, Oslo]

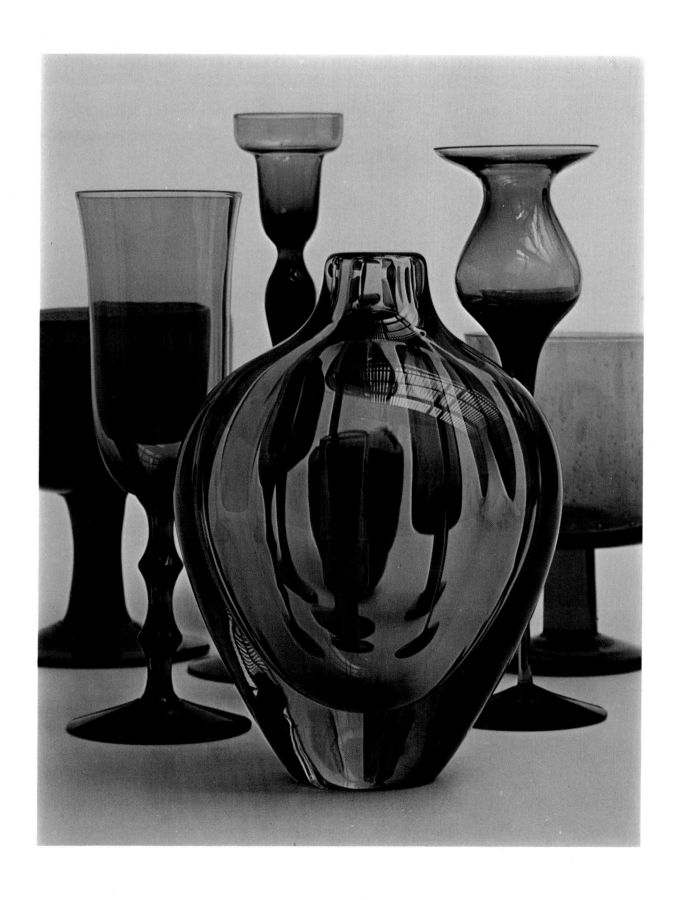

a
Unique art piece, bubble-glass plate designed in 1968 by Kaj Franck, made at Nuutajärvi

b
Unique art-glass plate. The painted decoration is within the layers of glass. Diameter about 10″, made at Nuutajärvi and designed by Oiva Toikka

c
Glass sculptures in hot-joined blown glass; unique pieces by Oiva Toikka at Nuutajärvi, 1967 and 1968

a

b

c

Arne Jacobsen is best known for his "Egg," "Swan," and "Ant" chairs, Poul Kjaerholm for his innovative chair of steel and cane, and Alvar Aalto for his pioneer work with steam-pressed laminated wood, which is also the technique of Bruno Mathsson. These men are architects first and furniture artists second. Along with Denmark's Poul Henningsen and Kaare Klint, they decried the lack of appropriate furnishings for their innovative buildings and began to design their own. They share the furniture hall of fame with such greats as Charles Eames, Mies van der Rohe, and Eero Saarinen. Saarinen's white pedestal table and chairs (created to reduce the forest of furniture legs in a room) are today seen everywhere and have been copied almost as much as Wegner's armchair. Eero Saarinen was the United States–born architect son of Eliel Saarinen, renowned Finnish architect, who moved to America at the height of his career. Eero is thought of as an American talent, of course, but his artistic leanings and interpretation stemmed from a Finnish heritage.

Perhaps the greatest single factor in the success of furniture design in Scandinavia was the extensive functional study made by Kaare Klint of Denmark, whose brilliant leadership will be discussed later in this chapter. Professor Klint's designs and teachings were based on measurements, first of the human anatomy and second of the storage needs of the average family. His dedication was to comfort and to the elimination of waste space and material. His many students have since amplified his research.

In Sweden, Erik Berglund and Sten Engdal also directed comprehensive function studies concerning furniture, a project they undertook for the Swedish Society of Arts and Crafts and Industrial Design. Their work led to statistics that not only showed designers the normal shapes and sizes but also served as a guide to variations from the norm. From this study came information educational to the consumer as a guide in buying furniture, including all kinds of tables, beds, chairs, and storage units. An invaluable condensation of this study is to be found in *Modern Scandinavian Furniture* by an expert and author I much respect, Ulf Hård af Segerstad, Sweden, who is a leading art critic and authority on Scandinavian architecture and applied arts. He writes for *Svenska Dagbladet,* was editor of *Form* magazine, and has written many books and articles. Mr. Hård points out that careful planning of scale and technical strength has nothing to do, really, with cost of production. No matter how inexpensive a chair, the joining should not be faulty or incorrectly glued, nor should it be frail or too small or large. The least expensive woods and less expensive methods of finishing are actually the most durable, he reminds us. Therefore, the buyer should expect durability at any price, and on the other hand expect to pay for luxury features which involve more craftwork or more expensive materials and finishes. More costly fabrics, custom fitting or upholstery, the use of a rare wood—these are the features which elevate price. *Kinds* of wood are purely a matter of preference, but the *quality* is vital, for bookshelves must not sag, doors must not warp, and drawers should open and close smoothly and yet fit snugly. Such is the Scandinavian producer's message. Honest performance means honest merchandise.

Especially for Children

Children's furniture comes in for its own special share of attention. Kristian Vedel and Nanna Ditzel of Denmark have made furniture for children according to needs, rather than miniatures of adult furniture. Vedel's child's chair (Torben Ørskov and Co., Copenhagen) is made of sturdy molded plywood in semicircular sections, from which can be made a table, a chair with eating tray, a rocker, or the base for a seesaw. It was awarded a silver medal at the Milan Triennale. Nanna Ditzel's children's things (Møbelfabrikken Kolds Savvaerk, Kerteminde, Denmark) include a wonderfully simple "climbing tree" pole of Oregon pine, a pine cradle which can be rocked or locked in position, and a high chair, all three ideally suited to mechanized production at minimal cost to young parents, and—most important—suited to children.

Alvar Aalto (for Artek, Helsinki, Finland) did a practical and cheery-looking group of birch tables and chairs for the young, topped in tough and colorful linoleum, which can be separated and moved about in small, varying clusters, for single or group activity. Stefan Gip's "BA" series (for Skrivit of Sweden) was based on body-measurement studies of children two to six years old. As an example of thorough testing for durability, the rocking chair of this series was given an abnormal load of over 150 pounds and rocked about 87,000 times, with no sign of weakness. The Swedish designer Suna Fromell has designed a series for children named *"Växa med Läxa"* (Grow with Learning), and grow it does. It consists of units for combining in a multitude of ways, adaptable to the child's activities throughout growing years, and still appropriate for adult living. Employing two colors of wood with natural finish and simple, unassuming lines, the system is handsome, practical, and ageless.

Wood but Not Furniture

All that is wood is not furniture, and vice versa. There are many fine examples of woodcraft made in Scandinavia, such as serving platters, salad bowls, cutlery handles in teak, walnut, or rosewood. Wood sculpture in the way of figurines of people, trolls, and animals is still a prominent handicraft, either in peasant-art forms, or as sleek and impressionist as Arne Tjømsland's streamlined, sculptured elk family carved in fir (Hjorth and Østlyngen, Norway). Mention should be made, too, of Tapio Wirkkala's inventive dishes and other forms carved from laminated layers of aircraft plywood, one of them dubbed by *House Beautiful* magazine as "the world's most beautiful object of 1951," the year he began experimenting with this technique for dishes and tables. Carving these layers of wood in a sculptural manner reveals veining and grain effects of unusual beauty. Wirkkala's work in this technique has won this remarkable Finn several Grand Prix at the Triennale, and in this medium he created the imposing "Ultima Thule" wall panel at the "Creative Finland" exhibit for Expo '67 in Montreal.

Small articles are handcrafted in Lapland, where native arts have

a
Kristian Vedel is one of the many
designers throughout Scandinavia who
believe children's furniture should not
be simply miniatures of adult furniture.
This child's chair by Vedel has won
more than one award for good design.
It has been produced by Torben Ørskov
& Co. of Denmark since 1957. It con-
verts from chair to table to rocking
toy, is made of stretch-molded beech
plywood, in natural, red, or blue.
[Courtesy Den Permanente]

b
Child's high chair in teak, oak, or beech,
designed by Nanna and Jørgen Ditzel in
1955 for Møbelfabrikken A/S Kolds
Savvaerk, Kerteminde, Denmark.
[Courtesy Den Permanente]

a

b

been given encouragement by two young organizations, the Same Ătnam and the National Federation of Lapps, working with minimal funds but lots of enthusiasm to preserve and promote the Samish (Lapp) culture, and to help it develop know-how in tune with new uses and the times. Knife and ax are still the simple traditional tools used, although the Lapps will occasionally try new things, such as a band saw, to simplify the rough work. It is said one craftsman likes to use a dentist's drill for some of this work. But only manually does the Lapland craftsman patiently bring forth that glistening pearly gleam from a birch bowl, just as his forefathers had done before him for generations.

Other wood handicraft from the Land of the Midnight Sun includes such interesting items as hot-dish pads of sixteen small "slices" of juniper fastened together in a square of whorls, woven birchbark baskets and jars, and the fragile, delicate beauty of the well-known St. Thomas Cross, hand-carved into a lacy filigree from a single piece of wood—an old peasant art.

To go from peasant craft to a most sophisticated line—Dansk Designs is a firm well known for the select small objects of wood, stainless steel, glass, and textiles they market. This is a conglomerate organization which began some years ago as an export sales group for Danish applied arts. Dansk wooden pieces are up-to-the-minute in design, practical, and exquisitely crafted. They feature such articles as end-grain-block carving boards (which do not dull knives), wooden pepper mills with salt shaker tops, and of course Jens Quistgaard's now famous teak ice bucket, considered such a classic as to be included in the collections of six museums.

Great strides have been made in the manufacture of non-wood furnishings, utilizing steel and aluminum, with hemp, leather, or fabric upholstery, and the new plastics such as polyurethane. Finland, with its large factories capable of broad production, is the leader in this area. Since more and more firms now want to receive their clients in quality surroundings (remember the atmosphere of fusty old offices years ago, with their cluttered rolltop desks?), there has been a steadily better market for wood, metal, and plastic furniture which not only has durability and style but also dignity. Finnish furniture design has fulfilled these needs admirably, and been welcomed as appropriate for creating exactly that kind of setting. It has a discreet richness, without seeming sterile or overly impersonal.

It should be added, while we discuss "non-wood," that upholstery from Scandinavia displays some of the most magnificent leatherwork imaginable. Still referred to as saddlemakers, leather artisans work closely with furniture makers. The leather is complementary to both wood and metal, and becomes more handsome with use. The most popular leather used is an oxhide in a glowing peachy-beige tone. I have never run across this beautiful color of leather elsewhere.

Denmark

It is said that a Finn was once overheard remarking that Finland had the world's most modern and completely mechanized furniture factory. A Dane standing nearby remarked in a horrified tone: "But how can you possibly make really good furniture except by hand?"

A natural reaction, for the Danes elevated handcrafted furniture to new heights at a time when the rest of the world was industrializing furniture production. Typically, another Dane has commented that mass production has a "vulgarizing effect" on handicrafts.

Danish handcrafting today has a new design theme unrelated to the old peasant crafts. Danish folk art almost died out in the twenties, and even today the now-flourishing handicrafts of Denmark do not often reflect ancient peasant art, as they do in Norway, for instance. The most notable break with the past came in 1925, when a group of less than twenty cabinetmakers felt themselves being cut off by industry. What's more, they considered these industrial products to be of low artistic standard. The Danish Cabinetmakers' Guild, as a work guild, had existed for over four-hundred years, and oblivion was not acceptable. So they dedicated themselves to a goal of revitalizing Danish furniture design and even gave up most of their earnings during the first two years of their crusade.

The guild's members wanted to awaken manufacturers and people to awareness of good and bad taste and workmanship. They tackled this by holding an annual exhibit of only the best cabinetwork. The first showing was in 1927 and they have not missed a single year since. Manufacturers promptly got the message, and through a sort of osmosis, good designers and better artisans were soon incorporated into their production. At the same time, the public became enlightened, demanded the best, and bought discerningly.

The guild conducted competitions for each exhibit, which served as a laboratory and a powerful stimulus to achievement, with the accent always on quality—not only in the technical sense but in relation to materials, use, proportion, and that mysterious intangible known as human appeal. The program through the years has been inspirational to furniture art on an international scale.

The exhibits are held in October at the Danish Museum of Applied Art, 68 Bredgade, Copenhagen, where there is also maintained a permanent showing of antique, recent, and current Danish handicrafts. The guild also has its own quarters year-round in a picturesque and pleasant section of old Copenhagen at 21 Studiestraede, where visitors may see what is being newly produced.

Danish producers were formerly inclined to look toward foreign countries for their models. Since the Cabinetmakers' Guild took up its crusade, the tables have turned; other countries learn from the Danes, and people from all over the world come to study with Danish masters. They are men who revere the grain of wood, disdain shortcuts, and think in six dimensions—height, width, depth, volume, tactility, and contour, which also involves a seventh dimension, the play of light.

Industrially produced furniture was beneficially affected in regard to design and workmanship within the limits of keeping the price within reach of the average family. Manufacturers, too, now have annual exhibitions similar to those of the guild. They voluntarily set up a com-

prehensive control program, forming the Danish Furniture Manufacturers' Quality Control Board, which tests every item of furniture at the Technological Institute in Copenhagen before it goes into production. Also behind the movement for better household furniture has been the Danish Cooperative Society (FDB), a large retail outlet.

About the time the guild began its exhibits, other Danish artist-craftsmen were inspired to organize a sales-and-display headquarters, Den Permanente (The Permanent Exhibit) on Vesterbrogade in Copenhagen. It has an expert and fussy committee on selection, and presents the very best of Danish handicrafts in surroundings of good taste with uncrowded displays. These articles are largely the products of individual artists in private ateliers. It also selects and shows the cream of the furniture crop. Illum's Bolighus, up the street on Strøget, houses another choice and delightfully exhibited display of outstanding design from all the Scandinavian countries, but Den Permanente is strictly Danish. To my knowledge, no one has ever walked through either place without becoming permanently addicted to Scandinavian applied arts.

The Danish Society for Industrial Design (under the direction of Viggo Sten Møller) works to ensure the best design in all kinds of manufactured goods. Craftsmen and artists are trained at the School of Arts and Crafts and the School of Cabinetmaking. Advanced training is given at the Royal Academy of Fine Arts in Copenhagen. There is also a School of Interior Architecture at Falstervej, Fredriksberg.

Concerns such as the furniture manufacturer Fritz Hansen's encourage experimentation at their establishments by talented young students and individual artists toward adapting their designs to industrial production. Further encouragement comes from the Danish Society of Arts and Crafts and Industrial Design, which hovers over all Danish applied arts, arranging annual exhibitions at home and abroad and publishing news journals for the trade.

Although at the end of the nineteenth century Danish cabinetmakers already excelled in their field, it was Kaare Klint who instigated a new way of thinking about furniture, based upon technical studies of human anatomy and activities. His studies resulted in desks, beds, tables, and chairs being made to provide comfort for various sizes and shapes of human beings. Later he extended this research to storage needs. In the twenties he produced a buffet which held as much as previous pieces of the type but was about half the overall size. He did exacting measurement research on items a family usually stores in such a buffet, and then entirely eliminated waste space, such as drawers overly deep for their usual contents. Consideration was given to reach and eye level. The outer form and detail took shape mainly from technical factors and were rather conservative. Klint's pieces did not reflect historic styles, although he used some fundamental principles from past designs if he felt they could benefit his new models. Professor Klint was originally an artist, and paint to him was something to use on canvas. He believed that painted or varnished wood was absurd, and even preferred leather in natural color and fabrics of flax or sheep's wool in white, black, gray, brown, and tan. His fittings and all details were scrupulously adapted, and his surfaces were treated to achieve the suitable aesthetic effect.

From historic works, Klint used structural or joinery accomplishments he thought were not improvable. He liked, for example, the faultless sense of proportion seen in the designs of Chippendale. However, he carefully avoided any frippery from the past styles, and his own forms were always rationalized and efficient.

Professor Klint taught his sound design principles at the Danish Academy of Art, where his influence mushroomed through his students. It was the beginning of furniture which showed concern for its user. Soon measurement and function studies became the basis for all Scandinavian furniture art, though some traditions from the past which had merit were still retained where appropriate.

Klint's students, in contrast to the Bauhaus teachings of that time, studied earlier design and were shown how to benefit from it and how to integrate its sound ideas with functional factors, rational form, and the best workmanship, all pointed toward service to the owner, who, he always reminded them, was bound to be a human being, a fact many furniture designers often forget. Italian contemporary furniture, for example, shows many original and exciting ideas and *looks* good, but sad to state is seldom well made, and seating is so low that one has to slouch. It is impossible for a woman to sit down in or arise from a chair with any kind of poise. Furniture should not be made only "for show"—it ought to be comfortable.

After Klint's death, the architect Ole Wanscher, one of Klint's ardent followers, succeeded him at the academy. Here again was a man with a deep understanding of construction and form. His works, like Klint's, reveal an occasional nuance of the best of English period furniture. Professor Wanscher designed many different styles and types of furniture, all of it with a dash of the elegance and finesse he so respected in eighteenth-century furniture design.

Poul Kjaerholm, Arne Jacobsen, Ole Wanscher, Mogens Koch, and Edvard and Tove Kindt-Larsen were all contemporaries of Kaare Klint in the thirties who, each in his own way, contributed to the great strides in Danish furniture-design progress at that time. They were joined in the early forties by now-famous furniture architects—Hans J. Wegner, Børge Mogensen, and Finn Juhl.

Arne Jacobsen was a renowned Danish architect blessed with a lively, unrestricted imagination and a vast amount of technical know-how. In 1958 he designed the Royal (SAS) Hotel in Copenhagen and all its furnishings and interior fittings. He was also a leading industrial designer in textiles, wallpapers, glass, cutlery, and above all furniture. Jacobsen's works always have been the result of the need for complements to a specific room or building, and later were adapted to industrial manufacture. Besides his "Egg" and "Swan" chairs, he has gained laurels with a small chair known as the "Ant" because of its shape and slender metal legs. This is a simple and attractive stacking chair of steam-shaped plywood. Veneer layers a millimeter thin, peeled from a log, are stacked with grains alternating, glued under pressure, eight layers thick. The top and bottom layers are from diagonal cuttings to gain the most attractive veining. With its three legs of steel tubing, nickel-plated, this efficient and entirely unique chair is ideally suited to modern production

methods, low in cost, and compactly shipped. It is an excellent example of progressive Danish design thinking. When wood was waning as the dominant material for furniture, as against metal and plastics, pioneers in bentwood, such as Jacobsen, Aalto, and Mathsson, helped show that wood could be a whole new material through processes such as steam bending and laminating, which make wood pliant.

The architect Mogens Koch worked on many things—outdoor furniture, church furnishings in metal, wood, and textiles. He was a structural perfectionist, and his designs always encompassed great precision of detail and clean-cut lines.

Finn Juhl is yet another Danish architect who contributed much to furniture art. He began a collaboration with the cabinetmaker Niels Vodder in 1937. Juhl was an inspiration to the craft, particularly in his love for graceful sculptural curves. Breaking from the Klint school of functional and sometimes stolid shapes, he departed entirely from the past. He regarded woodwork as a sculptural art. His pieces were light and full of soaring curves and graceful motion, impeccably made. In a more conservative mood (which he had from time to time), Juhl designed an office series (France and Son, Hillerød) in teak, of which the magnificent desk won the 1964 AID design award. This distinguished grouping is softened by the rosy warmth of the teakwood. Also somewhat conservative is an earthbound chair of masculine proportions and appearance, called the "Bwana" (also made at France and Son) in natural, pale wood with softly padded, leather-upholstered seat and back. It has sturdy, self-assured, squarish lines. Broad leather cushions curve gracefully over the arm supports, and carved atop the tapered legs is a flattened, round finial, the perfect resting place for the hand. Most of Finn Juhl's other chairs were tense and full of motion. Some had almost S-curved armrests with tautly drawn leather upholstery.

Klint's furniture was restrained and puritanical in style. Though Juhl believed in Klint's sensible construction, he felt artistic factors warranted more consideration. In returning to sculptural lines, Juhl's furniture was entirely functional but still very expressive. His flair for curves is also seen in some exquisite teak salad bowls designed for Kaj Bojesen's workshop.

Peter Hjorth and Arne Karlsen, on the other hand, represent a group of younger Danish designers who felt the tendency toward flowing curves was becoming overflowing. They considered these designs contrived, and felt that furniture should not be so busily conspicuous. Their own designs were curved only where there was a reason for such shaping, but were otherwise more or less angular or straight. They felt this allowed furnishings to meld into the general atmosphere of a room, and to serve their purposes unobtrusively. The firm Interna makes their designs, and the theme of their work is always simplicity.

An invaluable asset to Danish furniture history was the arrival on the scene around 1940 of Børge Mogensen and Hans J. Wegner. Both were formally trained cabinetmakers from the School of Arts and Crafts furniture department. Both came well prepared with a vast knowledge of wood and experience with wood techniques to give reality to their imaginative ideas.

Wegner, often referred to as the "master of sitting," approached his work as a carpenter, and all his pieces demonstrate his great love for and competence with wood. His internationally admired chairs are distinguished by the headpiece joining the back and arm in one graceful curve, with the joinery an integral part of the artistic effect, not just used to disguise a technical requirement. He has a long list of awards, including the Lunning Prize, the AID design award, the Grand Prix and a gold medal from the Milan Triennale.

Over thirty years ago, Wegner and the cabinetmaker Johannes Hansen began working together at new design concepts which today seem natural to us. They showed their pieces at the guild exhibits, but they were not really appreciated until about ten years later. In 1949, Wegner and Hansen exhibited "*The* Chair," an unusual folding chair, and an easy chair made up of three laminated shells, all of which earned acclaim. "*The* Chair" was such an unusual piece of work that people, stopping automatically to admire it as they ambled by, could not resist reaching out to touch its impeccable finish and gentle curves. The sculptural lines and superior craftwork were admirable. Here, at last, was an acceptable, livable example of contemporary furniture. This chair represents the ultimate in painstaking thought and workmanship, in addition to its artistic appeal. Wegner does not make many designs, but continually reworks his earlier ideas to perfect them further.

Hans Wegner's designs show the integrity of his personal approach, what he demands of himself, and what he expects from wood. He has said that chairs should look good and be comfortable, not just hold people while they rest their feet. He knows that chairs don't have to be big or bulky to provide even a portly person with comfort. Most of his chairs are of average size and virile in appearance without seeming bulky. His work method is to sketch his idea and then to craft the original model himself, experimenting as he goes along. Painstakingly he sculpts and alters details until finally he is absolutely satisfied. Then, and only then, is the model turned over to Johannes Hansen, who still makes all Wegner's furniture. The joinings in Wegner's chairs demand much of Hansen's craftsmen.

Wegner's favorite woods are center cuts of oak and Siamese teak, both of which he prefers for strength as well as beauty. Finishes consist of oiling, buffing, rubbing with wax, done by the eighteen master craftsmen on the staff of Johannes Hansen's workshop, each of whom is as much of a perfectionist as Wegner and Hansen themselves.

Some of Wegner's designs are now made partially by mechanized methods and are available at lower cost, but they are still given scrupulous personal attention. Hansen's hallmark guarantees impeccable craftsmanship and the use of only the best wood, handpicked and seasoned from six to twelve months, then rough-cut into sections, kept in a drying room for three to six weeks, and finally stored ten more months before use.

Børge Mogensen, a productive furniture artist, used infinite patience and some ten years or so of persuasion to help convince both Danish and Swedish furniture companies never to turn out shoddy products which could degrade the good reputation of their furniture. Like Kaare Klint,

a
Armchair and ottoman in rosewood with leather cushions, designed by Ole Wanscher in 1959. Wanscher was a master at delicacy of line and proportion. This chair is made by P. Jeppesen, Denmark. [Courtesy Den Permanente]

b
Graceful deck chair with canework in the seat, back, and footrest, designed by architect Kaare Klint of Denmark in 1933, and made by Rud. Rasmussen's Snedkerier. [Courtesy Den Permanente]

c
Chair "Safari," a design of Kaare Klint's. Although this chair is entirely collapsible and compactly stored or moved about, when set up, its lines and comfort suffer nothing from the convenience incorporated into its design. [Courtesy Den Permanente]

a

b

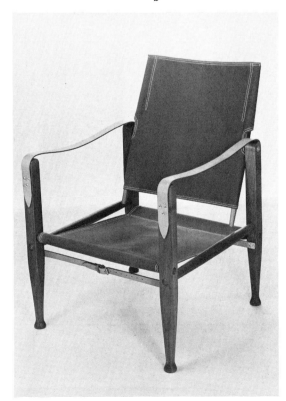

c

c

a
"Diplomat" seems like an appropriate name for this distinguished desk, chair, and Cresco wall-unit system in teak or rosewood, designed by well-known architect Finn Juhl. It is made by France and Son of Hillerød, Denmark. The "Diplomat" tables were granted the American Institute of Interior Designers award in 1964. [Courtesy Den Permanente]

b
Chair with caned seat by Hans J. Wegner for Carl Hansen. [Courtesy Danish Society of Arts and Crafts and Industrial Design]

a

b

Easychair with foam-rubber padded
leather upholstery made by A. P. Stolen
from a 1961 design by Hans J. Wegner.
[Courtesy Den Permanente]

he believes that enough thought about the function of a piece will determine its overall form. With his architect colleague Grethe Meyer, also a Klint disciple, he refined earlier function studies, and the two have designed from these studies an extensive cabinet system called "B.B." (for Boligens Byggeskabe, Denmark, which builds it), which has easily set-up units providing versatile storage/shelving for every imaginable family possession. Mogensen also designs for Swedish firms (Lauritsen and Sons Møbelfabrik, and Andersson and Sons AB). He prefers Nordic woods, and his distinguished designs are sculptural in a trim sort of way, with simple masculine lines and proportion, and precise detailing.

The Danish architects Tove and Edvard Kindt-Larsen show a highly personalized style in their work. The influence of tradition is seen, yet there is a refreshing individuality and inventiveness in their designs. In recent years they have organized and contributed to the annual furniture exhibit, and their work has had a pedagogic influence.

Jørgen and Nanna Ditzel are designers (together and separately) of furniture for many uses, some of which is made of polyurethane, fabric-covered, and is composed of sectional mix-match pieces without legs, in tune with the needs and thinking of young moderns. Nanna Ditzel's thoughtfully designed children's furniture has been mentioned earlier.

An outstanding example of Danish innovation in the way of industrially produced furniture is the famous "Ax" chair designed by Peter Hvidt and O. Mølgaard Nielsen (Fritz Hansen's, Copenhagen). The side frame of beech veneer over a mahogany core has a laminated seat and back-support frame for each side; cut in the middle, lengthwise, the outside strip is bent upward to form an armrest, the inside section bent downward to form the seat and back-support portion. Grooves in each side accommodate the slipped-in molded plywod seat and backrest components. The front edge of the seat is molded carefully downward to avoid any knee discomfort. This clever design is perfectly adapted for industrial production.

Ib Kofod-Larsen is a young Danish designer who has had comparatively little publicity but who designs some charming furniture and does not deserve to go unsung. His chair frames flow gently, curving artistically where needed, and are extremely good-looking in front, in profile, from the back, from any angle at all; it would be shameful to place any of his pieces against a wall. He designs for Christensen and Larsen in Denmark, but also for some Swedish firms. The Selig Company in America imports chairs by Kofod-Larsen.

Another upcoming young design team in Denmark are Kastholm and Fabricius, both architects. They focus on combining comfort, visual appeal, and superb craftsmanship. Their most popular collection has a graceful tripod steel base on which swivels a curved shell, high-backed and with an upward curve shaping into armrests, the whole molded to body curves and upholstered in custom-tanned leather.

One of the finest Danish cabinetmakers was the late (1930–65) L. Pontoppidan, whose workmanship would tolerate microscopic examination for flawlessness. Son of cabinetmaker Eskild Pontoppidan, he learned not from his father but from the master artisan Sven A. Madsen. He then spent two years with the firm of Georg Jensen, and finally joined his father in business three or four years before his untimely death. Pontoppidan was a master, especially in executing designs for desks, cabinets, and other such complicated pieces (sometimes surfaced in rosy oxhide or inlaid with a delicate design in sterling silver) requiring fitting of drawers and doors so perfectly as to resist the attempt to slip even a piece of tissue paper between drawer edge and frame.

Recently the Danish-made "Sibast column" has made news on the world market, although some Danish critics (such as Sven Erik Møller, whose opinions are always sound and valued) considered it a bit bulky for most rooms and credit it merely with being amusing or novel rather than a timeless piece of furniture for the average-size room. Mr. Møller did feel, however, that the experimental initiative demonstrated in this design is worthy of respect, though the column is somewhat unusual in the customarily restrained milieu of Danish design. The column is made to the design of Palle Pedersen and Erik Andersen for Sibast Company of Stenstrup, Denmark. It consists of an upright steel pedestal, on which cabinets and/or shelves can be arranged at various heights and utilized from four sides. It revolves freely on its column and has many possibilities for variation. The "Sibast column" needs a space of about a square yard. Thus, it is more useful in larger rooms; but in a place where it is not possible to affix storage units to the wall for reasons of construction or a cranky landlord, this piece of furniture fills a need in an attractive and inventive way.

Kaj Bojesen (who died in 1958) and his workshop are legendary and beloved in Denmark. His wooden Danish soldiers, elephants, zebras, and, most of all, his jolly monkeys, have made history in the field of woodcarving, and have brought joy to many children everywhere. He was also the designer of the now-classic double salad bowl, top and bottom forming a sphere and usable separately. Bojesen was one of Denmark's most internationally admired industrial designers and a much loved man personally. First and foremost a silversmith, he was trained at the firm of Georg Jensen and designed award-winning tableware, which became an archetype, and other useful objects of silver. But he was also admired greatly for his talents as a woodworker. Arne Karlsen and Anker Tiedemann, in their charming book *Made in Denmark* have described Bojesen's knack for carving wood into merry and educational magic for children:

"Kaj Bojesen understood the child's need of using his imagination. He liked children because they could conjure up a brindle cow from a simple speckled stone. His toy animals are therefore elementary forms which every child can understand: sometimes angular, sometimes well rounded, often simply wooden blocks which a single cut of the knife has given the characteristics of an animal. They are all pleasant to grasp. Through his fine wooden toys made of good materials he has smuggled the first slight realization of quality into many a child."

In all his work, Bojesen held much the same basic attitude as Kaare Klint in eliminating pointless embellishment. He swore by simplicity and logic. The essence of Bojesen's attitude was that things should seem

a
Beautifully designed conference table in
rosewood, and chairs in rosewood with
natural-colored leather. By Ib Kofod-
Larsen, executed with perfection by the
cabinetmakers Christensen and
Larsen of Denmark. This designer is
one whose chairs are carefully planned
to look handsome from any angle. They
give the appearance of being substan-
tial without bulk, masculine without
massiveness. [Courtesy Den Perma-
nente, Ib Kofod-Larsen, and Christensen
& Larsen]
b
Terrace furniture in weatherproofed
birch, designed by Ole Gjerløv and
Torben Lind, and executed by L. Pon-
toppidan (1930–65). Pontoppidan was
an artist at cabinetwork such as closely
fitted pieces with many small drawers
or doors. [Courtesy Mrs. L. Pontoppidan]

a

b

Furniture in natural birch and provincial in feeling, by Børge Mogensen, a leading Danish designer (for Fritz Hansen's). The end of the sofa can be let down for reclining, held in the desired position by leather thongs. [Courtesy Den Permanente]

friendly and appeal to the sense of touch. Since his greatest contribution was in the field of silver, this fine designer will be discussed further in Chapter 7, but it should be added here that, concerning his famous and merry little wooden monkeys, he once remarked that he made them not necessarily to look like monkeys but to look like what people *thought* monkeys looked like . . . and that helps explain the "pleasantly rounded" Dane who was Kaj Bojesen.

Sweden

The Swedish producer Andersson and Sons (Huskvarna) spoke for the trade and its artisans when it published this: "Details are not trifles. Maybe no one will notice and appreciate that the leg is correctly and skillfully joined to the table top. Oh, yes, we will! That's why we prefer to do the job right from the start . . . to do it well for its own sake."

The Swedes have worked hard at perfecting their factory-made furniture, in keeping with Sweden's long history in this field. For it was in Sweden that it all began—the whole trend toward fresh modern concepts—starting in the thirties with the carefree, all-out functional expression of Swedish Modern furniture.

The war years of the forties were crippling to the furniture industry in Sweden, whereas these years passed in Denmark with a different effect. There, handcrafted furniture experienced a period of extra attention, perhaps as a subconscious reaction to the grimness of Occupation. The ill wind blew some good in this respect, for it brought new appreciation of handwork and individuality, of modified functional furniture. By the rebounding postwar years, Denmark had the international market at its feet.

In the fifties, however, Sweden worked at rationalizing its factory production, wisely incorporating the talents of architect-artists in their program. Once again Sweden gained its share of sales and respect, particularly for its high standards of good form, and quality in factory-made furniture available at reasonable price levels.

Much of this was due to the efforts during this period of the Svenska Slöjdföreningen (Swedish Society of Arts and Crafts and Industrial Design), an amalgamation of manufacturer, designer, distributor, and customer. Virtually every event of importance to Swedish design has been inspired, supported, or supervised by this group, which is noncommercial and acts as a forum. It works steadfastly to raise quality and consumer taste conducive to gracious living for everyone. The organization conducts instructional courses and reaches out to the people with its exhibits and its magazines, *Forum* and *Kontur*. It has worked hard to introduce designers into industry and handicrafts. It has sponsored research on measurements, functions, durability, and artistic standards. The society's slogans have been "Artists to Industry" and "More Beautiful Everyday Wares." (An interesting sidelight is that young couples in Sweden may obtain a state loan for the purpose of setting up housekeeping for the first time. The Svenska Slöjdföreningen has an information service which newlyweds can consult for expert advice on investing in new products for their first home.)

Typical of the early studies conducted by the society was one concerned with tables. Facts gathered on sizes and shapes of people, old and young, and their many uses for tables, provided sound statistics for measurements in designing different kinds of tables. It was discovered that although well over one-hundred different models were being manufactured in Sweden at the time, not one approached sensible measurements for its purpose! Industry welcomed this study, of course, and was then able to produce fewer but more appropriate sizes with ensuing savings in assorted machinery and wasted man-hours, in turn effecting lower prices. It in no way limited aesthetic efforts . . . it simply yielded more efficient production, more considerate of the user, at a lower cost.

The most important men in Swedish furniture design have been Carl Malmsten and Bruno Mathsson. Malmsten was Sweden's bridge between old and new—the Grand Old Man in the creation of Swedish design in wood. He took the best qualities from traditional European styles and, so to speak, translated them into Swedish. Malmsten had a gift for incorporating Swedish peasant art into a style that had manor-house dignity and elegance.

Malmsten's contribution to Swedish design was part of this country's entire cultural life beginning in 1916, when he won a competition for decorating the Stockholm Town Hall. He promoted a movement for better design in ordinary objects long before the Stockholm Exposition. When this event occurred, he opposed its extremism, its utter rejection of Sweden's cultural heritage. Malmsten agreed that a fresh concept was needed but felt it should retain a theme of Swedish peasant art. His own works embodied the best of the old newly interpreted with functional simplicity, showing that the identity of Swedish provincial and traditional arts need not be completely abandoned.

Malmsten crusaded for fifty years to keep warmth and personality in home interiors, as a relief from the cubical monotony of apartment-style living, which began in his day. In the early stages of the hot-blooded charge into pure functionalism, Malmsten was sometimes accused of being a diehard in clinging to certain themes of past times. But after the initial stark phase it was recognized that his message had been wise: "Moderation lasts. Extremism palls . . . and in any event there is always a place for some of both, and every conceivable degree of variation in between the two."

Designer, carpenter, teacher, always proud of and faithful to his Swedish heritage, this man, who was still designing and teaching throughout the fifties, has had a wide and basic influence on the arts and crafts of his native land. He and his son Vidar have recently designed an entire line of furnishings especially worked out in minute detail for use by elderly people. Sofa seats are higher for easier sitting and rising. Backs are straight and supportive. Armrests curve slightly upward, and tables are at a convenient height. All these features aid the sitting, standing, and resting problems of a specifically geriatric nature. The initial study was done for the Swedish Society of Rural Communes, and the resulting furniture is in use in Swedish homes for senior citizens.

a

Kaj Bojesen is famous for his work in silver, wood, and other materials, but is perhaps most beloved for his amusing and appealing wooden monkeys and other small animal toys so well crafted from wood. [Courtesy Den Permanente]

b

Bojesen's award-winning spherical salad bowl and servers, in teak. A careful look at this double bowl will command the greatest admiration for the artistry and craftsmanship involved in its shape and interlocking. [Courtesy Den Permanente]

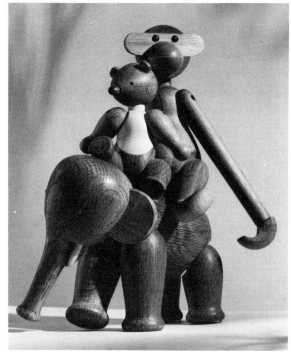

a

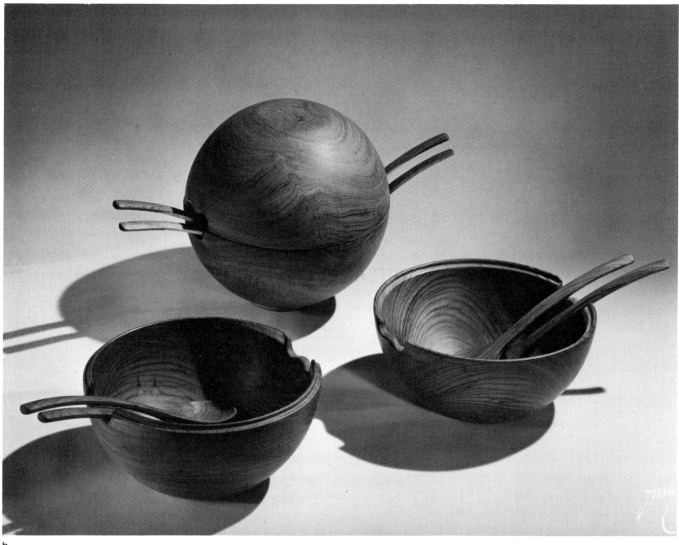

b

The designer Bruno Mathsson, born in the woodsy district of Småland, was really raised in a woodwork shop. He grew up with a background of experience with wood and all it could do. In the 1930's he began experimenting with bentwood (as did Alvar Aalto, in Finland, and Marcel Breuer, who left Germany about that time to live in Britain). Mathsson made analyses of proportion and weight-bearing stresses, and found new ways of bending and laminating, using industrial processes. His inventive approach not only awarded him new solutions but a new style, so forward-looking that his pieces designed in those years seem even more appropriate now than they did at first. They are still produced almost entirely as originally made. All Bruno Mathsson's furniture is made in his father's firm (Karl Mathsson, Värnamo). Beech, local and sturdy, is his material, and he keeps its natural light color. Woven leather strips are a favorite of his for upholstery.

Mathsson developed a table leg which splits and spreads at the top into a Y. Not only is it light and attractive but it technically gives added supportive stability to the table.

Recently Mathsson approached a design problem in collaboration with Piet Hein (who is, of all things, a Danish poet—but also a brilliant technician and mathematician). Hein works out simple, able solutions with regard to profound theoretical reasoning, sometimes with computer assistance. Mathsson translates these into practical application. The problem they first tackled together was to work out a shape for tables to be used where squareness saves space but roundness is desirable due to traffic flow. They came up with the super-ellipse, the super-circle, and even a tri-ellipse form for tabletops. Simultaneously, they invented a self-clamping leg—three or four metal rods slipped into a tubular foot, splaying out at the top and fitting securely into a simple mounting under the tabletop. This leg is light, easy to attach, and gives a table the steadiness of Gibraltar. It is easily produced and detached for shipping or storage, and graceful and light in appearance. The tabletops themselves are so perfectly crafted by the Karl Mathsson firm that the center division is barely perceptible even upon close inspection—each one is a magnificent example of cabinetwork. The super-elliptical table solves the space and traffic problems which were posed. The so-called expansion leg has many possibilities. This is the sort of ingeniousness that makes design history.

Another man important to Swedish furniture art was the Viennese architect Josef Frank, who worked in Sweden for over thirty years. His craftsmanship was outstanding, and his designs conveyed into Nordic furniture a little of the delicacy and gentility of Austrian works. Some of his designs are still made by Svensk Tenn, Stockholm.

The architect Axel Larsson helped spearhead the late 1930's movement to soften and humanize the cubist look in early functional furniture. He concentrated on reducing the bulk, making early changes toward more comfortable arm- and backrests, and lessening floor-space clutter by hanging cupboards and shelves on the walls. Larsson designed both for handcrafting and for mass production. He loved to work with native Swedish woods, such as ash, setting off its handsome grain by using uncluttered lines so as not to distract from the wood itself. Behind his works lie research and function studies, and his forms have a pure and simple dignity. He is also a prominent interior designer.

Architect Carl Axel Acking leaned toward the experimental and unconventional in both handmade and production-line furniture. For ten years he was headmaster at Konstfackskolan (State School of Arts, Crafts, and Design) in Stockholm and then became Professor of Basic Design in the Department of Architecture, Institute of Technology, in Lund, Sweden. Some of his students who are now well known in their own right are Sture Anderson, Olof Pira, and Hans Kempe. Lunning Prize winner Acking's many commissions include the interior furnishings of the Continental Hotel in Stockholm, the Swedish Embassy in Tokyo, the Swedish Prime Minister's office in the Chancery, and ships of the North Star Line.

Karl Erik Ekselius, a student of Malmsten, designs furniture of conservative form and elegance, made with meticulous care by the firm of J. O. Carlsson in Sweden. He is well known as an exhibit designer in Sweden and elsewhere and is one of Sweden's most distinguished furniture artists today. He is a reserved, composed, and modest man, and his precise designs reflect his own quiet personality and artistic integrity. Everything he turns out is immaculate. There is a story extant that, when his son Jan recently graduated from the Royal Academy of Design in England, he returned home to offer his talented father the (unsolicited) suggestion that he was perhaps too conservative and old-fashioned for these times and should be doing something more daring, using the new plastics and metals. The elder Ekselius shook his head and informed his son that he truly *loved* the things he made from wood and was not inclined to change, but that was not to say the more adventuresome son should not plunge ahead with new things as daring and avant-garde as he could find inspiration for, and more power to him. It developed that the very first chair the son designed, a "wondrous strange" abstraction in the newly popular materials was an overnight sensational best seller. It was ever thus. Though I, for one, continue to be more in tune with the quiet designs of the father, the son is talented in his work; they are a gifted pair.

Another famous Swedish designer in wood is Hans Agne Jakobsson. Not only does he devote his attention to furniture, but he uses wood in his many experiments with lighting. Lampshades crafted of wood shavings set in stair-step circles, one above the other in decreasing/increasing sizes, and wood veneer, boxlike lamps for floor, hanging, or tabletop, help carry out his scientific attempts to control better the direction, refraction, coloring, and intensity of lighting, to shade the eye from glare, and to accomplish this with artistry. He also designs holders for non-electric light sources, using wood, glass, brass, iron, and textiles as his materials.

Jakobsson has many and varied interests which he serves at Markaryd, Sweden, where he lives beside a lake. His wood lamps are produced at a nearby factory (Ellysett AB), but everything else is made at the Jakobsson AB's factory on the spot at Markaryd. He has a lighting museum there, too, with exhibits, lecture halls, and laboratories for his experiments in lighting technology. Adequate and attractive illumina-

a

Carl Malmsten was one of the first in Scandinavia to pioneer new furniture design in forms inspired by peasant craftsmanship. In the 1930's, these were revolutionary designs which seemed extremely severe; today these pieces seem suitable and even rather conservative. The grace and proportion of the furniture remain excellent. The textiles in "half linen" are by the famous textile artist, Märta Måås-Fjetterström. [Courtesy Svenska Slöjdföreningen]

b

The corner cupboard "Dala" by Carl Malmsten in natural pine employs a hand-carved decoration inspired by old Swedish peasant craft. [Courtesy Svenska Slöjdföreningen]

c

Chair "Pernilla 2," designed by Bruno Mathsson in 1966. [Courtesy Svenska Slöjdföreningen]

d

Sweden's Bruno Mathsson and Danish poet/mathematician Piet Hein designed this new super-ellipse table with chromed steel legs, made by Fritz Hansen's. The elliptical table form allows for more variable seating accommodations than a rectangular table. [Courtesy Den Permanente]

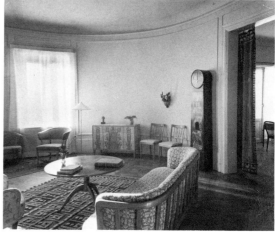

a

b

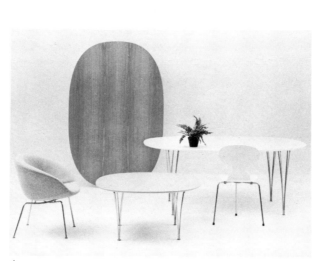

d

c

tion for street, school, factory, church, and home . . . all these come within his wide frame of interest. The wooden "chip" lamps are made of finely veined deal (a type of fir), and the light shining through reveals the beautiful natural structure of the wood. These lamps are not meant for diffuse lighting but for special effects in spaces intended for relaxation and romance; they create a soft, warm aura like that of candlelight or a glowing fire.

Completely upholstered and skirted sofas or lounge chairs with no legs or framework showing are conspicuous by their near-absence in Scandinavian production, perhaps due to the Nordic housewife's propensity for wet-mopping all floors on what seems like an hourly schedule. But there are a few such designs, and they contribute to some reduction in the profusion of legs involved in the decor of a room. Folke Ohlsson has designed a skirted sofa for Dux, Sweden's largest producer of upholstered furniture. This is a firm with a progressive design policy, whose new "Lotus" chairs have recently made an impressive entrance on the world market. "Lotus" has a low-slung tub-type base of polystyrene with a glossy white finish. It flares out flowerlike at the top to hold a puffy, inviting, and comfortable-looking cushion covered in bright printed cotton. Alf Svensson is another bright young furniture designer working chiefly for Dux, which is the trade name of LjungsIndustrier AB of Malmö. Svensson has earned gold medals at the Triennale and at Sacramento, and the Diplome d'honneur, among other awards. His special style is the use of a softly rounded-off wooden framework, with upholstery which looks adequate and comfortable but not overstuffed or overdone. He also designs lighting fixtures and lamps.

Count Sigvard Bernadotte, son of the late king, Gustaf VI Adolf, has been active in the modern-design movement in Scandinavia. He has won the Reed & Barton award for his work in silver (often for Georg Jensen). Now he works almost exclusively in industrial design in various materials, including wood, plastic, and metal—kitchen stoves, cabinet modules, fans, sinks, and plastic homemaking accessories, for example. Count Bernadotte's own self-designed kitchen features stunning teak cabinets with white fronts, a handsome and most practical combination, set off by black-dotted brown tiles on the counter tops.

Quite a remarkable fellow is Hans Johansson, who has come up with furniture made entirely without screws or glue, and held solidly together merely by the tension of the material itself, a difficult technological accomplishment.

There are more than one thousand furniture manufacturers in Sweden, with even the smaller firms employing the furniture function and measurement studies done by Erik Berglund and Sten Engdal (mentioned earlier), who themselves have incorporated their research in the efficient and tasteful "Contenta" cabinet series for Johannesdal of Sweden. Other shelving systems from Sweden include the "String" series designed by Nils Strinning and Bertil Berglind (for String Design AB, Vällingby) for a competition in 1950 specifically concerned with light, movable, adjustable bookshelves. This remarkable design has been extended into a widely diversified system. The "String" system consists of lightweight, white, plastic-coated metal, two-point support panels, and teak shelving sections. One tiny foot and one small nail anchorage in the wall supports each upright divider panel. Clamp on the shelves at any desired level and the unit is installed, sturdy and neat-looking. A wide assortment of components such as units for radio, TV, desk space, and various closed cabinets are made to fit into this simple, attractive, and mobile system. Twenty-four feet of this shelf space come apart for moving and pack flat into a parcel no larger than an average suitcase. My own "String" shelf system has traveled over half the world and back many times, and within five minutes is set up and ready for books. To say it has been "worth its weight in gold" would be an understatement, since it doesn't weigh very much at all.

Also in the line of collapsibles, John Kandell has developed (for Haglund and Sons, Sweden) a carefully thought-out and efficient series of upholstered furniture, easily reassembled after shipping in seconds, even by people with ten thumbs. The frame of laminated and bent beechwood consists of a back and front section with the seat-frame members slipping alongside one another for clamping. Upholstered seat, arm, and back cushions fasten easily into place and provide a comfortable chair which two minutes earlier arrived flat. Omitting one or both arm segments permits sections to be combined into sofas of various sizes. Although the design theme is squarish, the bend of the leg and back uprights softens the severity, and the front of the backrest cushion is carefully contoured to give comfortable support.

Kandell is an industrial designer who renounces carelessness in any detail. His primary approach is to purpose and material, just as Kaare Klint and Mogens Koch imbued Danish furniture art with its uncompromising attitude toward wastefulness or ostentation. Such thoroughly planned furniture as Kandell's is well suited to mass production, efficient for shipping, timeless in its good taste, and always dependably comfortable.

It is not surprising that the practical Scandinavians came up long ago with extendable dining-room tables with built-in storage for two or three extension leaves. One of these is "Malta" in Rio rosewood or in teak (made by AB Hugo Troeds Industries, Bjärnum, Sweden). Others have been designed in Denmark from time to time. These models, which happily solve the problem of where to store unused table leaves safely, are meticulously crafted, so the leaves and the permanent sections all have their graining expertly mated.

Spindle-backed chairs, such as Carl Malmsten's "Åland," are popular throughout Scandinavia, but are, in fact, typically Swedish. They are the most common chairs produced, either plain or painted, and nearly every designer has taken a shot at doing his own variation. This type of chair is easy to make, and its simple practicality has given it appeal and suitability for many generations.

As in Denmark, many groups support good design and craftsmanship. To name a few, in addition to Svenska Slöjdföreningen, already mentioned, there is Hantverkshuset (Swedish Institute for Trade and Handicrafts), which has faithfully promoted handcrafted furniture, and Nordiska Kompaniet, the huge Stockholm department store which has its own workshops in Nyköping and continually sponsors and promotes

a
This side chair in laminated wood shows in every detail the perfectionism present in all designs by Karl Erik Ekselius, one of the most highly respected furniture architects in Sweden today. [J. O. Carlsson]

b
This uninhibited contour relaxing chair was an immediate success for its young designer, Jan Ekselius, son of Karl Erik Ekselius. [J. O. Carlsson]

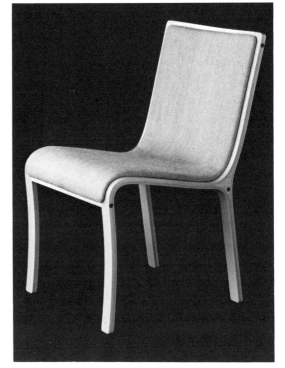

a

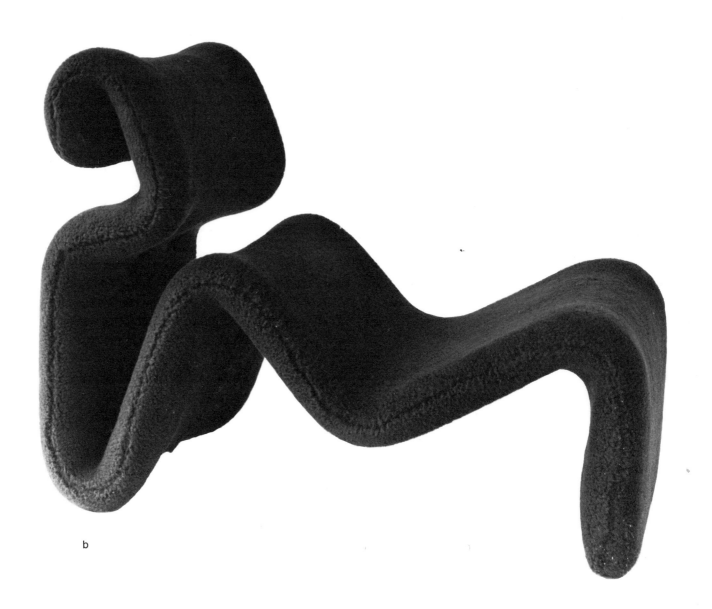

b

improvements in Swedish furniture and other applied arts. Another organization of this sort is the Göteborg Society for Industrial Design, which has trained many noted designers, including Folke Ohlsson, Folke Sundberg, Gunnar Myrstrand, and Alf Svensson.

A few years ago, eight furniture designers and eight leading cabinet-makers in Sweden organized a working group (apparently unnamed) to experiment together on new types of furniture, some of which might well prove suitable for mechanized production, though this was not their major aim. It was felt by them that, although furniture for the average budget has to be a main concern, today's more affluent society has numbers of people seeking some exclusive custom-made items, and they cooperate to fulfill this need.

There is also a group of furniture, textile, and lighting firms cooperating under the name Bra Bohag (Good Household). They pool their resources for promotion and marketing, and give interior-decoration exhibits which are meant to be educational to the public. Swedese is the name of another cooperative of several smaller manufacturers. Yngve Ekström designs for this group and he is very good. His contour chair and ottoman, with an exposed curvilinear frame in natural wood finish, upholstered with sheared lambskin, and was designed in the forties, was so ahead of its time that it looks contemporary and undated today; it is still in production, and very much in demand. I personally have resisted this chair's siren song for about eight years, but always came back to look at it and want it, and somehow each time held back. Now I have finally succumbed to its inviting look and bought one, and if a chair and a person can "have a thing" together, we have it.

Allan Röstlinger is typical of artists represented by Konsthantverkarna (Swedish Craftsmen's Guild) in Stockholm. He is an artist-artisan who makes exquisite handcrafted hand mirrors and wall and floor clocks, items that for too long had gone unaffected by the twentieth century's revolutions in design. His grandfather clocks in teak are so adapted to now and the future they might better be named grandson clocks. The hand mirrors, devised from a single piece of wood, have a flat frame growing into a handle which curves up and over the back of the mirror. It is handsome on the dresser top, covenient to hold, and occupies less space than one with the protruding standard handle.

The Swedish Craftsmen's Guild in Stockholm is the permanent exhibit and salesroom, opened in 1951, of the over two hundred craftsmen who are voluntary members. It has given many of them their first exposure to the buying public. Its highly qualified jury selects for the exhibit on the basis of artistic merit and craft standards.

Finland

In earlier times, the Finns were restricted to their native woods, such as pine, birch, and juniper. Thus it was no accident that when Finnish furniture reached out for new developments, such as Aalto's bent laminated wood in the thirties, the material favored was pale birch, rarely considered elsewhere as a particularly good possibility for furniture. The use of imported wood was accepted slowly at first, but soon teak and mahogany had their day in Finland. More recently, a new method of plastic treatment on birch has solved the problem of keeping this lovely wood white without yellowing, so birch is once again the leading wood used in Finland.

Finnish peasant tradition in furniture design exists today merely in the context that simplicity and good contour dominate design themes, or in furniture meant for country homes. In rural communities it was folly to produce other than sound, functional articles, which were automatically more efficient in use than complicated devices; clean-cut form just naturally appeals to the Finn, as it always has. Frivolity or decorative touches were, and are, indulged in only to satisfy aesthetic needs and the Finn's unswerving insistence on individuality. We see the latter characteristic in their freewheeling ideas, so fresh and new, in glass, ceramics, decorative textiles, and jewelry, too. When it comes to furniture, the open-minded approach is prevalent, yet function is a major concern, and any decorative effect is developed through choice of material and the magic of color, warm but restrained, alive but never gaudy.

The Finnish designer is above all an independent thinker. The only preconceived notion he has is his deeply rooted belief that structural clarity and concern for use lead to the right paths for any new impulses. His straightforward outlook is shaped by needs, new materials, and new methods of exploiting them in his own individual way. There is no attempt to copy anything, and no cheap gimmicks are tolerated.

With the exception of a small amount of good furniture designed by Arttu Brummer, Alvar Aalto, J. S. Sirén, and Werner West forty years or more ago, Finnish styling in the earlier decades of this century had little to offer design-conscious buyers. In 1949 a huge exhibition by the furniture trade was held in Helsinki. The press reports and public reaction were highly critical. One called it "a select showing of worthy design and a large amount of mediocre items." Finns don't like the word "mediocre," and very promptly there was a generalized improvement, led by such responsible manufacturers as Artek and Asko Finnternational. Since then, the development has been astounding. Finland does not have a handcrafted, studio-produced line to any great extent, but its industrial designers have given their country an internationally acclaimed range of furniture for public buildings and office space, especially in stackable, easily stored and shipped, boldly original furniture in steel, leather, and the new plastics. Often their contracts are for furnishing an entire building, such as a hotel, and in America alone examples can be found at Princeton, Yale, the Chase Manhattan Bank, the World Bank, and the fine Olli Mannermaa chairs at the Harvard Medical Library, to name only a few.

Eliel Saarinen and Lars Sonck were Finnish architects who pioneered free thinking in design for interior appointments. At the time, Art Nouveau still held sway, and these architects yearned for furnishings and accessories in harmony with their buildings, which were representative of Finland's national culture. Taking up the program were Carl Johan Boman and Werner West in the twenties. Boman was very much an idea man, but he also had technical and handicraft experience

a
Wall clock of teak. Atelje Römer, Djursholm, Sweden. Designed by Allan Röstlinger. [Courtesy Konsthantverkarna, Stockholm]

b
Dressing-table hand mirrors artfully handcrafted at Atelje Römer, Djursholm, Sweden, by Allan Röstlinger, a member of Konsthantverkarna, Stockholm

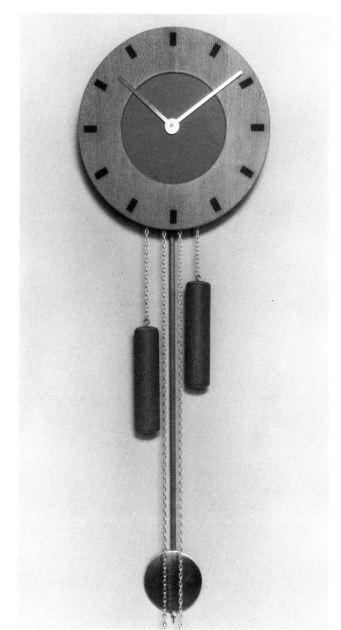

a

b

in furniture production. He concentrated on the development of adjustable, stackable, folding chairs and row seats with an interesting new look.

In the thirties came Alvar Aalto, another gifted architect, who devised furniture of bent birchwood with simple, functional elegance. His tables and chairs were timeless and are on the market today, unchanged and entirely right for out time. The firm of Artek, set up by Mrs. Maire Gullichsen, who is herself a designer and artist, produces and markets Aalto's furniture.

Aalto has always been an architect whose innovations in building environment include every exterior and interior detail. His feeling for material and form can be noted in the tiniest detail of whatever he creates. It is interesting to realize, too, how his furniture, light fittings, etc., are by and large as suitable for modest smaller dwellings as they are for some of the great houses and buildings he has designed.

Like Frank Lloyd Wright, Aalto was one of the first to insist that a building be an integral part of the landscape where it stands, and one of the first to think personally about the people who would live, work, or study within his structures. Aalto stays with natural materials such as wood, copper, clay brick. Characteristic of his architecture are curved, wavy ceilings, walls with acoustical advantages, and dramatic, efficient lighting effects obtained by the use of ceiling portholes. Forty years ago considerations of site and people and activity zoning were not common practice, let alone the idea of specifically designed furnishing detail.

Göran Schildt, in his book *Alvar Aalto,* described Aalto's goal in his career-long drive for better design of all kinds: "Alvar Aalto's own attitude [was] to accept, without a trace of romantic refusal of reality, the whole of the modern age with its technical and economic resources, but to be clearly aware of the dangers and to show that technics can be made to serve man, instead of the reverse. This was Aalto's architectural program."

Aalto's first experiment with steam-bent laminated wood was done for the furnishing of the Paimio Tuberculosis Sanitarium. He sought and found in it a material which could be made more pliant and was better suited to the human body than cold and rigid tube steel. It was a fine accomplishment, and much has developed from his beginnings with this process.

Aalto's famous "X" stool, perhaps one of the most original and copied pieces of furniture of this century, features legs which appear to grow or pour from the top, and in a sense they do, for there are no screws at all. The legs are each made of five vertically laminated pieces joined to the seat with mortise-and-tenon construction. The wood used is ash or birch in its natural color, its satiny glow (which unfortunately is hard to catch with a camera—you need to see it first-hand) brought forth by perfect craftsmanship. The seat is carefully upholstered in leather. A prototype for later variations with backs or higher legs, this Aalto stool is a classic of originality, understated elegance, and the architectonic genius of this gifted man. It was designed in 1954 and is made by the Artek firm. It is not inexpensive as stools go, but is in constant demand each and every year.

Besides his world-famous architecture and fine bentwood furniture, Aalto has worked in textiles, metals, and ornamental glass; in all these materials he has demonstrated his close relationship with nature and with whatever specific raw material he is using. Now late in life, he is still productive and presently heavily involved with city planning for the current renewal of downtown Helsinki, a giant project.

The war years in Finland were a period of artistic sterility, but afterward the Finns rebounded with an artistic drive which amazed even themselves. The fifties and sixties found them giving the world exciting and highly original works, not only in articles for everyday use, but in extravagant flights of imagination expressed in exclusive handcrafted objects made purely for aesthetic delight. The seemingly unlimited originality in Finnish design stems partly from the small number of historic relics, buildings, or other guidelines from the past which might otherwise have inhibited their thinking. In the late fifties and early sixties, having already established an awesome reputation for making off with most of the awards at every Milan Triennale and the Sacramento design exhibits, Finland went to work to improve her export abilities. Ably assisted by the Finnish Society of Crafts and Design, Ornamo (the Association of Industrial Designers), the Friends of Finnish Handicrafts, the hardworking Finnish Foreign Trade Association, and the Finnish Foreign Ministry, Finland has now made waves in the world marketplaces. The Finnish Council for Furniture Export Promotion awards to producers and designers their particular export mark for quality. This mark on furniture indicates that it is indeed "Made in Finland," that its design is original and outstanding, and that it is built with excellent materials and workmanship. So, in the last decade, Finland's export furniture has come into its own, especially since the country is possessed of factories large enough to produce in the impressive quantities required in furnishing large business premises. Finland's factories are big, highly mechanized, and rationalized. Twenty years ago, little was exported except some kitchen equipment. Today Finnish furniture for home and office is widely sought after and internationally known. Asko's "Globe" chair, designed by Eero Aarnio, has been a real eyecatcher; its fiberglass spherical shell in various colors is foam-padded in its entire interior, with loose Dacron cushions inside to sit on. Sitting on—or rather *in*—it to read or contemplate is like being in a miniature sheltered world of one's own, and it has been aptly dubbed a "private sitting room."

Oy Iskun Tehtaat, at Lahti, Finland, has found a worldwide welcome for its handsome "Rosario" lounge chair and footstool in leather. It swivels, rocks, and has an adjustable headrest. It is masculine in its appeal and is suitable equally for home or for office. Tehokalusti office furniture is also well known, particularly its "VIP" chair, to be seen at Harvard and at the World Bank in Washington, D.C. Also at the World Bank and in the Trattoria restaurant in New York is Lepokalusto Oy's furniture, imported through International Contract Furnishings in New York. In fact, United States import trade for Finland's enterprises of many sorts has become so great that a fifteen-story streamlined building named "Finland House" is being erected in the heart of Manhattan, adding impetus to export and cultural ties. Many Finnish firms and

a
Stools by Alvar Aalto. [Courtesy Artek, Helsinki]

b
Alvar Aalto's famous stools of lam- inated birch bentwood. [Courtesy Artek, Helsinki. Photo: Rolf Dahlström]

c
Alongside: Detail of design and crafts- manship. Note overlapping of layers in the laminate, giving the necessary added strength where needed. [Photo: Petrelius]

a

c

b

associations will have headquarters there, in addition to space reserved for the Consulate and the Foreign Ministry of this progressive, high-spirited country.

The whole Finnish concept is charged with originality. Other avant-garde pieces destined for wide acceptance include a circular sectional seating group, upholstered except for its pedestals, which permits a variety of arrangements. Named "Roulette," it was designed by P. J. Wainio for Vilka Oy, Mastola. Recently, several new series have been created with special appeal for young people, featuring wooden frames painted in bright fresh colors and cushions upholstered in Op art black-and-white prints, the set purposely kept low-cost as is suitable for this age group. "Pompeli-Pop" is another of these "young" designs, made by Oy Iskun Tehtaat, and it is interesting to note the wide range of interest in this particular firm's production; it is well known also for its dignified office furniture. Another example of this across-the-board design policy is found at SOK Furniture Factories at Vaajakoski and Lahti. Presently they are making "Hippa" for the young crowd, in yellow-painted wood, boxlike sectional bases with giant pelt-print black-and-white cushions, while at the same time they present the "Tupa" range of natural pine furniture in a design as rustic as if it had been handcrafted a hundred years ago in the Finnish woodlands. This series is, of course, aimed at *hytte* living.

Esko Pajamies is the designer of the "Pele" chairs (Lepokaluste Oy, Lahti), which are provincial in feeling but have a polished touch in wood treatment and joining. The wide flat arms give a man a place on which to set his drink or ashtray, and the deeply cushioned leather upholstery and somewhat massive look of this chair make it inviting indeed to the weary head of the house. Esko Pajamies has also designed a similar series called "Bonanza," with easy chairs and sofa, again with great masculine appeal and embodying Finnish furniture making at its skillful best. Another of his designs is named "Polar," a pedestal and circular form with a rotating seat, in steel and leather.

Antti Nurmesniemi, designer in both wood and metal, is also an outstanding exhibit designer. In his sauna stool, which has won international awards, he demonstrates both the rugged heritage and the sophisticated progressive thinking of the Finn. The rustic strength of the heavily grained wood is, in this stool, combined with contemporary functional form and the special effects obtainable from laminated wood. Another stool designed by Nurmesniemi in 1960 has been acquired by the Museum of Modern Art in New York. The museum considers this an "exceptionally harmonious treatment of leading materials of our decade," with its chromed-steel supportive base and pale leather seating pad worked with meticulous stitching.

Ilmari Tapiovaara is a highly versatile designer with a love for experiment, another who has branched off from wood into metals. His forte is the mastery of the technicalities of mass-produced furniture which is stackable, folding, or easily disassembled for shipping. He also designs lamps and is an interior decorator of prominence. Tapiovaara believes in capitalizing on exposure of the constructional details as an integral part of his chair designs. His chairs "Lukki" (for Lukkiseppo)

and "Kiki" (for Merivaara, Ltd.) both have attractive metal frames and upholstered seat and back sections, and both won gold medals at the Triennale. This designer has also made the chair "Wilhemina" (W. Schauman, Ltd.), which has a bent-plywood frame eliminating side struts from front to back legs by grafting a supporting piece into the curve of the back legs. For this ingenious design Tapiovaara won still another gold medal at the Triennale.

Pine has recently made a big comeback in Finland. Designers have rediscovered how the texture, grain, and suppleness of this wood are advantageous for the new furniture trends. Ilmari Tapiovaara is one of these. He likes pine because it is indigenous to Finland, because it planes nicely, and because it is good for work requiring solid blocks as against plywoods. Cognizant of pine's weak points (it is soft) and yet aware of its good properties, Tapiovaara has created some resourceful designs in the way of rustic tables and benches, cradles, as well as his "Pirkka" chairs (Laukaan Puu), with their charming rural character. The seats of these chairs are split, almost as if improvised by a farm craftsman from two hand-hewn pieces of wood, and rounded off at the edges in artful simulation of a hundred years of faithful service to sauna sitters. Contrary to most Finnish woodwork, which is left natural, Tapiovaara likes to stain his pinewood pieces in a dark earthy brown.

Pirkko Stenroos likes pine, too. She has done a notable series for Artek, featuring clever extension tables, and buckle-back chair upholstery, in colors flattering to pine and giving delightful decorative effects. Other designers with renewed interest in pine are Eero Aarnio, with his chair series "Pine" (Askon Tehtaat Oy), and Olof Ottelin in his dining-room furniture (Oy Stockman), which has a more sophisticated country air.

Ilmari Tapiovaara, Antti Nurmesniemi, and Olli Borg maintain studios of their own. Other designers of prominence who work for large firms are Reino Ruokolainen, Olof Ottelin, Olavi Hännin, Lasse Ollikari, and Carl-Gustav Hiort. Runar Engblom is a good designer of handcrafted furniture, a rarity in Finland.

Other chairs from this country which are attracting worldwide kudos are "Karuselli" (Haimi Oy) by interior designer and Lunning Prize winner Yrjö Kukkapuro, an inviting upholstered chair on a ball-bearing swivel and spring pedestal, which permits turning and rocking, and a related model "Amoeba," which also swivels on a base and has a softly spreading, "melting" outline inspiring its name. The café at the Helsinki City Theater uses the "Amoeba" chairs dramatically, in white with strawberry-red leather upholstery. Eero Aarnio, who designed the "Globe" chair in fiberglass for Asko, has now come up with a related but more open model christened "Brandy Glass," which describes its shape.

Yrjö Kukkapuro in 1970 once again outdid himself in designing the "Saturnus" chair (Haimi Oy). This is one of the most inviting-looking chairs of all time. Its softly padded curves, its roomy look, its fine leather upholstery in wonderful colors should prove enticing to any male, and a slim young lady curled up in its depths should feel and look charmingly feminine. The pedestal base is practical and neutral, and the overall

a
Eero Aarnio designed this newsworthy "Globe" chair for the firm of Asko in Finland. Like a miniature private sitting room, the chair is made of fiberglass, the base of metal, cushions of polyester foam and Dacron fiberfill, and is made in white, red, black, or orange. [Courtesy Asko. Photo: Matti A. Pitkänen]
b
Named "Pastille," this artfully designed chair, by Eero Aarnio for Asko of Finland, is made of white, red, or yellow fiberglass. Certainly a creation for today and tomorrow, the chair was awarded the American Institute of Interior Designers award in 1968

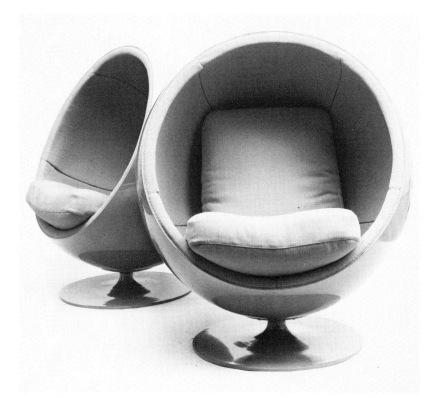

a

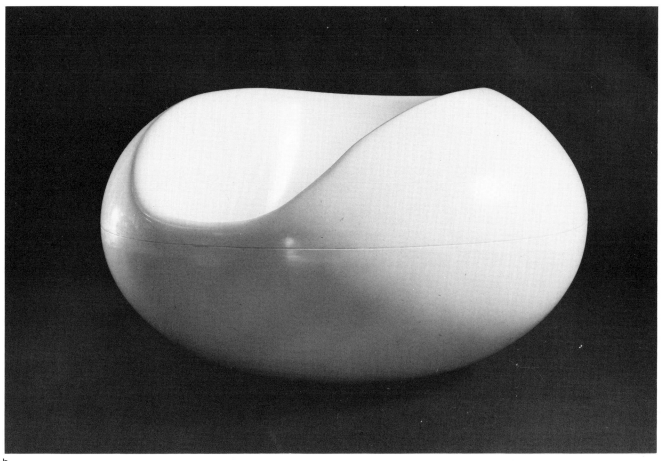

b

The Museum of Modern Art in New York added to its collection in 1964 this stool designed by Antti Nurmesniemi of Finland. It is described by the museum as a neat harmony of leather and chromed steel—materials of the century—with a seat surface enhanced by beautiful stitching [Studio Nurmesniemi. Photo: Pietinen]

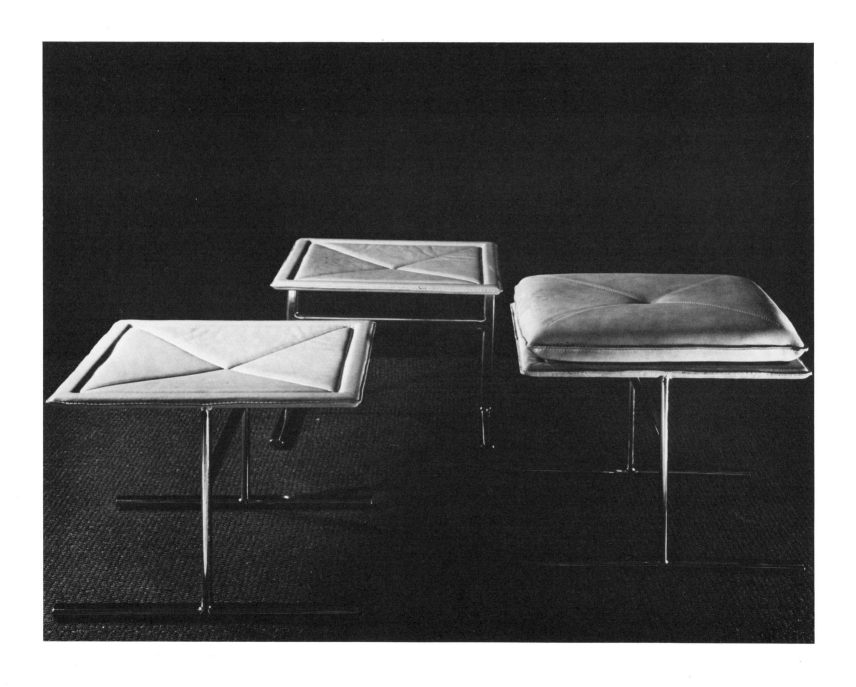

look enables this chair to take its place either in a home atmosphere or on business premises. With or without the detachable arms, the chair may be grouped to form a sofa or rows of seats. Based on the same fiberglass pedestal form is an entire mix-match series of tables in various components to create cocktail, occasional, bridge, or dining sizes and heights.

Asko, at Lahti, is Scandinavia's biggest furniture factory, with Eero Aarnio, Eric Johann, Jussi Peippo, and Aulis Lainonen on its design staff, and Ilmari Tapiovaara and Tapio Wirkkala as freelancers. The main production area covers about seventeen acres of floor space, turns out about forty thousand pieces of furniture daily, and boasts an outstanding variety of design and the finest of joinery skills. The fifty-year-old firm has won many awards for its furniture for public premises and its home furniture for all rooms, including the kitchen. It has a design policy that is genuinely Finnish but still international in appeal. The products are practical and not overly expensive, leaning toward sturdy, virile styles with excellent proportion and form, and using fine leather upholstery, softly padded. Finnish birch is the favored wood, and lately the firm has been making news with the aforementioned fiberglass chairs of Eero Aarnio and such pieces for the mod generation as "Pastille," in molded fiberglass.

Near Pori, on the west coast of Finland, is a small, fascinating workshop called Norrmark Handicrafts. It is another brainchild of Maire Gullichsen, daughter of the Ahlström family, founders of one of Finland's big industrial concerns. Herself an artist and patron of artists, Mrs. Gullichsen is the guiding light of Artek, which markets not only Alvar Aalto's designs but retails the choicest of other Finnish and Scandinavian applied arts in ceramics, crystal, etc., with the aid of a personable (and Stanford-educated) Finnish manager named Åke Tjeder. The Ahlström estate is in itself a parklike setting around three family mansions; the latest is Villa Mairea, built and entirely furnished to the design of architect Aalto; it is the home of Mrs. Gullichsen. This house is considered one of the architectural landmarks of our century.

The entire setting is picturesque, with old structures carefully preserved and used. There are little wooden bridges, paths, and fountains, a sawmill, and scattered cottages dating back to the late 1880's. There is a century-old log house which is a display place for Norrmark pine and birch products.

Mrs. Gullichsen, with the help of designer Bertel Gardberg, founded Norrmark to preserve the old skills in an age of automation, and to keep the community busily involved in arts and crafts. The work began in 1965 with bowls, platters, and other simple things. Now this dedicated group makes safari chairs in wood and leather, stools, folding tables, clothes trees, and high chairs. Designs have been contributed by Gardberg, Nanny Still, Ben af Schultén, Birgitta Bergh, Lars Gastranius, Kristian Gullichsen, and others. Proper treatment of wood, simple but good form, and sturdiness are important. Norrmark also makes whimsical small articles like Nanny Still's lathed pine candlesticks, which

have one set of basic parts from which almost a dozen different arrangements can be made. In turning these wooden sections, the grain of the wood has been carefully accented. There are also stands for hats and wigs, for pins, needles, and spools of thread, ice buckets, and so on. Everything is carefully hand-finished until it feels wonderful to the touch. This establishment does a booming business. About 40 percent is exported to France, Sweden, the United States, Canada, and Bermuda.

Design in wood runs the whole gamut in Finland. Recently, at the Finnish Holiday Land in Sweden, twenty-five prefabricated houses complete with furnishings were assembled by Finnish producers, with the emphasis on vacation homes. The furniture, mostly pine and birch blending appropriately with the country atmosphere, was simple and practical, with a contemporary rustic look. Yet none of it was so rustic as to be in any way unsuited for city dwellings.

Beyond extensive furniture production, Finland is becoming successful in selling its prefab vacation homes of wood, designed for efficient shipping to anywhere in the world. This includes many sizes and versions of the famous Finnish sauna, to be built either in an already existing room or as a separate outdoor structure. The Finnish Sauna Society was founded in 1937 to extend knowledge of this health ritual, record its history, research its physiological effects. The society spreads the gospel of the sauna rites to foreign lands with the fervor of missionaries. The export division has been set up to promote, inspect, and supervise the quality of manufacture. For those saunas made with the exacting care the society demands, it awards the mark "FS" as a guarantee. This states that the product was designed, made, and thoroughly inspected in Finland, is of good functional and technical standards, and is considered architecturally pleasing. This mark is applied also to approved sauna accessories, such as stoves, buckets, ladles, thermometers, toweling, whisks, soaps, and even sauna foods and beer (served afterward).

Finland's people have had to make a lot of different things from wood, and they still do now, more as a matter of experience and tradition than necessity. Buttons, for example, and small accessories such as candlesticks and beads. Combining the last two has been the work of Kaija Aarikka, who makes chubby turned-wood candlesticks and decorates them all around with wooden beads. They are made in natural finish, stained or painted in many colors including white, and are most Finnish in spirit. She markets these candlesticks with the just-right candles designed by Pi and Timo Sarpaneva (for Juhava Oy), candles round or shaped in good proportion and made in a rainbow of exquisite and unusual color combinations. Miss Aarikka's candlesticks, as well as her intricate wooden-bead jewelry (made by Ibero Oy), are lovingly assembled by hand. Timber is also basic to the "Finnweb" tablecloths, a new product (Suomen Vanutehdas-Finnwad, Ltd.) of specially treated wood fibers. The designs are exciting and imaginative, the colors extremely pretty, in these hygienic, water-resistant, soft, and antistatic, disposable cloths.

There are only four and a half million Finns. It is a tribute to them

that so many are so gifted that they have, in the short time since World War II, attained so prominent a place in the design and manufacture of furniture and all the other applied arts.

Norway

At the time of the early growth of industrialization, with its threat of overshadowing handcrafted things, Norway turned to its peasant art for inspiration. Beautiful as it was, the village folk art was not adaptable to mass production, however. Neither handicraftsmen nor artists were certain how to tackle the problems of adaptation, so Norwegian production lagged behind for a while in developing good machine-made furniture.

Norway's furniture design and fashions followed the Danish lead in the 1900's, with Art Nouveau giving way to classicism during the twenties and functionalism adopted on a modest scale in the thirties. Herman Munthe-Kaas and Knut Knutsen were the leading designers in the latter style. Rustic furniture, either inherited antiques or good reproductions, has been a continuously popular furniture type in Norway, which has proudly carried forward the old Norsk traditional provincial cabinetwork, of which the intaglio rose carving is truly admirable. A minor tendency to retain neoclassic influences has hung on in furniture produced for the average consumer, but suddenly, in the past five to ten years, Norway is coming out with furniture for export which is entirely new and international enough to be compared with Danish design. Export possibilities are being explored and developed. Norway, however, has few people, a high standard of living, no unemployment, and high wage levels, so production costs make it difficult for this country to compete in mass-produced goods as yet. Its success must rely on professional workmanship and a Norwegian approach to furniture art.

Norway's vast forests have provided ample wood as a building material for houses and furniture, so the Norwegian's skill with this material spans a thousand years. Today's craftsmanship has been given an important and much-needed boost by the contributions of some inspired young design talents with a national and an international outlook. Current designs are usually light and suited for the smaller homes and apartments for which they are intended. They are still on the conservative side compared, for instance, to some of Finland's more daring models.

Norwegian finesse with wood is reflected in precise joining and fitting. Natural finishes and rush seats are favorites. The Norwegian designer is inclined to avoid any specific datable styling, for to his mind style is a fickle mistress, and an impractical one in the long run. Ferdinand Aars, in his book *Norwegian Arts and Crafts and Industrial Design,* illustrates perfectly how the Norwegian considers the way many artists the world over have become enticed away from practical considerations by the whims of fashion and market pressures. His example was con-cerned with the onslaught of streamlining, a logical change in automobile design consequent on horsepower and speed, "which strangely enough led to streamlined perambulators, even though speed is hardly an important characteristic requirement of this class of vehicles, and subsequently to the streamlining of radios, jewelry, and other stationary objects." To the down-to-earth Norwegian, this is nonsense.

Another tendency which brings forth cries of scorn from the honest, levelheaded Norwegian is that of faked value—making objects seem more expensive than they are, a pretension completely foreign to his code of living. Why in the world, he contends (and rightly), should a designer be fettered by such fool notions, when in truth wood and clay and cotton and clear glass each have an organic beauty of their own to be developed, admired, and respected?

The Norwegian never casts aside the past entirely. He believes that designers of today should build on the best of the past, stamping their creations with new ideas and modes of expression in tune with their time, but recapturing the spirit of the old arts, including the reverence for craftsmanship and good material. Naturalism is still a predominant characteristic and always will be.

There are, in Norway as in the other Nordic countries, fine old manor houses with all the vestiges of past arts and fashions remaining in their furnishings—treasured English or French neoclassic antiques, trompe l'oeil walls above carved dado rails, a satiny Biedermeier table, perhaps a fine tapestry, huge portraits in great baroque gilded frames, a delicate Sheraton-style writing desk. These were and are the *store gårder* (great estates). But most people live in small or medium-size homes and modern apartments, without servants. Here the contemporary may dominate, but usually there will be more than a sprinkling of heirlooms proudly linking the family with its forebears. It is rare to be able to buy an ancestral chest or carved cabinet. These are not parted with for money but are passed down the family tree.

Relationship with the great out-of-doors is ever important, and all apartments have balconies on which flowers are grown. The major furniture grouping in the living room is invariably placed near the picture window, where housewives compete to see who can grow the most lush jungle of plants and vines under, over, and around this transition between outdoors and indoors.

In 1918, the Norwegian Society of Arts and Crafts and Industrial Design was formed (also known as the "Brukskunst" Association), and it functions as do similar groups in the other Nordic nations to promote understanding between artist, artisan, manufacturer, and the people. This group, deploring Art Nouveau or mechanical repetitious copying of even the old Viking motifs, undertook important market research, working toward dependable quality in construction and more up-to-date artistic thinking. They strive to elevate both taste and design and educate the consumer to what is good, by means of exhibits, contests, aid to young designers, and the publishing of a periodical. Designers are encouraged to come into workshops, study processing, and learn what could be accomplished by craftsmen and the new mechanical production techniques. The Brukskunst Association also assists struggling young

a
Metal candlestick with wooden beads
designed by Kaija Aarikka
b
Wooden candlesticks with special
glossy colors designed by Kaija
Aarikka

a

b

artisans and helps them make connections with manufacturers, if they so desire.

This movement uncovered many good designers who brought to industrial production more rational forms, compatible with current cultural, social, and economic trends. During the grim Occupation years of World War II, these efforts were set back considerably (except perhaps in ceramics), after which Norway was slow to recover momentum in regard to furniture. Now at last, designs are fresh and vital, though "living tradition" in form, color, and general feeling for material is still much in evidence.

Aage Schou and Alf Sture led the renaissance in design in Norway, followed by the architects Bendt Winge, Rolf Rastad, and Adolf Relling (the last two work together). Other leaders are Torbjørn Afdal, Arne Halvorsen, Thorbjørn Rygh, Sven Ivar Dysthe, Bjørn Ianke, Tormod Alnaes, and Bjørn Engø.

Bjørn Ianke is a student of Sweden's Carl Malmsten, and a skilled cabinetmaker who approaches his designs in the same manner as the Danes Hans Wegner and Ole Wanscher, working up the model in his own workshop.

Bendt Winge—designer, decorator, architect, carpenter, teacher—has had a vast influence on Norwegian arts and crafts and industrial design. His style is a careful blending of old and new, and his pieces evince human comfort with a hint of elegance. He has a real knack for industrially produced furniture highly practical for its stackability and disassembly for shipping, yet never humdrum or revealing of the practical factors involved. For example, a seat and back will be affixed to the support structure with an inconspicuous catch, or a sturdy yet graceful armchair will have legs slightly splayed to permit stacking, this touch subtly unnoticeable in the overall proportions of the chair. One of Winge's most popular pieces is a table of teak (by Arna) of ultrasimple lines, the construction of which allows two heights, so the table may be used as a dining or a cocktail table. He made this a long time ago, and the idea has been copied often ever since.

The Norwegian architect Alf Sture emphasizes his country's folk-art traditions in creating an interior. Untreated woods, his "Jaerbu" chairs (Edv. Wilberg Moelv) with their Viking-look, squarish, painted-wood frames and woven-rush seats, the use of rya rugs with truly Norwegian motifs . . . these are typical of a Sture atmosphere. He likes to use knotty wood planks, these being more authentic in updating the Norsk milieu. Sture's furniture looks invitingly comfortable, and his rooms communicate the cogent rationale and robust spirit of his homeland. Alf Sture and the State School of Handicrafts and Industrial Arts (where Norway's furniture designers are trained) have worked together to modernize furniture making in Norway, always retaining the feeling of Norsk tradition in design.

Anne-Lise Aas, Norwegian designer of both furniture and textiles, is conservatively contemporary. Her work carries the stamp of Norsk respect for past arts in her frequent use of woven-reed chair seats and backs, and some natural, some painted, wood surfaces. Her pieces usually have simple, uncluttered lines and good overall proportions.

Interior decorator Aage Schou has led the design department of Norske Husflidsforeningen for over twenty years. This organization is devoted entirely to keeping alive the traditional Norwegian handicrafts. It encourages and serves as a promotional and sales outlet for craftsmen in wood, textiles, wrought metals, and ceramics, and this especially includes Lapp (Samish) arts and crafts.

For a time Norway, too, used a great deal of the imported woods like teak, palisander, and mahogany, but presently the swing is back toward a sensible and welcome return to Norway's ample supply of prime native woods, such as birch, pine, elm, spruce, and oak. The inspiration of exhibits and contests has encouraged young designers and artisans to develop their talents and new ideas, vastly improving the Norwegian furniture art at last.

Iceland

Lacking native wood, what was Iceland to do to come up with something in the way of furniture which would be stamped with Icelandic expression? Well, the Icelanders *have* conceived something of their own, and though they cannot hope to compete in the export market with their Nordic neighbors or anyone else, they are proud to produce this much representing their national culture.

The Valbjörk Furniture Factory in Akureyri is one of the leading furniture makers of Iceland, at home and for export, the latter being sent largely to America. They feature a clever design in a three-legged teak stool-table with a modified triangular top. The unique feature is that the top is reversible, one side plain wood, for table use, and the other upholstered, for use as a stool. The upholstery is sometimes a woolen textile, but more charming is the use of sheared Icelandic lambskin, which harmonizes with the teak and is soft to sit on, besides. Also being made is a nicely thought-out sling chair with metal frame; the sling portion is made of sheared lambskin. It is pictured in the textile chapter, where the uses of Icelandic lambskin are further discussed.

The Overview

In between two extremes—the many people who love the older styles of home furnishings and those freethinkers who prefer today's sleekest, most abstract and inventive new forms—stands the present major Scandinavian concept: well-made furniture of practical and softened forms, with grace, dignity, and beauty, affording the best natural features of wood a chance to enrich the finished piece. The workmanship is expert, not only on obvious surfaces, but behind, under, and built-in. Metals and versatile new plastics have come in for their innings, too, especially in designs intended for business space and for young marrieds, but wood with its warmth and patina still tips the scales as the leading material for private home furnishings. As wood becomes more scarce with the years, these pieces of furniture will grow more precious.

This well-proportioned, solidly comfortable chair—suitably called "Restman"—is a recliner that, at last, doesn't look like one. Designed by Sigurd Resell for Lenestol Fabrik, Norway. [Photo courtesy Wim and Karen Sanson, Scandinavian Furniture, Inc., New York]

b
"The Norway Falcon," a sling chair with sculptural lines designed by Sigurd Resell for Lenestol Fabrik, Norway. The frame is made in beech, rosewood, or steel, and the comfortable upholstery is leather. [Photo courtesy Wim and Karen Sanson, Scandinavian Furniture, Inc., New York]

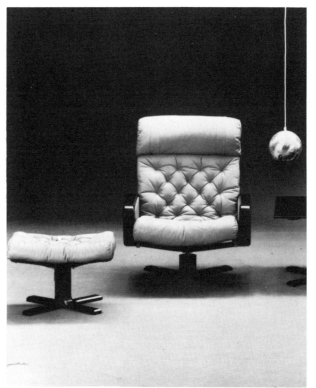

a

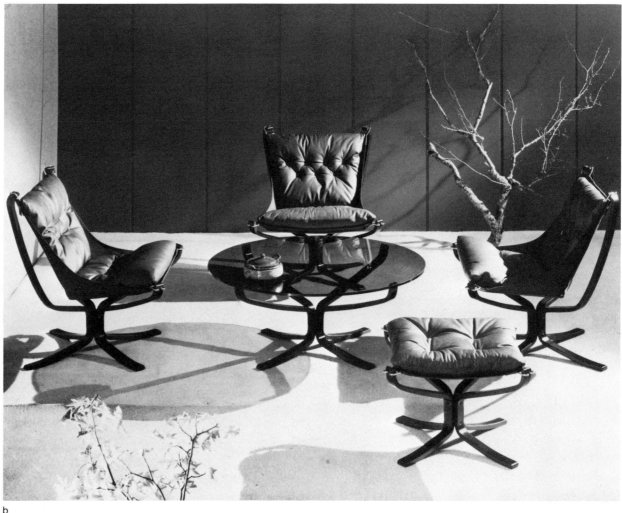

b

The "Kengu" chair is produced in
rosewood with black or cognac leather,
or shows its Norwegian origin in pale
beech with a fabric-covered cushion.
The graceful lines of this comfortable
chair are the inspiration of Elsa and
Nordahl Solheim for O. P. Rykken & Co.
[Photo courtesy Wim and Karen
Sanson, Scandinavian Furniture, Inc.,
New York]

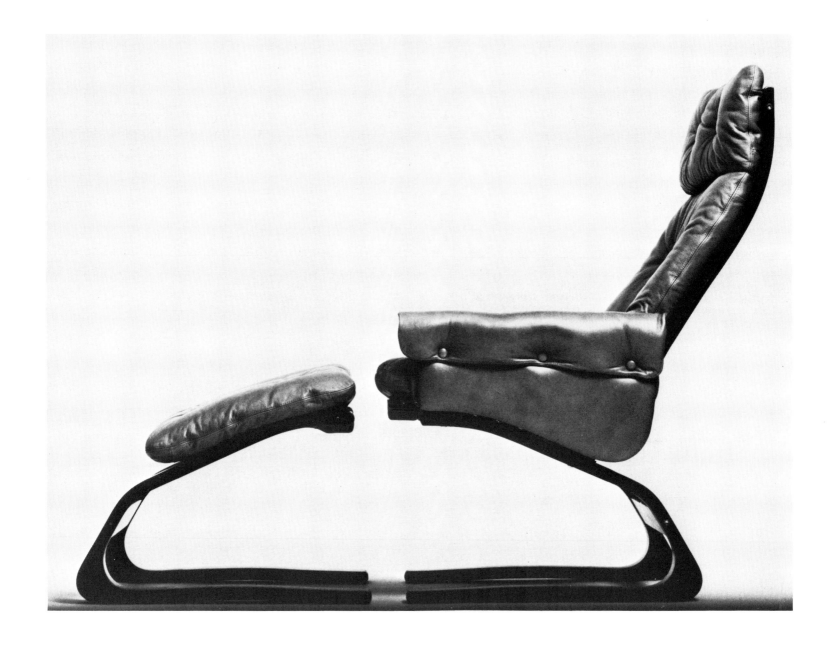

Scandinavian (or any) craftsmanship can best be appreciated or judged by examining specific parts closely. It is important to check the detail in the joining of a chair or table leg, or the way a chair arm is shaped to feel just right under the hand in repose upon it, then how it is joined to the back in an attractive manner that also provides strength at this point of stress. Simultaneously, the angle should be related to both grain and position, and to the proportions and appearance of the chair as a whole. Here is where scrupulous technique and understanding of material is combined in Scandinavian furniture with a proficiency not always—or even often—found elsewhere. It is this quality which has been the key to export success and the prerequisite for the continued respect the world accords to Scandinavian furniture. In Denmark over seventy manufacturers willingly submit their products to the Danish Furniture Makers Control Board, fully cognizant of the rejection hovering in the background for those who permit the least bit of slipshod workmanship in any piece. No one will see casually made furniture from Nordic countries when such great store is set upon perfection.

Are the Scandinavians in tune with future trends in this field? It would seem so, with such advanced ideas as "Pastilli," "Baghdad," and "Polar" coming from Finnish designers, to please those with futuristic ideas. With storage furniture disappearing into walls as built-ins, more living space is acquired. Less clutter and more informality are desired, and there is awareness of this. Younger people tend to consider furnishings as service equipment to some extent—anonymous, mobile, undemanding, and simplified. They are a "portable" generation, nomadic and nonconforming. What they collect and what they choose for adornment is natural and unpretentious. They show a warm affinity for small, humble, handmade or natural objects, a deep, near-primitive appreciation for what is pleasant to touch, see, hear, or hold, with no great monetary complexities involved. Surely this automatically leads them to acquiring what is nature-related, pleasant to the senses, practical, and lasting, though not necessarily costly.

Since this has been the Scandinavian theme for decades, it has been easy for their designers and producers to respond to this worthy trend with things especially designed to appeal to young people. It seems to be a good indication that, whatever way future household arts develop, the Scandinavians will manage to keep ahead, or at least abreast.

V. GLASS AND CRYSTAL

It's easy to become a slave of crystal. Its refractive brilliance is hypnotic, clear, and cool, yet aflame with lights. Surely it was no accident that the old folktales of fortunetellers should involve conjuring up visions by gazing mesmerized into a perfect crystal ball. Even if you close your eyes to this magnetism, the entrancing material called glass appeals strongly to the sense of touch. A sign at a glass display reading DO NOT TOUCH is offensive (if sometimes prudent), for part of the artist's message to one who will own his work is in its appeal to both sight and touch. He wants you to do more than look. He wants you to let the glass object give you, as it did him, a soothing sensation of pleasure. No shopkeeper should deny the lover of glass the privilege of holding it in his hand.

Crystal has become more and more a material for modern art forms. All major glassworks encourage experimental design in practical glassware, in crystal sculpture or polyoptic forms, and in individual art pieces such as vases and bowls. The designers working in this material are extraordinarily excited about it. They necessarily must have intimate knowledge of its processing, its stringent limitations and endless possibilities. They must think in three dimensions: form, color, and the intricate involvement of light. The blowing and shaping of glass still depend largely on the mouth and lungs and experience of the master glassblower, and it is astounding to watch what he can do with the pipe, sometimes even with a cigarette dangling from one side of his mouth as he blows into and rotates the pipe. Communion between this craftsman and the artist must be nothing less than 100 percent.

A glass designer's work is widely varied. He must supervise regular production, in addition to the making of special forms, and is often called upon to develop designs for the decoration of public buildings, a unique gift of state, perhaps, or other specific commissions. In all cases there must be intimate collaboration between the designer and the team at the glass oven for a thorough understanding of what has been and might be done with this raw material.

Few glass artists in Scandinavia began in this field. Usually they designed other things and eventually were tempted to sketch some container or other object to be made in glass. They were then captivated by the special magic of this material, and remained forever after entranced by its possibilities, and an eternal or at least frequent habitué of the glasshouse. Kaj Franck, Timo Sarpaneva, Tapio Wirkkala, Per Lütken, Willy Johanssen, Simon Gate, and Edvard Hald, Erik Höglund, Edvin Öhrström are all famous examples of this versatility, which finds many outlets but returns to or stays with glass as the ultimate inspirational material, both demanding and yielding in its challenge to the artist.

An Ancient Art

Glassmaking dates back to about 5000 B.C. in Persia and Egypt. The art traveled via Rome and Venice through Central Europe, and glass was first made in Scandinavia in 1556. This occurred in the Småland area of southeastern Sweden, where today about forty glassworks are still located . . . a lush sylvan bit of countryside, bejeweled with lakes, thus providing the water and fuel needed for the task of glass manufacture. The glass museum at Växjö, in the heart of this area, houses a fine collection, and tourists (no small children—too risky) are also invited to visit the factories and see the glassblowing process firsthand. Here are Orrefors, Kosta, Boda, and many famous others.

Finland's glass collections are housed in museums at the factories. Most impressive is the one at Iittala, whose design and layout are the work of Tapio Wirkkala. Riihimäen's collection is being kept, at last, in a pleasant old house. Nuutajärvi's display is charming and the collection itself excellent. In Norway, the Kunstindustrimuseet has a modicum of old glass, and there is a good collection to be seen when visiting the Hadeland Glassworks at Jevnakeer. The private collection of the Berg family (the sixth generation directing Hadeland Glassworks) is remarkable, and arrangements can be made to see it by professionally interested parties. At Orrefors in Sweden is a brilliant display, including magnificent pieces by Simon Gate and Edvard Hald.

There is much history in the ancient art of glassmaking, little changed in processing over five thousand years, except for perfections in handcraftsmanship.

Glasshouses are high-ceilinged, barnlike structures with tall brick chimneys belching smoke from the furnaces. The red-hot syrupy glass liquid inside the furnaces sends out tongues of light and heat that fill the atmosphere. Apprentices and experts in the teams pass back and forth carrying finished but still-glowing pieces from the work areas to cooling ovens, or assist the glassblower, who is at the nucleus of each team. The blower gives a little nod and the ensemble responds knowingly, moving about with the meticulous timing required by the demanding task at hand. It is much like a well-rehearsed ballet.

The basic ingredients of sand, potash, soda, red lead, or whatever the type of glass requires, are blended in the mixing room, then transferred to crucibles, where everything melts into the viscous mass of glass metal, heated overnight at 2,400° F. Small quantities of saltpeter and arsenic are included to facilitate melting and to purify the glass. If colored glass is desired, metal oxides are added, e.g., cobalt oxide for blue, chrome oxide for green, selenium, copper, or gold to give a red color. By 3 A.M., the mixture (called a "batch") is thin and fluid. Then the temperature is lowered to 2,100° F. to bring the material to just the right syrupy consistency for blowing by the time the workday begins. For crystal, which contains red lead, the batch is melted an additional twenty-four hours. A bleaching agent is required to produce a colorless crystal; ordinary soda glass always has a blue, gray, or brown cast, depending on the sand used. The resulting crystal is very clear, brilliant, and heavy. It has a musical ring when tapped and lends itself to thin and delicately blown forms more than ordinary soda glass.

The team—called a chair—supporting each blower is made up of a gaffer, a stem maker, a gatherer, two foot-and-stem gatherers, and a couple of assistants. The blower's pipe was invented two thousand years ago by the Phoenicians; the other tools are equally primitive. Every-

thing depends on the skill of the blower, who has spent fifteen years mastering his craft. After the glass metal is ready, the performance from then on is smoothly timed, as the carefully trained team creates all manner of objects from the excitingly malleable material.

The gatherer draws a glob from the mouth of the furnace, turning the long thin pipe until the glob is just the right size. An apprentice assistant then passes the blowing iron to the blower, who first uses a shaping bloc (like a great oversized wooden spoon), while rolling the iron pipe, which is supported on his workbench. The glob may now be, for example, pear-shaped. It is first dipped in water to provide a layer of steam between the glass mass and the shaping spoon, preventing rotation marks on the glass. Next, the blower stands holding the end of the blowing iron to his lips and supporting it further with his extended arm; he rotates it constantly while blowing the glass into the right size and shape, much as one blows a soap bubble. If a mold is to be used, the glass is once again dipped in water and the blower steps onto a wooden block, while an assistant closes the two parts of the mold below him. The blowing continues, and the glass object takes shape inside the mold. The blowpipe itself is of a length requiring the blower to stand on the foot-high block above the mold. The pipe is this long because that is as close as the gatherer can get to the oven opening and tolerate the temperature of the blazing fire inside the furnace.

Now a stem gatherer may bring another globe of molten glass on a pipe, drop it on the blown glass shape, and cut it off with shears. The stem and foot are shaped by hand and tool. The piece is then severed from the blowpipe with a precise blow over a steel bar. The raw edge is heat-softened and finished as desired with simple shaping tools. Perhaps a spout or lip is formed. The object is carried to the cooling oven and placed on a conveyor belt within, where during a two-to-three-hour journey it cools down from 2,000° F. to room temperature. This gradual cooling prevents distortion and breakage. The tunnel-like oven is called a "lehr."

"Sheared" glass is completed right at the oven by the members of the chair. The gaffer cuts the rim, reheats it, and shapes it even and smooth. "Cracked-off" glass is finished after cooling by other specialists in a different area of the glasshouse. A line is made with a diamond around the upper part of the glass. Exposed to gas-flame heat, the glass is cracked off along this line, the edge then ground smooth on a horizontal iron disk sprayed with carborundum, sand, and water, and further smoothed on a fine grindstone and polished. This glass is passed quickly through a gas flame, which melts the edge to make it smooth and lustrous.

There is still hand-finishing and decorating to be done, involving such treatment as applying designs to the surface by grinding, sandblasting, or etching. Deep cutting is done with sandstone or carborundum wheels. An abrasive of linseed oil and emery powder is applied with copper wheels to make a shallow intaglio which with light refraction creates the effect of bas-relief. Cutting is done in stages, first with coarse sand and an iron disk, then with finer sand, then with a grindstone. Polishing is accomplished using pumice stone and putty powder with cork or felt disks. In the cutting room, bottle stoppers are ground to fit each specific bottle by being placed in a rotating spindle and a carborundum emulsion, each stopper rotated in the bottle neck to which it will belong . . . a perfect airtight match. Polishing is sometimes done with concentrated sulphuric acid and hydrofluoric acid.

Engravers work from artists' designs. Outlines are transferred to the glass by a copying process, but details are all carried out by hand. It takes a dozen or more years to become an expert engraver. Etching is a different process, using acids and giving a more shallow effect.

You can easily realize how personal each beautiful object is when created from this material. Many individuals have added their skilled touches to an article during its processing.

"Good Glass" . . . What Does It Mean?

What is to be considered when buying glass? That it has not the tiniest flaw? That it rings when tapped? Actually, neither of these ideas is completely right. Yes, crystal will ring like a bell because of its lead content. But many kinds of "good" glass do not ring. Venetian glass won't, nor will some excellent pressed-glass pieces, and they are certainly not inferior in quality.

Flaws? A flaw is not always a defect. In handmade glass there could not be such a thing as flawlessness. A tiny imperfection testifies to its being a hand-wrought object, as distinguished from machine-made products. Slight deviations in glass are part of a natural charm, testifying to its being crafted by a human hand . . . personalized. An infinitesimal bubble, a shear mark, a mold mark, rings of light . . . these are only hallmarks of handcrafting.

Austere, clear-cut forms in glass demand a great deal in the way of quality in the material itself and absolute perfection in manufacture. Without texture and decoration to conceal serious flaws, the simplest designs are the most difficult to make, the most exciting to look upon, and the most beautiful when clear liquids are poured into them. Nothing is more entrancing on a well-set, candlelit table than the glow of ruby-red wine in a clear-crystal wineglass, well shaped and undecorated. In the search for something "different," it's best to remember that for wine and glasses to enhance each other, the simple, undecorated, clear-glass bowl is incomparable. Colored glasses should be used for liquids when the color is not important to its beauty on the table.

Too often in the past, and even today, glass was overtreated with ornamentation, detracting from its most exciting characteristic, the transparency of the glass itself. A beautiful object in glass should never deprive you of the vision of this material as a glowing, viscous, molten-metal mass.

It is to be remembered, too, that credit is always due to a new color in glass and crystal, for it represents a "discovery" of a chemical nature as well as an artistic variation. This should also come to mind when one sees a new color effect in a ceramic glaze or on finished stoneware, or in a woven or printed textile. Color effect is always a technical *and*

The art of glassblowing requires great craftsmanship and manual dexterity. The process, demonstrated here at Orrefors in Småland, Sweden, is much the same at all glassworks. [Orrefors glasshouse photos: John Selbing]

The blended ingredients are melted overnight (for crystal 24 hours longer) at 2,400° F. In the wee hours of the morning the temperature is lowered to 2,100° F and by the time the team (called a *chair*) reports for work the batch is of syrupy consistency.

(1) The chair consists of seven or eight men—the blower, a gaffer, a stem-maker, a gatherer, two foot-and-stem gatherers, and one or two assistants—each with a specific task. The blower is head of the team. To blow glass he uses a four-foot-long hollow iron pipe, its length established by how near the gatherer can get to the oven and still tolerate the heat

(2) The gatherer rotates the pipe in the crucible of molten glass and gathers the desired amount. It is then delivered to the blower by one of the assistants

(3) Sometimes a mold is used. If the piece is to have a stem, foot, or handle, the right amount of glass is brought to the blower on another pipe, the glob dropped onto the already-blown form in just the right spot and sheared off at the proper length

1

2

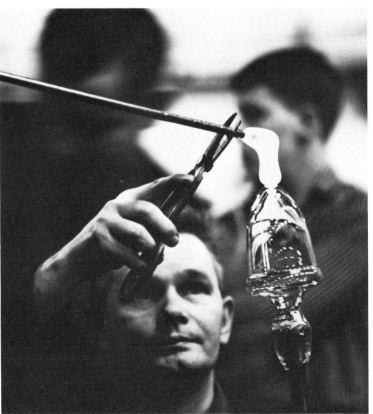

3

(4) Supervising the blowing of one of his original designs is Gunnar Cyrén, one of Orrefors's leading artists. Every piece of glass is the product of close cooperation between the designer, the blower, and the technicians

(5) Primitive tools are employed to turn and shape a large crystal bowl. When finished it will go through a tunnel-like oven (*lehr*) on a conveyor belt, where it is gradually cooled (annealed). This slow cooling makes the glass less likely to crack from thermal stresses

(6) Cutting is done in stages, with coarse and then fine sand, an iron disk, then a grindstone. The glass is then polished where cut. After a final inspection, the object may be engraved or etched. Engraving by copper wheel with oil and emery powder is largely done freehand. Etching is done by using acids, giving a thinner and quite different effect from engraving, and often used for monograms or emblems

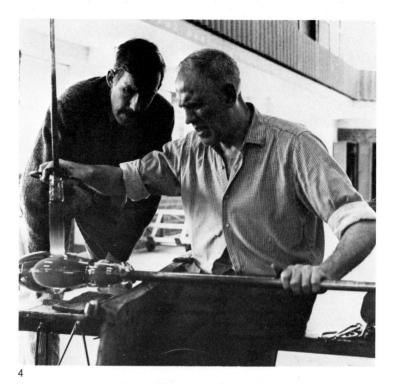

4

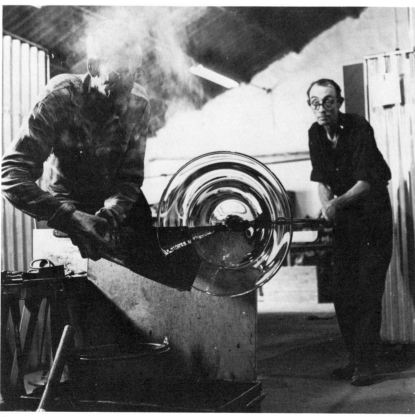

5

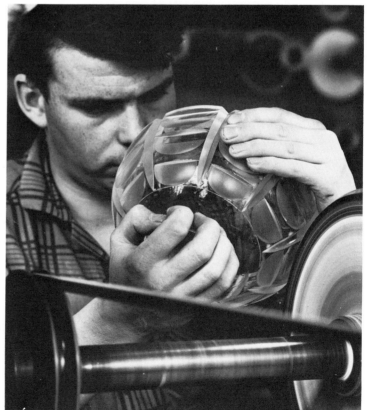

6

artistic feat which deserves respect and special interest. Color accomplishment shares the design spotlight with form and finish, and is of vast importance to the quality of the design as a whole.

All the Nordic glass producers—I am referring to factories in Sweden, Finland, Norway, and Denmark, since Iceland to date produces no glass on a commercial basis—have created especially interesting colors of their own. Hadeland has perhaps the most exciting cobalt shades, a garnet red, and a warm brown typical of their production. Riihimäen, in Finland, has developed some exquisite topaz and amethyst shades, and most of their glass colors are in fact keyed to nature's colors.

Finland turns out a white glass labeled "Opaline." It is not the same as American "milk glass." The pieces are of delicate proportion and are thin; they consist of an opaque white layer overlaid with a layer of clear glass, giving a glistening, semipellucid effect. Iittala has produced some of Alvar Aalto's and Timo Sarpaneva's designs in this opaline white. At Hadeland in Norway, Benny Motzfeldt has designed two or three vases in this technique, with the added innovation of two exquisite pastel colors (pale pink and butter yellow) in the opaline layer. They look good enough to eat.

Sweden

"Swedish crystal" has long been a key phrase in America and other lands, implying quality, refinement, and expertise. The first glassworks in Sweden was founded over four hundred years ago, after which many ovens were built throughout the country, each supplying its own area. Today there are still over fifty of them, with about forty clustered in Småland, in southeastern Sweden, sylvan and dotted with lakes so cobalt crystal they might have been blown by a giant glassworks themselves. Kosta is the oldest surviving glassworks, founded in 1742. Orrefors, nearby, shares the prestige spotlight with Kosta, but was not founded until 1898.

Not until 1917, when Simon Gate, Edvard Hald, and Edvin Ollers began to break away from copying foreign designs, could one say there was true Swedish originality in glass design, but once started on this path of creative thinking in glass forms, Sweden eventually became the world's leader in the field. Competition from the United States and a dozen European countries has grown, but Sweden still holds her own, with foresighted management, expert artisans, and distinguished artists.

The atmosphere throughout Småland is of an entire community wound up in glass production, an entire "country team" proud of its production, though each firm has a characteristic style, from the traditional forms of the past to today's modern industrial enterprise and contemporary forms, and looking forward always to whatever innovations tomorrow may bring.

Orrefors has hosted interested travelers from around the world since the late twenties, and aside from its spectacular products and glass museum, the factory itself is picturesque. On the timbered shoreline of a small lake sits the old glasshouse, largely unchanged but now surrounded by modern work buildings, a new office building, a sleek exhibition hall of steel and glass designed by Bengt Gate, and a charming guesthouse with snack bar.

Orrefors makes cut, engraved, and undecorated crystal, and lighting fixtures. The original Orrefors product was, surprisingly, iron. Glass production was started as a sideline in 1898. In 1913, a first-rate manager, Albert Ahlin, was hired, and he in turn put on the payroll Simon Gate and Edvard Hald, who revolutionized glass design. They were given a free hand, and developed new techniques, such as multicolored "graal" glass, and "ariel," which involves air bubbles that give added dimension and effect. They experimented with stemware, art glass, reliefs, and spectacular exhibit items. "Swedish crystal" eventually became a byword in design circles around the globe. Gate died in 1945, but Hald is still active on a limited basis.

Simon Gate was a painter of landscapes, portraits, and decorative work, and a book designer. He is represented in international museums and collections. Edvard Hald is also a painter. He is a glass and ceramics artist and acted as managing director at Orrefors. Hald studied under Matisse, and like Gate is represented in many museums around the world, including New York's Metropolitan and the Chicago Art Institute. He was made an honorable fellow in many design faculties and societies, and is certainly one of the greatest leaders in the overall development of Swedish applied arts. Hald loves simple forms in crystal with cut or engraved styles.

A great artist who followed in Hald's footsteps is Sven Palmqvist; another is Nils Landberg. Both these men grew up around the glassworks. Palmqvist is well known for his innovative series in glass called "Fuga," simple, sturdy, and devised in an entirely original technique. Neither blown nor molded, "Fuga" is created under centrifugal force. Its form, therefore, is as natural and simple as can be. Palmqvist has been at Orrefors since 1927, and has also trained as an engraver. Experimenting further with the graal technique, he developed a version he calls "Ravenna," using deep colors layered and employing air bubbles in a unique manner, giving, sometimes, a quicksilver appearance. He is today an experimenter in prismatics and is still fascinated with the special refractive effects created within blobs of glass.

Nils Landberg's designs are usually paper-thin, delicate, hand-blown forms, extremely graceful and refined. Landberg has been with Orrefors since the early thirties. In 1956 he designed an elegant, light series of wineglasses in a tulip form, one of his finest works. The glass is extremely delicate and made with a colored layer on the inner surfaces. The bowl is blown, and then the slender stem and foot are drawn right from this same two-toned glass, rather than being added separately. This draws the inner color down and emphasizes it in the stem. The edge of the foot is turned back on top to form a small rim. These glasses are difficult to blow, and so graceful they seem fit for a fairy princess. Landberg's works are in several museums, including New York's Museum of Modern Art.

Nowadays, Gunnar Cyrén and Ingeborg Lundin are the most exciting and well-known designers at Orrefors. Miss Lundin has an original and

"Pippi, with Teardrop," two of many sizes in wine service, made by Kosta of Sweden. On the right, a Kosta vase typical of the color delights offered by this fine glassworks, the oldest in Sweden. The inside is lined with colors from brown to soft violet to smoky rose, blending into a dozen other hues as the piece is turned and light is refracted through it. [Photo: Kjell Munch, Oslo]

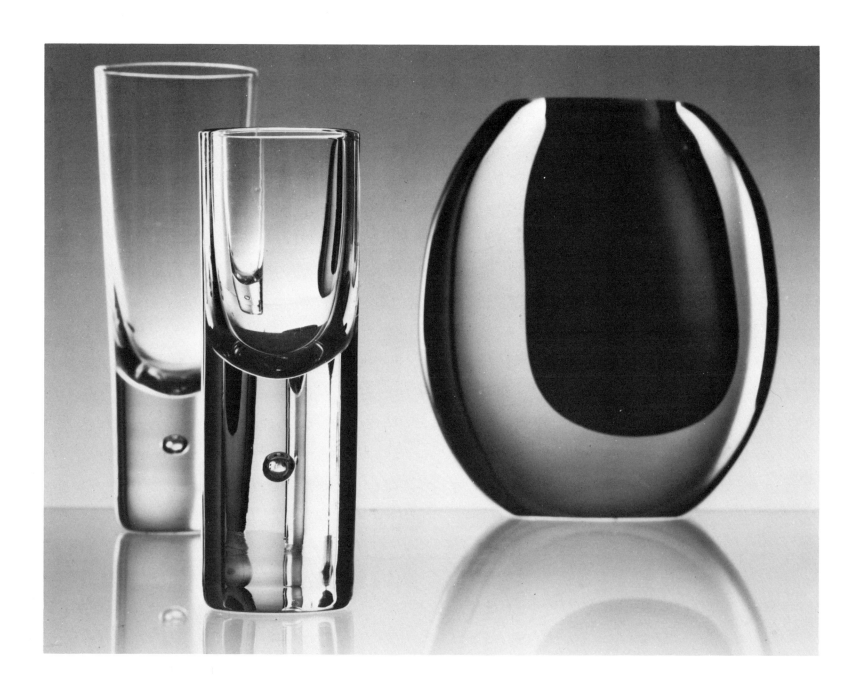

a
Crystal bowl, engraved by the "Semi-ramis" technique. Design by Ann and Göran Wärff at Kosta, 1966. [Courtesy Svenska Slöjdföreningen. Photo: Sten Robert]

b
Sparkling crystal stemware from Kosta. Its name—"Cecile"

a

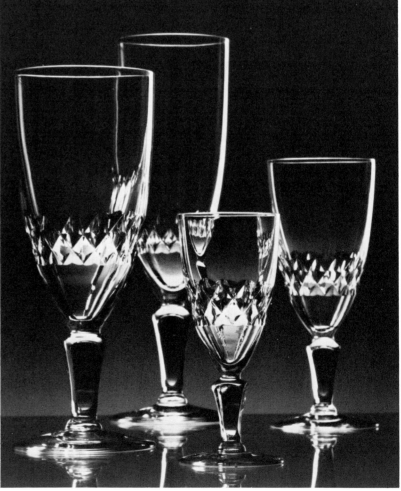

b

a

New and old design side by side, illustrating how comfortably old motifs can be incorporated in simplified modern forms. Orrefors's "Valdresse Briljant" illustrates the "caro" or "diamond cut" popular for generations, and with good reason . . . it is a diamond-bright sparkler in candlelight. At right, the refractive advantages of the diamond cut are suitably applied in the modern idiom by Ingeborg Lundin. [Photo: Kjell Munch, Oslo]

b

L. to R., from Orrefors: (a) Slender decanter by Ingeborg Lundin, (b) Delicate vase by Nils Landberg, (c) A graceful older design bottle by Simon Gate, (d) Vase by Nils Landberg, made in all clear glass, gray with clear, or green with clear [Photo: Kjell Munch, Oslo]

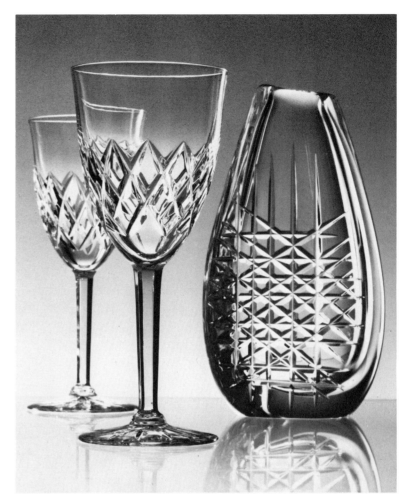

a

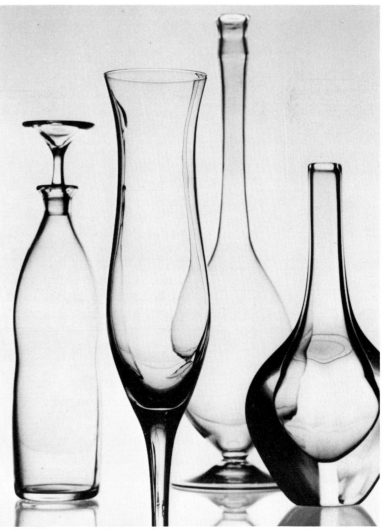

b

Edvin Öhrström, one of Orrefors's great design team, created this vase in the special technique known as "ariel," which uses air bubbles to create design within deep-colored glass. The method was developed by Simon Gate and Edvard Hald. The bubble design appears silvery, like fat threads of mercury within the thick glass [Photo: Kjell Munch, Oslo]

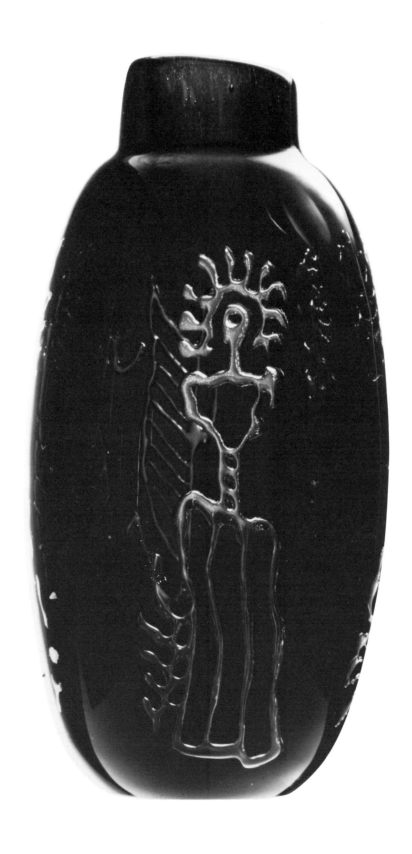

Sven Palmqvist designs crystal glasses
and wine services as well as simple,
artful bowls in ''Fuga'' glass, which is
made in clear and in some very beautiful
colors

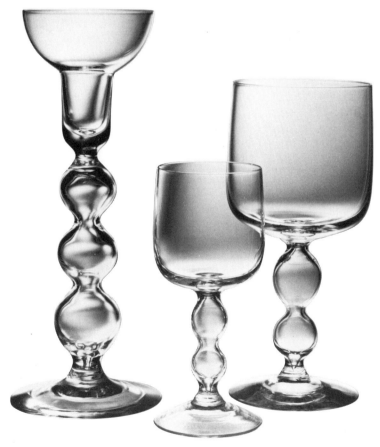

Nils Landberg, famous Orrefors
designer, typically produces handblown
crystal of great elegance and delicacy
[Photos: Kjell Munch]

Three views of the works of Ingeborg
Lundin, demonstrating the wide range
of her talents, from conservative forms
to excitingly imaginative contemporary
designs sculptural in feeling

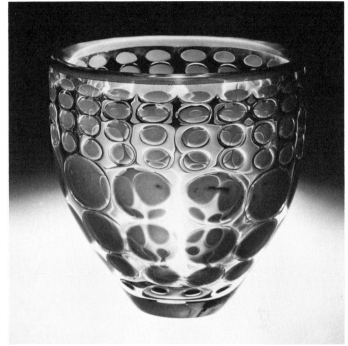

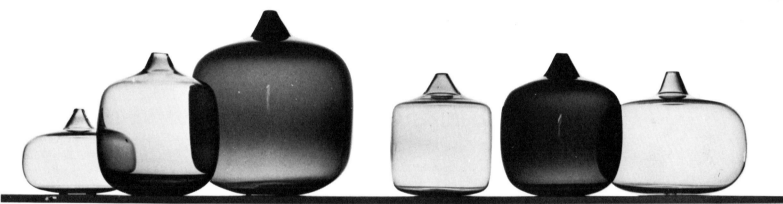

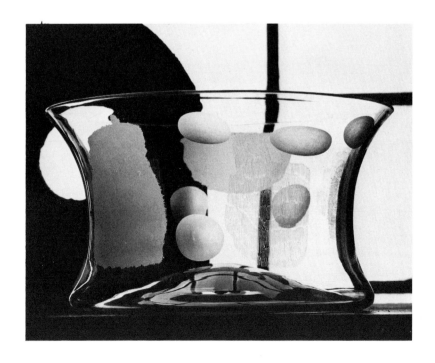

personal style, ranging from thin, bubblelike forms to heavier shapes. She can be spontaneous with blown-glass designs, or employ cylindrical or more formal shapes either prismed or excitingly engraved. The engraving is most often an abstract or graphically related design. She likes cutting that is left unpolished, or "matte." Miss Lundin is daring, and shows great sensitivity to everything the material can offer.

Gunnar Cyrén, young and venturesome, favors bold sweeps of design. He won (in 1956) the Society for Industrial Design award for "proficiency and industry." Cyrén's forms and decorations are usually abstract, full of strength and motion, and always fresh and new artistically. He was originally a silversmith.

John Selbing is another good designer at Orrefors, his forms showing his preference for the sculptural. Also at Orrefors since 1946 is a fine designer of lighting fixtures in glass and crystal, Carl Fagerlund. He is also a teacher of design.

Vicke Lindstrand, who once worked at Orrefors, has been the leading designer at Kosta since 1950, designing everything from tableware to art pieces, such as his polyoptic prisms—blocks of crystal engraved in juxtaposition for unique effects—and sculptural cut-crystal blocks such as "Prisma." He is an artist with endless energy and inspiration, and with expert technical knowledge of his material. He likes effects that are unusual and free in form, asymmetrical as against any classical shapes. Lindstrand also does painting, ceramics, and poster design, but seems to find his greatest inspiration with glass. Required with the hot, viscous mass is an immediacy of inspiration which appeals to him and seems to draw forth his best talents. In design thinking, he is entirely unfettered by any tradition.

Monica Morales-Schildt is another fine designer at Kosta, well known for her glass of layered colors through which she cuts two or three large facets to gain interesting refractions. She also designs ceramics, and has been with Kosta since 1957.

The Boda Glassworks, now about one hundred years old, has twice burned down but was promptly rebuilt each time. It has grown into one of the largest glassworks in Sweden making art glass and is a leader in developing new forms.

First among its designers is Erik Höglund, who joined the firm about fifteen years ago, newly out of Stockholm's renowned Konstfackskol, eager to design, mold, create, with glass as his first choice of material. He was given a free hand, and for almost two years he merely experimented and studied the possibilities of the material. Höglund's tendency has been to return to the provincial in glass styling, to blend glass with wood and forge iron, when the rest of Sweden's table and art glass had become famous for delicacy and formal shapes.

Höglund, born in 1932, winner of the Lunning Prize in 1958, has traveled extensively on scholarships and is already well represented in many museums. He is also a sculptor (in cast bronze) and has done glass murals for several public buildings. Höglund has a primitive grasp of glass as a material and has reintroduced old techniques such as applied and stamped decorations. In revolt against formal elegant design, he prefers expressive primitive glass forms, a refreshing contrast to the polished styles so typical of Sweden. Höglund likes amber, gray, and blue glass, bubbled, refractive, and colorful. His chandeliers and candelabra of wrought iron with glass medallion pendants have been warmly received. Höglund's designs have a definite handcrafted look, and though very contemporary, they are closely related to the glassware of bygone days. His creations relate to rustic decor, yet are well groomed and sophisticated. He does sculptural compositions in glass, and is well known for his personable bottles in the form of chubby figures with arms and clasped hands. Höglund's characteristic effects are the artistic antithesis of fussiness and frailty, but exude winsome grace and charm.

Fritz Kallenberg also designs for Boda, concentrating on the more disciplined, conservative forms. He has spent most of his life at Boda, and is a brilliant artist in a refined manner. Bertil Vallien, already well known as a ceramic artist, joined the firm some time ago, following a scholarship awarded by the Swedish royal family, first prize in the "Young American" competition of 1961, and top honors at the biennial Everson Museum of Art exhibition in New York. Also freelancing at Boda are John Kandell, an architect who likes to work out his own glass features for his buildings, and Lena Larsson, who is also an architect.

Many younger artists at Boda and elsewhere in Sweden have followed Erik Höglund's refreshing lead. For example, Bengt Edenfalk's glass design for Skruf Glassworks is massive and thick, but lightened with air bubbles. This designer is also a painter and was awarded first prize in the competition for decoration of the Stockholm subway in 1956. He has shown his works in the Exhibit of International Contemporary Glass at the Corning Museum of Glass in 1959, and is represented in several other museums.

At Reijmyre Glassworks are found Monika Bratt and Tom Möller, whose designs are certainly modern in feeling but are tempered with the restraint of the traditional. Reijmyre makes a ruby-red glass that is especially beautiful.

Kjell Blomberg designs at Gullåskruf Glassworks, a firm founded in 1927 which makes high-quality utility glass, particularly pressed glass. Blomberg contributes his youthful ideas to practical glassware and to decorative pieces. The products of this firm are largely undecorated tableware with good lines and excellent craftsmanship.

Near these firms are about thirty others, all making beautiful glass. The only other one I will name specifically here is Strömbergshyttan. Run by the Strömberg family, this glasshouse is to be praised for the remarkable clarity of its crystal. The designs are largely massive, conservative in shape, and often beautifully engraved, but because of the quality of the glass itself, the undecorated forms are especially appreciated and coveted.

Perhaps there is still a place where the names Orrefors and Kosta are not already legend and where students of the arts do not revere the names of Edvin Ollers, Simon Gate, and Edvard Hald, the gifted men who first devoted themselves to original and creative Swedish glass design. These artistic giants were the first to depart from the conventional

Gunnar Cyrén is one of Orrefors's more
adventuresome artists in glass. His
designs have masculinity and strength.
Here are two views of his works

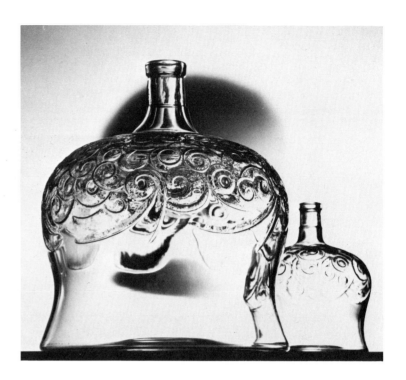

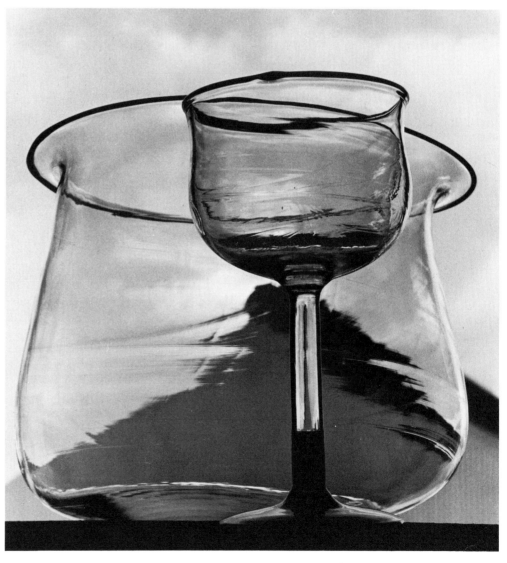

Vicke Lindstrand designed this crystal
sculpture at Kosta. [Courtesy Svenska
Slöjdföreningen. Photo: Beata Berg-
ström]

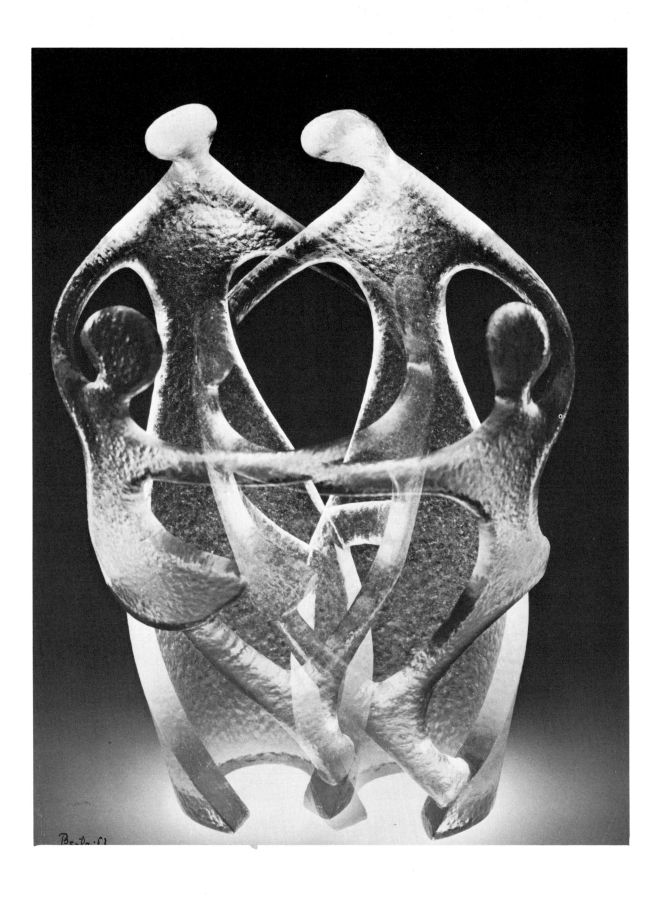

Monica Morales-Schildt is world-famous
for her designs for Kosta. This vase
demonstrates her "Ventana" technique,
layers of glass partially cut away to
show the color of each layer. 1960.
[Courtesy Svenska Slöjdföreningen.
Photo: Beata Bergström]

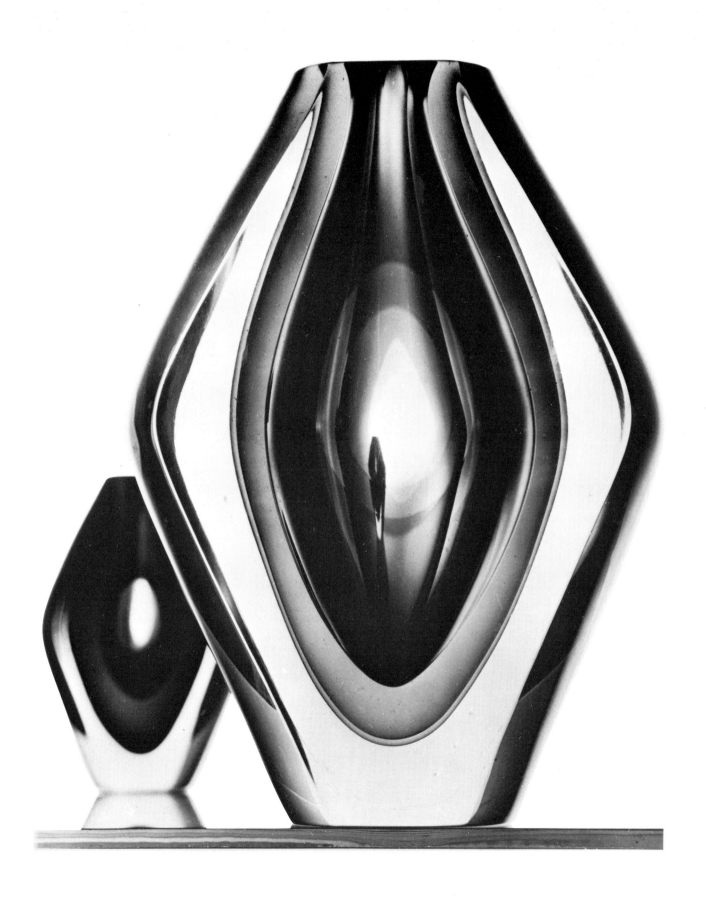

a
"Pompadour" is the name given by Boda Glassworks to this elegant cut-crystal service. Hand-cut stem, foot, and bowl make this service costly, but deservedly so. [Photo: Kjell Munch, Oslo]

b
The gifted touch of justly famous master engraver Vicke Lindstrand creates a three-dimensional illusion in an amusing work on a lovely vase from Kosta. The mirror is on the opposite side. [Photo: Kjell Munch, Oslo]

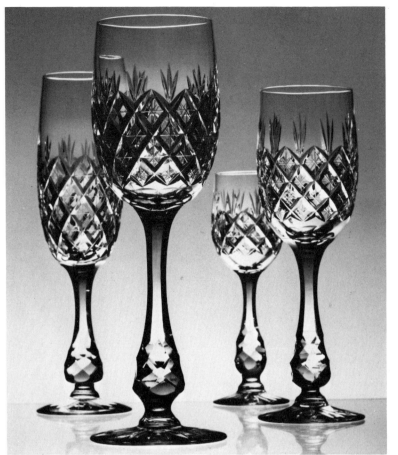

a

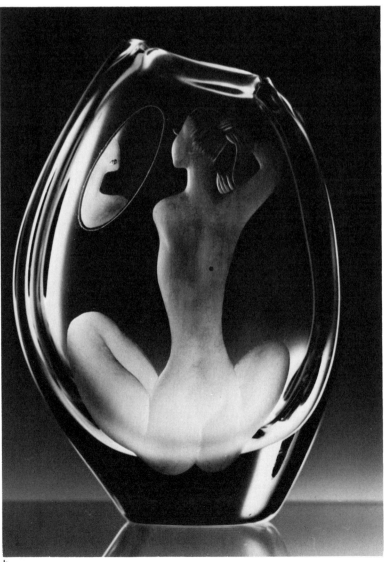

b

a
Cocktail pitcher and glasses in beauti-
ful Finnish soft blue by Timo Sarpaneva
for littala

b
Drinking glass (berry dishes, too, in
this series), by Timo Sarpaneva for
littala, are stackable, inexpensive stem-
ware, yet they interpret plainly the
natural flow of glass in its molten state

c
Versatile, stackable bottles in clear
and colors. Timo Sarpaneva received
the AID medal, 1962, for this design

a

b

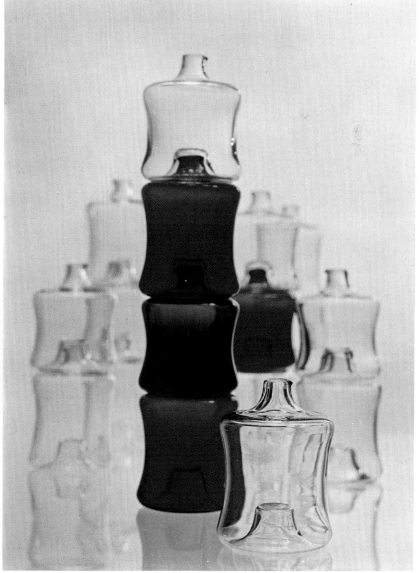

c

a

"Blue top" kitchen jars were designed by Willy Johannsen for Hadeland. The tops double as dishes, and inside there are plastic tops, for airtight storage. The graceful olive green and teak cheese dish was designed by Benny Motzfeldt. [Photo: Kjell Munch, Oslo]

b

Hadeland is famous for its reproduction of cobalt blue in glass. Shown here are two replicas of museum pieces. The originals of these pieces (c. 1810) are part of the fine collection of old glass at Kunstindustrimuseet, Oslo. [Photo: Kjell Munch, Oslo]

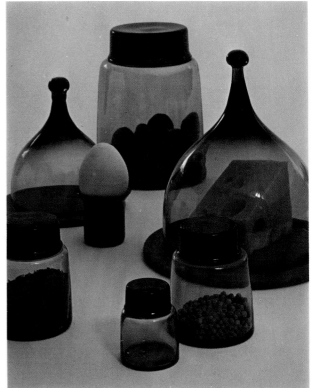

a

b

a
Decorative wall hanging by Rolf
Middelboe of Denmark. [Courtesy
Den Permanente]
b
Tapestry by Kaisa Melanton of Sweden,
handwoven, one of a kind. [Courtesy
Svenska Slöjdföreningen]

a

b

a
The wave-and-fire motif, and at least a touch of the asymmetrical, appeared in most ryas dating from the Art Nouveau era. This one, "Lokki" (Gull), by Jarl Eklund is a "bench rya." Bench ryas reached from the wall over the bench to the floor, so they were long and narrow, with higher tufting to withstand harder wear. [Courtesy Finnish Society of Crafts and Design]

b
At the beginning of the twentieth century, ryas made a transition from folk weaving to an artist-designed craft, pioneered by the Finnish painter Aksel Gallen-Kallela and the Friends of Finnish Handicraft, a society which, since its foundation in 1879, has been the nucleus of rya weaving in Finland. Gallen-Kallela's rya "Lisko" (Lizard), shown here, was woven in 1904 and was clearly influenced by the Jugendstil of that time. His inspiration—from the Finnish national epic, the Kalevala— was the River of Death (Tuonela), on the banks of which sits a menacing lizard, its long tail coiled amid blood-spattered stones. [Courtesy Finnish Society of Crafts and Design]

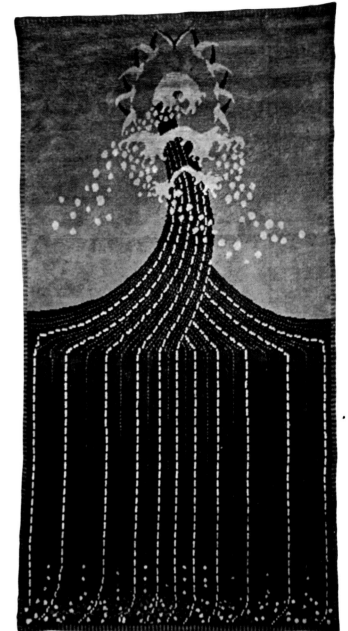
a

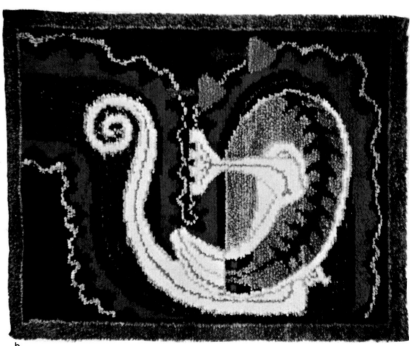
b

a

"Palokärki" (Black Woodpecker) won the Grand Prix at the Milan Triennale in 1954 for Kirsti Ilvessalo, and was acquired by the Victoria and Albert Museum in London. Her earlier rugs were often free and individual interpretations of old rya traditions. [Courtesy Finnish Society of Crafts and Design]

b

"Ares" rya is typical of the beautiful Ritva Puotila's equally beautiful work, for which she has won a gold medal at the Milan Triennale. She often stresses a lengthwise axis as used here. Turquoises and purple-blues, touched with golden tan, is a favorite color combination of hers. [Courtesy Finnish Society of Crafts and Design]

c

Kirsti Ilvessalo's design themes are now unrestricted and exciting, as seen in this recent rya, "Myrskyjen Meri" (Stormy Sea). This great textile artist has her own weaving shop, but has been director of the Friends of Finnish Handicraft weaving department. As a teacher at the Institute of Industrial Design in Helsinki, she has influenced the new rya-artist generation. [Courtesy Finnish Society of Crafts and Design]

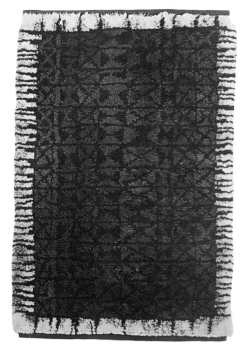

a

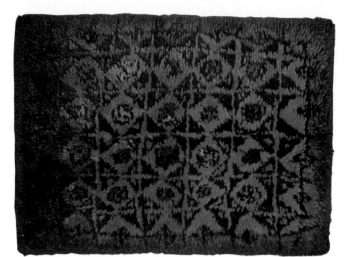

b

c

a
Coffee spoons in enamel on sterling,
gold-plated, from David-Andersen,
here demonstrate the glowing colors
this firm has perfected with this
technique

b
Masterpiece enamel on sterling coffee
service designed by Guttorm Gagnes.
There are only a few workshops in the
world where enameled coffee sets are
produced. The firm David-Andersen
of Oslo has specialized in this
technique for over seventy-five years,
and this exquisite model from their
workshop has been accorded the
highest praise from collectors and
designers alike. It is also made in
white or blue, or in other colors by
special order. Handle and finial
are ivory

a

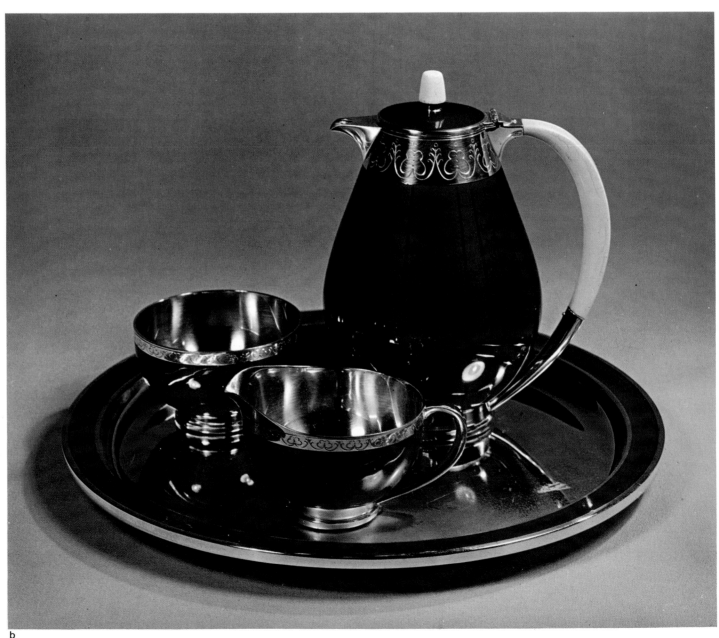

b

a
Jewelry from Scandinavia covers a wide range: L. in oxidized brass, pendant by Pentti Sarpaneva based on a *Kalevala* motif; next above, pendant in silver with Finnish native stones, by Björn Weckström; next below, earrings and ring in oxidized silver by Jóhannes Jóhannesson, Iceland; bracelet and three pins based on old Norwegian motifs (the filigree brooches are part of native costumes from the various valleys of Norway, each valley having its own style); the contemporary earrings are by a talented young designer in silver, the Norwegian Tone Vigeland, associated with PLUS, at Fredrikstad, a design center for Norwegian artists in all fields of arts and crafts. [Photo: D. C. Beer]

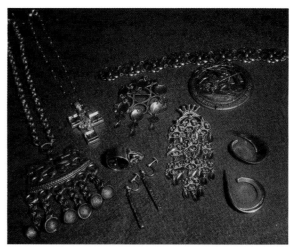

a

b
Sweden's most outstanding designer in precious metals is without question Sigurd Persson. He is famous for his beautiful works for churches and cathedrals, such as this cross and candlesticks in sterling. [Courtesy Svenska Slöjdföreningen. Photo: Karl-Erik Granath]

b

a
Tivvy and his girl, Fauni trolls, take a
little stroll in the Finnish countryside
b
Timo Sarpaneva's wrapping papers
were awarded the "Eurostar" for
packaging achievement in 1968. Printed
on low-cost paper stock by a patented
process by which more than twenty
colors could be applied with a single
run of the press, the papers are as
inexpensive as they are beautiful.
The process has also been applied to
a handsome line of stationery and to
dress and decorating fabrics. It is
designated as the "Ambiente" line

a

b

to a trend in undecorated shapes and plain surfaces—without the then-popular gilding, cutting, or engraving. They developed new tints of green and blue, emphasized the beauty of unadorned purity of form, and utilized the charming refraction of bubbles. From their beginnings, the spotlight of world recognition shone ever brighter on Sweden's creative art glass.

With her reputation long established on the world market, Sweden continues to hold her own with sparkling leadership in the field of sophisticated art crystal and tablewares of glass. Though some of the traditional patterns are still going strong, Sweden's product today offers a preponderance of straightforward contemporary and advanced modern, reed-slim stemware. Swedish culture tends toward the more formal, and this is particularly evident in the gentility of her people's etiquette at table. Her art glass reflects this facet of the nation's personality. The Swedish tendency toward economy of material and form began long ago when life was austere, natural resources limited. In today's prosperous, affluent Sweden, this trace of the past remains, not by necessity, but because these forms adapt so well to modern taste and industrial techniques, without the sacrifice of beauty or splendor.

Swedish engraving has become its own hallmark. The glass itself is famous for its fragile but simple splendor and clarity, its talent for appearing with equal grace either on an informal table or in an elegant setting.

Finland

Finnish glass design provokes reactions that are radically different from the cozy, dignified constancy communicated by Norwegian art glass and the air of polished elegance surrounding Swedish glass. Finland's design is pure, unadulterated excitement and adventure, translating into tangible, visible objects the vitality and forward movement of its culture.

The powerful rise of all modern Finnish design is a result of the vigorous new freedom of their art concepts. The Finn has a history of aptitude for construction, an eye for line, proportion, composition, and color. Always somewhat isolated geographically, the Finn is accustomed by his heritage to originating his own designs. He emulates no one. He creates freely, unburdened by outward concepts or tradition.

Finland's glass is full of geometrics, polyoptics, prismatics, blended with graceful curves and new colors. It is at once severe and delicate, daringly advanced and timeless. It exudes a creative intensity and a fierce pride in its own integrity of design. Yet it whispers with a gentle loveliness through its soft plays of light, its perfection of contour for its own sake.

Finland's leading producers (Iittala, Nuutajärvi, and Riihimäen) support and foster its highly gifted designers—Tapio Wirkkala, Kaj Franck, Timo Sarpaneva, and others. All these artists design in other media. Bound by no outmoded notions, their fresh use of color is stimulating—for instance, soft amethyst, shades of wet green, or midnight blue with olive green. Kaj Franck expresses color sensitivity thus: "Reaction to color is a personal opinion. Everybody is right, but nobody can prove it." He further explains how the Finn seeks and finds a subtle violet in snow shadows, a delicate green in melting ice or shimmering dewdrop, a warm new yellow from scales on a winter-whipped aspen, and a strong blue in the spring's first brave anemone, rich and inspiring against its backdrop of still half-frozen, subdued, earth tones. And so it is that Finland's art has the gift of color discovery, and standard run-of-the-mill color is conspicuous by its absence, in glassware as in all its other arts and crafts.

At the Sacramento (California) Exhibition in the fall of 1961, Finnish exhibits won twenty-three gold medals—more than any other nation. Nine of these were for art glass. After the 1950's, more and more prizes were captured by Finnish design in international competitions and the world began to notice. Relatively free from foreign cultural influences, the Finns, when stimulated to begin a drive toward new creative work, produced original, sensible designs that were highly appealing to a jaded world. There was a genuineness about the well-proportioned shapes, a natural beauty to the colors, a practicality and adaptability to the whole which had immediate acceptance. A new way of life, accepted by the Finns, led to a new scope in styling home art objects . . . easy to use and store, versatile, attractive, but retaining personal, handcrafted quality.

There were glassworks in Finland—for the most part making bottles, flasks, and drinking goblets—as early as 1681, followed in 1748 by Åvik Glassworks, a firm which attained a good reputation. Nuutajärvi was founded in 1793 and is now the oldest glassworks still operating. At first the materials were local and the skilled blowers were imported, mostly from France and Belgium. Now the raw materials are imported and all the blowers are Finns.

The importing is done to obtain pure sand without ferrous oxide. Fuel oil is also imported. But in the early days, due to degrees of impurity involved in the use of native materials, the colors were cloudy greens, browns, light blues, and grays, all with much charm, grace, and purity of line, and enhanced by flecks, bubbles, or a misty effect (much sought after again in today's designs).

The nineteenth-century glass reflects, as in other countries, the then-popular offerings of cut and delicately engraved crystal. These glittering styles lost most of their appeal with the onset of simplified modern taste. Still, they were masterpieces at the time, demonstrating the amazing techniques and skills involved in this type of work. The Art Nouveau period followed, with all its ornamentation, rippling, twisting, fluting, and pretense at mimicking porcelain or silver.

Suddenly there was a revolution to escape the tiresome, forced ostentation of the past, and designs returned to the pure and simple forms, allowing appreciation of the innate qualities of the glass material itself. Arttu Brummer, working at Riihimäen, entered the scene early in this century and in Finland led the return to clarity of form and a new attitude toward timeless art in glass. Most of the great names in Finnish glass design today studied under Brummer at the Atheneum College of

Art in Helsinki, where he was director from 1944 to 1951. His student successors have given us dazzling creations in their fresh approaches . . . glass as exciting and varied as sharp slivers of ice, or as softly rounded as a tear, as clear and sparkling as a raindrop in the sunlight. Brummer was an inspiring teacher and a great individualist in his creative works, in furniture and glassware. His early years coincided with the beginning of the tendency toward a freer artistic ideology along with the cubist departure from the classicism of the twenties. His taste was exciting and splendid, though he never let it lead him to extremes, in the opinion of historians. In his famous "Sibelius Finlandia" vase, made in 1945, he demonstrated his love of the elegant look executed with a certain restraint. As a teacher, he had a keen interest in and a special charm for the young students, and was quick to spot new talent and encourage freedom for the especially gifted. He taught at the Central School of Arts and Crafts in Finland from 1919, and in 1944 became its art director. Brummer also worked with Ornamo, Friends of Finnish Handicrafts, and the Industrial Art Museum.

At the Central School in the fifties, the rector was Rafael Blomstedt, who represented the opposite viewpoint. He was a farsighted, well-rounded man in an era when specialization was the coming thing culturally. Between the humanistic, conservative Blomstedt and the adventuresome Brummer, the training at the school was sound and fruitful, and today's high level of craft training in Finland is credited largely to these two men, whose teachings become more appreciated as the years pass.

Gunnel Nyman was another particularly fine glass artist in Finland whose works in the forties are still among the most outstanding in Finnish crystal. Economy of line, grace, and a profound awareness of her material are evidenced in all her works. She was a brilliant leader at the beginning of a new era, and her untimely death in 1949 was a great loss. Her works are still valid, beautiful, and inspiring today. She designed for all three of the large Finnish glassworks, and some of her most famous pieces include "Roseleaf," which has the effect of glittering opal (in Nordenfjeldske Industrial Art Museum at Trondheim, Norway), and "Veil," which creates an effect of tulle with bubbles, and the graceful "Serpentine" vase, with its one long, slender, winding bubble drawn up and around as if blown by a small fairy ballerina twirling with perfect rhythm.

Finland's glass firms make household glass of great purity of color, luster, and mechanical strength, and the decorative glass is uniquely beautiful. Experiment is an everyday procedure in Finland and there is no pressure, nor are there any preset ideas from the past to clutter the thinking of artist or producer. The pure form inherent in glassmaking techniques is never obscured, and individuality is always encouraged. There are many great designers in Finland, and the keen competition they give each other has spurred them on to ever-greater improvements.

The firm of Nuutajärvi at Urjala, two hours' drive from Helsinki, is owned by Wärtsilä, the huge and progressive Finnish complex which also owns Arabia and the factory making "Finel" metal and enamel kitchenware, among other industries. At Nuutajärvi is Kaj Franck, one of the most important teachers and leaders in glass design in Finland. Here he is art consultant, director, and designer, along with his work at Arabia and his teaching at the Atheneum. The exciting young designer Oiva Toikka is also associated with Nuutajärvi. The firm makes blown and pressed household glass and art glass.

Gunnel Nyman and Erik Lindqvist (she as designer, he as manager) put Nuutajärvi on the world's glass map, and Kaj Franck keeps it there. Lindqvist gave Gunnel Nyman a free hand and she began by going to the glassworks, watching the blower, suggesting, demanding, encouraging. Her designs departed from the traditional and she produced thick, heavy, blown shapes without the use of a mold. She experimented with optical effects. Unfortunately, when she died in 1949, still very young, the company lacked another imaginative designer. Its troubles were doubled by a disastrous fire in 1950. The Wärtsilä concern took over at that time and put Kaj Franck in charge. The blowers, just getting used to blowing thick glass, were now confronted with a man who wanted to make thin glass. Franck succeeded in putting his ideas across, and experimented with artistic shapes for everyday household use and other innovations in colored glass combined with the simple shapes he so loves. He is a constant exponent of the theory that one should not really notice the glass he is using but merely take pleasure in its use. Anonymity of style, comfort in the hand, practicality in the kitchen cupboard—these are Franck's themes. Art glass (though he often dabbles delightedly and rewardingly in it) he leaves largely to Nuutajärvi's imaginative young genius, Oiva Toikka, who excels at the fantastic and free form, the undisciplined in art glass, the wildly original.

Even in his designs for everyday ware, Toikka throws the past aside and creates such fairyland forms as "Flora," with stylized flowers molded in relief as an integral part of the design itself. "Flora" refracts light from its raised floral decor on thin glass blown in hand-carved molds. It is made in stemmed and goblet form and in bowls and pitchers, in clear glass or blue, violet, amethyst, or dark gray.

Another of Toikka's popular designs is a hobnail glass plate called "Kastehelmi" (Dewdrop), made in clear, blue, or green pressed glass. Like most of his tableware designs, there is versatility of use. Toikka is equally inclined to design abstract art forms in crystal. He is considered one of the most interesting young talents of the new generation in glass design and innovation, along with Timo Sarpaneva, and Bertil Vallien of Sweden. Ulf Hård af Segerstad, in *Svenska Dagbladet* (February 12, 1967) considered Toikka "a future, self-evident addition to the galaxy of international Finnish stars. Some anxiety," he continued, "has been expressed about the future of industrial art. The Toikka-Vallien duo [which had an exhibit of their sculptural works at Stockholm's NK store at the time] is evidence that the future has already arrived. New York next for these two men."

Toikka went from the Institute of Industrial Art in Helsinki to Arabia in 1956 as a ceramist. In 1959 he left for four years to teach school in Lapland, but returned to creative arts in 1963, designing household and art glass at Nuutajärvi. He loves to experiment, employing clear glass,

a
Tumbler by artistic but practical Kaj
Franck for Nuutajärvi. The thinned top
edge gives pleasure to drinking; the
shape of the bottom is for comfortable
holding. [Photo: Pietinen]

b
A charming and award-winning art
piece by Kaj Franck. Named "Wood-
cock," it is executed in a delicate
smoky tone, has tiny metallic particles
fused within the crystal. [Nuutajärvi.
Photo: Pietinen]

c
Glass plate "Dewdrop" ("Kastehelmi")
by Oiva Toikka for Nuutajärvi is repre-
sentative of the new romantic influence
returning to design. Toikka has also
designed the "Flora" line beverage
service, with stylized flowers and plants
in relief. He often uses gold or platinum
particles fused in the glass

a

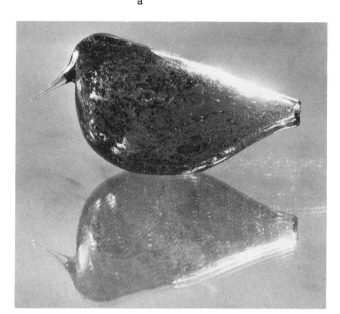

b

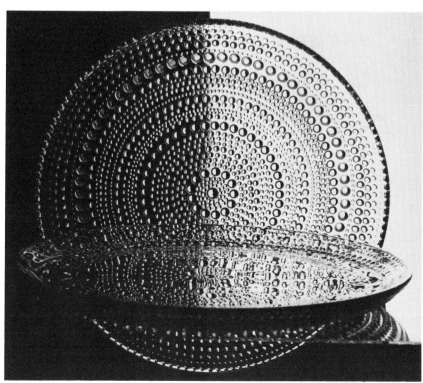

c

a
Spun-glass art piece in crystal by Kaj
Franck, made at Nuutajärvi. It is named
"Kehra"
b
Stackable tumblers from Nuutajärvi,
made in different sizes and in the most
subtle and naturally lovely colors . . .
ruby red, violet blue, smoke, olive, and
clear. By Saara Hopea

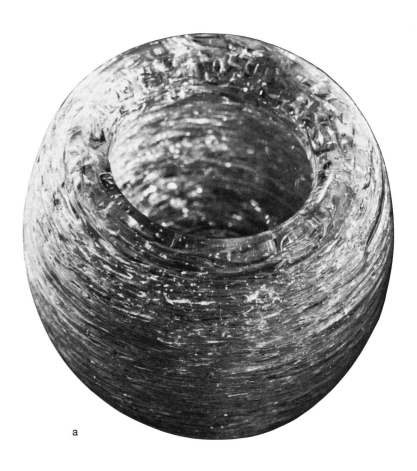

a

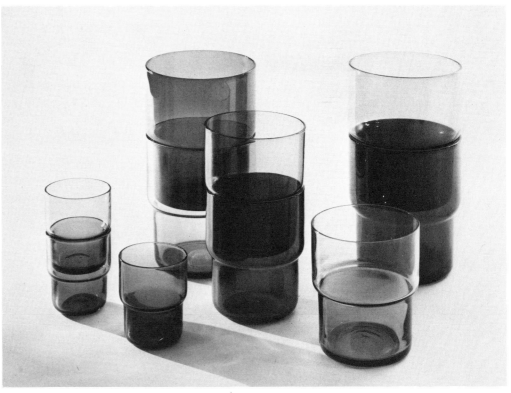

b

gold or platinum particles fused within glass, hot-joining for building shapes, and relief designs dominating enough to be considered part of the general shape.

Kaj Franck has been mentioned earlier for his vast accomplishments in ceramics, but his works in glass are also famous. As in ceramics, his designs are for the most part beautiful forms on the conservative side and carefully conceived from the standpoint of usefulness (simple practical forms), charm (soda-glass bubbles in soft shades of bottle green or amber brown), and intimacy with the nature of glass in its molten state. At times he lets his imaginative instincts take over and designs amusing objects, such as his bird with metallic flecks, his bowl with spun-glass effect, or large serving plates of several pretty colors in combination. Some of his works are interesting for their colors and some for their shapes, and he has designed everything from birds to simple stacking tumblers to smoky "soap bubble" vases. In each case he demonstrates his remarkable sense of value in regard to simplicity, line, and shape. He has won the Lunning Prize, many medals at the Triennale, including the Diplome d'honneur, the Grand Prix, and the Compasso d'Oro '57. He is represented in many museums, including the Museum of Modern Art in New York.

Franck's crusade has been to incorporate artistic standards in products for industrial manufacture, and he has accomplished this with unusual imagination and rationalization. He is deeply motivated and has a strong sense of responsibility to his profession and to the consumer, to his country and to the young students he teaches. The results of his experimentation are both charming and practical, but never so extreme that they become dated or tiresome with passing time and daily use.

A former colleague of Franck's at Nuutajärvi was Saara Hopea, who designed much useful glassware with stackable shapes. They are still made by the firm, although the artist has married and moved to the United States. Her everyday glass tumblers are delicate and simple in form, and blown in beautiful colors, such as a deep midnight blue like the winter sky. She has done some artistic hourglass designs for long-stemmed wineglasses. Miss Hopea is also an artist in silver, and she is doing some free-lance work in this field in America. She won a silver medal at the Triennale in 1957.

The Karhula-Iittala Glassworks, founded in 1881, has two glass factories, one for machine production at Karhula and one for hand production at Iittala. Like Nuutajärvi, Iittala employs and works with some of Finland's greatest designers, the most famous being Tapio Wirkkala and Timo Sarpaneva, both of whom design everyday glass and outstanding art pieces. When Alvar Aalto designs something in glass, it is made at Iittala.

A versatile artist, Sarpaneva—who had his career beginnings as a graphic artist—has designed door handles, textiles, cast-iron pots, rugs, paper products, candles, and men's fashions, as well as the glass and crystal objects which have made him world-famous. Possessor of dozens of awards from the Milan Triennales, the Lunning Prize, the Eurostar award, Young Scandinavians-U.S.A. award, he is also an honorary member of the Royal Society of Arts in London; he is represented in many museums and great collections of the world. His ideas seem inexhaustible and his works show flair and brilliant inventiveness, impeccable taste and masterful technique. Exhibit design is another of his specialties, and he is color consultant for various firms. His "Ambiente" textiles and papers are made from an entirely new system of printing, invented and developed by him. His work is always perfection and the result of inspiration, originality, and studied development.

It was Sarpaneva who, in 1967, developed an entirely new way of handling glass to be formed in molds. He began with the mold charred by the hot glass mass and normally discarded at this point. Nature had created here fascinating and intricate imprints of its own on the wood, and the artist longed to use and amplify this natural effect. He carved by hand into this charred material, turning out glass forms with an entirely new effect, each different, according to nature's own patterns in the wood. The results were pebbly, curvy, veined, and alive with new reflections of light. Timo made sculptures, then vases, then magnificent drinking glasses and candlesticks for Iittala (called "Festivo" in Europe, "Senator" in the United States) with this technique. The vases and sculptures are in museums or owned by collectors, although commercial versions of the vases have been made and are available. Since this revolutionary new approach was developed by Sarpaneva, many others have experimented with a similar technique as a starting point.

Sarpaneva has traveled much, and does considerable lecturing and teaching. He believes that imitation is deadly and that the wide acceptance accorded Finnish design is based on its originality, simplicity, and lack of sophistication, like a child of nature. He points out the remarkable fact that Finnish design has had its warmest reception in the countries of old culture, such as Italy, though it shows no traces of foreign currents or old traditions.

Of all his many interests, Timo Sarpaneva's greatest love seems to be his feeling for the deep secrets of glass, which inspires him perhaps more than other raw materials. It is important to touch and hold all objects made by Sarpaneva. There is nothing he creates that does not involve the fringe benefit of feeling marvelous in the hand. He is one of the most sensitive artists in this regard.

Wirkkala and Sarpaneva, as glass designers friendly rivals for pride of place in Finland, show in many respects kindred temperaments, although their styles are miles apart. They both represent the refined style that has raised Finnish industrial art to its present high level. The creations of these artists, characterized by a daring and original play of line, surface, and form, executed in an unfettered, modern spirit, have met with favor throughout Europe and America. They are also akin in their great versatility.

Wirkkala, too, has achieved recognition as a graphic artist and a designer of exhibits, silverware, dishes, and objects in airplane plywood. In glass he has shown great versatility, having mastered many techniques in this material, such as his "Chanterelle" vases of paper-thin glass, massive crystal forms such as the "Iceberg" vase, and other shapes in opaque blown glass, engraved clear crystal, brutal solid forms, and delicate, graceful pieces. Wirkkala's art is powerful and dynamic. He has

1

Shown here is a group of Timo Sarpaneva's sculptural forms in crystal. (1) This vase began with a mold already charred by molten glass, after which it was hand-carved by the artist to create the effect shown (2) Light from within and from without are factors offering endless challenge to artists like Sarpaneva working with this magical raw material. These vases, each from a hand-carved mold by Sarpaneva, are in clear and smoky crystal. One of the collection is now in the National Museum, Stockholm, and one of the sculptures is in the Victoria and Albert Museum. Several more are owned by European private collectors and galleries (3) Vase, height 2', in smoky crystal (4) Close-up view into two of Sarpaneva's handmade vases helps to show that they are equally interesting to sight and touch on the inside, and always true to the nature of the raw material. [Photos: Pietinen and Ornamo]

2

3

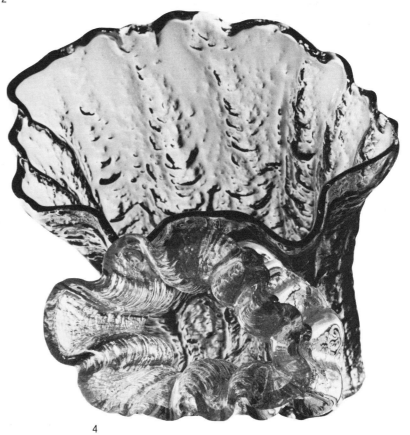

4

Left to right: (1) Timo Sarpaneva's
contender to prove that small things
can be beautiful. This little piece,
graceful to see and a sensory delight
to hold in the hand, shades from deep
forest-pine green to clear (2) A sensi-
tively designed small piece by Helena
Tynell, Riihimäki (3) A frosty free-form
bowl by Tapio Wirkkala. The finish—a
method considered a professional trade
secret—both looks and feels like white
velvet. [Photo: Kjell Munch, Oslo]

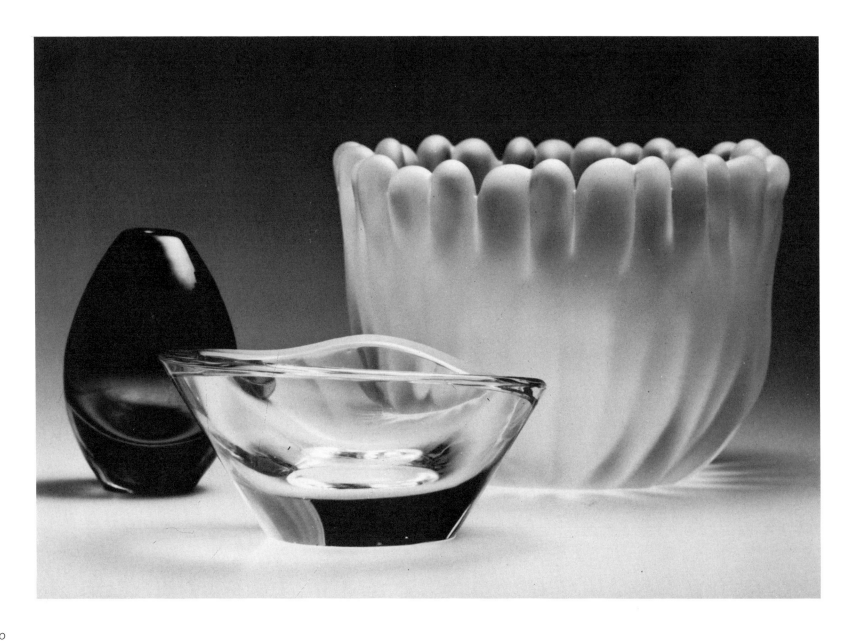

Three of Wirkkala's more delicate pieces, demonstrating the wide range of his talents and techniques (Per G. Thømte collection). [Photo: Kjell Munch, Oslo]

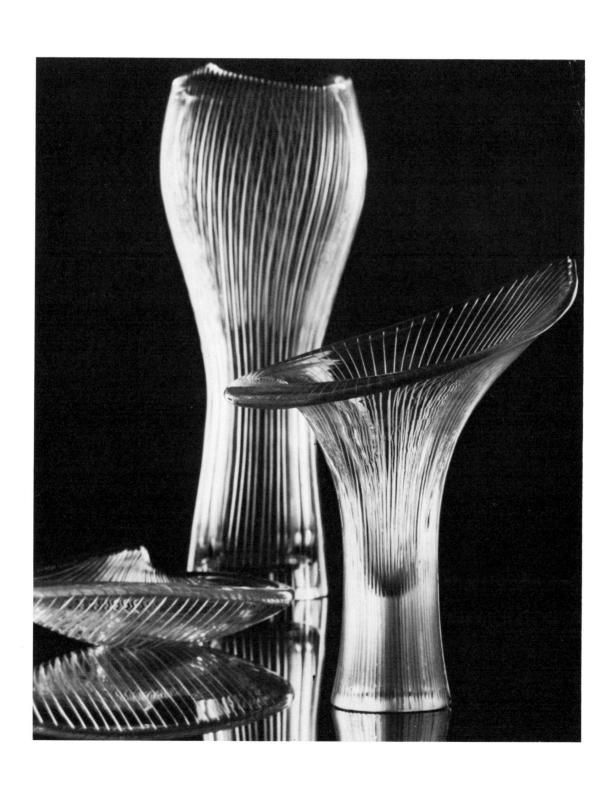

designed crystal vases which seem to be an explosion immobilized. In sharp contrast, he has done small-sized pieces, with peaceful simplicity of line, their gentle shapes gathering light and mirroring it in scintillating play.

Tapio Wirkkala was born in 1915, and has been associated with Iittala since 1947. He undoubtedly is one of the most prominent figures in the field of arts and crafts and industrial design in Finland today. He is dark-haired and swarthy, an inveterate pipe smoker, and presents a calm, thoughtful manner, soft-spoken and composed. He has a profound insight into many materials, and unrestrained thinking as to what can be done with them. Wirkkala's imagination serves him equally well in designing a free art form in plywood or plastic, a set of table glassware which is not easily tipped over, or the very best Finnish *puukko* knife ever designed. He has won many Triennale awards, the Lunning Prize, and has worked with the Raymond Loewy design firm in New York. Presently he designs for the Rosenthal Studio in porcelain and glass. His work for Rosenthal seems restrained, and yet the powerful elements of his dramatic style are apparent. In his "Polaris" candlesticks of cut crystal and his "Porcelaine noire" tea service can be seen his love for convex and concave curves set against one another, strong and graceful, just as is seen in his designs for Iittala. There is seldom anything dainty in this man's designs.

Wirkkala created the fabulous laminated wall of wood at Expo '67 in Montreal. He has also designed bank notes. He has won prizes in silver competition at the New York Museum of Contemporary Crafts, is represented in the Museum of Modern Art and the Metropolitan in New York, the Victoria and Albert Museum in London, and many others. He has had a traveling personal exhibit in the United States arranged by the Smithsonian Institution. Recently Wirkkala designed new glasses for Finnair's inflight libations on their newly instituted New York–Helsinki route. Because they have beaded texture, they do not frost up and "sweat." Like so many of his table glasses, they are squat, masculine, and secure enough for sea- and skyworthy stability.

While Tapio Wirkkala demonstrates a force fired by powerful intuition and then developed technically, his colleague Timo Sarpaneva approaches much of his creative work first with brilliant intellectual approaches, studying the technical possibilities and processing, which in turn inspire him to some new effect to be extracted from a specific material. The nature and processing of glass, studied by him right at the glasshouse fire, inspires in him a new idea, and thereafter these two factors are worked over by him with feverish intensity until the whole results in an object of incomparable perfection. Wirkkala at times works this way, too. I have seen him sit in his atelier, his pipe tucked under his bushy mustache, contemplating for long periods of time three blocks of plastic, one a cube, one an oblong, and one a cone, waiting for some idea to dawn in regard to the possibilities of this material.

Sarpaneva is scrupulous about how his designs *feel.* As mentioned earlier, the things he makes should be held and touched. There is nothing of his that does not fit well in the hand or give a pleasant sensation when touched, all the way from his crystal sculptures right down to the most unprepossessing drinking glass. In mass-produced items, one may find 1 percent less than the perfection he demands, but a Sarpaneva original will always be perfect in all respects or it is destroyed.

Also at Iittala is Göran Hongell, who concentrates largely on everyday glassware. His forms are fairly standard, but pure of line. For this reason he is not widely known, but his sound designs deserve praise, and he has inspired many other glass artists in his own quiet way. You might say that Wirkkala and Sarpaneva are the shiny gold and brilliant jewels of this firm and Göran Hongell the sterling silver.

Finland's largest glassworks is Riihimäen Lasi Oy, founded in 1910. For its art glass, Riihimäen commissions many top glass designers, including Nanny Still, Helena Tynell, and formerly Gunnel Nyman. This company has developed unique and jewel-like colors for glass, ranging from pale pinks, mauves, and greens to delicate yellows and lavenders.

Helena Tynell, who also designs lighting fixtures and pottery, is well known for the use of rainbow effects captured in mother-of-pearl crystal. Her heavy crystal bowls are chunky and artfully simple, often with bits of engraving. Her art glass for Riihimäen includes her recent spectacular "Polar" series of vases, with such motifs and names as "North Star," "Northern Lights," and "Midnight Sun," each group of shapes and colors communicating the artist's version of these polar wonders. The series includes also a "Lapp Hat"–shaped vase with a deep-blue inner layer and complex cuts that afford fascinating refractions. Helena Tynell has been with the firm since 1945. She is represented in the Corning Museum of Glass in the United States.

Nanny Still loves color in glass—either very deep or very pale, and no in betweens. She has achieved beautiful results as a designer of both decorative and utilitarian glass, as well as wooden objects. Nanny Still has searched for new methods for decorating glass, but mostly she has revived old ones. Her objects are simple and winsome, harmonious in shape, and suitable for everyday surroundings. She studied at Finland's Central School of Arts and Crafts, 1945–50, and has had study trips to Italy, Switzerland, England, France, and other Scandinavian countries. Her designs are almost invariably feminine in appeal and full of personality.

One last person to mention from Finland is Yki Nummi, a prominent designer of light fittings in glass (and plastic). His lampshades are represented in New York's Museum of Modern Art and he has won several gold medals at the Triennale. He trained in decorative painting and has worked in all handicrafts except ceramics. He has also designed interiors for public and industrial buildings including many in the garden city of Tapiola. Nummi uses white opaline glass or Perspex, aluminum shades with enamel, and newly developed plastics in his handsome lighting fixtures.

Norway

For those who just aren't the fragile type, Norway's vibrant glass is certain to have special appeal. It has a friendly warmth, a virile and

a

A recent beverage service designed
by Tapio Wirkkala. Called "Icebreaker,"
it is a typical expression of his feeling
that beverage ware should sit firmly,
not be easily tipped over. Made by
Iittala. [Photo: Kjell Munch, Oslo]

b

This heavy ashtray or shallow flower
bowl demonstrates Wirkkala's under-
standing and feel for his material.
[Photo: Kjell Munch, Oslo]

c

Small, squat, and square—a delightful
bit of engraving on a firmly contoured
vase by Helena Tynell, Riihimäen Lasi,
Finland. [Photo: Kjell Munch, Oslo]

d

"Saturn" vases made by Riihimäen. The
designer, Nanny Still, devised for these
vases two exquisite new glass colors,
one a soft golden yellow, the other a
delicate shade of violet. Nanny Still
has designed a vase which carries its
color and proportion exceedingly well
in both the small (about 2″ high) and
larger (about 6″ high) versions.
[Courtesy Riihimäen and Finnish
Foreign Trade Assn. Photo: Pietinen]

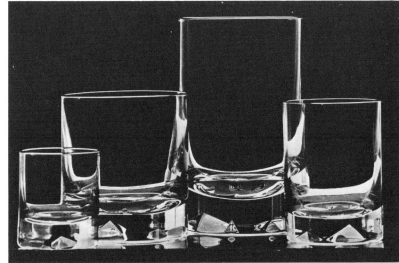

a

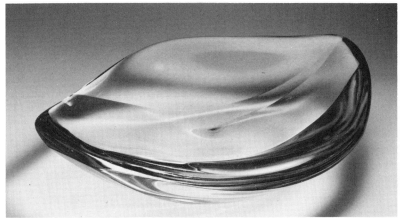

b

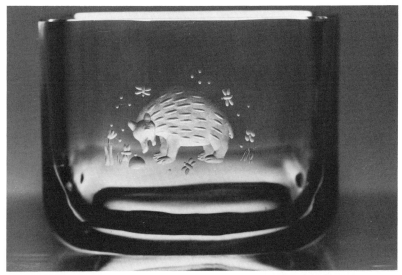

c

d

Masterful engraving has a history in
Norway as old as its first glassworks
at Nøstetangen, but the trend for some
years has been toward unadorned
pieces of pure form and prismatic
effect. To show what its two master
engravers, Thorbjørn Gustavsen and
Einar Andersen, could do today, art-
and tradition-conscious Hadeland set
them to work full-time on a museum-
oriented covered crystal bowl designed
by Ørnulf Ranheimseter. It represents
months of painstaking, punctilious,
skilled work. The "Slaraffenland" bowl
illustrates an old fable about a child
who eats through a wall of sweets
surrounding this magic land of plenty,
with pretzel trees, soda and wine
fountains, bushes laden with jewels and
luxurious garments. Owned by the Berg
family, it is kept in the Hadeland
private collection, along with the
Nøstetangen design book. [Photo:
Kjell Munch, Oslo]

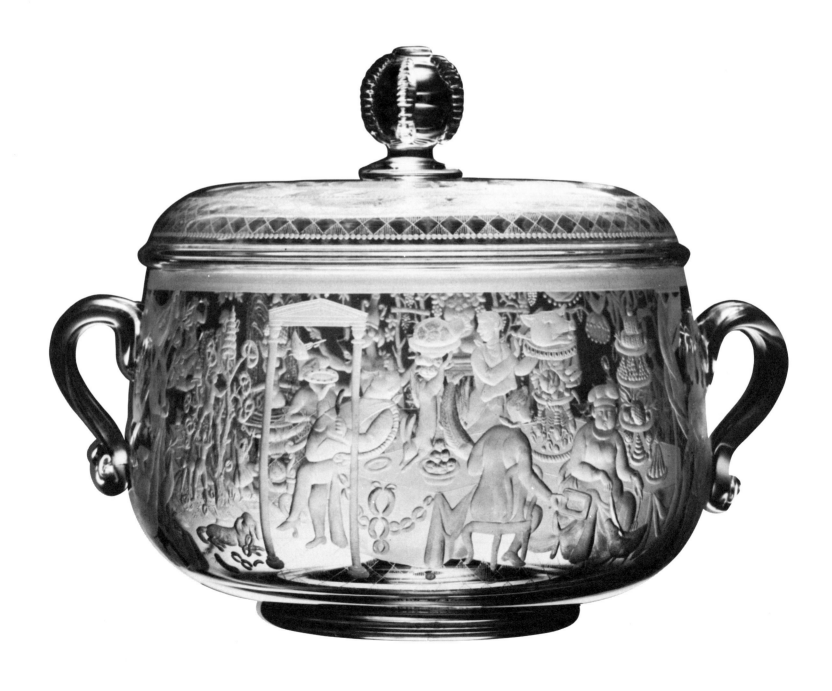

a
"Jarlsberg." Two crystal vases and a bowl of great distinction and breathtaking beauty. [Hadeland]

b
"Lilje" vase, engraved with Oseberg Viking ship. [Hadeland]

c
The range of design at Hadeland has its roots in the 1763 design catalogue of Nøstetangen Glassworks. In this picture one sees the faithfulness with which the firm has reproduced a design from the old Nøstetangen book, and how suitable this design is for today's living. It is called "Tangen" (renamed "Christina" for U.S. import) and is made in clear or antique gray. Alongside: Reproduction in full lead crystal of a similar design from the 212-year-old Nøstetangen book: "Rex," with a circlet of bubbles in the base of the bowl and teardrops in the stem. [Photo: Kjell Munch, Oslo]

a

c

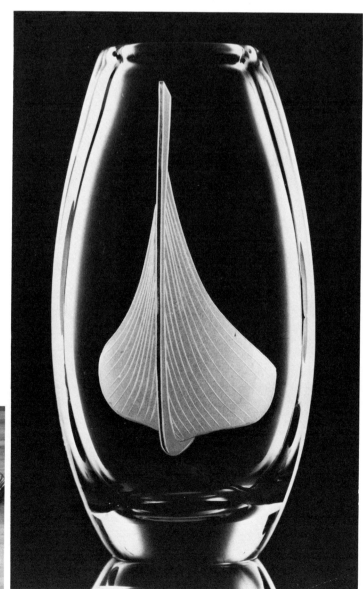

b

amiable gusto all its own. More than the glass of other Scandinavian countries, Norwegian glassware bespeaks a Viking heritage. Norway is famous for its water-clear, brilliant, full lead crystal, and for its antique gray and royal-blue glass, incorporated into old pieces and advanced new designs.

The oldest Norwegian glassworks is Hadeland, founded more than two hundred years ago, a firm proudly careful to preserve and renew the traditional designs of Norway's past. Even Hadeland's continual sponsorship of experiment subtly reflects its desire to maintain a distinctly provincial Viking strength. Side by side with fresh contemporary forms, Hadeland conscientiously continues production of exact replicas of many historic patterns and timely adaptations of precious museum pieces from centuries past.

Comparatively new on the Norwegian art-glass scene is the Norwegian Glassworks, located at Magnor (called simply "Magnor" by most people). Magnor is near the Swedish border and for a while the firm was influenced by Swedish and Italian designs. Now, having hired some Norwegian designers, Magnor is finding its own niche in the marketplace, daily creating more Nordic-looking wares and adding new colors and ideas.

Though there were several glassworks in Norway after the early 1700's, only one of the old works made glass of truly high quality. This firm was Nøstetangen, in Drammen, founded in 1744. It was later moved to Hurdalen. In Norwegian museums are many good examples of Nøstetangen glass—chiefly crystal chandeliers and *pokaler,* majestic wine goblets often blown and engraved to commemorate great events or to be used as royal gifts. The original Nøstetangen design book is a yellowed document revered by its owners, Hadeland and the Berg family. From its now fragile pages of hand-drawn designs, Hadeland has carefully adapted several highly prized crystal patterns for the dinner table ("Rex," "Regina," "Christina") and magnificent goblets which the Norwegians still use as awards and gifts of state. These *pokaler* are as symbolic of Norway as anything can be.

Hadeland, founded in 1763, has been dominated by the Berg family; Jens W. Berg represents the sixth generation to direct this glassworks. Still with Hadeland are loyal craftsmen and technical experts whose forefathers have worked there generation after generation. Table glassware has been the major output, but for the past thirty years Hadeland has produced some of the most beautiful art-glass pieces, and contemporary crystal lighting fixtures from this company have earned an international reputation. Experiment in contemporary design is constant, the pioneer designer in this line having been Sverre Pettersen, who experimented with new forms even through the lean years of the Nazi Occupation during World War II, when articles of necessity were almost all that could be made.

Hadeland's production has followed a double path of proudly reproducing historic designs and encouraging their designers to bring out modern shapes and colors. The two goals have never conflicted and the firm has been highly successful. Hadeland has accomplished wonderful things in the way of lighting for public buildings, and in artistic

glass panels using sandblasting for the designs. The Berg-Hadeland principle has always been that design should be a natural effort in harmony with environment and not an exaggerated drive to create something novel or controversial.

Material and craftsmanship, too, must be as perfect as possible. The water clarity of Hadeland's glass is well known. The origins of this dazzling material are prosaic, yet represent far-flung beginnings. Silica sand comes from the Netherlands; lead oxide, soda, and limestone from Great Britain; borax from California; sodium nitrate from West Germany and Poland; potash and potassium nitrate from France; cryolite from Greenland. Nothing is too much trouble for Hadeland in order to get the best quality glass for their production. The International Association of Glass Manufacturers has never come to an agreement on a definition of "crystal" in regard to percentage of lead oxide, but at Hadeland it contains 30 percent, a significantly higher amount than is the case in many other factories. This is typical of the firm's deliberate opposition to the general trend toward mediocrity which follows industrial production, believing that machines alone cannot achieve, in this particular industry, what able craftsmen can do. The firm also believes in carrying on the traditional features of Scandinavian, and Norwegian, design and further exploiting them. One of the best of its reproductions is a 1763 design called "Tangen" (renamed "Christina" for United States export). The shape is flowing, simple, with a thick bottom to the bowl, wherein rests one great bubble to catch the light. The design is so basic that it is as modern as it is traditional.

After the war and Occupation, young designers followed the lead of Sverre Pettersen and artistic ornamental designs were once again produced. Willy Johanssen, whose father was one of the glassworks' most skilled craftsmen, proved to have technical knowledge and great artistic talent and he was appointed designer. His forms are simple and in harmony with the material, gracefully proportioned, and often very inventive. Johanssen won a Diplome d'honneur at Milan in 1954, and gold and silver medals at subsequent Triennales. Also, the AID award in 1968 and many scholarships have been awarded him. He was born in 1921 at Jevnaker and has been an employee since he was sixteen years old, except for study and training periods. He designs molded glass and costly blown-crystal pieces, and all his work—blown or pressed, tableware or art pieces—displays simplicity and perfect proportion. He has designed a colored-glass platter with deeper color toward the edge, which is ringed with a chaste white border. This particular design theme has become something of a trademark for him. His works are in many European museums.

Hermann Bongard is a good-looking Norwegian who designs elegant art glass for Hadeland. He has been awarded the Lunning Prize and gold medals at Milan. His works are held by several European museums and the Smithsonian Institution in Washington, D.C. Bongard's forms are conservative and meant for use, but he lets his imagination run free when it comes to purely decorative designs. He also designs for the faience manufacturer Figgjo and for Oslo Silverware, and freelances for book publishers. He designs textiles, too, and has done

a
Red wine set "Medoc," made in crystal
by Willy Johanssen for Hadeland.
[Photo: Kjell Munch, Oslo]
b
Attractive everyday bowls in steel gray
or azure blue glass by Willy Johanssen
for Hadeland. [Photo: Kjell Munch,
Oslo]

a

b

Crystal vases by Willy Johanssen,
Hadeland. Left, steel gray and olive
green with brown core, plain. Right,
steel gray with brown core, facet cut.
[Photo: Ørnelund, Oslo]

a
Crown goblet (*pokal*), "Gustav,"
designed by Hermann Bongard in full
lead crystal, inspired by old pokal
designs. [Hadeland. Photo: Kjell
Munch, Oslo]

b
Decanter "Kongsvold," antique gray
with nickel-plated stopper. Design:
Severin Brørby. [Hadeland. Photo:
Kjell Munch, Oslo]

c
Flower vases and bowls in antique gray
with bubble edge, by Severin Brørby for
Hadeland. Brørby has won many medals
and awards, and his works are repre-
sented in several museums in Norway
and at the Corning Museum of Glass
in New York. He has traveled and
studied in Canada and the United
States. [Photo: Kjell Munch, Oslo]

d
Serving plates and bowl with decora-
tion, designed by Gro Sommerfelt for
Hadeland, who also designs packag-
ing and textiles. [Hadeland. Photo:
Kjell Munch, Oslo]

a

b

c

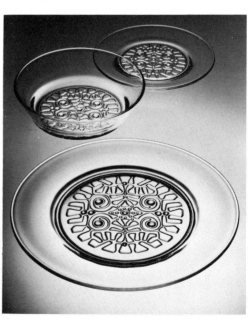

d

a
Bowl "Medoc" in crystal, designed by Willy Johanssen. The acid matte engraved decoration is light and ethereal, and a specialty of Gerd Boesen Slang, a Hadeland artist exceptionally gifted and especially trained in acid-etched and sandblown and engraved crystal design. [Photo: Kjell Munch, Oslo]

b
Sandblasted decoration designed by Gerd Boesen Slang for a square full-lead-crystal vase by Hadeland. [Photo: Kjell Munch, Oslo]

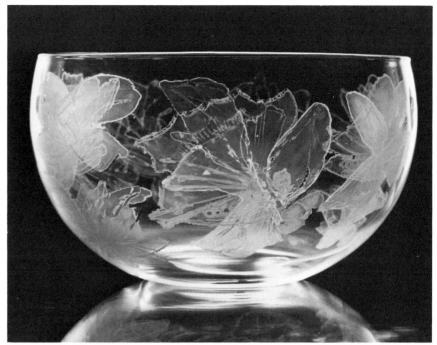

a

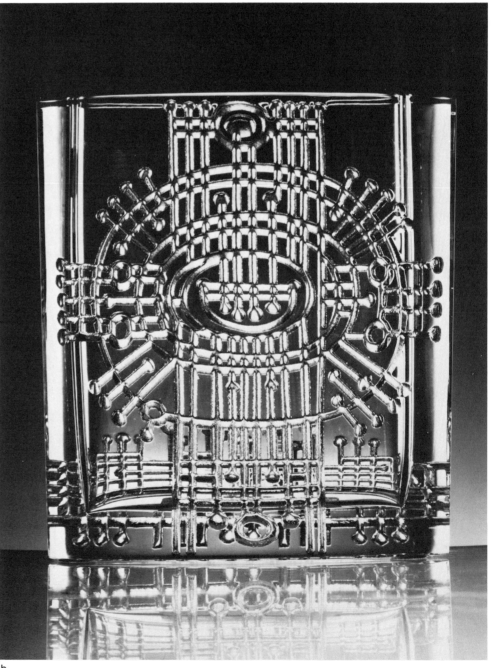

b

industrial design on large projects, including ship decoration and furnishings.

A most exciting designer with Hadeland is Arne Jon Jutrem. A painter and draftsman, he also creates fabrics, pewter, copper, ceramics, and industrial products such as appliances. His technical knowledge in all these areas is extensive. He has captured the Lunning Prize, gold medals at the Triennale, and is represented in several museums including the Corning Museum of Glass. Whereas in the past Norwegian glassworks kept to the best traditional designs, Jutrem injected a spirit of freedom. Some of his clear-glass pieces speckled with brown seem inspired by ancient glass, though presented in a new way. He came to Hadeland in 1950 from the State School of Crafts and Industrial Art. Improving household appliances occupies him these days, but let us hope this distinguished artist has not abandoned glass as a material.

Severin Brørby is one of the younger generation with Hadeland, and his pieces are highly individual. He has a wonderful color sense, mixing, for example, a smoky taupe with soft-green blobs for decoration, and layered geometric designs with brilliant green and deep cobalt in combination. Born in 1932, Brørby has been with Hadeland since 1948 and is a qualified engraver. He is represented in several museums including the Corning Museum of Glass.

Gro Sommerfelt and Gerd Boesen Slang also design for Hadeland, the latter specializing in designs for sandblowing, engraving of glass and crystal, and acid etching.

Benny Motzfeldt, who designs excellent vase forms for Hadeland, one day created a design for some small crystal ornamental birds, just for fun. Arnulf Bjorshol and Knut Sunde made up a little folktale to go with the "Icebirds." These turned out to be so popular with the tourist trade that Mrs. Motzfeldt designed some colleagues for the birds . . . the Crystalfish . . . and Sunde came up with another fairy tale. On and on it went, until each new creature became a collector's item; the collection in its entirety has been acquired for a museum. Now there are the following, available at Christiania Glasmagasinet, Hadeland's Oslo department store:

1. The Icebirds—captured by hunters in the icy northland and released on Midsummer Night

2. The Crystalfish—who help that big salmon get off your hook

3. The Space Hunters—three small men you can't see until your third day of walking through snow and ice, and then they disappear anyhow

4. The Eiderduck—who changed the sleeping habits of Norwegian fishermen's wives

5. The Ever-Happy Seal—an eternal optimist despite the weather where he lives

6. The Wise Penguins—who fail to understand man's urge to leave home

7. The Forgetful Troll—a magic creature who will help you forget something unpleasant if you look in his eyes and say "Frufloreliusensripsbusvekster" three times without stumbling

8. The Owl—who cannot be heard flying

9. The Shadow Dwarfs—who lived shapeless in the winter twilight until they visited Hadeland and found a permanent shape resistant to daylight

10. The Hare—about whom it is said, in part: "It's rare to be where you can look at a hare"

11. The Nice Mice—haughty aristocrats who hold their pointed noses snobbishly aloft.

The stories are given here, of course, only in brief.

Norsk Glassworks, Ltd., at Magnor, has some very good designers at its service. Arne Lindaas is one of them. He also designs fabrics, ceramics, and wood articles, and has complete familiarity with the material in each case. His glass forms are essentially simple, practical, and of excellent proportions. Axel Mørch also designs for this firm. He has been awarded a silver medal at the Triennale and is trained as a sculptor. Still in his early forties, this designer offers much promise in the field of glass art. He has been at Magnor since 1955. Another good designer at Magnor is Eystein Sandnes, also a silver-medal winner at the Triennale. He designs in ceramics also, his works produced by Stavangerflint and Porsgrund. Having now recovered from its setback during the Occupation of Norway in World War II, this young firm has made much progress, and with its fine young team of designers should now continue to show the market excellent products in glass.

Denmark

Denmark, in comparison with its Nordic neighbors, has never produced glass in any great quantity, since there were no great forested areas to provide fuel. Now that new fuels are available, the two Danish glass producers, Holmegaard and Kastrup, have joined forces to forge ahead in this field. Holmegaard has a two-hundred-year history behind it. It features good, simple designs demonstrating the natural forms that evolve from glass, and proves simplicity need not lead to monotony, standardization of design, or absence of aesthetic appeal.

Holmegaard is located in the southern part of the island of Zealand, where glassworks families have worked for over 150 years. The glass here is made from iron-rich sand imported from Holland, plus soda and red lead, which gives it weight, clarity, and ring, and a characteristic color. Per Lütken is the major designer. He has worked with glass for some twenty years, and characteristic of his work is his faithful adherence to soft, rounded, restrained contours echoing the glowing, curving flow of the glass in its viscous state. Lütken designs vases, decanters, pitchers, and table glassware, favoring smoky gray, green, and blue. He is also a painter and a draftsman, and has been at Holmegaard since 1942. His works have been bought by many museums worldwide, including the Corning Museum of Glass, and the Joslyn Art Museum of Omaha.

Lütken, like Willy Johanssen of Hadeland, likes to combine colors in the ancient glassmakers' technique of adding filaments of one or two other colors of glass to the blob of main color, after which these are

a

Benny Motzfeldt (a woman, wife of a Norwegian general) designed for Hadeland some candlelight and wine whimsy in the form of small crystal birds. Arnulf Bjorshol and Knut Sunde then created a little folktale about them, dubbing them "Icebirds." It turned out to be sales serendipity. In the wake of the Icebirds' success came shining "Crystalfish" with a folktale of their own. In hot pursuit came crystal penguins, a hare, the Shadow Dwarfs, an owl, the Ever-Happy Seal, the Eiderduck, the Space Hunters, and the Forgetful Troll. They have now become collector's items, and why not? Not only are they charming, but they are beautiful on the dinner table in candlelight

b

"Perle" glasses by Per Lütken for Kastrup-Holmegaard, Denmark. Designed in 1967. [Courtesy Den Permanente. Photo: Tue Lütken]

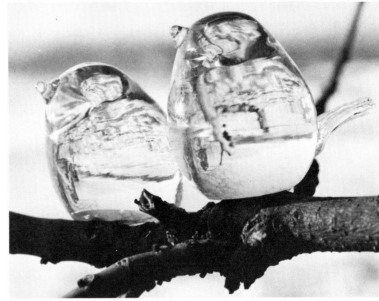

a

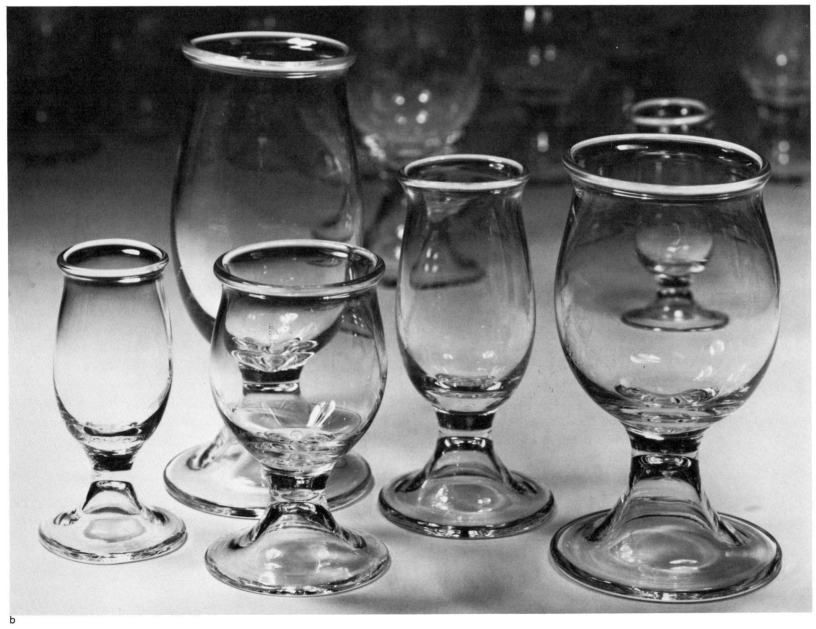

b

worked into each other before blowing the form in the wet wooden glass mold. The effect is one of casually undulating streaks of color that do not have the "painted on" effect of striping added later as a decoration.

Jens Quistgaard, another Danish glass designer, creates contemporary forms, but with a classical purity of line. He has designed an interesting series of flower vases with a scalloped or fluted side, not only attractive but an aid in arranging. As an example of inter-Nordic cooperation, these vases designed by a Dane were blown in Finland. The color of glass used was selected by the Finnish artist Ritva Puotila (a gifted artist in textiles and rya rugs, too), who used three different greens to be compatible with flower stems and a natural color companion to blossoms. Quistgaard also designs handsome stainless-steel flatware for Dansk Designs, Ltd., which Dansk has aptly called "tabletop sculpture."

At Kastrup, the outstanding designer is Jacob E. Bang, a practical and precise designer whose pieces are entirely in accordance with his feeling that things should be sound and sensible, pleasant and fairly uncomplicated. His tableware has simple, well-thought-out shapes. There is no superfluity or nonsense in Bang's designs, and he develops an idea by working it over and over until every detail is exactly right for the appearance and uses of the product. Jacob Bang is an architect, and also trained as a sculptor.

Also at Kastrup-Holmegaard are designers Grethe Meyer and Ibi Trier Mørch; both are women, architects, and industrial designers. Their glassware designs concentrate on space-saving, e.g., glasses which are stackable in two different ways (in either case no glass rests against the fragile wall of the glass below it). Grethe Meyer often works in co-operation with Børge Mogensen, too, in furniture design. (See Chapter IV).

Bjørn Wiinblad's works in the realm of glass extend only to designs (such as his "Lotus" for Rosenthal) that are decorational features applied to shapes created by other designers. He has, however, designed the shape for the "Tulipa" candlesticks in crystal for Rosenthal. They are tall, delicate, and have a liquid, flowing line in harmony with the glass material.

Kastrup has sponsored modern design contests, which brought forth good new models and inspired designers in other materials to take a new interest in glass. Danish glass should continue to make great progress in the future.

VI. TEXTILES

Man learned to weave as long ago as the Stone Age, according to the evidence of bits of flax and flax yarn found in the remains of ancient Swiss lake dwellings. Egyptians and Mesopotamians wove textiles as early as 4000 B.C. One cloth woven about 2500 B.C. has 540 warp threads to the inch, so developed was this art even then. (Today's fine percale sheeting seldom has more than 150 warp threads per inch.) Historians' facts are astounding, for one is more inclined to think of animal skins being used in pre-Egyptian times, rather than woven cloth. Invention of the spinning jenny and power loom in the late 1700's revolutionized textile-making methods, taking weaving out of the home for the first time; later factory weaving became dominant throughout most of the world.

In Scandinavia, however, hand-looming, embroidery, and weaving of all types have always been common and still are, for they remain an artistic pastime during long winter months for the many still living in comparative isolation. Norway, Sweden, and Finland . . . even Iceland . . . have preserved national textile traditions. Denmark, too, has a long history of picture-fabric weaving, though the craftsmen who produced great tapestries for castle walls, etc., were usually brought in from abroad, and Denmark, until about thirty years ago, still imported most of her cloth.

A strong color sense but, on the other hand, color restraint have always been characteristic of Scandinavian textiles. Three or four decades ago, designers and craftsmen, reacting against boredom with factory goods, and stimulated also by a new era in furniture-design development, turned eagerly to experimentation with simple hand weaving and a reversion to the natural colors of sheep's wool. More recently, there was a reaction toward the siren song of the color wheel, and the charm and drama of the Nordic color sensitivity appeared again in the textile arts. White tablecloths, for example, became almost extinct, except for the most formal dinner-table settings; linens of this type became colorful block or screen prints. Charming new damasks appeared in many variations of design and color. Table surfaces treated by modern methods to withstand spills offered the possibility of much wider use of handsome handwoven and/or block-printed mats, a real inspiration to artists and handicrafters.

There arose a movement to recruit new talent, and a fostering of hand-weaving artists in their individual ateliers and home studios. The gap between the hand loom and industrial production still existed for some time, but was finally bridged by bringing textile artists into cooperation with mills. The results were highly successful. The move was aided by architects and furniture designers of the time, who were desperate for upholstery fabrics more in harmony with their own advanced design. Today's textiles in the northern countries have quality, practicality, and an appealing freshness, and few of them ever seem to be run-of-the-mill products.

One of the reasons Scandinavia can be counted on for originality, top quality, and rich color in textile collections is the policy of producers, reflecting their awareness that they cannot base their exports on quantity but must let their textiles embody charm and a reflection of their countries' images . . . a uniqueness of artistic design combined with excellence, reflecting several hundred years of tradition and experience in handcraft weaving, spinning, and knitting accommodated to mechanical methods.

One can hardly find a single school, bank, hotel, church, or other public edifice in Scandinavia which does not display some exciting and unique example of the weaver's art. As only one example, those who appreciate textile accomplishment might visit the Munkegaard School, Gentofte, Copenhagen, to see the stage curtains made of coarse flax dyed pure red and interwoven with diamond shapes of intense yellow, orange, pink, red, and purple. In combination these give a glowing color effect to the overall composition. This masterwork was woven on a huge carpet loom by Kirsten and John Becker, from an original design by the renowned Danish architect Arne Jacobsen. Mammoth embroideries and tapestries are to be found everywhere, so wherever you go in these countries, take time to notice and examine the textiles, for they are invariably noteworthy.

As is presently happening almost everywhere, handcraftsmen in Scandinavia have a natural tendency to back off from the technical perfection inevitable in industrially produced goods. They have thus continued to re-explore the oldest techniques, combining them or adapting them to new interpretations. Primitive examples give them design inspiration, and such methods as tie-dying, dying by color-resistant areas, handblocking, and overprinting are still very appealing. Partly as a reaction against the machines, the multitudinous floral designs of the forties, and the overly geometric patterns of the fifties, and partly as a response to new room and wall shapes and large window and wall areas, today's textiles emphasize modified geometrics and abstracts which have restraint of patterning but amplify color schemes.

Scandinavian textile designers recognized that curtain fabrics must have a texture and color that admit a pleasing tone of light over the entire room when the sun shines through and that look exciting, too, when electric light is used on a gray day or night. Much practical research has been the forerunner of casement and drapery-fabric design. An important contribution in this field was made by the Swede, Tryggve Johansson, a color analyst who worked out a natural, sound, color system which enabled many designers and manufacturers to have a common base for their color ranges, including the makers of rugs, furniture, and other mass-produced items.

Drapery-fabric designs have yielded carefully thought-out casement types, with delicate, loosely spun threads that have tangled fibers to let just the right amount of filtered light into a room, in addition to affording the proper look from both inside and outside the house. Printed drapery fabrics are also planned for the special effects they assume from the natural folds of the fabric when hung or draped, the patterns having been devised not only for color effect but for pattern repeats without too much waste of material. Designers have been quick to realize that the large grouped window areas in contemporary houses need a softer, refracted light as a specific new element in home design.

Embroidery as an art form has retained an important place in

Scandinavian handicrafts, including the popular cross-stitch, white work, appliqué, and free stitchery. Appliqué and embroidery are often combined in wall hangings for three-dimensional effects. Embroidery techniques are used for wall hangings of many kinds, including works so great as to be classed with tapestries, often done as a textile "painting," worked out entirely freehand without preliminary sketches. Among the artists who excel in this field are Hannah Ryggen and Thorvald Moseid of Norway, and Edna Martin and Sten Kauppi of Sweden.

Table linens are a treasure trove of enchanting color combinations, and all five Scandinavian countries excel in this division of textile weaving. Table-setting contests are frequent, and one would hate to be a judge for them since every entry has so much appeal. It's been a long time since the white tablecloth was a must or even desired for any dinner, formal or informal, and it has long been apparent to people that dark-colored cloths, such as eggplant or deep olive, dramatize the tableware the way a dark velvet cushion sets off a brilliant gem. Bright colors, subtle grays combined with sunny yellow, show off dishes and crystal and are far more cheerful than many pastels.

Sweater knitting is still largely a "cottage industry," and a busy one. Firms and shops in the cities buy the wool at wholesale prices, ship it by train, bus, or sled to tiny hamlets and farmhouses to be knit into beautiful sweaters, then ship it back to town as finished goods. Some knitters use a small hand-operated knitting machine for sections of the sweater, but it is still essentially knit and assembled by hand. Thousands of women knit at home, providing an excellent home industry for non-city dwellers in need of added income.

Stoles, shawls, and car robes (also called throws, plaids, or knee rugs) offer an unbelievable profusion of color in the softest, fluffiest, and lightest of wools. Norway excels in this field, as does Finland, where the magnificent colors suggest legends of blue-shadowed fells and aquamarine lakes, or the autumn fireworks of northland sunsets. The fluffy throws can be used as blankets, as a splash of color for interior decoration, or as "every woman's mink cape," as one producer puts it.

Norway

Examples of Norwegian woven cloth have been found dating back to the fifth century A.D., and Viking burial finds have yielded pieces of everyday fabric and woven tapestries. Old Norwegian tapestries housed in museums reveal a difference from those of other countries because, except for a few examples, they have flat, linear designs and unnaturalistic colors. They are not imitations of paintings. To brighten the dark interiors of Norwegian churches and great houses, brilliant colors made from vegetable dyes were used, with blue and red the favorites. The brightness of these colors after hundreds of years is quite amazing. Fine examples can be seen at Kunstindustrimuseet in Oslo. One rarity in their collection is the Baldishol Teppe from a *stave* church of the twelfth century. The figures of April and May remain of the original whole, which included all the months. Bright-colored, flat figures of men and horses blend into the background as a part of the entire decorative design, rather than entities meant to be noticed specifically. There are birds standing on their heads, and whether this was planned or accidental, they add a naïveté to this fine tapestry.

Weaving declined after the twelfth century, through the Black Plague period, and until the sixteenth century, when a broader loom and a wider variety of colors and materials became available. The seventeenth-century baroque period yielded rich tapestries for homes and churches (the same trend occurred in Sweden). The weaving was done largely in the affluent areas of southeastern Norway and the valley of Gudbrandsdal. Local interpretation and humor can be noted in "The Wedding at Cana" with the biblical bride dressed in the local valley costume, or Salomé holding John the Baptist's head but doing a Norwegian folk dance with a partner. The figures each demonstrate a specific personality, and though the conceptions are somewhat primitive, the scenes are quite clearly dramatic.

After this period, the weavings became more stylized and geometric, nearly abstract. Again the quality and quantity of weaving declined, until the nineteenth century. The craft was never entirely discontinued, however, and today's tapestries and weavings still build largely on traditions of weaving and do not often try to imitate other art forms.

An exception to this is Hannah Ryggen, who is in a class by herself in Norwegian tapestry-making. She considers herself (quite rightly so) a "fine" rather than an "applied" artist, and her works are indeed like paintings. Her motif is usually political, full of powerful significance, and excitingly done in regard to color effects. She weaves her great works right on the loom, without sketches, as an artist approaches a canvas, palette and brush in hand . . . a rare accomplishment when the canvas is a loom, the palette a range of colored yarns.

Painters sometimes work closely with textile artists, weavers, and needleworkers to produce tapestries or embroidered wall hangings. Else Halling is one of the most famous tapestry weavers. Her style is pictorial. She and her assistants at Norwegian Tapestries, Ltd., have created many huge works for public buildings, the largest covering about thirty square yards. One of her most famous projects can be seen in the Oslo Town Hall, woven in 1948 from a design by the artist Kåre M. Jonsborg. It depicts a village scene of daily life, in harmony with the other works of art in this amazing building on the theme of labor and industry in Norway. Else Halling uses hand-spun outer wool from "Old Norwegian" sheep, giving a sheen and rich gleaming effect to the finished tapestry.

Annelise Knudtzon is another Norwegian weaver who works from sketches, by the artist Knut Rumohr, and in weaving them into rugs or wall hangings uses special techniques to add a unique textile value to the artist's concepts. She also lends her talents to the weaving of curtain and furniture fabrics produced by Røros Tweed. This firm specializes in Norwegian wool, and Miss Knudtzon, as one of their designers, has realized that woolen curtaining materials for today must be different from the heavy hangings once popular in overstuffed drawing rooms. Her textiles are delicate wool near-transparencies, woven

Textile printing is depicted here as it is done at Sandvika Veveri, in Haslum, Norway. Textiles must be printed with extreme care, for it is done on sections of fabric many yards long, and an error in the design or the equipment will multiply itself and become disastrous as production proceeds. A design is first created on the artist's drawing board, then is broken down into separate screen patterns for each color. The stencil (1), being examined here by Øivind Grimnes, manager of Sandvika, is made of pure silk or nylon gauze stretched onto a frame of wood. The most common technique is to draw the design onto the silk with lacquer or chalk. The rest of the screen is left plain, and the whole thing is coated with varnish. Where the design was drawn, the varnish does not penetrate. The lacquer or chalk is then removed, and the pattern appears as openings in the coating of varnish. (2) The fabric is unrolled over a long printing table, the top of which is layered with felt, covered with waxed rubber sheeting. (3) Two metal rails guide a trolley, which carries the stencil, with stop blocks to assure that the movement is accurate as the stencil is advanced along the length of fabric coming from the bolt. (4) Back and forth along the stencil rolls a "doctor" with two long handles for the printer, or the doctor is hand-operated, as shown here. This applies the color, the exact amount of dye flow being carefully regulated.

1

2

3

Prints are then dried and made color-fast by heat or steam. Then follows a neutralization processing, treatment with chemicals, rinsing, boiling, and washing, then a drying. A tenter frame is used to treat drip-dry or no-iron fabrics and finally the product is graded as to body, softness, etc. Shrinkage control is next, done with humidity processing, controlled by electronics at this factory.

(5) Tucked away in tiny Haslum, this progressive firm surprisingly enough uses an automated system for storage of patterns. Where before it was necessary to store numbers of large framed stencils or make all new ones each time the pattern was to be produced again—which created storage problems and expense—the stencils are now recorded on small cards by computer and filed. The frames are then returned to use for the next new design. The file card, inserted into the automated machinery later, instantly turns out new stencils whenever needed.

(6) Some finished fabrics from Sand-vika Veveri—personally designed, semi-handprinted, colorfast, pre-shrunk, and usually processed for no ironing. [Picture 4 courtesy Svenska Slöjdföreningen. All others Sandvika]

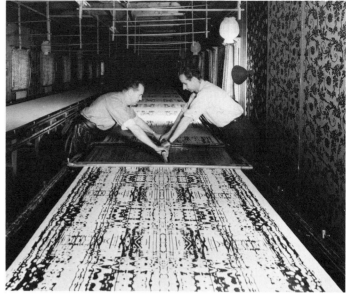

4

5

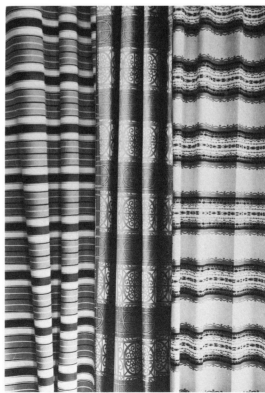

6

lightly into stripes and checks, in lively colors wonderful against the light and casting a cool or warm glow upon a room, as needed. Woolen furnishing fabrics in Norway are well adapted to the Scandinavian way of living and building: the warm colors and strong textures complement the timber, brick, and pine paneling used in abundance. On the other hand, if one is a collector of antiques and faced with reupholstering a fine old Biedermeier sofa, it is at Røros that one finds such a rarity as a wool-and-rayon-blend upholstery fabric that has a shiny horsehair effect. There one can also find appropriate fabrics for rococo or Regency antiques, for which most contemporary weaves are inappropriate. Because so many of the great old estates in Norway are filled with eighteenth-century pieces (acquired at the time when most local furniture was imported), there is still a demand for these textiles, and Røros still produces them, right along with the most modern types of furnishing fabrics.

Outstanding in the field of printed cottons and synthetics is Sandvika Veveri. The factory nestles in Haslum, a tiny suburban town near Oslo in an atmosphere where one would never expect to find such a modernized mill with the latest methods for processing and automated punch-card filing systems for patterns to be reproduced later. Sandvika manufactures charming cotton prints from the excellent designs of Jorunn Jo and Gunnvor Sture. The themes, whether folk design or abstract florals, take their inspiration from Norwegian tradition, and the quality of the output in regard to wear, washability, colorfastness, and shrinkage is of the best.

A fine talent of the younger generation in Norsk textiles is Grete Lein, who is especially interested in ecclesiastical works. Fanny Mørch and Eli Marie Johnsen have also shown outstanding talent for, among other things, embroidery reviving the old traditions in this art but embodying them in modern expressive forms.

Sigrun Berg, who has had her own looms since 1947, works in woolens in collaboration with industry, but also makes colorful rya rugs, tapestries, and carpets using old techniques. She is well known for her gigantic accomplishment in weaving ten huge ryas for the Bodø Cathedral and a magnificent decorative woven-fabric hanging for Haakon's Hall in Bergen. She has been awarded a Diplome d'honneur and a gold medal at the Milan Triennale (1954 and 1960), for her woolen fabrics.

Another handcraft textile form especially popular in Norway is called "smettevev," a combination of weaving and hand stitching. It is taught by Ragnhild Tretteberg and Eli Marie Johnsen at the State Industrial School for Women. Dora Jung of Finland has also used a similar technique occasionally in wall hangings of coarse damask weave with color-inlay stitching.

Weavers in Norway are so numerous it is impossible to name them all, though they all deserve mention. The craft is constantly encouraged in such as the State Industrial School for Women and the State School of Crafts and Industrial Art. The Association for Norwegian Home Arts and Crafts (popularly known as "Husfliden"), with shops in Oslo and Bergen, serves as a sponsor and marketing agent for most of the arts and crafts made in outlying homes and home workshops, including a heavy emphasis on textiles of a traditional nature. This is a nonprofit organization existing to encourage handwork by individual craftsmen and preserving the old traditions in a nation where cottage crafts are still an important business.

The Norwegian provincial costumes deserve a book of their own, but here it should at least be mentioned that each parish, valley, or district developed its own festive apparel, exquisitely embroidered and uniquely fashioned. Similarly, the knitted sweater patterns traditionally represent a specific area of Norway where the design long ago originated.

Two million Norwegian sheep graze in the mountain coolness all summer and produce a wool that is strong, lustrous, and deserving of the strict supervision under which wool is processed and woven. It is suitable for rugs and all kinds of furnishing fabrics and, of course, for sweaters, which are sought after around the world. Since all five Nordic countries knit similar sweaters, and all are high quality and attractive, it is then the highest compliment to say that in this specialty there is no question that Norway excels.

The best Norwegian textile products have a character of their own, original forms and colors, and imaginative designs. Textiles for the home, especially, have a warmth and friendliness typical of the home-loving attitude in Norway, which is often called "the country where they know how to keep warm."

Denmark

Only thirty years ago Denmark was a textile *importing* country; now, Danish fabrics are in use in South Africa, Kenya, Argentina, Ecuador, Malaysia, all of Europe, and the United States. Alfred Lund, known as the father of Denmark's textile industry, was the man who first reasoned that since other Danish handicrafts were admired and sold elsewhere, textiles, too, would enjoy export business if produced with the usual Danish quality and imagination. Today textile exports from Denmark represent a $40 million business annually, and although the Danes are not able to turn out low-priced, massively produced fabrics, they do very well marketing high-quality textiles of unique and charming character.

Today's textiles from Denmark seem unrelated to earlier creations. They include handwoven utility fabrics, special themes in interior decorating goods created for architects and furniture designers who incorporate them with their designs, and other types produced from artists' sketches to achieve an entirely specialized textile expression.

In the fifties, along with the developments in furniture and the interest in increasing exports, textile producers became interested in applying Danish design to industrially made fabrics, and began to associate with Danish artists. These artists turned to more daring color and to new weaving techniques, using coarse-spun wools, freely related stripes, and more free-form color design. Unique fabric prints, over-

prints, and even direct brush painting were introduced, crossing over sometimes into the fine arts. Ruth Hull and Ruth Christensen, for example, both used painting in combination with traditional printing. Tusta Wefring employed painting as her sole technique. Paula Trock experimented with rough-spun wools in curtain fabrics, and Franka Rasmussen made tapestries that incorporated new weaving techniques with varistructured yarns. Rolf Middelboe adapted overprint designs to mass production with great success.

Lis Ahlmann is a weaver whose "Cotil" collection for C. Olesen, Ltd. has become the pillar for the Danish textile industry. This collection, developed first in the fifties, has artistic merit and fine technical quality. Lis Ahlmann displays a sensitive understanding of the yarns with which she chooses to weave. Her plaids are strong but employ calm and complimentary colors . . . for example, her combination of natural-colored wool from Faroese sheep and a muted dark blue. Her feeling for her material comes from the fact that she personally completes the entire job, from sorting the sack of wool to carding, spinning, and weaving. Working with architect Børge Mogensen, she has designed textiles in nature-related colors in harmony with the natural wood tones of the furniture to be upholstered.

Lis Ahlmann earlier collaborated with furniture designer Kaare Klint and was as devoted as he to tradition and folk culture, exploiting the qualities of her yarn with simple and traditional weaving, and favoring wool in natural colors—black, white, gray, and brown. Later, working with Børge Mogensen, she learned to adapt her weaving to massive machinery, enriched her colors and contrasts, and enlarged her patterns. With a long professional life already behind her, Lis Ahlmann gave a new forward thrust to Danish textiles, and the "Cotil" fabric collection continues to represent the best of Danish production each year, in keeping with the sound beginning she gave it.

Another of the first Danish firms to seek artistic improvement in textile products was Unika-Vaev, which collaborated with abstract painter Gunnar Aagaard Andersen. So remarkable was this artist's clear color range that his initial line still forms a basis for all the firm's furnishing cloth. Unika-Vaev was also the first Danish firm to accept chemical fibers as replacements for known organic fibers. They have brought out the aesthetic possibilities of the synthetics in an exciting way, including knitted furnishing cloth, elastic and able to cling or mold to the free form of modern furniture.

Also on the staff of Unika-Vaev is Rolf Middelboe, mentioned above. Middelboe is an experimentalist in the art of printed fabrics who has attained worldwide acclaim. His patterns used to be freehand and spontaneous, applied with brush, spatula, or stippling. Since he joined Unika, he has deliberately developed precision in pattern and color, and is meticulous in his preplanning of both color and pattern. He designs with an eye to the fabric's use in modern-day rooms with plain wall surfaces. For example, his fabric "Minisol" is first of all a geometric stylized sun with radiant varicolored rays, half a length printed in small block repeats, and the other half in giant motif on plain white, giving a glass curtain and drapery effect in combination, when hung. Further-

more, part of it is translucent and part opaque, and the variations for use of this piece of fabric are many and fascinating.

Among the artists who earlier left their mark on Danish textile weaving was Marie Gudme Leth, who in 1934 found block printing too slow and imprecise for her ideas. Wanting to produce good textiles for every home rather than for only a few wealthy ones, she traveled to Germany to study the screen-printing process, a technique not yet introduced in Denmark. With what information she gathered, she revolutionized Danish textile printing, and within a year her workshop was turning out large and perfect lengths of printed fabrics at low cost. Miss Leth, in pioneering new techniques in textiles for Denmark, demonstrated artistic and commercial accomplishment as well as commercial endeavor. Her wide variety of patterns proved a powerful influence on the design of her period.

Marie Gudme Leth loved silhouettes in happy themes, very often done in one color on a natural background of half-bleached linen. After a tour to the Far East, she used Oriental floral and animal motifs in her textiles, yet with a distinctly Danish interpretation. Two of her most famous designs, "Mexico" (1935) and "Village" (1936), are much alike in their country look and good humor. In the forties, she turned to the sea for inspiration, drifting into more naturalistic designs and away from the stylized "sampler" type figures of her earlier prints. In 1930 she was appointed head of the textile printing department at the Copenhagen School of Arts and Crafts, and through her teachings she continued to influence the textile design for the subsequent decade. During these years, her works were the only ones made in quantity. Though other Danish textile artists were good, almost everything was still hand-loomed, so the quantity produced was small until the industrial expansion of the fifties.

Another form of specialized textile printing is that of hand-printing with carved blocks, one for each color in the design. An outstanding Danish artist in this field is Dorte Raaschou, who, in her small workshop, using a few simple tools, creates custom fabrics for both curtains and dresses. Her designs are simple and discreet, with motifs taken from nature and stylized with her own delicate expression and charm. Sometimes she combines block- and screen-printing techniques, overprinting here and there to develop an enriched color scheme especially effective for fabrics which fall in soft folds.

Another individualist in weaving is Vibeke Klint. She has her own studio in an old stable along the shore road north of Copenhagen toward Helsingør (Elsinore), with a view of Sweden on the opposite shore. There she finds the proper inspirational atmosphere for her unique weaving, which is for the most part as traditional in feeling as her atelier. Although she designs fabrics for industry, she works mainly on handwoven fabrics for private individuals and large custom weavings for public institutions. She is happiest working in traditional weaving methods, taught to her by Gerda Henning. (Gerda Henning was one of the pioneers of modern Danish weaving, and had the workshop, until her death in 1951, before Vibeke Klint.) Miss Klint does not work from drawings but feels that, by winding samples of the yarns

a

Table cover, hand-printed, designed by
Rolf Middelboe of Denmark for Unika-
Vaev, Copenhagen. Middelboe works
with plain and easily understood ideas
in pure colors. Experimenting in his
own workshop, he has become a very
prominent designer of printed and
woven textiles, employing printing
and overprinting techniques. [Courtesy
Den Permanente]

b

Painted textile wall hanging, designed
by Tusta Wefring. Colors include black,
light and dark blue, light and dark
yellow-green. [Courtesy Den Per-
manente. Photo: Inger Ellejus]

c

Silk handwoven stole by Vibeke Klint,
in her own atelier. [Courtesy Danish
Society of Arts and Crafts and In-
dustrial Design]

a

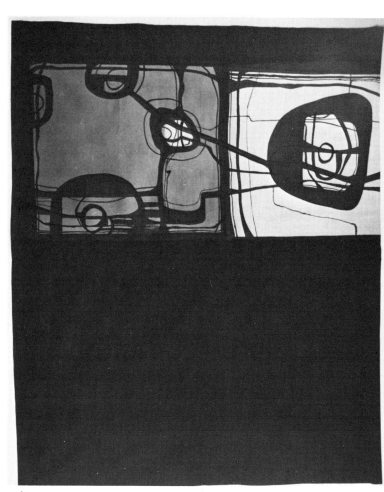

b

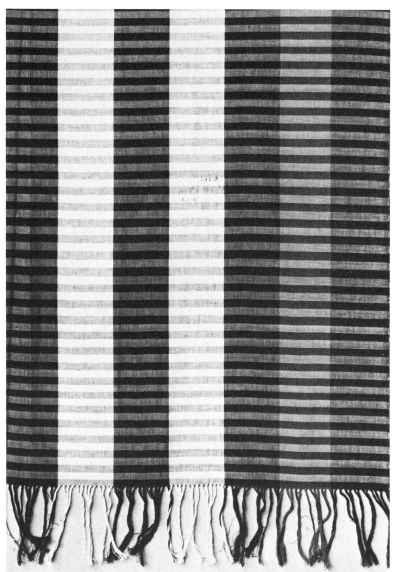

c

on small pieces of cardboard, she can better plan her color scheme and the number of threads of each color which may be needed to produce any special effect she is seeking.

Franka Rasmussen of Denmark represents, also, the type of weaver who uses yarns, colors, and techniques as an artist paints, largely for decorative and artistic expression, and especially in the form of wall hangings. She combines different materials and textures, flat and pile weaving to "paint" abstract impressions, usually of nature, such as dawn, dusk, or the seasons. Another of this distinguished group of textile "painters" in Denmark is Ruth Christensen, whose compositions, each one an original, are not sketched or planned but created as she works, and are printed by a combination of block and brushstroke techniques.

Sweden

Sweden's versatile textile industry depends on its well-organized home-craft production system for most of its traditional handicraft textiles, and turns out a mammoth production of beautiful yard goods with its modern, well-equipped factories. Many private weavers' studios create exclusive works to round out the textile picture in this country.

In the old days, cotton was expensive, imported from Holland and South America, so native linen and wool were most easily available. For a while, there were attempts to raise silkworms in Sweden, but this experiment did not succeed. The major forms of weaving were Flemish (*Flamsk vävnad*), a high warp tapestry, especially typical of south Sweden; *rölakan,* a low warp tapestry, usually more geometric in pattern than the Flemish; and double weaving, using two warp and two weft threads, the last done largely in Bohuslien near Göteborg and Jemtland in the north. These traditional methods are still used today.

During World War II most of Scandinavia was occupied, leaving neutral Sweden in an isolated position and suffering from a serious lack of goods and material. This had both good and bad effects on the textile industry there. There were drastic restrictions on manufacturing, but material shortages led to the use and further development of synthetic textiles, and printed fabrics became fashionable. This prodded such pattern designers as Sofia Widén, Edna Martin, and Marta Afzelius to come up with some rich and widely varied patterns for the new fabrics. The textile studio of Nordiska Kompaniet of Stockholm (a company which has always done much to foster good design of all kinds) contributed valuable efforts, and the firm of Elsa Gullberg advanced in the techniques of screen printing. Borås, Göteborg, Mölnlycke, Almedahl, and other firms were at last put in the position of needing and using more Swedish designers, and they soon proved to these big factories that Sweden need not depend upon foreign talent. This trend continued after the war, with Elsa Gullberg doing much to encourage this development. Elsa Gullberg was a pioneer involved in the Society of Industrial Design and continued to have an important part in promoting artistic design in industrial production, particularly in

drapery, furniture fabrics, and table linens. She is now retired, but turns out some things occasionally.

The use of color in Swedish textiles is inclined to vary with areas, reflecting climate, flora, and fauna, as found in the various parts of this thousand-mile-long country. In the south, Flemish influences still linger in the rich patterns used and the strength of the colors. Toward Dalarna, patterns are commonly more bold in color and size, with floral themes frequent. North of Dalarna and Siljan, color schemes grow somewhat somber, and then there is a return to the cheery bright reds and blues of the Lapps in the northernmost region. The handicraft societies in Sweden strive to retain these local color influences as well as patterns from the past as valued prototypes of the days when dyes were created from local plants, a skill which is also carefully preserved and nurtured today.

It is amazing how many of the old methods, colors, patterns, and techniques are not only entirely suitable for today's environment but are often easily adapted to mass production, if so desired. The several crafts societies in Sweden continue to promote peasant handiwork and the preservation of traditional Swedish crafts. They do this with support, inspiration, advice, and sales-distribution aid, so that this heritage will maintain its place in a streamlined world.

The Friends of Swedish Handicrafts Association (Handarbetets-Vänner) is one of these dedicated organizations. Here beautiful fabrics are made, both for decoration and practical use, in wool and linen. There is a school (with its own shop) in Stockholm, and one in Dalarna. At the Stockholm school, the chief is Edna Martin, mentioned earlier. She is a remarkably versatile and talented artist, and supervises younger artists in the creation of extravagantly embroidered and woven wall hangings, rugs, tapestries, religious works, and everyday fabrics, from drawing board to loom. Mrs. Martin is also head of the textile division of the School of Arts, Crafts, and Design in Stockholm. The ecclesiastical textiles made at Mrs. Martin's school are indescribably intricate and beautiful. The students follow the artist's sketch, first weaving a sample, then the perfect final version. Lurex thread is used in the sample work, and real gold thread in the final piece.

The painter Alf Munthe also designs textiles and worked with the Friends of Swedish Handicrafts for fifteen years, concentrating largely on huge decorative weavings, particularly in the double-weaving technique, where the pattern appears on both sides, one positive and the other negative, and employing a special multiple-shaft technique. Greta Gahn is now his associate in a workshop near Dalarna. Another colleague of Edna Martin is Kaisa Melanton, who has her own workshop in addition to teaching. She, too, designs for industry, but her handicraft specialty, like Alf Munthe's, is double weaving, particularly in black and white. Much of it is for ecclesiastical use.

Kaisa Melanton is one of the top textile artists in Sweden. She has done much to enrich and expand the art with her special talents. She has co-authored an embroidery book, written a comprehensive history of double weaving, and teaches composition at Handarbetets Vänner. She has woven magnificent sacral textiles for churches, a Gobelin for

the Metalworkers' Union Building in Stockholm, and made rya rugs, appliqués, embroideries, and special napkins and fabrics for SAS, among her long list of accomplishments.

One of the greatest pioneers in modern Swedish weaving arts was Märta Måås-Fjetterström. Her unique style was inspired by peasant handicrafts and tradition, which she sometimes combined with Oriental techniques. In her drive to raise Swedish textile arts to a higher level, she was supported by the Friends of Art Weaving and Needlework, the Licium studio, and the Libraria. For thirty years of her working life she influenced the weaving profession, using both traditional and innovative approaches and various techniques, all with skill. After her death in 1941, a company bearing her name was founded (in 1942) at her studio in Båstad, and it carries on her work in carpets and art weaving through its artist-designers, Barbro Nilsson, Ann-Mari Forsberg, and Marianne Richter.

These three reproduce some of their teacher's designs but also create new ones. Barbro Nilsson is expert at various techniques but favors tapestry. Good at bold design and color schemes, she is often commissioned to weave enormous hangings for public buildings. Marianne Richter, a fine colorist, prefers a rug-weaving technique in which specially knotted pieces of yarn are worked simultaneously with a woven foundation, giving a live and changing color surface. Miss Forsberg concentrates largely on embroideries, tapestries, and rugs in soft, cool color schemes and light airy designs.

Sofia Widén, one of whose fabulous linen appliqué panels ("Lapponia") can be seen in the National Museum in Stockholm, also played a large role in the fifties in Sweden's textile history. She was inspiring as a teacher and developed great technical expertise. All her designs and color schemes were typically Swedish, involving restrained colors and rather intricate geometrical motifs. Since her death, her work has been carried on by Alice Lund, in her studio at Hytting, near Borlänge, Sweden. Alice Lund and Sofia Widén have both become famous for their individualized ecclesiastical compositions, Sofia Widén having works in over a thousand Swedish churches. Her techniques included blending weaving methods within one composition, giving more emphasis to the tactile effect. Later she liked to give free rein to her imagination with near-paintings in complicated appliqué work.

Another technique still used in Sweden, particularly by the talented young weaver Birgitta Graf, is *rölakan*—a traditional technique that employs a linen warp with yarn inlay, crossed and tied with a characteristic knot. An artist presently using a very similar technique is Inga Brand, who makes bold designs in rugs with this method in her private studio.

Also prominent in industrial textile production in Sweden is Astrid Sampe, who works for Nordiska Kompaniet in Stockholm. Miss Sampe designs rugs and carpets, furnishing textiles, printed fabrics of all types, and other home textiles. She also designs elegant carpets for the Kasthall firm, and is active in organizing and coordinating exhibits and displays of textiles. She not only designs for Nordiska but is organizer of its entire textile production. The magnificent rya rug at the United Nations

in New York, embodying tree motifs symbolizing five continents, was designed by Astrid Sampe.

Viola Gråsten, whose works are produced by Mölnlycke's mill, must be mentioned, too, as one of the most important talents in printed-fabric design in Sweden, especially cloth for draperies. She began in the field of rya-rug design and gained prominence, but now she contributes her first-rate designs to standard textile products.

Iceland

Homecrafts in knitting and weaving are still popular in Iceland, where for centuries families combed, spun, wove, and processed their own wool. Iceland Homecrafts now organizes the buying and selling of hand-woven products, including sweaters, hats, socks, and blankets in natural colors. Dress and men's-suiting fabrics are also produced in Iceland these days.

Greatly admired are Icelandic handwoven shawls and scarves, made from the finest local wool combed and spun on the spinning wheel, a method that should survive, as such fine work can be obtained no other way.

The wool used in Icelandic knitting comes from this country's Lopi sheep, whose wool grows as long as ten to fifteen inches. The yarn is cashmere-soft and very durable, and most beautiful in the original natural colors from pure white to shades of gray, brown, and black. Eighty-five percent of the sheep are white, whereas only 5 percent are gray, a color recently become fashionable. Extensive cross breeding of sheep is now taking place, so that specific shades of gray can be offered. Norway and Iceland are now trying to discover a method of separating the fine and coarse hairs by machine, which will make the uses of wool more varied and lead to new woven textile effects.

Recently the sheared sheepskins have been used by a firm named Sindri to upholster chairs and stools; they are applied over soft sponge rubber. The sheepskins are tanned, clipped short, and used in natural colors. Since two skins are needed for each chair, they must be carefully selected for length of hair and matching color. This upholstery is entirely washable, like one's own hair, with lukewarm soapy water (and rinsing, drying, and combing), after which the chair looks like new. The Sindri chair was chosen recently for the "House of the Year" by Great Britain's *Woman's Journal* magazine.

Icelanders also weave handsome rya rugs, and have recently marketed kits for weaving these wonderful rugs at home.

Finland

In addition to their fame for magnificent rya rugs, the subject of another section (page 148), the Finns have made a name for themselves in the sixties in the world of fabrics. The simple but effective subtlety of several rich shades woven together has found appreciation everywhere. Table mats and cloths such as those woven by Ritva Puotila and sometimes marketed through Dansk are excellent examples of the Finnish gift for

a
Multicolor design on light background,
typical of Märta Måås-Fjetterström.
[Courtesy Svenska Slöjdföreningen]
b
Rug in wool (flossa), "Buketten" (Bou-
quet) by Edna Martin, Sweden. [Cour-
tesy Svenska Slöjdföreningen. Photo:
Roto Studio]
c
Stig Lindberg, famous ceramist, also
designed this handsome wall hanging
"Lustgården" in linen for Nordiska
Kompaniet. [Courtesy Svenska
Slöjdföreningen. Photo: E. Holmen]

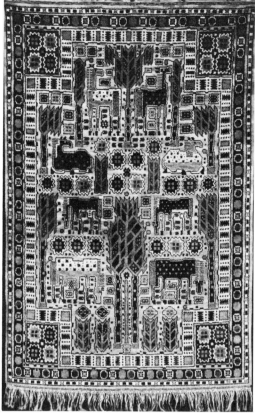

a

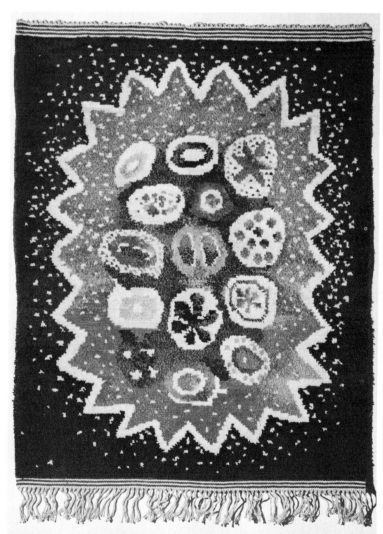

b

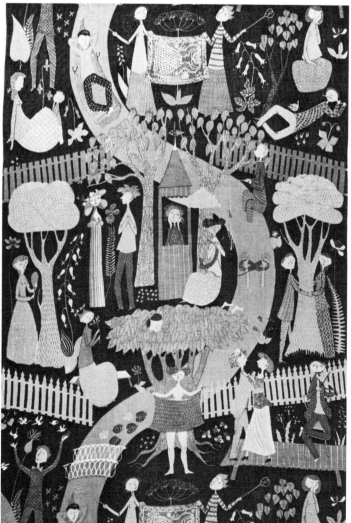

c

Grande dame of Swedish textile arts
was Märta Måås-Fjetterström, whose
contributions to textile development
were many and great. After her death,
a company bearing her name was
founded in 1942 at her studio in Båstad,
to carry on her work in carpets and art
weaving through its artist-designers,
Barbro Nilsson, Ann-Mari Forsberg,
and Marianne Richter. Barbro Nilsson
completed this design "Röda Rabatten,"
in wool (flossa). [Courtesy Svenska
Slöjdföreningen. Photo: B. W. Foto,
Malmö]

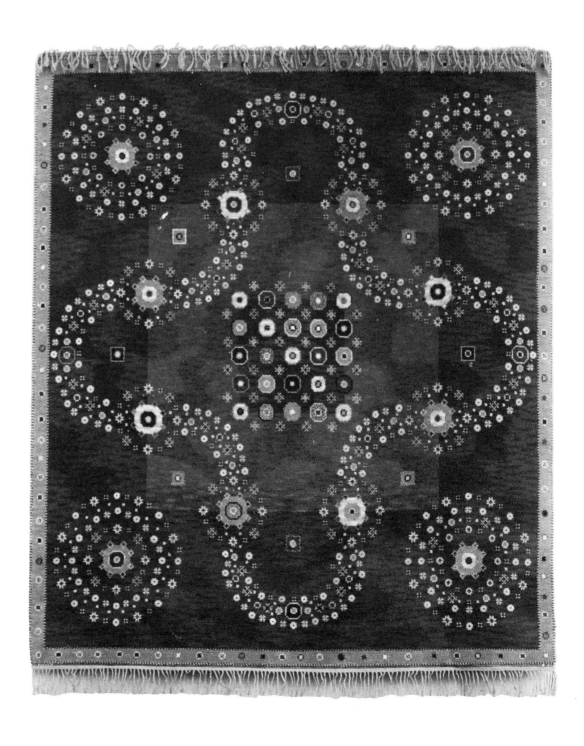

a
"Strålar," *rölakan* rug designed by
Marianne Richter for Märta Måås-
Fjetterström
b
Tapestry "Valdemarsskatten" by Ann-
Mari Forsberg at Märta Måås-
Fjetterström studio. [Courtesy Svenska
Slöjdföreningen. Photo: Pål-Nils
Nilsson, Lidingö]

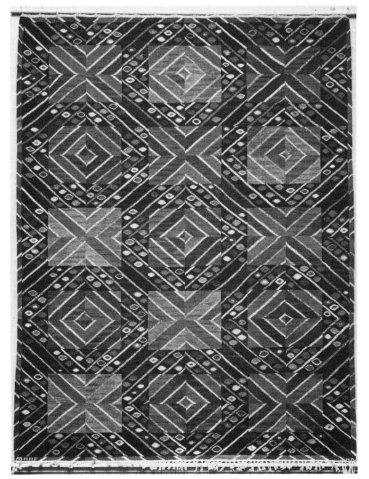

a

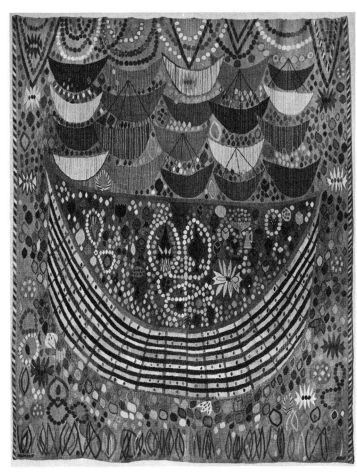

b

a
"Jungfrulin" design by Viola Gråsten,
sanforized cotton, 47½" wide, an
unusual width for cotton fabrics, making
it excellent for use as a drapery fabric.
By Mölnlycke. [Courtesy Svenska
Slöjdföreningen]
b
The "Sindri chair," upholstered with
Icelandic sheepskins over soft foam-
rubber padding, has comfortable
lines embodied in a molded-plastic
fiber seat with steel legs. Intended for
export, it is also designed for ease of
transport and packaging. Designed by
Asgeir Einarsson, son of the Sindri
firm's owner. [Photo: Petur Thomsen,
Reykjavik]
c
"Ulmus," award-winning design by Viola
Gråsten of Sweden in 1956, especially
printed on part-linen fabric by
Mölnlycke for the Nordiska Kompaniet.
[Courtesy Svenska Slöjdföreningen.
Photo: E. Holmen]

a

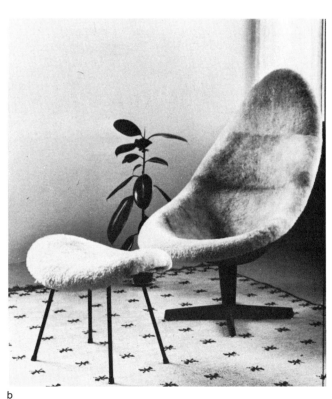

b

c

color. Deep glowing purples woven with grays and browns, burnt sienna with gray, white, brown, and black, purple with turquoise and green—such combinations yield beautiful new table settings.

In addition, the Printex-Marimekko textiles with their big, wild, and wonderful blobs of pattern are greatly in demand today, not only for creative fashion but for upholstery and wall hangings. Some designed over ten years ago are entirely in tune with the decorating ideas of the current generation. So are the fabric designs of Marjatta Metsovaara and the fashions of Maj Kuhlefelt, Vuokko Eskolin Nurmesniemi, and others.

Alongside these Finnish specialties are Dora Jung's inspired linen damasks, using natural white, copper, olive, graphite, or yellow colors and stylized flower or delicate abstract patterns, all of which she created when the world was sick to death of the same old chrysanthemum, iris, and ivy damask designs so long used for formal tables because they were the only thing available with sufficient dignity. Dora Jung's damask "Linen Play" won the Milan Triennale '57 Grand Prix and started a whole new era in linen design.

Another form of textile art for which the Finns are well known is the downy lap robe and the knitted stole, feather-light and fur-warm, again demonstrating a color sense like none other anywhere. Finnish lap robes are so beautiful they are nowadays tossed across a top corner of a sofa as much or more for the addition of a glorious touch of color as for any useful purpose. Ritva Puotila excels in this endeavor, as does Lena Rewell, and the Kotivilla woolen yarns used by the latter are kitten-soft and magnificently colored.

Lapp styles in weaving rugs, throws, and upholstery fabrics are also a unique accomplishment in Finland, the leading designer being Aune Gummerus with the famous "Lapponica" series for Villayhtymä Oy. Aune Gummerus is a designer-engineer who is principal designer for Uniwool at their factory in Klingdahl. This textile artist works exclusively in native Finnish wool, turning for inspiration to the fells and deep-turquoise lakes of the north, the autumn blaze and moody darks of the Lapland winter, and embodying the folk-art motifs of the area. Aune Gummerus has exhibited many times since 1959 in Europe and America and holds several awards, including the gold medal from the California State International Textile Fair in 1964.

Since 1965, a freer international exchange of goods has spurred Finnish textile mills into expansion. Newer machinery and rationalization of production managed to lower costs while preserving quality and variety. At the same time, industry underwrote the fine work done by Finnish designers in creating new patterns. Most of these textile artists had already achieved international reputations in one form of design or another, and at that time all Finnish textile mills utilized free-lance fabric designers. Thanks to this cooperative program between the mills and the designers, fabrics from Finland have won many international prizes, and the market demand for their products has grown about 35 percent annually. Some of the designers are now permanently employed by the industry; others remain free-lancers; but all retain their artistic independence. The largest industrial textile producer in Finland is Oy Finlayson-Forssa AB at Forssa, which concentrates on long series in screen- and roll-printed fabrics turned out by thirteen hundred power looms.

Power looms have taken up the story of linen in Finland, but this material has a long tradition in Finnish home life. Ancient folktales mention linen cloaks and tow shirts, and linen sheets were once part of every bridal trousseau. Adapted today to modern surroundings and requirements, linen is still one of the all-time-great materials. It has natural luster and life, is good to touch and to look at, shapes well, and washes beautifully. Linens, formerly off-white or pure white, now lend themselves to unusually beautiful dye colors. Linen and the sauna being natural partners, Finland devotes much skill to linen terry toweling and handwoven stool and platform covers, such as the refreshing "Sauna" series of textiles designed by Ritva Puotila and manufactured by Helmi Vuorelma Oy for this now-international pastime.

Working together, the textile manufacturers and designers in Finland have created a color wheel that they all use. It guarantees that standard textile products on the regular market for the average consumer will harmonize regardless of the manufacturer—an idea similar to the mix-match harmonizing color wheel featured by *House Beautiful* magazine in the United States.

Täkänä tapestry weaving technique results in a specifically Finnish textile, using an ancient method similar to the double weave. Wool or linen is woven into a pattern that may be either ornamental stripes or an intricate design, depending on the skill and imagination of the weaver. The reverse side is, of course, as neat as the upper, but in negative. This gives the täkänä textile suitability for door curtains or room dividing, or for a reversible rug or bedcover. The fabric is usually coarse yarn, woven to give a smooth surface. It is sturdy and warm, yet lightweight. Laila Karttunen, in her own studio, specializes in this technique. Her themes are usually folk motifs in subdued colors.

Finnish versatility is not limited to color and technique, but extends to material as well. Greta Skogster and Liisa Suvanto have been experimenting with weaving grass, birch bark, and metal threads into textiles with much success. Finnish woolens have remained very beautiful through the decades. The hallmarks of Finnish wool textiles are richness of color, lightness of weight, wonderful warmth, and a deep luster.

Cottons first gave recognition to Finland in the world market. They were highly original in style and color and immediately aroused interest at design exhibits. The leading cotton mills include Oy Finlayson-Forssa AB, Oy Tampella, Porin Puuvilla Oy, and Barker-Littoinen Oy. Sweden, herself a fine producer of textiles, is nonetheless Finland's main buyer, which ought to signify something. The bulk of wool export is marketed by Villayhtymä Oy (Uniwool, Ltd.), where Ritva Puotila lends her talents to a 100 percent worsted series with such tempting names as "Seawater" and "Midsummer."

In fact, there is simply nothing ordinary about anything when a Finn puts his or her mind to doing something original, practical, and with a flair. It always attracts those who look for distinction, quality,

color, and design, whatever the medium or product. It is to Finland where one goes to find originality.

Dora Jung is a good example of Finnish original thinking. She is world-famous for revolutionizing the weaving of damask, which for centuries was white, of standard floral design, and frankly boring. Dora Jung saw no reason damask should not be of interesting designs, and not necessarily just one color. Her contemporary interpretations have given new life to the more formal world of damask cloths. Her well-known "Hundred Roses" scatters stylized blooms over the entire cloth, and she uses feathery lines or other abstracts. She is also renowned for her tapestries and has mastered complicated techniques. She works most often in her own studio, where she makes the originals of her distinctive damasks and her sensitive wall hangings and special works for churches. Her table linens are produced by Tampella, and thus are available to an appreciative general market. Her equipment and technique were developed by her personally, which gives her the deepest possible insight into her craft, and her work, therefore, is perfection.

Finnish originality extends into cotton fabrics, too, of course. They have become highly specialized in this country—for example, Rut Bryk's "Seita" series for Vaasan Puuvilla Oy, especially worked out in a winter weight and evoking the autumn tones of Lapland with its rich spectrum of northern lights. The series is thick, twilled, and reversible, and includes stripes and checks suitable for draperies, for leisure wear, for the table.

Sarpaneva's "Karelia" series for Porin Puuvilla Oy—and his more spectacular "Ambiente" designs for Tampella—involve gay splashes of subtle color with a rhythmic flowing pattern especially attractive for large surfaces. One thinks of oil-paint globules dropped on water and stirred into glorious flowing and ever-changing free forms. To a resourceful decorator, the "Ambiente" series offers myriad possibilities. The printing method used for this Sarpaneva series is Timo's own invention, originating with his use of it for inexpensive but beautiful gift-wrapping paper, for which he won the Eurostar packaging achievement award. Later he was able to apply the method to fabrics. Timo Sarpaneva designs textiles for some Swedish firms, too. He has also created rya rugs for Villayhtymä Oy, cottons for Porin Puuvilla, fabrics for fashions and for interior furnishings, and both the cloth and the fashion design for a line of men's and women's suits and coats known as the "Juniper" collection, with his wife, Pi Sarpaneva, as collaborator. Currently Pi Sarpaneva is designing just about everything she happens to get interested in, especially textiles, ceramic tiles, and complete interiors. She and Maj Kuhlefelt have teamed up to decorate an entire hotel with their custom-designed fabrics, and they have recently designed the interiors of Finnair's new DC-10 aircraft, flying from New York to Finland since the spring of 1975.

A specialty of Lapin Raanu at Rovaniemi is the *raanu,* a lightweight, woven-wool throw used for centuries by the nomadic Samish (Lapp) people not only as a warm blanket but to cover their huts. It has the warmth of wool but does not become soaked. The yarn used is thick and coarse, but the weaving is airy and loose, rather than matted.

Elsa Montell-Saanio, director of the firm, raises her own sheep, and the handicraft throughout her production is the finest. The colors used interpret the scenery, light, and shadow of the area. There is an exhibit hall at the works which is visited annually by about ten thousand people.

The ancient *raanu* blanket has been rediscovered for modern-day use. Its colorful stripes are suitable for contemporary furniture and interior decor. Its glowing colors make it a stunning wall hanging, and it is also useful as a door curtain, a bedcover, or a warming throw. Its warmth, light weight, water repellency, and non-shrink and non-fade qualities are in tune with the Samish way of life amid snow, wind, and rain, much of it involving sled travel. Many of these *raanu* blankets have been official gifts to visiting foreign heads of state, as a unique art form of which the Finns are justly proud.

Another specialty of Finland once again popular, even in the most refined surroundings, is the gay cotton rag rug, clean-lined and colorful. Formerly these were handwoven in homes, but now are artist-designed and produced industrially.

Finland is the only one of the five northern countries to excel in the world fashion market. Designers of fame in ceramics or glass have joined textile and pattern designers to create unique styles in knockout colors, entirely in tune with trends of today and tomorrow. Finnish fashion design has international appeal, avant-garde boldness, clarity of line, and comfort in the wearing, which has immediate appeal for today's Beautiful and even Not-So-Beautiful People.

The most well-known line is that of Marimekko (fabrics by Printex, its mother firm), then Finn-Flare, with textiles by Marjatta Metsovaara and designs by Maj Kuhlefelt, then the "Vuokko" line, with fabrics and designs by Vuokko Eskolin Nurmesniemi. There is another new collection called "Revontuli" (Northern Lights) by Oy Suomen Trikoo Ab, and yet another, the "Merry-Finn" export collection. All of these have found their place in the world's leading fashion-bible magazines around the world. The "Juniper" collection, designed by Timo and Pi Sarpaneva, was mentioned earlier. It has reached many countries. Pi Sarpaneva formerly had her own haute couture studio, later she associated with two other friends in the "TEAM" fashion shop in Helsinki. Pi is a gifted stylist with an innate feeling for matching fabric to design, and her original creations compare with any Paris collection.

The Printex-Marimekko combo is now represented by over four hundred retailers at home and abroad, covering more than twenty countries. Armi Ratia began Printex in an old oilcloth factory, with more interest in coming out with something fresh and new in printed fabrics than in clothes. Born in Karelia near the Russian frontier, Mrs. Ratia is more than a textile designer—she is an excellent businesswoman and calls herself a fashion hater. Marimekko styles are meant to be freedom from fashion, a way of life. The fit of a Marimekko is determined largely by the fit of the shoulders, with most of the dresses designed to fall loosely from there to the hem. These uninhibited prints and styles, which appeared in the early 1960's, were like a forecast for the uninhibited living of the 1970's.

Armi Ratia immediately abandoned all conventional patterns and produced innovative, non-figurative, graphic designs of her own. For some years these somewhat wild and oversize prints did not catch on, until Maija Isola, whom Mrs. Ratia hired along with several other young designers, turned these refreshing textiles into clothes. The quality, the bold patterns, were not only artful and flattering but extremely comfortable. They made sense to people and became highly successful in Finland and elsewhere. The fact that Mrs. Jacqueline Kennedy Onassis bought nine of them early in the game didn't do any harm in publicizing the line in America, along with photo features in *Life* and *Look* in the mid-sixties.

In 1966 the expansion of the firm was so great that Mrs. Ratia began the execution of an old dream of hers, to build an entire village of about three hundred family houses surrounding a new factory at Bökars, an idyllic setting. It is now in use, known as "Marivillage." In 1968 a new printing hall began operating in Helsinki, and later that year some sideline designs were contracted out to other factories for production. The firm now produces, not only interior and dress fabrics and fashions, but jewelry, toys, bags, aprons, place mats, mittens, scarves, umbrellas, ties and shirts for men, and many other things. Teamwork and freedom from work pressure are the keynotes of Mrs. Ratia's firm, and the resulting products are happy in feeling.

Maija Isola is still the leading designer, and Liisa Suvanto remains with the firm, though others of the original crew, such as Vuokko Eskolin Nurmesniemi, have branched out on their own.

Maija Isola does much of her designing at home, where she likes the ample space she has and where she can be alone, as she is a retiring sort of person. The wide variety and inventiveness evident in her design are amazing; she explains them away in her quiet manner by saying one design leads to suggestions or ideas for another. She is also a painter, and her abstract sketches have been exhibited in Scandinavia, Germany, and Brazil. Her fabrics have been in a multitude of industrial-design exhibitions in all the European capitals and in the United States.

Many Finnish artists making beautiful things are themselves beautiful, and Marjatta Metsovaara is one of these. Beginning with her own exhibition in Helsinki in 1957, she has continued to prove herself a gifted textile artist. In addition to having her own studio and weaving mill, she designs furnishing fabrics for Uniwool and for Belgian and Danish mills and rugs for a Portuguese firm. She also excels at throws, stoles, rya rugs, carpets, and dress fabrics, the last for the Finn-Flare collection. Miss Metsovaara holds two gold medals from the Milan Triennale.

The world of Marjatta Metsovaara is a dazzling kaleidoscope of color and pattern. She is extremely versatile; through all her endeavor there is one predominant theme: color. "Color is a mood," she has said. "It is joy, sorrow, sadness, happiness, delicacy, power." She backs this up by using an enormous variety of colors and combinations, rich and exuberant. Her prints are as varied as her colors, from bold, oversized motifs to mini-prints, from the daring to the restrained. Her partner in Finn-Flare fashions is Maj Kuhlefelt, who designs from Metsovaara

fabrics refreshing and casually elegant mix-match collections, including sportswear, smocks, shirts, dresses, coats, bikinis and other beachwear and accessories, hostess gowns, maternity clothes, seagoing attire, sporty hats, caps, and boots.

Maj Kuhlefelt's collection demonstrates her personal fondness for sensible, relaxed, functional clothing, to which she adds a giant helping of chic. From a lively Metsovaara stretch-sailcloth print (such as "Figures-of-Eight" in cerise and rust), for instance, she creates "teddy wool"–lined jackets, raincoats, ski pants, capes, slacks, skirts (interlined with soft cotton flannel), hats, and boots, for that total look which will withstand rainy and wintry days with a cheering effect.

Marjatta Metsovaara designs many things besides fabrics for Maj Kuhlefelt and Finn-Flare. She creates exquisite wool-and-mohair stoles and lap robes in plaids of the most exciting color combinations. Finnish plaids are in a class by themselves because of the rich color tones and sheen of Finnish wool. The customary tartans of the Scottish clans are used, and stripes, checks, and plain colors also seem original because of color quality. Kotivilla Oy produces wool yarn that is of significant interest for weaving these soft articles. The native Finnsau sheep, whose silky wool is beautiful, were nearly lost in the late eighteenth century in favor of a breed of English sheep more fertile but whose wool had no sheen. Since 1960 Kotivilla has been improving Finnish wool, first by stimulating the breeding of the Finnsau sheep, and second by refining dyeing and spinning methods to the point where the yarn itself is an artistic accomplishment. Spinning the yarn from the wool of several flocks of different shades gives it a springy or lively quality and a uniform color; this, in turn, leads to improved color control in the dyeing process. Marjatta Metsovaara, Lina Rewell, and Ritva Puotila are weaver-artists who appreciate this.

Vuokko Eskolin Nurmesniemi, wife of the renowned Finnish architect-designer Antti Nurmesniemi, began in textiles with Marimekko and earlier had a career in ceramics. When she branched out on her own, she was an instant sensation. She markets her fashions as "Vuokko." Her dresses are strikingly original, largely 100 percent cotton prints identical on both sides, thanks to a new through-printing technique. She often works in eye-arresting black and white. Other favorites of hers are brilliant turquoise combined with scarlet, or a dramatic yellow-green with light blue and a rich, deep golden-yellow. Vuokko has won a Triennale gold medal for glass design, too, and the Lunning Prize in 1964. She and her husband won first prize for design of the Finnish section at the thirteenth Triennale exhibit, and the Grand Prix for their holiday-time display at the fourteenth Triennale.

With Marimekko, Finn-Flare, Vuokko, Merry-Finn, Revontuli, and now a new firm called Finn-Helen, a truly Finnish fashion world has carved a large place for itself everywhere . . . fresh, youthful, advanced, and based upon the pleasantly different fabrics designed in Finland, where colors are richer, subtler, more sophisticated.

Dora Jung's beautiful damask woven designs are a suitably elegant setting for a formal dinner table. Shown here are three: (1) "100 Roses," (2) "Violet," and (3) "Anemone." All are produced at Tampella, Finland. [Photo 1: Caj Bremer. 2: Pietinen]

1

2

3

Silk-screened cotton "Viikuna" by
Maija Isola, Marimekko, 1968

Silk-screened cotton print "Nooa,"
designed by Maija Isola for Marimekko.
[Photo: Pitkänen]

Decorative silk-screened cotton-print
fabric "Ruletti," designed by Maija
Isola for Marimekko. [Photo: Pitkänen]

a
One of the newest handprinted designs
of Maija Isola, "Siren." Manufactured
by Marimekko

b
Kerstin Ratia designs for the cotton-
dress collection, also small accessories
and interior fabrics. This is a silk-
screened cotton "Alphabet." By
Marimekko. [Photo: Pitkänen]

c
Also by Kerstin Ratia: Silk-screened
cotton "Nokipoika" (Chimney Sweep).
Marimekko, 1968

a

b

c

Marjatta Metsovaara is a versatile textile artist, working in fabrics, rya rugs, and fashions. She is shown here with four of her vibrant fabric designs. (1) "Jacquard" upholstery textile in multi-blue tones, (2) Printed cotton "Harlekiini," (3) Printed cotton, "Karuselli," (4) a wall of "pyramids" covered by various upholstery fabrics designed by Miss Metsovaara and displayed at an exhibition of her works in Helsinki in 1966. [Courtesy Marjatta Metsovaara. Photos: Kristian Runeberg, Helsinki]

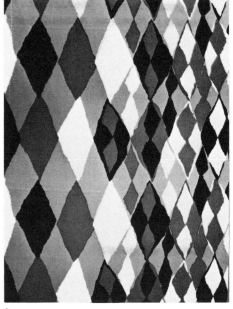

1

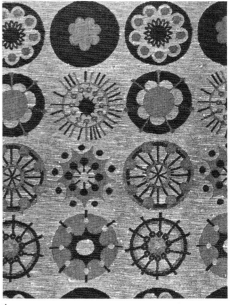

2

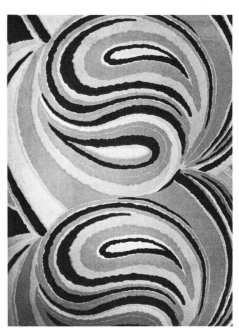

4

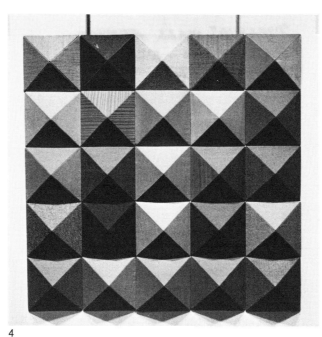

3

In 1963, Marjatta Metsovaara teamed her fabrics with the avant-garde fashion designs of Maj Kuhlefelt to form the fashion house of Finn-Flare. The entire line is based on a mix-match plan, with exciting accessories in the way of hats, caps, gloves, and boots. For women's fashions to be "lasting" implies far more than quality in the fabrics and workmanship—it means the style, too, must not be easily datable. Examples shown here, designed several years ago, have been chosen to demonstrate that Kuhlefelt and Metsovaara have obviously accomplished their purpose. [Courtesy Finn-Flare. Photos: Caj Bremer]

The Art of the Rya

The rya rug is no longer a stranger in America or around the world. It is not just a rug but a work of art, often hung upon the walls of regal mansions, museums, and more modest dwellings, like a fine painting, which is the general idea in the mind of the weaver as the rug is woven. Its changing color blendings, the glow of its woolly sheen, its deep and light shadows, the charm of the artist's mood and message interpreted in a textile medium just as a brush artist communicates in oils—all these factors have earned the rya its place in the art world as well as in the world of hearth and home.

Although the rya has a history in each of the Scandinavian countries, the Finns are considered to be its true sponsor, and are credited with being the originators of what might be termed "painting with yarn." As thus representing a distinctly national product, the Finnish name "ryijy" has been carried down through its history. (The sound phonetically is *r-iieé-yü,* the *ü* sound being similar to the German vowel with an umlaut. In modern usage, the Swedish-Danish-Norwegian-Icelandic version is rya, pronounced much the same.) However you spell it, however it is designed, it is today a powerful manifestation of folk and fine art in a textile material.

Earliest historical mentions of these shaggy-pile coverlets are found in Scandinavian records of the mid-fifteenth century. They were then used as bedding. In inventories of estates, they were considered a semi-valuable, after precious metals and jewels, comparable to tapestries. Some 250-year-old ryas exist today in museums; their durability deservedly added to their worth. They were a practical article in a frigid climate, luxurious and long-lasting. Making them was also a pastime for the long winter months.

Ryas were used extensively as payment for taxes, in sales of land, in inheritances and dowries. Young couples consummated their marriage in the cozy warmth of the rya that came with a bride's possessions. It is not recorded if a maiden was more sought after for herself or her rya, but it was certainly an important item in her dowry. A widow's number-one legacy was her right to her own rya. The rya lent its warmth as a lap robe to sleigh riders in the northern cold. It was issued to soldiers and even served to plug up cannon holes in the walls of war-torn villages.

All five northern countries make beautiful ryas. A hand-knotted original design costs $500 or more, and is an art treasure. In the early 1960's, a loom was invented in Finland which could knot a rya from the artist's plan at least partially by mechanization. This has made available some rugs that are not mass-produced but are made in limited quantity from one design. These can be sold at approximately $100 to $200, depending on size. So popular have these become that kits were brought out with materials and instructions for the individual to knot a rug at home; these cost about $75. It's not just a female handicraft. I personally know many men who find knotting a rya more challenging than cabinetwork.

In Sweden, at the Kasthall factory, an Axminster-type loom was soon developed to weave room-sized rugs of the rya type, with Marianne Richter and Ingrid Dessau the leading designers. (Dag Hammarskjöld ordered one for the main reading room of the United Nations library in New York, a design incorporating a characteristic tree for each continent.) Mechanization can go only so far. Attempts have been made to create cheap copies of the rya; most of them look like thirty square feet of worms.

A rya consists of a warp and woof (weft) thread to create the basic fabric foundation. In and out of this are woven various types of knots to create the pile. The pile is woven or knotted securely and can be various lengths or densities. In the oldest ryas, the pile was about one half to three quarters of an inch long, and sometimes it was on both sides. Today it is one to two inches long, thick, shaggy, gleaming with light, dark, and intermediate tones and shadows. One favorite of mine has very long linen or flax threads every few knots, perhaps two and a half to three inches long. Hung vertically on a wall, it depicts a "Snowy Forest" (En Snöig Skog), and with its three-dimensional effect it truly looks its name. It is by Aappo Härkönen of Finland, and can be seen at Stockman Oy department store in Helsinki.

The earliest rugs were largely utilitarian, in natural colors of white, gray, and black. Designs were improvised right on the loom. In the sixteenth century, the pile became shorter and the rugs lighter and more ornamental, until in the nineteenth century they reached a splendor to equal tapestries. At the turn of the twentieth century, the rya became a medium of creative art in a more free form of design, much fancied by such romanticists as Eliel Saarinen, the world-famous Finnish architect and furniture designer, and painters such as Axel Gallén-Kallela. Today it can be compared to a landscape painting—a blaze of sun and shadow like the northern lights or the brooding depth of colors found in a deep forest glade. Designers and weavers of these nature portraits are highly individualistic artists.

Rug knotting is an ancient technique. The rya, in particular, with its very deep pile, effects a blurred and changing pattern of color as its pile is brushed or combed in various directions and light is shed upon it in degrees of intensity or from different angles. It is expressionistic in character and in color composition, an art with motion and variation. In the beginning, ryas were knotted in plain colors, or with borders, then geometrics, figures, crosses, flowers, etc., according to the times. Today they are as free-form as expressionistic paintings. Each has a name, such as "Midnight Sun," "Icicles," "Explosion," "Jack Frost." Happy or moody earth colors are fused with elegant, fashionable new dyes, with many shades of each hue in an area, rather than solid patches of one shade. In the rya of today, folk art has found a loving balance with sophistication, and to make this possible, the industry developing yarns and dyes has risen to the demands of the artists by supplying the tools and materials with which they can work out their ideas unhindered by technical limitations.

Different types of knotting for a pile have been found in textiles in oak-coffin graves from the Danish Bronze Age. The earliest historical mention of a rya being used in Scandinavia is in a manuscript of the year 1451–2, from a convent at Vadstena. From the early sixteenth century, there are reports from Sweden, in inventories, indicating they

were considered of value. In Norway, a bill of sale at Afflodal in 1460 listed a rya as part of an estate.

The old ryas usually measured 210 x 150 cm. to 270 x 210 cm., and the amount of material was, for example, "75 lbs. of Swedish wool and 30 lbs. of English wool for three rugs," or thirty-five pounds per rug. Sometimes "hempen warp" and "shed-wool" are mentioned as used for warp or weft. At any rate, we can figure they weighed close to forty pounds. Woven with a similar principle or technique to that of an Oriental, the difference is a greater interval between rows of pile, and a greater length of pile, plus the difference in the thickness of the woolen threads. A rya generally has 66 to 304 knots per square decimeter. Looms in the early days were very narrow, and many of the old rugs were pieced together down the center lengthwise.

From 1460 on, the rya appeared more and more often as an item of worth, along with fur rugs, tapestries, and the like. In those days, plain ryas outnumbered those with color, and were mostly natural, white, black, and gray. Yellow, a local vegetable dye, was next represented. Some rugs were white with a yellow border, or white with black "framing." "Frame" was used in the sense that the borders were woven separately and sewn on. Red seemed to be the next color on the scene, and occasionally blue. Earliest patterns other than borders or simple geometrics were coats of arms, then the cross, then "dice" (a square tipped over to stand on a point). With experience, more vegetable dyes being discovered, and the shortening of pile for more ease in design detailing, flowers and male and female figures began to be used.

The art of knotting ryas, begun in the castles and manors of the Swedo-Finn, where there was time and the means to acquire the materials, gradually spread to the rest of Finland, from the cultured classes to the wealthier farms, and finally to the greater mass of farmers. The rug was largely simple in design at first and then followed the fashions of the upper classes, who led the way. In Sweden, styles varied greatly according to districts. In Norway ryas existed in everyday form, for daily use, particularly in the families of fishermen in the north and west. In Denmark the rya disappeared almost completely for many years but has made a comeback today. The art of knotting carried over during that period in Denmark, however, in the form of cushion covers, with long and short pile forming the design or accentuating it.

In time a class of itinerant rya weavers arose; these craftsmen paid visits with their wide horizontal looms when summoned. It took two people to weave on these looms. One knotted pile and worked a treadle, moving rollers on one side. The other worked a treadle on the other side. The warps were heavy and it took two treadles to lift them. This wider loom ended the making of rugs consisting of two parts sewn together. They were already rare in the eighteenth century.

Utilitarian ryas were longer-piled, more sparsely knotted, and more quickly and easily finished. For a rya to be used for decorative purposes, a shorter, denser pile was desirable, as it more plainly showed the intricate designs then becoming popular. Swedish designs grew complicated in pattern, but had not yet shown any real freedom of motif. Zigzag lines, rhombs, squares, crosses, arms, human and animal forms continued there.

The Finns through the years became more and more skilled technically, and motifs of flowers, hearts, trees, birds, fruits, religious symbols such as Adam and Eve, chalices, trees with snakes, were used. Finally, the Finns ventured away from stereotypes to purely pictorial, and at last entirely free design, with the emphasis on color.

The tree motif was also used in Norway as early as the seventeenth century. Tulips, developed into full cultivation in Holland from 1630 on, hit the design world about 1660. The European "tulip craze" hit rya-rug design in the next century, and many of these rugs are still preserved. Windmills shared the spotlight with tulips. These themes were not so popular in Sweden, however. The Egyptian palmetto appeared in designs about 1792 and thereafter, soon to be nosed out by rococo garlands, lions, and deer. Gustavus III of Sweden, toward the close of the reign of Louis XV, became interested in French styles, and there followed a "Gustavian" style, interpreting these French motifs with Scandinavian enrichments. The style embodied straight lines, looped garlands, and vertical columns or stripes. These themes appeared in ryas as the nineteenth century arrived. There were stylized versions of fluted columns entwined with a ribbon, and in between vertical columns were rows of flowers, brightly colored, and there were wide, vividly patterned borders. The entire design would be extremely complicated and busy, yet beautiful in its own way, and representing painstaking handwork.

Next appeared "sampler" types, involving carnations, wreaths, flower pots, and figures. In the mid-nineteenth century, a new factor appeared on the scene: romance, and the romantic style, with its natural forms, cornucopias, Cupid darts and arrows, turtledoves, and such scenic devices as Chinese pagodas and foot bridges, or landscapes with castles. These, in turn, led to a whole new series of picture ryas, at that time usually religious in theme, such as Christ on the cross. Historians state that the Finns were not as good at this kind of rug as other Scandinavians.

Actually, the Finnish claim to fame with ryas has been above and beyond the design itself. It is color which marks their excellence. Because of the remarkable color sensitivity with which the Finns blend their tones of each color and blend one color into another, one feels nearly mesmerized by the color effect rather than by the pattern detail. People with an educated color sense have been quick to acknowledge that the Finnish color wheel, be it in wool, crystal, or any other medium, is admirably soft and keyed to nature, and therefore endlessly pleasing to the eye.

Nowadays, a multitudinous color choice in the finest of woolen yarns is available to weavers, and every possible advantage is taken of it. But from what did the old colors come long ago? Commonest were those from club moss, marigold, camomile, wild rosemary, bog myrtle, bedstraw roots, birch bark and leaves, heather, spruce cones, and the like. Yellow was found early in birch leaves with sap on them, for example. Black was called "bog black," and made from alder bark and black mold from bogs.

Certain main colors help to identify the age of an old rya. In the sixteenth century natural wool colors were used—gray, black, and white. Yellow appeared next. The blues, reds, greens, and brown-reds were

a
The modern rya making can be
justly considered a work of art. The
wall hangings have superb pattern, and
a lustrous surface of warm, glowing
colors. Ryas for use on the floor are
equally well designed and crafted, but
the aim is for a quiet surface decora-
tion to harmonize with furnishings,
rather than more striking effects of
color and pattern. It begins with the
artist's brush . . .

b
The linen warp is wound around the
warp beam and passed through the
heddles before going through the reed
and being tied

c
The rya follows the artist's sketch

d
The handweaver selects the yarns
according to the artist's drawing. In
Finnish ryas, several shades are
used in each knot

e
Tufts are knotted in the warp

f
The knot is pulled tight

g
The rya grows, row by row, knot
by knot

h
All the warp threads pass through
the eyes of the heddles

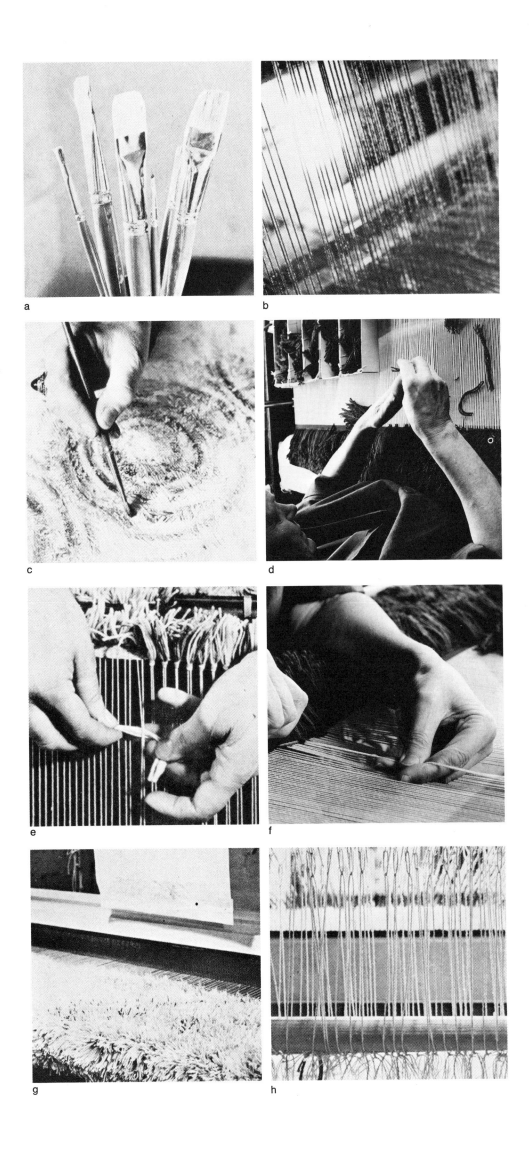

i
The pile weft is wound around a stick and then cut open, to make tufts of the desired length

j
When the wool is spooled, the yarn is put on a winding frame to avoid tangling

k
Exquisite colors and tufts from 1¼ to 2½ inches long make the rug cloud-soft. If the pile is brushed different ways, and lighted from various angles, the color effect is varied

l
A colorful array of wools is available. Neovius, the Finnish rya-making specialists responsible for most of these pictures, has 160 colors in their standard range, and will produce any shades the artist may desire

m
The weaver, too, must have an artistic flair in interpreting the designer's intent

n
Rya yarns on spools, sorted according to color and function

o
The warp threads must be wound firmly onto the warp beam for perfect results

p
Detail of the rya made from the sketch in picture 3. Finnish ryas are famous and shipped all over the world. Many have been acquired by museums

Series courtesy Osakeyhti Neovius and Oy Finnrya AB, and *Designed in Finland,* publication of the Finnish Foreign Trade Association, Helsinki

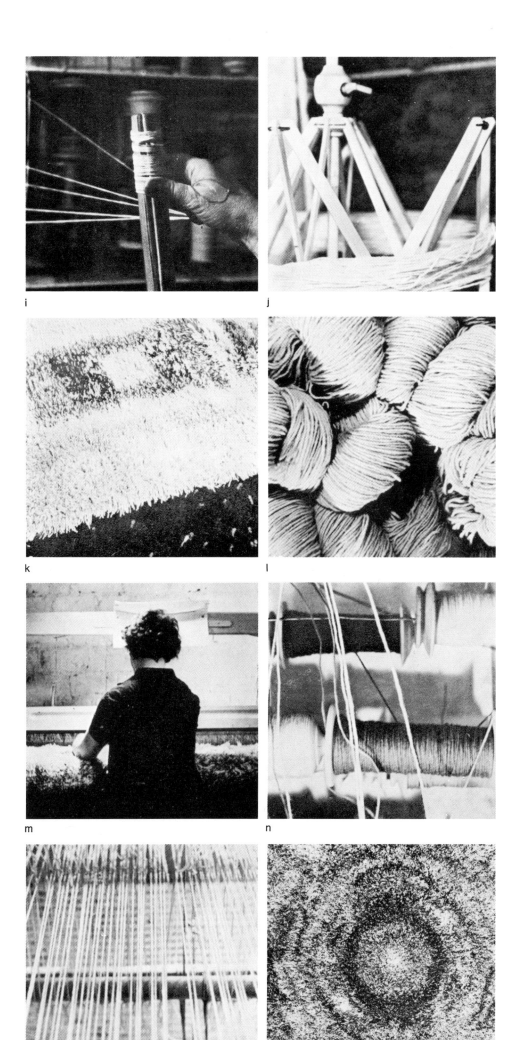

i

j

k

l

m

n

o

p

used more in the late eighteenth and early nineteenth century, no doubt the result of that great innovator and mellower Time and its teachings. Certain colors were favored in certain areas, perhaps due to the availability there of the ingredient to produce, for instance, a fine green dye.

The present era of rya "art" began at the turn of the century. The many extraordinarily fine artists in Finland who have mastered the technique of rya knotting among their other accomplishments are highly impressionistic and individualistic in all their works. Their ryas can be identified by those familiar with their personal style. Organizations which take energetic measures toward preserving traditional crafts in all five northern countries are such as the Friends of Finnish Handicrafts (Suomen Käsityön Ystävät), The Swedish Handarbetets Vänner (Friends of Swedish Handicrafts), and Konsthantverkarna (Swedish Craftsmen's Guild), and in Norway, "Husfliden." They sponsor classes, underwrite gifted newcomers, maintain studios and showrooms, arrange competitions and scholarships.

One of the stars in the firmament of rya design and weaving is Sigrun Berg of Norway, who likes to create ryas using the old methods. She has produced great works, such as ten ryas for the Bodø Cathedral in north Norway. Sweden's Marianne Richter has a flare for original techniques and a tapestry-like style. Ingrid Dessau of Sweden designs for handwoven and machine-woven rugs, employing geometrical and linear motifs, but always in some fresh manner, using glowing color combinations. The textile artist in Sweden who comes closest to the Finnish style in rya design is Viola Gråsten, whose designs are made for the Nordiska Kompaniet in Stockholm. The reason is simple—she first made a name for herself in this field when she lived in Finland, and brought with her to Sweden not only the Finnish techniques but the innate sense of color so typical of Finland's artists.

Lise Plum of Denmark early abandoned routine pattern design in favor of emphasis on color power, material, and artistic expression, rather than draftsmanship. Juliana Sveinsdóttir, an Icelander well known for her rugs, has been living in Denmark for some years. She is an outstanding painter, as well as a fine textile artist. Characteristic of her work are abstract designs in natural sheep's-wool colors of gray, brown, black, and off-white.

The list from Finland is long, and it is impossible to mention all. Uhra Simberg-Ehrström is considered the greatest color artist among the many experts; her emphasis is less on pattern or composition than on, for example, related panels which in combination complement each other, a result she obtains from weaving dense and heavy rugs packed with yarns whose colors vary from knot to knot for a rich and exquisite, deep, shadowy glow. Her designs are woven in the workshop of the Friends of Finnish Handicraft, as are some of Eva Brummer's, Kirsti Ilvessalo's, Ritva Puotila's, and those of many others.

Ritva Puotila brings fresh use of color to her rugs—bright and cheerful turquoise tones, moving into shadowy somber purples and plums . . . very imaginative. Timo Sarpaneva has done some of his best ryas entirely in subtle shades of light and dark sand and earth tones. Eva Brummer, along with good color techniques, likes to use an unevenly cut pile, giving a relief effect.

To my way of thinking, and as witness her many awards and the acquisition of numbers of her rugs by various museums, Kirsti Ilvessalo of Finland is today's Queen of the Rya, hands down. Photographs simply cannot truly capture the whole depth of beauty in her rugs—you must see them in person. If you are in Finland, or at the Victoria and Albert Museum in London, the National Museum in Stockholm, the Stedelijk Museum, Amsterdam, the Louisiana Museum in Denmark, or the Art Museum in Trondheim, Norway, to mention a few, be sure to view her works.

I visited Kirsti Ilvessalo's home and studio. Her studio occupies the first floor, her home the second, dominated by a lovable dachshund named Crisse, who likes any language but English. Kirsti Ilvessalo has one or two assistants to help with the knotting, and it is here that she does all her experimental design, choosing new color combinations from racks and racks of beautiful colors of yarn, mixing, changing, planning, sketching. She prefers to create ryas of a large size, so as not to limit her artistic fantasy. She has always favored rich reds and red-browns, and a rug in these shades was in process on the large loom. Hanging on the wall of her office was her beautiful black-and-white rya named "Safari," visual proof that black and white *are* colors, after all. She executes her designs first in the form of a painting, then like a draftsman extends the design into a technically detailed pattern or graph which her assistants can carry out on the loom under her watchful eye.

To own one of Kirsti Ilvessalo's ryas represents an expenditure of several hundred dollars, but one will have bought a masterpiece. She also designs fabrics and upholstery textiles, travel rugs and blankets, and entire interiors, all with generous sweeps of color in varied shades of gray, blue, green, turquoise, glowing reds and oranges combined with brilliant yellows. Her works have won awards at three Milan Triennales; she has exhibited in over fifteen countries and is represented in seven museums; she has also earned six gold medals at international textile exhibitions in Sacramento, California, since 1960.

I doubt if any one of the many other fine designers of rya rugs in all Scandinavia will think I have slighted them in naming Kirsti Ilvessalo as the designer to be considered best in our time, for they, too, are numbered among her fans.

Ritva Puotila is a beautiful and talented woman who has rapidly gained fame both in rya art and other textile forms, thanks to her sensational gift for fresh color effects and a sense of composition so distinctive that one can quite easily identify her works from all others. If Kirsti Ilvessalo is the present-day Queen of the Rya, Ritva Puotila must surely be considered the Princess.

The modern rya, boldly colorful and imaginative, suits all homes, small, large, modern, or period. It is timeless and adaptable. It softens the cold and sterile effect of a plain floor or bare wall, giving warmth, softness, and the cheer of color. It should be provided with focused, medium-bright light to point up its effects. It needs space enough to be at its best. The rya looks different on the wall than on the floor, which will affect one's thinking when selecting one.

The handwoven originals admittedly are not within the means of

Machine-woven jacquard rya
"Karlavagnen" designed by Ingrid
Dessau for Kasthall. [Courtesy
Svenska Slöjdföreningen]

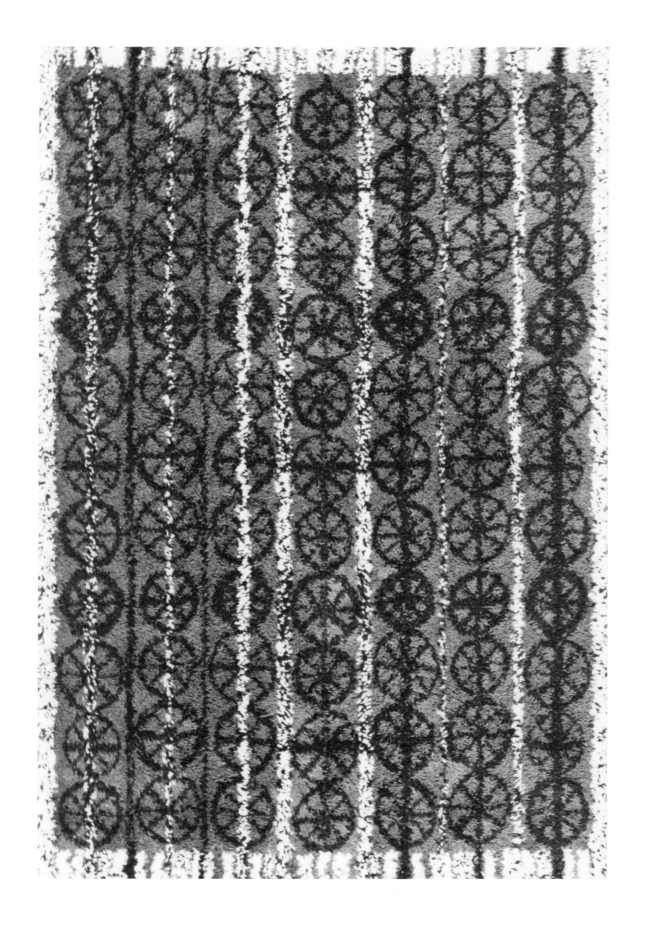

Rya rug called "Stegeborg," designed
by Marianne Richter for Wahlebecks
Fabriker in Linköping, Sweden. Miss
Richter has redesigned the rug in
three color themes, gold-sand,
red, green. [Courtesy Svenska
Slöjdföreningen]

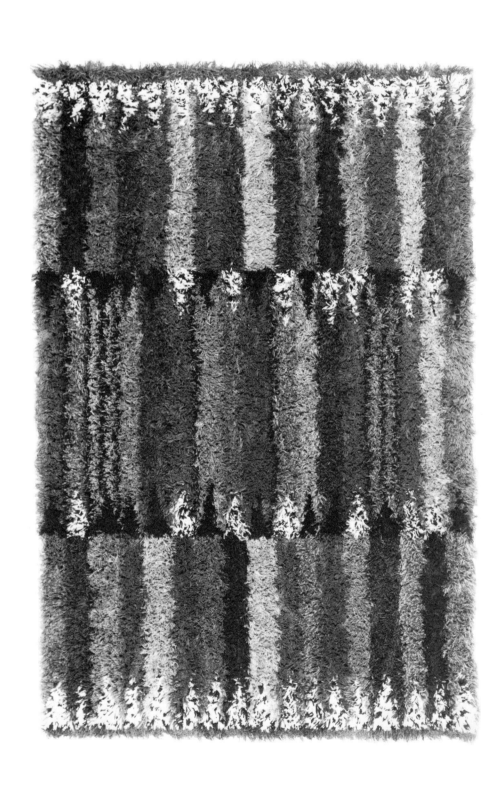

many of us. To encourage wider use, two leading Finnish manufacturers, Osakeyhiti Neovius and Finnrya AB, have introduced rugs that are partly machine-loomed and therefore less costly, and some rugs of less expensive material suitable for floor use. Other companies have since followed their lead. The weaving technique is the same. The yarn is thicker and tougher and the pattern less conspicuous, to give a restful background for furniture. These are worthy members of the rya family, and may be proudly owned and enjoyed. Finnrya makes a fine selection of designs by Ritva Puotila and Marjatta Metsovaara. Handwoven originals from Finland are available through Georg Jensen and Design Research in New York. Gefjun, Akureyri, Iceland, markets a rya kit of Icelandic virgin wool, outstanding in quality, and several Danish firms export kits also. For technical details in the history and knotting of the unique textile art form called rya rugs, let me recommend the monumental work by Professor U. T. Sirelius named *The Ryijy Rugs of Finland.*

The rug has become perhaps the most beautiful unique Finnish textile art, into which thousands of men and women have knotted their love, hopes, dreams, and tears. Today's designs are as modern as the future, yet communicate times as ancient as primitive rock carving and runes.

VII. JEWELRY AND METALS

Gold and silver smithery remained craftsmen's domains in the northlands until only two generations ago, with most forms and decorations imported or copied from Germany and other nations. The artistic level the Scandinavian jeweler's art has reached in our time is really a recent development. It is progress largely attributable to Georg Jensen and his associates in Denmark. The success of the Jensen firm, and others in Scandinavia that followed its example, are proof that a fresh attitude toward design in the precious metals was needed and quality appreciated. In contrast to jewelry using sparkling gems set in gold, silver, or platinum and meant to be splendid, the most notable success of Scandinavian jewelry is found in its elegantly simple designs, either unjeweled or set with crystal, jeweler's enamel, or semiprecious stones of local origin. Jewelry does not have to be costly to be treasured or appreciated; the design itself makes it a work of art and has little to do with price. The excellence of modern Nordic jewelry design is expressive of the same craftsmanship, taste, and sense of perfect form that characterizes Scandinavian furniture and glassware.

Through the ages, silver and gold have been symbols of wealth, honor, and prestige. They are lasting and valuable, and, best of all, highly malleable. An astonishing number of treasures made from silver have been preserved from ancient times, for example, from the royal tombs of Ur, dating back to 4000 and 3000 B.C., from Troy, Minoa, Egypt, ancient Greece, Etruria, and Rome. The inventiveness, grace, and workmanship in these can compete with much that later centuries offer. In Europe, the Italian Renaissance in the sixteenth century produced a great flowering of the silver- and goldsmith's art. Benvenuto Cellini is still acknowledged as one of the greatest goldsmiths known to history. English silver had its heyday during the eighteenth century, and held its lead for a long time. Industrialization late in the nineteenth century brought on a decline in taste and workmanship in all the applied arts, and even silver objects were overly decorated, badly proportioned, and sloppily machine-pressed.

By the time the century ended, there was a great need for someone who would break away and carry objets d'art and other art forms forward to new standards of form and material. In the field of precious metals, the man who gave heart and soul to this crusade was a Danish sculptor, Georg Jensen. He became one of the great silversmiths of history, revitalizing the art not just in his homeland but throughout the world. Georg Jensen's goals have been carried forward in the Jensen workshops by his talented colleagues and successors (including two of his sons), down through half a century and through several distinct changes of style and taste.

But to return briefly to the past, there is one old Nordic form still much loved and often reproduced today in either silver or pewter—the big baroque tankard (called a "krus") from the period 1660–1700. This was broad and squat, with either lion's or bird-of-prey claw-and-ball feet, and sometimes with a gilt metal lid. No sissy drinkers, the men of those days ordered the tankards as large as three quarts. Today they are popular as trophies to be engraved, or as planters for ivy lovers. Another container native to the area was popular in the 1700's, when the custom of drinking tea and coffee first became popular in the Nordic countries. The silversmiths learned to make teapots in curved forms with roughly carved fruitwood handles. The wooden handles turned out to be an artistically attractive contrast to the mirror finish of the silver. Later, so did ivory, bone, and eventually the handsome black nylon often used today. A splendid piece of the times was a tea urn similar to a samovar, with an interior tube for heat provided by burning charcoal. These were made in many variations in the last half of the eighteenth century. In Denmark it was copied in copper and brass, and became a symbol of hospitality, with families and friends gathered around its bubbling warmth. These pots and urns, along with the silver and gold "dresser sets" (composed of mirror, comb, brush, shoehorn, and small jars) went through the usual styles of rococo, classical, and *rocaille,* as in the rest of Europe, and continued until the beginning of the twentieth century to be simply a craftsman's art, right into the age of industrialization. The real beginning of creative work in the precious metals in the Nordic countries came, then, with artists, painters, and sculptors such as Jensen who became intrigued with the beauty and possibilities of the precious metals.

Scandinavian jewelry reflects the currents of the various periods in art and architecture (Georg Jensen's own work was heavily influenced at first by the Art Nouveau period, for example), but the national characteristics usually remain in evidence. The more independent movement away from the fashion trends of the Continent began in the first decade of the 1900's. In some instances there was more emphasis on detail, in others much more importance was given to proportion and graceful form. The latter emphasis proved fruitful, and from those artists came some eloquent demonstrations of the folly of buffing out hammer marks which give personality and distinction to the surface of the silver.

Silver was preferred in those years, partly because the young craftsmen could not afford to experiment with gold, but also because of silver's affinity to simple gems such as coral, amber (known as Nordic gold), moonstones, lapis lazuli, and turquoise.

In the thirties simplicity became so predominant that ornamentation was considered almost immoral. Functionalism was hostile to jewelry and international fashion gave women a masculine style, with long strings of beads popular, so development and innovation lagged during that period. Isolation during World War II for some perverse reason had a stimulating effect and resulted in fertile development of new ideas. Cut off from imports of foreign materials, jewelers found new impulses within their own borders. Unadorned jewelry, with the emphasis on the qualities of the metal itself, came into vogue. There was little use of decorative hammering to conceal imperfections, or flashy engraving; instead simple stone settings and naked form emphasized each movement of the hand and each reflection of light, resulting in the tranquil purity found in antiquities, which was not actually copied but reborn.

The fifties and early sixties brought a return of flights of fancy, in demand during this time of gaiety. and entertaining. Some pieces were wildly frivolous, like Arje Griegst's sensational "Face Tears," but most simply exploited the inherent qualities of perfectly forged metal with stones shining brilliantly in their settings.

Denmark

It was Georg Jensen's dream to create beautiful, functional silver for everyday use in modern homes. Ornamentation was never allowed to dominate. Jensen opened his shop in Copenhagen in 1904, and was later joined by another fine designer of that century, Johan Rohde, then by Harald Nielsen, and all three men were fanatics about craftsmanship. Most of their work was so perfect as to defy any accurate copying. In 1935 Jensen and Rohde both died, and Nielsen, carrying forth the fine traditions of the firm, was joined by Count Sigvard Bernadotte, an outstanding designer in many fields and a member of the Swedish royal family. He, too, was a man with complete mastery of his craft and the rare talent which permits eye and hand to work as one in creating controlled perfection in the form of an object. Later, George Jensen's older son, Jörgen, also an accomplished silversmith, joined the firm, then the sculptor Henning Koppel (the aggressive modernist among them), then Søren Georg Jensen, another son, then Ib Bluitgen, and finally the talented Magnus Stephensen. Georg and Søren Jensen, Henning Koppel, and Ib Bluitgen were all trained as sculptors before they became silversmiths. Rohde was a painter and a furniture designer. Stephensen is an architect.

One of the hallmark's of Jensen's designs was the motif of the little fruit clusters, which were used for decoration and to make handles for basically simple shapes of the most graceful proportions. Rohde and Georg Jensen complemented one another artistically. Where Jensen softened his forms with fruits, flowers, bunches of grapes (in conservative amounts), Rohde rejected all ornamentation that had no functional justification. He preferred to emphasize the quality of the material, logic, and a delicate sense of balance in design. Åke Stavenow, noted Swedish design authority, has said of Rohde: "He was a functionalist before functionalism was a conscious program. His larger pieces are so natural in form that they seem inevitable. Yet study of his numerous sketches reveals the effort required to achieve such extraordinary simplicity."

Bernadotte's silver had severe lines bespeaking the classic style and formality dominating Swedish design during the period of his earlier life, but interpreted flawlessly in a contemporary, very personal manner, with dignity and elegance. Koppel, on the other hand, departs from the traditional and symmetrical with irregular yet gentle shapes, aggressively modern, obviously sculptural, even abstract. As a sculptor, Henning Koppel naturally favors pure form, rather than any surface ornamentation in his silver designs. Light, shadow, and movement are important to the special graceful effects he achieves. His designs call for touching, stroking, holding in the hand. Magnus Stephensen favors softened surfaces, graceful curves, and omission of decoration. He is considered the artistic heir of Johan Rohde. Nanna Ditzel has also joined the staff of Georg Jensen artists. She is a well-known Danish designer of jewelry, and her specialty is modern gold and silver forms. Simplicity is her theme, not only in jewelry, but in the design of furniture, where her reputation is also well established. The works of Jensen designers have accumulated many high awards from international expositions, and many museums worldwide have old and new Jensen pieces in their collections. The fine Norwegian designer Tias Eckhoff also won an award for the firm with a design for flatware developed in 1954 in connection with a contest. The world-famous "Acorn" design (1915) of the Jensen firm was one of Johan Rohde's.

A visitor to the Jensen workshop in Copenhagen finds an air of bustling activity much like Santa's workshop. There are several floors, mostly unpartitioned open space, and cheerfully bright with sunshine from the many big windows. Normally there are about four hundred elves at work, highly skilled craftsmen for whom silver has been a lifework, a personal, non-mechanical, rewarding profession. There are specialists in hollowware (bowls, tea and coffee services, etc.). There are chasers and engravers, those who specialize in fine and delicate work for jewelry, and those who make tableware (also called flatware, as distinguished from hollowware). The silver which, after all the processing, brush and human-hand polishing, and multiple inspections, finally makes the grade is then stamped GEORG JENSEN and STERLING, DENMARK, which indicates 925/1000 silver, true sterling by international standards. (The routine Danish hallmark of three towers stands for 830/1000 silver.) Some pieces are also stamped with a design number and the initials of the artist.

A Jensen craftsman serves a four-year apprenticeship in all branches of the silversmith's art, and after working hours are over, he also goes to a school to be taught the theoretical background of his craft, including drawing, art history, and a technical knowledge of metals and gems. At the end of this period, he must craft a special piece in which every aspect of his knowledge and skill will be rigorously tested. Only after this has been judged by a committee of experts does the apprentice become an accepted qualified craftsman.

At the workshop are a few historic Jensen pieces, but the place to see and appreciate a comprehensive collection properly displayed is at the main showroom on Strøget, the famous "walking-shopping" street of Copenhagen, or, of course, in New York. Georg Jensen, Inc., with shops or outlets throughout America, is a cultural center as well as a retail firm. It occupies a place of immeasurable importance and respect, not only in its business sense, but in its promotion of good taste and artistic sensitivity. The firm is a corporate member of several neighboring museums with which it cooperates. Through all this, the name and spirit of Georg Jensen continue to evoke assurance that objects produced by the highly trained artists and craftsmen will always represent perfect workmanship and technical quality, sensitive artistic form, and timeless beauty.

Danish-born Frederik Lunning established the American branch of Jensen's in New York in 1922, now a world-famous establishment. Frederik Lunning became a pioneer in the introduction of Scandinavian applied arts in the United States. His ambition and work were carried on by his son, Just Lunning, after whose death the firm still continues in the Lunning tradition.

In 1951, honoring Frederik Lunning's seventieth birthday, the first Lunning Prizes were awarded. The prize (then $5,000, now $8,000) is given each year to two young Scandinavian designers, and is highly

A beautiful piece of sterling-silver hollowware is made entirely by hand, usually by one man throughout its creation. Silver is expensive, but it is also malleable, and eternal in its beauty. These pictures were taken at the silversmith workshop of Georg Jensen Silver, the largest in Denmark and certainly one of the most famous in the world. A bowl made from an old design of Georg Jensen is shown. (1) Raw silver, imported in bars, sheets, wire, or beads, is largely brought into Denmark nowadays from the western United States, Mexico, Canada, and Bolivia. (2) The tools of the silver craftsman are simple. (3) The bowl is made from sheet silver. The silver is folded over wooden blocks of various shapes and sizes and raised until the required form is achieved. (4) With an exact drawing of the piece in front of him, the silversmith continues to hammer the disk into shape, which takes more than a week. Tension arises from time to time in the silver. Heating the silver with a blowtorch until red hot relieves this tension and avoids splitting the metal. (5) Hundreds of thousands of hammer taps and about three weeks later, the bowl is smoothed and finished, using a broad-faced smoothing hammer and a file. (6) The famous Georg Jensen grape-vine ornamentation is built up and soldered together. (7) The ornamentation on the base of the bowl is chased. (8) Base and bowl are soldered together. (9) The finished bowl from the 1919 drawing by Georg Jensen. [All photos courtesy Georg Jensen Silversmiths, Ltd.]

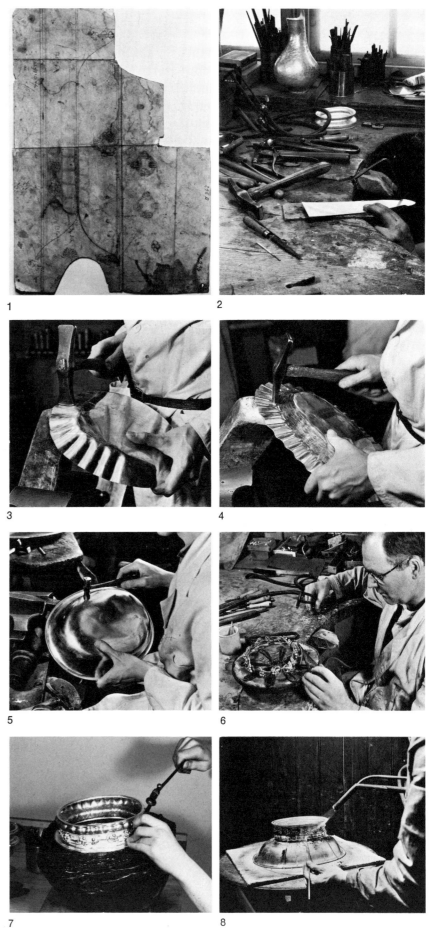

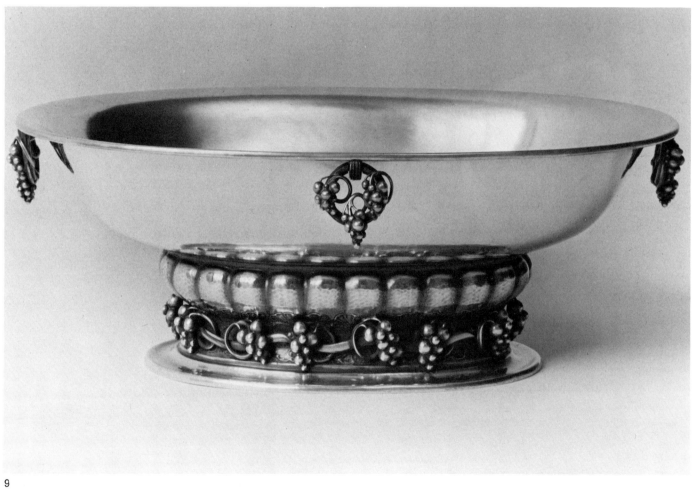

9

a
Silver flatware service designed by
Georg Jensen in 1908
b
Sterling coffee service designed by
Georg Jensen in 1906
c
Georg Jensen's first associate in his
silversmith firm was Johan Rohde.
Rohde delighted in unadorned simple
grace and proportion. This silver pattern
designed by him in 1915 continues to
be a favorite today. It is named "Acorn"

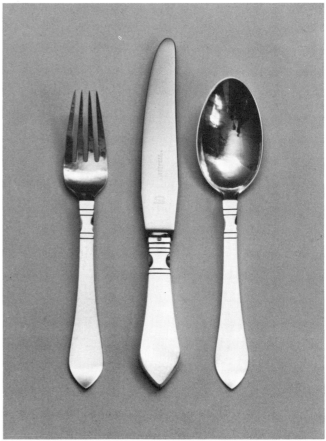

a

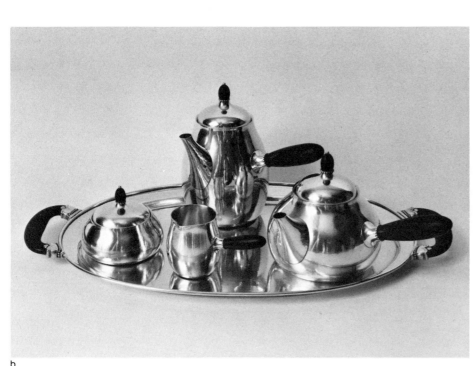

b

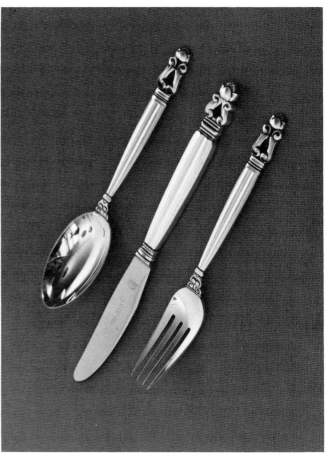

c

a
Graceful, sculptural in feeling, this
pitcher was designed by Johan Rohde
at Georg Jensen in 1920. This simplicity
was strange in those days. Rohde was
decades ahead of his time in his
feeling for unadorned surface
b
Silver bowl by Johan Rohde for Georg
Jensen

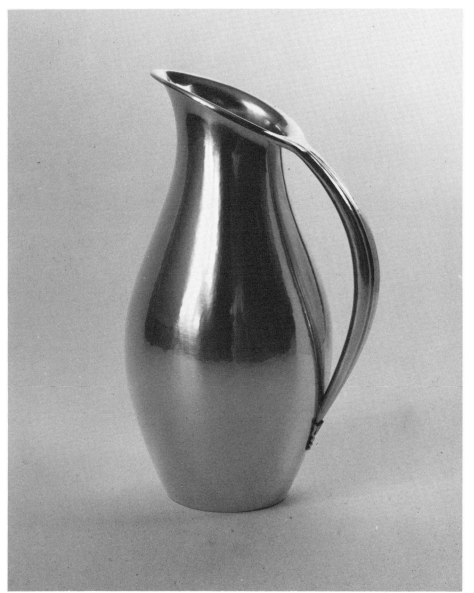

a

b

a
Henning Koppel's famous "Fish Dish,"
designed in 1954 for Georg Jensen,
original model acquired by the Museum
of Industrial Art, Copenhagen, in
1957. [Courtesy Den Permanente]

b
Søren Georg Jensen, a sculptor like
his famous father, designed this
sterling candelabra in 1963. [Photo
courtesy Den Permanente and Georg
Jensen]

a

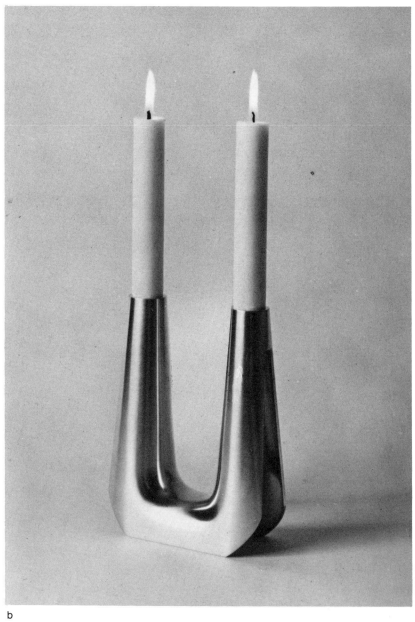

b

a
Brooch in gold by Henning Koppel,
1965. [Georg Jensen]

a

b
Pipkin for melted butter, in sterling,
designed in 1965 by Henning Koppel
for Georg Jensen

c
Condiment set in sterling (the dish
lined with blue jeweler's enamel) by
Søren Georg Jensen, designed in 1963

b

c

a

In 1954, to celebrate its fiftieth anniversary, the Georg Jensen firm invited all Scandinavian artists to submit designs in silver, offering cash prizes and royalties on designs chosen for production. A great number of artists responded; one of the most prominent designs was this one—"Cypress"—by Tias Eckhoff of Norway, also famous for his work in porcelain and other media

b

Nanna Ditzel and her husband,Jørgen Ditzel, became a leading designer of jewelry for the Georg Jensen firm. The necklace is in sterling with carnelian and black onyx stones, designed by the Ditzels in 1960. The bracelet is sterling, designed in 1955, the original now in the Museum of Applied Art at Trondheim, Norway, acquired in 1958

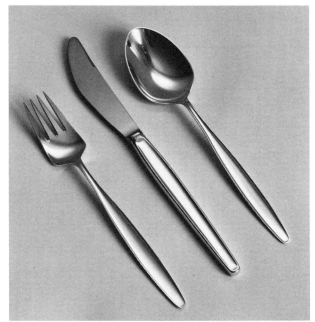

a

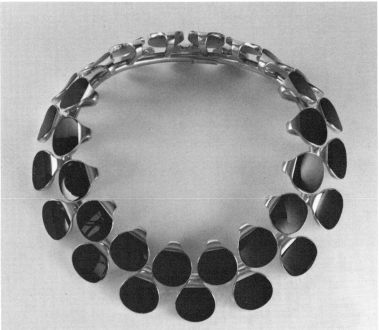

b

b

a
Silver service designed in 1961 by
Magnus Stephensen for Georg Jensen.
Note knife blade, designed to allow
full cutting edge when the knife is
held in the hand
b
Silver dish with cover by Magnus
Stephensen, 1962. [Georg Jensen]
c
Lidded container in sterling, designed
in 1951 by Magnus Stephensen. [Georg
Jensen. Courtesy Den Permanente]

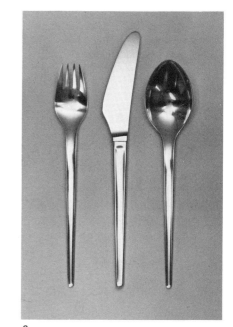

a

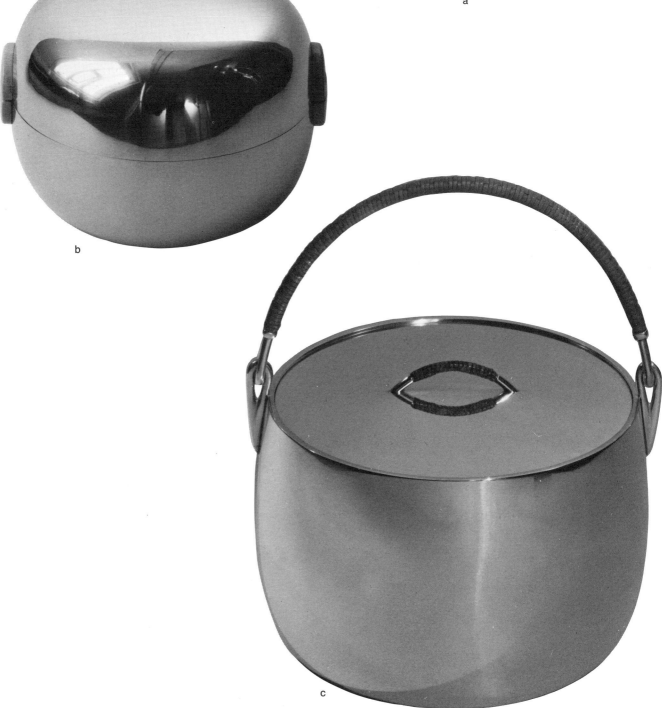

b

c

a
Two linked sterling bracelets charac-
teristic of the designs of Ibe Dahlquist.
Designed in 1965. [Georg Jensen]
b
An exciting Danish designer of jewelry
is Arje Griegst, who created this "face
jewelry." The "Face Tears" are
modeled here by a star of the Royal
Danish Ballet, Anna Lærkesen. It is
made of gold with Oriental pearls,
emeralds, rubies, and sapphires.
[Photo: Rigmor Mydtskov-Steen
Rønne]

a

a

b

esteemed. The winners are chosen by a committee in Scandinavia, not by the award fund. The recipients must be talented, show promise of further development, and be under thirty-six years of age. The jury fulfills its task with awareness, discernment, and foresight, and has indeed over the years succeeded in selecting the trend-makers and subsequent stars of Scandinavian design. The award money is stipulated to be used for travel and study abroad. The first awards, presented in Copenhagen on December 21, 1951, were given to Hans Wegner of Denmark and Tapio Wirkkala of Finland, about each of whom you have already read a great deal in this text. An exhibit in 1957 of the works of Lunning winners up to that time showed how vital and influential these Scandinavian artist/craftsmen have become in the world, and the caliber of articles was so excellent that the exhibit was circulated throughout the United States under the sponsorship of the Smithsonian Institution.

It is told that Frederik Lunning re-educated American taste not only with the beautiful things he presented for sale but with his inimitable Danish charm. He once, legend says, sold thousands of dollars worth of Jensen silver to a man who had simply wandered into his shop to borrow a telephone book. Starting at first with only silver, he later added Danish wooden articles, Royal Copenhagen porcelain, Orrefors crystal, and so on, ad infinitum, and now the firm represents a crucible of the best design from all the Scandinavian countries, and from other European countries as well. Lunning died in August 1952. His son Just, and his two daughters, Lis Lunning Rusch and Ruth Lunning Bailey, joined the management team then formed, along with four other members of the firm's staff. Just Lunning was already considered a "taste-maker" and an internationally respected expert on design, so the firm continued its phenomenal growth pattern, and it has not stopped yet.

Another long-standing, leading silversmithery in Denmark is A. Michelsen of Copenhagen, which for many generations has been well known for its receptiveness to new ideas and artistic developments in the design of precious metal objects. Anton Michelsen himself made conservative objects usually classical in theme, but the firm has also had under its wing a rare bird in Danish jewelry design named Arje Griegst, whose lively innovations included the famous "Face Tears" mentioned earlier. In this design, a thin gold wire loops behind the ears and over the nose, contoured somewhat like the bottom half of spectacle frames. From this, three tiers (tears) of droplets fall over the cheeks. In one case, they are tiny diamonds, rubies, or sapphires; in another, emeralds are glimpsed through a tiny pearl cage. Griegst was one of the first to design bracelets attached to finger rings by tiny jeweled chains. He was ahead of his time (1963) with these; presented again today, they would probably be newly sensational and popular. The many talents of the Danish architect Arne Jacobsen have also touched the world of metals, as, for example, in a set of table cutlery in stainless steel produced by A. Michelsen. Almost abstract in form, it is well-proportioned simplicity at its best and undoubtedly the easiest flatware to maintain of any ever devised.

Other long-established Copenhagen silversmiths include Carl M.

Cohrs, best known for production of "silverware for everyone" (in other words, old favorites acceptable to almost all homes), but who has nonetheless always welcomed the unusual from artists such as Knud Engelhart or Hans Bunde; and Hans Hansen, who graduated from the Cohrs firm into his own workshop in 1906 at Kolding, Denmark, and drew into his fold such fine designers as Karl Gustav Hansen, designer of the shell-like flatware named "Linje," a continuously popular pattern.

In Denmark there are a great many admirable artist-designers in the field of jewelry and precious metals and stones, but one of my own personal preferences (I have lots of company in this choice) is a young lady by the name of Jane Wiberg. She has her own atelier at 9 Hyskenstraede, Copenhagen, but it is easier to see her work in such fine shops as Klarlund on the more convenient street Vesterbrogade. Jane Wiberg, in only a few years, has emerged as one of Denmark's most brilliant creative designers of modern jewelry. She is represented in exhibitions throughout Europe. Her creations emphasize the use of links and polished native stones such as amber and amethyst, and have a distinct, though modified, Viking-maiden air. Jane Wiberg began her own workshop in 1960, and by 1964 she already had her own exhibition at Den Permanente. She gets her inspiration first of all from the gems she uses, letting the character of the various stones be the reason behind the form and the mounting in gold or silver a backdrop to emphasize the special splendor of each particular stone.

At Klarlund's shop one can also see the bold designs of Anni and Bent Knudsen, most often gracefully simple interpretations of modern forms in heavy sterling with large, local, polished gemstones. Klarlund also exhibits the work of Palle Bisgaard, a designer who is masterful at jewelry which is particularly handsome in its ultrasimplicity and honest craftsmanship. His ornamental stones are exclusively mother-of-pearl, polished and set in sculptural silver mountings. Bisgaard's jewelry is of high artistic value and exemplifies the finest workmanship. It has been acquired by art galleries throughout the world.

A uniquely Scandinavian piece one can see at Klarlund or at many other jewelers throughout Scandinavia is called the "Queen Margrethe" cup. According to tradition, this cup was originally used at her medieval court. It was made in splayed, fluted form with an eight-scallop rim, to permit seven ladies-in-waiting to drink before the queen, so she might be certain the wine was not poisoned. Today's replicas are made in heavy gilt silver, hand-wrought and profusely chased, and sometimes enameled also. Usually shown along with this cup are the gold or silver bridal crowns, tiny regal crowns with the points topped in small spheres, traditional over many generations for Nordic brides and believed to have originated in semblance of the small crown worn, in statuary, by the Virgin Mary.

Den Permanente in Copenhagen maintains a permanent display of Kaj Bojesen's sets of silver flatware and hollowware, all of which are considered modern classics. Bojesen was a happy person with genius. He is recognized as a symbol of the humane feeling in Danish handicraft and a leader in his inimitable way of the development of Danish silver as it departed from the bleak forms it has assumed during the

a
Sterling-silver flatware by Arne Jacobsen, made by A. Michelsen of Denmark, 1958. [Courtesy Den Permanente. Photo: Strüwing]

b
Table service "Linje" (Line) in sterling by Karl Gustav Hansen for Hans Hansen Silversmiths. [Courtesy Danish Society of Arts and Crafts and Industrial Design]

c
Necklace in sterling with fire gilding, designed by Bent Gabriel Pedersen for Hans Hansen Silversmiths. This jewelry artist's popularity has grown steadily since 1958. One of the reasons is his primary consideration for the way a necklace or bracelet should be contoured to sit perfectly on throat or arm. This necklace was designed in 1968. [Courtesy Den Permanente]

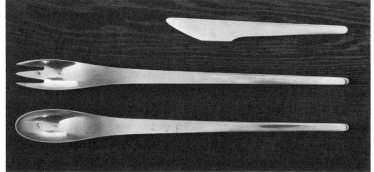
a

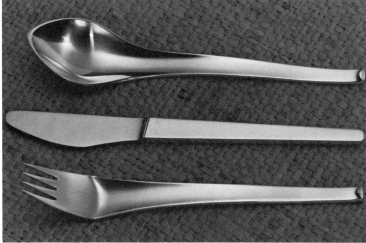
b

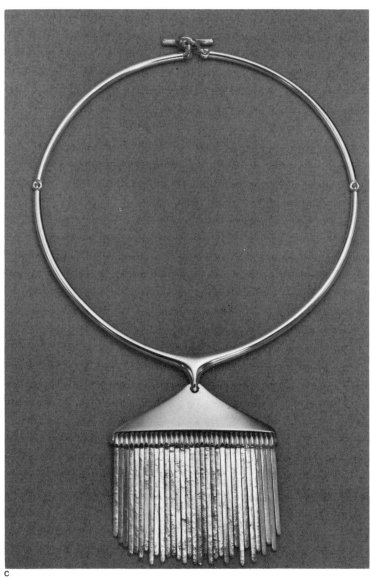
c

Klarlund Jewelers, Copenhagen, proudly displays handmade pieces by leading individual designers of jewelry in Denmark. Jane Wiberg is a silver designer who has become well known for her fine work, especially in her use of native amber and other semiprecious stones from Denmark. Shown here are some of her designs: (I) Linked ring in sterling with amber stone, (2) Bracelet in sterling, (3) Sterling pendant with amber, (4) Cuff links in silver with amber, (5) Sterling pendant with agate stones. [Photos courtesy P. Klarlund, Copenhagen]

1

2

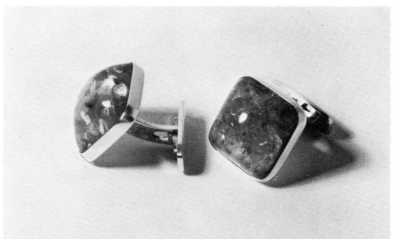

3

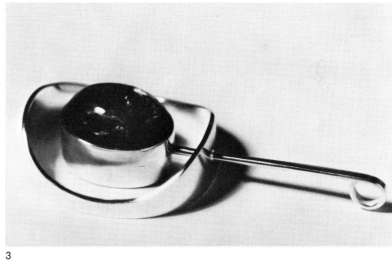

5

4

Goldsmith Ole Lynggaard works in his own studio in Hellerup, Denmark. He works mostly with precious stones. Some examples of his art: (1) Gold ring with diamond, (2) White gold ring with diamonds and an emerald, (3) Matched pearls with clasp in white gold with polished turquoise, (4) Gold with pearls and diamonds. [Photos courtesy P. Klarlund, Copenhagen]

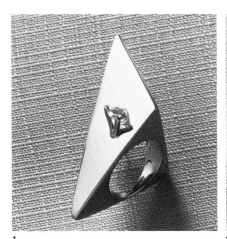

1

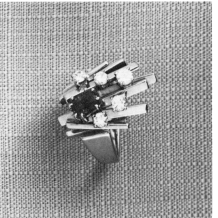

2

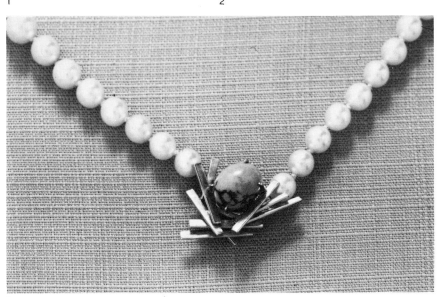

3

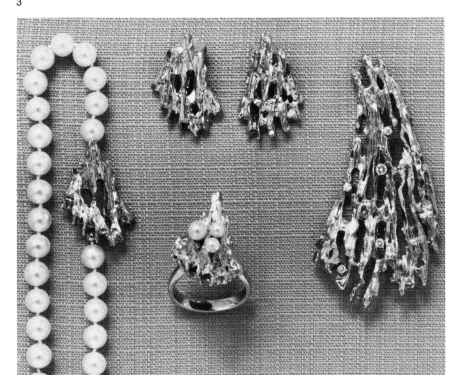

4

Anni and Bent Knudsen designed and made this necklace and its matching bracelet in their own workshop in Denmark. Sterling. [Courtesy Den Permanente. Photo: Jørn Freddie]

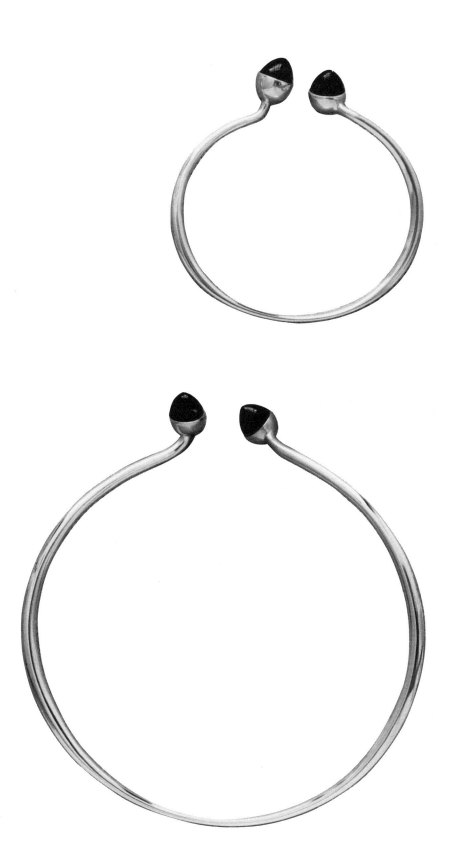

first years of international functionalism. He died in 1958, but his workshops continue to make the excellent designs he created in both silver and wood.

One of the most beautiful objects in all of Denmark's (or any country's, for that matter) silversmithery is the silver sauce bowl and ladle on a wooden tray designed by Kaj Bojesen in 1949. It is a simple, rounded bowl of perfect proportion and form, artistically set off to unaffected aesthetic advantage on a carefully worked, round teakwood stand, which underscores the natural luster of the silver. This talented and much-loved Danish designer has been mentioned in the chapter on wood, but his genius was essentially directed toward his career as a silversmith. He had a great gift for proportion and applied this sixth sense gently and lovingly to both materials. He liked to design everyday articles such as teapots, jugs, or pans with lids deep enough to be used separately. Silverware for regular use was his delight, and he constantly urged daily use of silver objects to bring out the sheen or patina which only the minute marks of use can bring to this metal. His silver pieces were clear of line but never sharp, angular, or impersonal.

Bojesen was one of the first to experiment with a three-pronged fork, less likely to split the food it pierces, and with angling a knife blade in relation to the handle, making it possible to cut with the entire edge rather than with just the tip, as in conventional designs. Most cutlery patterns in those days had little new development in form but were simply variations of well-established shapes with different decoration.

Kaj Bojesen having pioneered with some common-sense thinking in flatware design, the Danish architect Erik Herløw continued this progress in his stainless-steel pattern "Obelisk," the result of careful analysis of use, material, production techniques, and sensible yet artistic form. "Obelisk" makes the most of its raw material, exploiting the high-carbon bar steel imported from Norway, which can be tempered and which allows all pieces to be made from one material, whereas formerly forks and spoons had to be made from plate steel. The balance and shape of "Obelisk" (manufactured by the Universal Steel Company) are exactingly worked out in both appearance and feel.

Herløw, once diverted from silver to industrially produced stainless steel, revealed a natural flair for giving mass-produced articles an artistic fillip. He proved that inexpensive goods were well worth the effort and consideration of artist or architect, and in so doing set a new high standard for Danish industrial design.

Silver being expensive, many young families have turned to stainless steel; thus, Herløw and other designers, in the fifties and sixties, promptly provided good design in stainless ware to fulfill the need. This material is well suited to the simplicity of modern forms and is therefore a favorite with contemporary designers. It goes particularly well with teakwood, and with the new hard plastics in white or black. Denmark, like her sister countries, makes handsome stainless articles, proud of steel as a material, with no intent to imitate silver.

The great architect Poul Henningsen is worthy of a book of his own, but I want to mention him in this section chiefly for his accomplishments in the field of metal lighting fixtures. Henningsen has been a leader in spreading light in homes throughout the world. He stood alone against the technicians of the world in their fondness for phosphorescent street lamps, for example. He has carried out an experiment with incandescent lamps made by Louis Poulsen A/S, setting them up in a section of downtown Copenhagen in a relatively low position to throw light from the curb almost horizontally in the direction of the traffic, thus clearly silhouetting pedestrians and parked vehicles and leaving the driver's half of the road well lit and without reflections, even in rainy weather. This is the sort of architectonic expertise with which Henningsen approaches every design problem. His "Artichoke" lighting fixture (followed by others based on the same metal "petals" used to provide ample light reflected in exact directions with no glare) is adjustable to warm or cool light and has become world-famous. It isn't inexpensive, but for good reason. No more handsome and efficient lighting equipment can be found, for Henningsen made a science of it. It was an admirable development, much needed in countries where electricity is costly and low-wattage bulbs are used. Henningsen has designed many, many things. Because his initials appear on a multitude of award-winning articles, he has become affectionately known in Denmark as "PH."

It should be added here that almost everything created in silver in the Nordic countries is also made in pewter. A soft, lustrous alloy of tin, copper, bismuth, antimony, and lead in varying proportions, it is sometimes brushed, sometimes highly polished. This magnificent metal is very easy to fall in love with. It tarnishes little and requires minimal cleaning. A brighter and more durable form of pewter is known as "Britannia." It is said people are either mad about pewter or don't like it at all. Pewter is more sturdy and beautiful now than in its eighteenth-century heyday, and collectors or fanciers of this softly glowing metal can run amok in Scandinavia, where the pewterers make articles in both traditional and modern forms, some for elegant settings and others ideal for rustic environments.

Amber is a Scandinavian favorite, especially in Denmark, as a gem for jewelry. It is found in few places in the world, the Danish shore being one of them. Amber is a rare substance formed from the resin of prehistoric pines, solidified and carried by rivers down to the sea, which from time to time yields it up among the seaweed and anemones. Much tradition and superstition is woven into its history, such as protection from witchcraft and disease. Girls in olden times wore an amber anchor for hope, a heart for charity, a cross for faith. Golden drops of amber, according to legend, are the petrified tears of the sun goddess. Amber is full of life . . . if you rub it, its static electricity is apparent; warm it, and you will get a whiff of incense. Sometimes it is opalescent, sometimes a deep, dark red, sometimes as clear as a golden topaz. Craftsmen working with this precious material are specialists known as amber polishers and are fanatical devotees of their work. In fact, there is an old Danish saying: "First the man takes to amber, then amber takes to the man." Denmark has never systematically exploited amber. Rather, it is gathered at the seashore as nature decides to give it up to the craftsmen whose obsession it is. True amber is hand-worked; that known as "antique amber" is genuine enough, but is heated at 570° F. and

a
Sterling table silver "Grand Prix,"
designed by the great Kaj Bojesen in
1938, made by Kaj Bojesen Silver,
Copenhagen. Winner of the Grand Prix
at the IX Triennale, Milan, 1951.
[Courtesy Den Permanente]
b
Traditional bridal crown with gilded
balls made in sterling silver for
Klarlund Jewelers. Designed by
Theresia Hvorslev for Åge Fausing's
Silversmithy. The crown is customarily
engraved with the wedding date and
the names of the bride and groom.
It is a family piece, to be used genera-
tion after generation. [Courtesy
Klarlund]
c
An example of Scandinavian teamwork
is this beautiful necklace in sterling
with Orrefors crystal. Designed by Åge
Fausing for Klarlund of Copenhagen
and made at his own silversmithy in
Copenhagen. [Courtesy Klarlund]

a

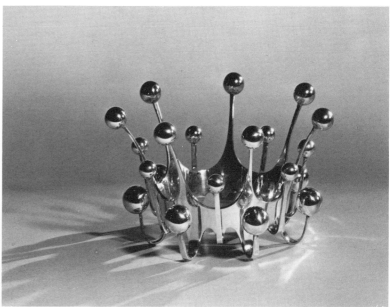

b

c

molded into shape. It has not always been confined to use for jewelry. In the eighteenth century, amber's heyday, wealthy families had silver plates with amber bottoms, royalty had amber chandeliers in their palaces, and foreign monarchs commissioned Danish amber polishers to decorate whole rooms in amber in their magnificent and ornate dwellings. Interest dwindled until recent years, when the return to natural materials has restored its popularity. Amber is found mostly in Danish shops, but designers in other Scandinavian countries are also proud to embody this gemlike substance in their jewelry design occasionally.

Norway

There are three major outstanding, long-established silversmith firms in Norway, namely, David-Andersen, Tostrup, and Thune. Since their pioneer spirits and artistic-technical quality are similar and closely related, the firm of David-Andersen can be an illustration for all.

David-Andersen is now operated by the fourth and fifth generation of this family. Of all the firms making the exquisite enamel-on-silver for which Norway in particular is famous, there is none better than this house, established in the year 1876. The fine traditions of the firm, inaugurated by the founder, David Andersen, have been continued by his sons Alfred Andersen and Arthur David-Andersen, his grandson Ivar, and his great-grandson John Arthur, not to mention a couple of ladies in the clan, Uni and Ben David-Andersen, who have their own design studio with a few other women silversmiths, turning out one-of-a-kind pieces and designs for reproduction in limited series.

David-Andersen productions consist of flatware, hollowware, and jewelry, in silver, gold, and enamel. The firm has received many international awards in Europe and the United States, and its articles are greatly admired for their beauty, superior workmanship, and high quality. The artistic tendency is conservative, with a small percentage of contemporary designs. Old patterns are favored, such as the rococo "Telemark," to which certain improvements have been made as a concession to convenience, like the small hook on the back of the graceful gravy ladle so that it will not slide into the gravy boat. "Oldemor" (Great-grandmother) and "Rokoko" are two other lovely old flatware patterns.

It is the firm's feeling that although industrial production is an important aspect of the gold- and silversmith arts (and the newer developments in design are often the result of today's automated methods, as well as contemporary taste), the ancient art of working in precious metals must retain nobler aims than merely satisfying practical demands and reasonable price requirements. The goldsmith's art must always try to produce the very best with artistic perfection and exquisite craftsmanship. The old methods are still used today; in this profession the handworker is still unmatched by any machine.

Imitations are unpopular at David-Andersen except in rare cases where goldsmiths of the past have produced works of gold and silver of such enduring loveliness that it would always be difficult to fashion anything better. A good reproduction demands great expertise on the part of the craftsman. David-Andersen's program includes a selected production of finely wrought replicas of famous old pieces, such as the magnificent Kvarberg tureen, crafted in 1700 by Oluf Hansen of Oslo (when Oslo was known as Christiania).

In fashioning jewelry and trinkets, this firm feels functional design is of course much less important than in other silver and gold smithery. Jewelry should be beautiful first and foremost. It should be designed to retain its aesthetic and monetary value in spite of changing fashions. The David-Andersen hierarchy side with the more conservative approach in the field of precious metals and jewelry. "We claim no monopoly on good taste," they say. "Nor do we know what will stand the test of future judgment or may prove of merely passing value. But as an educated guess we view with a measure of skepticism those aspects of design which are considered high fashion and which rely for their effect on the sensational, without achieving any notable aesthetic or practical advantages. Experiments which can be regarded only as incomplete solutions should never be offered for sale. Free art rarely should be experimented with in precious metals, although this should certainly never be considered an iron-clad rule by any means. Per se, any material should be considered a possible vehicle for creative art, but in the case of the precious metals, it would then be logical to be able to disregard entirely any practical considerations, and the opportunity for this would be exceedingly rare."

The goldsmith, then, is involved in the joys of creating uncommonly valuable, beautiful objects meant to raise our mood above everyday things, meant to last for many future generations, and furthermore often purchased with an eye toward increasing value. Most of the goldsmiths consider this a sacred trust and responsibility.

Jeweler's Enamel (*Emalje*)

Since Norway is the leader in this work, especially David-Andersen, this is a suitable place to discuss the ancient and modern art of *emalje* and return to the silversmiths later.

The Chinese, Egyptians, and Greeks were the first to use enamel for jewelry. This distinctive art reached North Europe about 200 B.C., and fine examples from Rhine regions, Limoge, and Byzantium are preserved in many museums.

Enamel is a glasslike, clear, colorless substance made principally from silicic acid. Oxides of various metals, such as iron and cobalt, are melted with this to create the various colors. The glass is heated, then poured from its crucible into cold water, which breaks it into small pebbles. It is then ground to a powder in porcelain bowls with porcelain balls and water, and centrifuged for half an hour. The powder is reconstituted as needed by mixing it with water. There are two types—one can be sprayed (*sprøyte*) and is used for large pieces, the other is painted on by hand using small spoonlike tools or minute mink-hair

Art Nouveau touched Norwegian arts and crafts as elsewhere. This pitcher was designed by Arthur David-Andersen himself in 1901 and is a typical example of the period or, more accurately, a forerunner of Jugendstil in Norway. [Courtesy Ivar David-Andersen. Photo: K. Teigen]

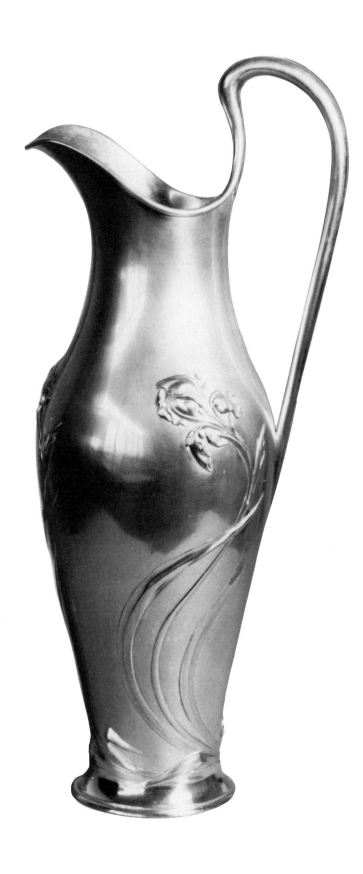

a
Salad serving set, rococo-inspired
design. [David-Andersen, Oslo.
Photo: ALL]
b
Salad serving set in sterling with
peasant-craft motif. David-Andersen,
Oslo. [Photo: Hayden & Steps, N.Y.]

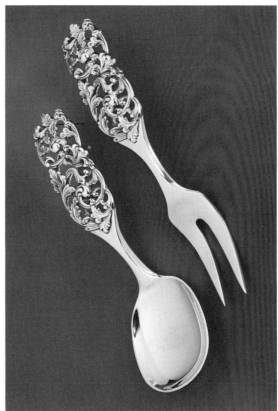

a

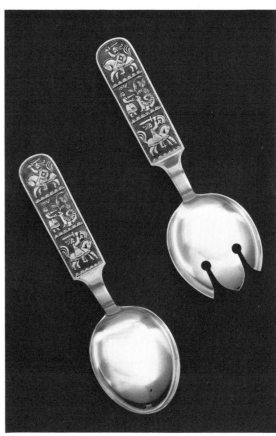

b

The Norwegian firm of David-Andersen
has always been a proponent of the
preservation of great works in silver
and gold from the past. This tureen in
sterling is a typical example of baroque
craftsmanship, notable for its richly
chased decoration, and bears eloquent
testimony to the high standard of the
goldsmith's art in Norway almost
three hundred years ago. The original
was the work of goldsmith Oluf Hansen
of Christiania, c. 1700, and is now a
part of the Sandvig Collection at
Maihaugen, Lillehammer, Norway.
About 13″ long by 8″ high. It is known
as the Kvarberg tureen. [Courtesy
Ivar David-Andersen. Photo: K. Teigen]

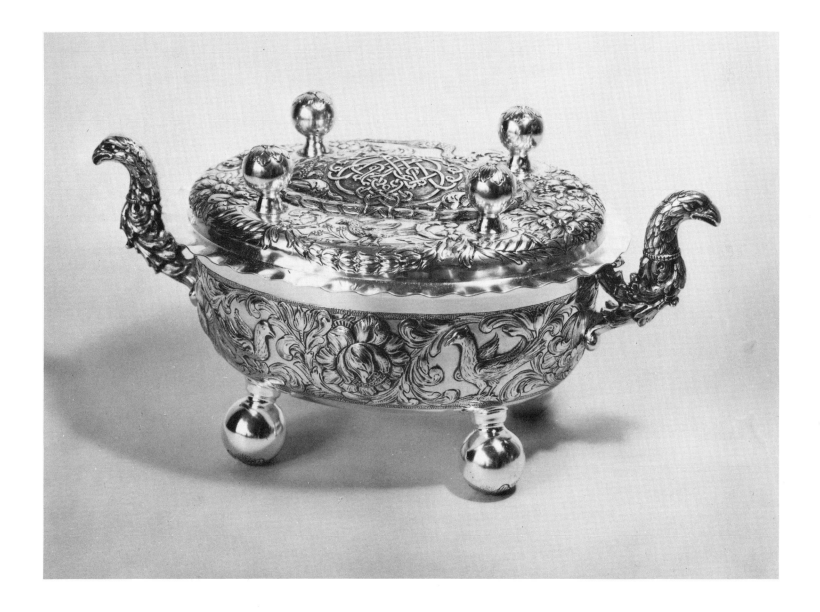

Jeweler's enamel on silver is an art for which Scandinavia, and most particularly Norway, is justly famous. Entirely handcrafted, the production is limited—each piece may be considered a collector's item. The design is first drill-engraved or acid-etched similar to the method used for stone or lithograph work. Lithograph chalk protects the pattern and the acid eats away the rest. A third method is by chasing, and a fourth by "guilliusjering," which is engraving done with a machine, much as money is made. A guide wheel guides the needle on the piece. (1) The vases being enameled here are embossed and the enamel is applied thickly and patiently with a fine mink-hair brush. (2) The pre-engraving can be seen in this picture. On larger pieces, the enamel is applied from three to five times, and is polished and baked between each application. (3) The smallest pieces receive the same delicate handcraftsmanship. At the David-Andersen Oslo workshop, where these pictures were taken, only 925/1000 sterling is used.

1

2

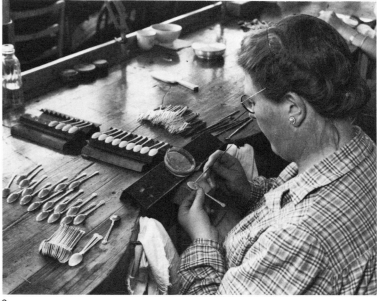

3

brushes (*gråv emalje*). The latter type must be centrifuged for about ten minutes; the colors lighten in the processing which follows. It is tricky, meticulous work.

Before the enamel is applied, the surface of the silver article is most often given a decoration of hand-engraving, chasing, or engine-turning (*guilloche*) to intensify the color glow and to give light and shade effects. The jewel-like glow of the finished enamel results, first, from its application to silver (at David-Andersen 925/1000 sterling is used), and second, from the reflections and refractions of the underdesign. Enamel can be applied to stainless steel, aluminum, or copper, each of which lends its own sheen to the enamel, but the most gemlike and iridescent effect is unquestionably achieved with enamel over sterling silver.

Two or three coats are used, each "burned" (fired) and filed down with a carborundum stone to smooth perfection. This makes the surface dull, so it is then refired to recapture its brightness and clarity. In large pieces, or pieces in which several colors are used, the firing may be repeated as often as six or seven times. Finally, the surface is vigorously polished with small pearwood disks and felt. If the piece is to be gilded, it is then subjected to an electroplating golden bath. The enamel is unaffected by this since glass will not conduct electricity. The thin topcoat is 24k gold, and each coat takes half an hour. The vats are ceramic. Small pieces are polished automatically, in soapy water with tiny steel balls in it; large pieces must be polished by hand.

The firing in the electric oven at about 1300° F melts the enamel and makes it adhere to the silver, in about one minute, more or less. The more or less is vital; everything depends upon the keen eye of the ovenmaster, with a few seconds making all the difference. The skilled ovenmaster is as important as any master chef preparing a royal feast. Timing means everything, and is more dependent on the experienced eye than on any precise-second formula. Most colors change entirely in this process. Yellow and gray after cooling ten minutes turn to light yellow. Bright red turns to dark green, etc. The workers in the shop cannot smoke or eat, especially fruit, as the enamel is seriously affected.

There is no secret formula for the success Norwegian silversmiths enjoy in this field. It is simply that they have, in the eighty years they've been working with the process, improved techniques. The melting point of silver is about 1750° F, the enamel having a melting point very close to it, and the heat expansion of the two differs, so expertise has been a matter of skill, perseverance, and experience.

Unfortunately, the extraordinary glowing beauty of enameled silver does not photograph well. The camera cannot properly reproduce the deep brilliant color and shadow-light effects resulting from the clear enamel over the underlying sheen of silver and the delicate engraving patterns which bring such life to the finished piece.

Now that the art of adapting enamel technique has been developed for application to stainless steel, copper, and aluminum, there can be found a wide range of elegant and useful articles in Norway in a lower price category. Developed by Grete Prytz Korsmo, the Cathrineholm

firm of Halden, Norway's oldest enamelworks till it ceased operation some years ago, had perfected the technique to the extent of winning a gold medal at the XI Milan Triennale. Cathrineholm products were found throughout the world as they were both artistically and practically suitable for the preparation and serving of food. The even less expensive enamel-on-copper or aluminum articles, though less durable than the others, are very lovely, since the apricot or gray-white gleam of the base metal lends special color effects through the transparent enamel. The pinks and pearl-white pieces are especially distinctive.

The Norwegian Designers

Besides the David-Andersen family, other artist-goldsmiths associated with the firm have included Guttorm Gagnes, Harry Sørby, Unn Tangerud, Bjørn S. Østern, and, greatest of all perhaps, the artist Thorbjørn Lie-Jørgensen, so admired and loved by friends and colleagues alike that a fine book was published in his memory when he died at the age of sixty in April 1961.

Lie-Jørgensen was silversmith, designer, and painter. He made his way to Oslo after an apprenticeship with the famous silversmith Henrik Lund in Telemark, the district known as the "birthplace of skiing." He then studied at the Royal Academy of Design, winning a scholarship given by the Norwegian Goldsmiths' Union that enabled him to acquire four years' training in the craft at the State School of Industrial Arts and Crafts in Oslo. He became famous while still a pupil for several large works in silver, and thereafter joined David-Andersen, where he remained for thirty-three years, until his death. He is also recognized as one of Norway's leading and most highly prized artists, with paintings in many galleries in Norway and abroad.

Lie-Jørgensen's silver designs were bold, often pictorial, and he had a knack for softening shapes. A very famous piece of his is a large, round, flat, bordered silver dish commissioned by the officers of the Royal Norwegian Navy as a wedding gift to Crown Prince Olav and his bride, Crown Princess Märtha, in 1929. Acclaimed by connoisseurs as the finest ever executed in Norway, the dish is notable for its broad edge embossed, in an almost Cellini-like way, with delicate and perfectly proportioned reliefs depicting Viking ships interspersed with zodiac symbols. Altar vessels and candlesticks designed and made by him were considered almost an exhibit in miniature "of pure and noble form and exquisite treatment of the medium," according to Dr. Reidar Kjellberg, director of the Norwegian Folkemuseum and author of the artist's tributory book. A famous creation in the way of jewelry was his golden cross, enameled and adorned with pearls and diamonds, yet retaining an elegant simplicity. It was made as a christening present to Princess Ragnhild in 1930, commissioned by all the women of Norway who bore the same Christian name.

With the onset of functionalism in the 1930's, Lie-Jørgensen retained a sense of balance (as Norwegians are prone to do in everything) in his personal study of simplification of form. His hollowware shapes became

a
Sterling tea set with black fiber handle,
handmade for David-Andersen of
Norway by designer Harry Sørby.
[Photo: K. Teigen]
b
This coffee set made by David-
Andersen and designed with aesthetic
expertise by Bjørn S. Østern has been
acquired by the Nordenfjeldske
Kunstindustrimuseet. [Photo: K. Teigen]

a

b

One of the greatest designers and silversmiths associated with the David-Andersen firm was Thorbjørn Lie-Jørgensen, who died in 1961. One of his major pieces was a silver dish designed and made in 1929 as a gift from the Royal Navy of Norway officers to (then) Crown Prince Olav and his bride, Crown Princess Märtha. Acclaimed by connoisseurs were the flat bottom and broad edge with its beautiful proportioned reliefs and delicacy of craftsmanship, seen in this detail close-up. Border about 3½″ wide, in sculptural relief

more sparing of ornamentation and emphasized elegantly refined shapes executed with discipline and restraint. The spouts and handles of his coffee pots, for example, were integrated more closely with the main shape and proportion of the pieces, a development which proved a milestone in contemporary design of such articles.

With the exigencies of the Occupation years, Lie-Jørgensen lent his talents to some small Macassar wood boxes by inlaying silver designs in the lid, either forest/animal designs or modified geometrics. After the war, he continued making these, having discovered the natural affinity and interplay between these two materials. An example made by him in 1942 may be seen at the Kunstindustrimuseet in Oslo.

Until recently Norwegian churches were spartan as to furnishings; with the altar silver made by Lie-Jørgensen, a beginning was made in ecclesiastical decoration. It is simple and conservatively sacred in feeling. Following Lie-Jørgensen's example, church adornment is now receiving more attention from silversmiths and textile artists, though much remains to be done in comparison to Norway's neighbors, Iceland, Denmark, Sweden, and Finland, where religious buildings contain a wealth of art and are in themselves architecturally fascinating.

Another leading contemporary Norwegian jeweler is young Tone Vigeland, an attractive woman whose talent focuses on abstractly simple forms in sterling. Her "Sling" earrings, for example, are similar to a three-dimensional numeral 6, the top fitting behind the ear, the in-curve hooking in by the earlobe, hanging the earring in place very comfortably. They are reversible, and involve no clamps, wires, posts, or other clipping devices, which not only complicate production but are a weak spot subject to breakage or poor adjustment. Tone Vigeland, Anna Greta Eker, Odvar Pettersen, Ragnar Hansen, and Erling Christoffersen are all young silversmith artists working at PLUS in Fredrikstad, Norway. Set in a picturesque location, the ten studios of the PLUS applied-arts workshop represent an organization for encouragement of designers, craftsmen, and industrial enterprises dedicated to improving artistic and technical standards in such fields as silver- and goldsmithery, ceramics, weaving, carving, etc.

Grete Prytz Korsmo, whose enamel work was discussed above, is the daughter of the grand old man among Norwegian silversmiths. Jakob Prytz was an inspiring influence (until his death in 1962) as head of the State School of Crafts and Industrial Art (Thorbjørn Lie-Jørgensen was trained by him) and as a great artist with a perfect technical and aesthetic knowledge of his material. Mrs. Korsmo seems to have inherited, happily, her father's gift. Although she has great respect for the traditional, she prefers experimenting with new forms and techniques. She used her Lunning Prize funds to study in America and Mexico. In 1958 she began some interesting work with Paolo Venini, an Italian glass artist, experimenting with jewelry and other objects combining sterling and free-form crystal shapes. She designed the ornaments; he made colored glass pieces. Although Venini's death halted this venture, she has not given up the idea and may develop it again. With her husband, Professor Arne Korsmo, she has designed a beautiful series of large plates, bowls, and vases in jeweler's enamel over engraved stainless steel for Cathrineholm A/S, as well as a range-to-table series of kitchenware in porcelain enamel guaranteed forever against chipping, flaking, or cracking. "Lotus" is the most-often-seen design in this line outside of Norway.

Grete Prytz Korsmo's best-known design in jewelry is a wide, oxydized, silver armband, with rows of small "shells" punched out and slightly elevated, not only for decorative reasons but to lighten the look of an otherwise heavy piece. For the jewelry and silver firm of J. Tostrup in Oslo, she not only designs a multitude of articles in metal and enamel but supervises their exhibits and sophisticated window displays.

Professor Arne Korsmo has designed a delicate and graceful flatware service in silver plate, also for Tostrup. It is conceived so that the form is an expression of the method involved—each piece is pressed from one sheet of metal—an excellent example of a logical approach to the best use of a material. His particular style has all the sculptural flair seen in the work of Henning Koppel at Georg Jensen in Denmark. Arne Korsmo is an architect deeply involved in the theoretical side of environmental creativity.

Tias Eckhoff of Norway has been mentioned earlier for his work in ceramics and porcelain. His flatware design "Cypress" won an award from Georg Jensen in 1954 on the occasion of that firm's fiftieth anniversary and also captured a gold medal at the Milan Triennale that year. An often-honored designer in many materials, he is the creator of a handsome pattern in stainless-steel flatware called "Maya," the only steel tableware represented in the Norwegian Museum of Cultural Arts. For the Dansk Knivfabrikk, Eckhoff has designed two other sets in stainless—"Fuga" and "Opus"—both of which embody, as always, his sure sense of simple balanced form and weight with practical innovations in shape, including his own version of the slanted knife blade and a short-tined fork that can double as a spoon.

Hermann Bongard is another of those many-faceted Norwegian artists who work in several media. He has designed flatware in stainless and in silver, also some handsome enameled trays. Mons Omvik is a Norwegian who works with pewter, using only handcraft methods. He developed a way of applying relief decoration, and uses designs for this by Arne Jon Jutrem. Alf Sture, Bjørn Engø, and Steinar Flatheim also work in metal, and each of them designs with distinction in other materials. The late Ferdinand Aars also did distinguished work. Last but not least, the team of Else and Paul Highes is producing fascinating jewelry, distinctly sculptural and based on the heavy ornamental work of Viking times. Their rings, brooches, and pendants are modeled in wax before casting, and this cire-perdue technique means that no two articles are ever exactly alike. Their work is most impressive, with a distinct sculptural charm.

Norwegian kitchen equipment, in stainless steel and aluminum, has won its share of artistic attention and can compete with other nations in that regard, but the factories are not yet large enough to supply international markets, so one sees them mostly in Norway. They can hold their own in quality and good design, and there are certain to be excellent developments and considerable growth forthcoming.

a
Sterling table service "Rådhus," designed with simple dignity by Lie-Jørgensen for David-Andersen. [Photo: K. Teigen]

b
Sauceboat with ivory handle, designed by Thorbjørn Lie-Jørgensen many years ago and entirely suitable now or at any future time. Awarded the gold medal in 1955 at the Milan Triennale. [Courtesy David-Andersen]

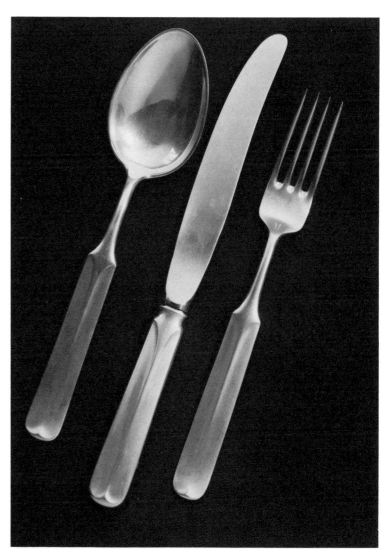

a

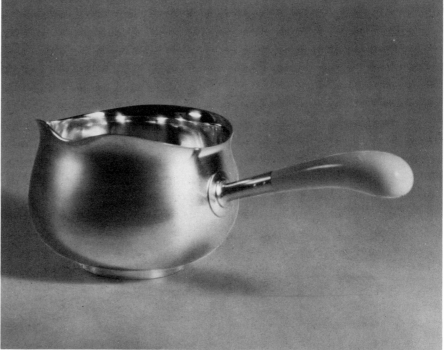

b

Finland

Much jewelry and other Finnish design reach back to the pagan forms and themes of the great Finnish heroic folk epic, the *Kalevala* (Land of Heroes), which consists of about 12,500 verses collected from a vast quantity of traditional poetry. Published in 1835, the *Kalevala* has influenced and given distinctively national character to Finnish applied arts and literature. It stimulated the study of folklore, in which Finnish scholars have such a high reputation. At the other extreme, Finnish jewelry designers are giving us some of the most advanced sculpturally modern forms in jewelry, original and exciting.

In the late forties, a renaissance came to jewelry, as well as to other arts, leading to a purification of form and a revival of a relationship to nature. This is especially noticeable in Finland, where jewelry design went back to what was originally Finnish, to discoveries of ancient jewelry made in the area. These were quite intricate, large and inspiring, with strong emotional appeal. Replicas by trained designers led the way to new creations and interpretations. Finnish goldsmiths, already famous in the nineteenth century (many Finns worked in the Fabergé workshops in St. Petersburg), were fully capable of the new excursion into ancient arts. The use of stones of local origin—many of which had been known and used in earlier times—contributed greatly to the new era in Finnish jewelry design. The discovery of beautiful quartz, garnets, labradorite, and other native gemstones in the bedrock of Finland offered many fascinating possibilities. Smoky quartz, rose quartz, and cordierite offered challenging qualities fully comparable to imported stones, and new methods of setting and polishing were developed for other stones which, though beautiful and of suitable quality, were too soft or opaque to be worked with in the same way as conventional gemstones. Finnish jewelry today covers a wide range, with some artists drawing on the past for inspiration (e.g., Pentti Sarpaneva, brother of Timo) and others experimenting boldly with new ideas (Björn Weckström), both offering collections of robust elegance and richness. Many use uninhibited abstract themes, full of artistic vision and creative vigor. The use of raw crystals and uncut or unpolished stones, and even metals such as raw iron ore, emphasizes the Finnish depth of allegiance to natural effects.

Kalevala Koru is a firm which has attained an international reputation by manufacturing exact reproductions and modern interpretations of traditional Finnish jewelry, as well as embracing the work of contemporary designers of Finnish bangles, such as Eero Rislakki and Börje Rajalin, the latter having been awarded a gold medal at the XII Triennale and the International Design Award of the American Institute of Designers, in particular for a large but delicate screen of silver circles, some filled and some open. In sterling silver and bronze, embellished now and then with the Finnish spectrolite stone or an occasional cultured pearl, Pentti Sarpaneva presents at Kalevala Koru his unique collection of pendants, contemporary yet ancient in feeling, and emphatically in tune with today's fashion trends. In fact, it is hard to say, in connection with this or other design coming from Finland, if the Finns have anticipated the fashions of the seventies or if today's younger people have just discovered Finnish design. To those of us who have followed modern Finnish design for the past ten years or more, along with the changes which have occurred elsewhere (at least in England and America) in only the past four years, it is amazing how the two have converged.

Kalevala Koru models date back to the seventh and eighth centuries. Those that are very Finnish have little round knobs on them as part of the design motif, and date back to Viking forms. One of the most historic and technically intricate pieces is a handsome chain copied from part of the Halikko treasure. Each small silver ball in this necklace carries different filigree work and has been reproduced with meticulous care by today's craftsmen. The Halikko hoard consisted of three pendant silver crosses and a filigree necklace and was hidden in the ground in a roughly made earthenware pot in the twelfth century, when Christianity first came to Finland. The necklace, with its richness of motif, takes us back through the ages and demonstrates the splendor surrounding the Catholic Church in the Middle Ages.

Another series carefully duplicated by Kalevala Koru artists are the old Lapland ornaments, spoons, and cups concerned with the betrothal and marriage customs of the Samish people. The custom for a lovestruck reindeer herdsman seeking a bride was to collect many gifts, such as silk scarves or silver jewelry of ancient design handed down through his family. When he had accumulated enough to impress, he gathered them up and also brought spirits to offer the girl's parents, for it was inconceivable to start talking without a drink in one's hand (a custom which is still going strong!). The suitor served the drinks from a small silver cup or a large pear-shaped spoon, the design of which has come down from the Middle Ages. The ornaments offered consisted of a silver brooch, silver coins, spoons, goblets, and belts, and of course rings, plus gifts for the parents and other relatives. Not until all had had their share of these presents (and of the drinks) could the suitor dare to place the engagement ring on the little finger of his sweetheart's right hand. The bride wore the whole collection at her wedding, plus any other ornaments she had inherited . . . the more the better. There were also silver and gilded beads and decorative buttons, often with rings or charms attached—protection from evil spirits. The beads and buttons were later attached to the Laplander infant's cradle and around the child's neck, for the Lapps believed that hallmarked silver prevented the earth spirits from exchanging the child for one of their own. The Lappish courting gifts are faithfully crafted by Kalevala Koru artisans in sterling, and oddly enough are entirely in tune with today's fashion trends, if that matters.

Alongside these fascinating reproductions, this firm presents modern design in silver, gold, and bronze by Bengt Eriksson, Berit and Börje Rajalin, Paula Häiväoja, Kai Lindström, and Pentti Sarpaneva. The last's work is often inspired by the drawn-thread filigree work done in Karelia. Recently, a twenty-five-piece collection designed by this artist was made at Turun Hopea of Turku. Other traditional objects related to native Finnish crafts can be seen at Kalevala Koru, for example, the beautiful Finnish wood-shaving objects, such as the St. Thomas Cross, and the graceful Karelian cuckoo mobiles and Lapp birch-bark slippers. It is

striking to notice again that the contemporary articles shown by this firm are often what we call today "far out" or even "way out" or "outré," yet there is a definite aesthetic relationship between the new and the ancient designs. Kalevala Koru was begun in 1950 with Martta Ritvanen as director (she now has her own business, Kaunis Koru Oy) and should be a must for every visitor to Helsinki, for it offers not only artistic articles but a glimpse of the history behind them.

Without question, Björn Weckström is the most imaginative young designer of jewelry among many good ones in Finland today. Less than ten years after his completion of goldsmith school (1956), this artist-goldsmith was already widely exhibited throughout Europe, had won numerous Finnish and foreign design contests, was represented in the Victoria and Albert Museum in London with his fantasy ring called "Fairy Castle." He also won first prize in an international jewelry-design contest in Rio de Janeiro. He was then only thirty-one! In 1968 he won the Lunning Prize, which came as no surprise to anyone, for he is a great originator in his artistic thinking and his craftsmanship is perfect.

His "Lapponia" series is typical of what has been his characteristic style in the late sixties, deeply carved (as tree bark) gold pendants, brooches, rings, and cuff links, combined sometimes with jewel droplets of lustrous pearl or polished Finnish semiprecious gems, with an occasional discreetly small diamond. Each creation is a superb piece of work. The "Lapponia" jewelry is represented in the Victoria and Albert Museum and at Röhsska Konstslöjdsmuseet in Göteborg, Sweden. It has a sculptural factor, free form, and interprets such titles as "Flowering Wall," "Rain in the Mountains," "Dewdrops," and "Devil's Wheels."

In 1970 Weckström presented his devoted and appreciative followers with an entirely new series of bangles christened "Space Silver." He has always favored gold, but once he became interested in sterling, the results were daring and excitingly new. Motion, flight, and unreality are the overpowering essence of this, again, sculptural series. Fantasy and an imaginary trip into space are the themes, each design winged and celestial, with names such as "Dance in the Galaxy," "Near-Eruption," "Man from Mercury," and "In Cloud." The space silver is full of motion and sweeping rhythm. It awakens introspection with its sculpted folds, hills and valleys, sometimes with little abstract figures in a dreamlike, shining landscape. Weckström's revealing definition of his idea in this collection is "Jewelry *is* sculpture . . . with a human background." Björn Weckström may be the most outstanding artist in gold and silver of current times. His creations are displayed and available in many countries outside of Scandinavia.

Another clever jewelry designer in Finland is Kaija Aarikka. Her designs are profuse, and in jewelry particularly she shows a lively imagination and a pixie's playfulness. Linked circlets, silver bangles, tiny bells, are featured in her brooches, rings, bracelets, and necklaces. In addition to her work in silver, she makes a line of costume jewelry in which she combines metals with vividly dyed wooden balls, a characteristic theme she also uses for candlesticks.

Tapio Wirkkala has also recently lent his talents to some descriptively named gold pendants hand-forged by Westerback Oy of Finland.

Displayed at the recent Culture Olympics in Mexico were his necklaces "Ax and Spear" and "Moonlit Landscape," one medieval in feeling, the other a circle of cratered gold in tune with the space age.

In the line of metal work, it was always a longing of Wirkkala's to design a better, in fact perfect, *puukko* knife, and this he finally did, creating perhaps the finest of all knives of this type. From the abundant wood supply of their forests, many Finns still carve furniture, skis, sleds, and boats. The principal tool is the *puukko,* a razor-sharp, sheathed knife, which in some regions of Finland is still tempered by a secret family process. It is used not only for carving household utensils or decorative objects but is an essential tool as far as lumbermen are concerned, and fishermen, too.

Wirkkala's version embodies an ideal handle shape. A user of *puukko* sheath knives from childhood, Wirkkala felt impelled to improve this important tool for carving and camping uses. He chose his materials for ideal durability—the blade in tough white stainless steel, the handle in a nylon made more durable than wood yet smooth to the hand. The well-proportioned knife has a sculptural elegance characteristic of Wirkkala's work. Its use in whittling is aided by the gradual sloping lines of the blade's back, which narrows toward the point. The knife was tested for three years by craftsmen before it was put into regular production. Its leather sheath is elegant, its only decorative touch the paw-print of a running bear, and its surface is darkened by treatment with bear grease, a symbol of magic and masculinity in old Finnish mythology. The Wirkkala *puukko* knife was awarded a silver medal at the Milan Triennale of 1964. Tapio Wirkkala has also designed a handsome and practical set of kitchen tools for Hackman and Co., named "Finpoint," again thoroughly thought out in regard to shape, use, appearance, and technical quality. That's the way the Finns seem to do everything.

Bertel Gardberg has had a wide and beneficial influence on all design in metals in Finland. He is a productive designer of jewelry, church silver, and utility items, and holds one gold and three silver medals from the XII Triennale. As a teacher at the Institute of Industrial Design, he has been an inspiration to many young craftsmen, including Börje Rajalin, Eero Rislakki, Björn Weckström, and Eli Kauppis. Though trained in Denmark, Gardberg has remained free from foreign influences and retains an individual style. He often combines materials such as bronze or steel with teakwood, or silver with semiprecious stones, or leather. One of his most famous necklaces has a chain of elongated gold links, from which hangs a tiny shadow box housing a smoky quartz; this has been acquired by the Victoria and Albert Museum. Gardberg has designed many stainless-steel serving-and-cooking utensils and cutlery for Hackman and Co. and Oy Fiskars AB of Finland. So prolific is Gardberg that it would be a good guess that just about everyone in Finland either wears, eats from or with, or cooks in something designed by him. The sure taste of a silversmith has guided him to the same refined elegance in stainless steel.

Eero Rislakki, designer of slim and elegant coffee percolators with plastic handles and knobs, and at the other extreme well known for his contemporary gold-jewelry design, has had his own studio since

Björn Weckström is unquestionably
one of Finland's greatest talents in the
field of design in precious metals. (1)
Bracelet in gold with pyrite stones,
(2) Cuff links, a virile interpretation in
gold, (3) and (4) Two necklaces in gold
with tourmalines, (5) Brooch in gold
with tourmalines on tiny gold chains,
(6) Chunky bracelet in gold with pyrite
stones inlaid. [Photos 3 and 6: Laakso
Studio, Rest: Studio Wendt]

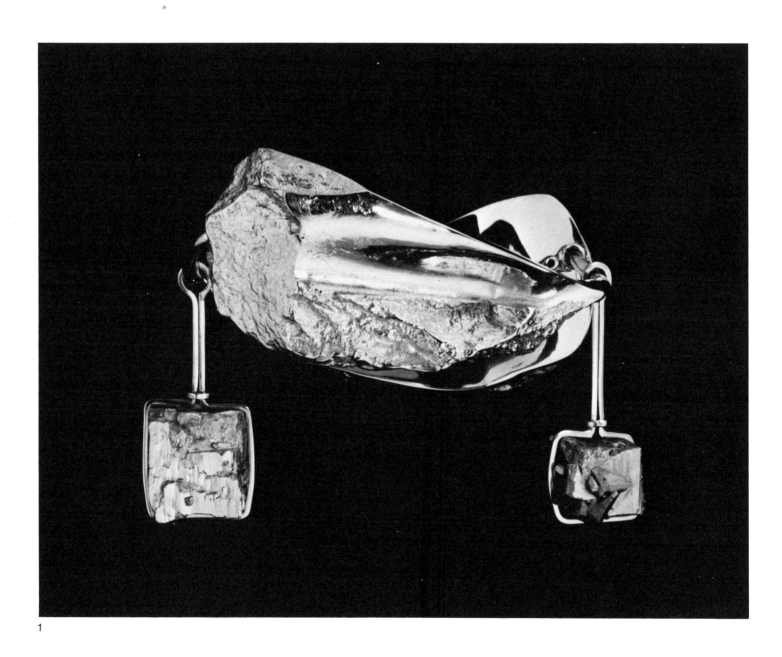

1

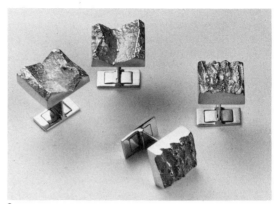

2

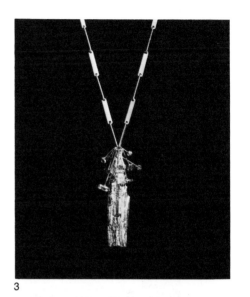

3

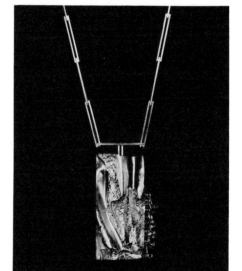

5

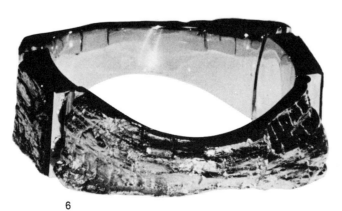

4

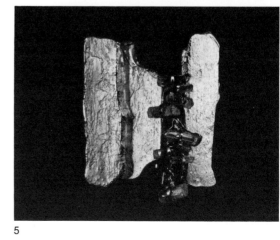

6

1960. He has found the new hard plastics must gradually replace wood where durability is the first requirement, though aesthetically wood still remains incontestably superior.

Lisa Johansson-Pape and Yki Nummi are two more Finnish designers covered with Milan gold medals for their work in metal and plastic, especially lighting fixtures, light engineering, and the technics of illumination. Their lighting fixtures, like Poul Henningsen's, exemplify the fact that one can almost take it for granted that most products in Scandinavian design represent not only attractive appearance and good form but are the result of endless research and consideration as to functional and technical aspects. Miss Johansson-Pape is also art director for Stockman-Orno and has designed rya rugs and exhibitions. Yki Nummi is a well-known color expert and has designed textiles, carpets, wallpapers, plastic articles, and furniture; furthermore, he is a fine graphic artist. Two books illustrated by him have been awarded the title "Most Beautiful Book of the Year" in Finland. He is a lecturer on industrial design and an exhibit designer. One of his lighting fixtures is exhibited at the Museum of Modern Art in New York. A favorite lighting theme of his is the combination of smoky and milky-white plastic lamps, graceful in form, easy on the eyes, and technically perfect as to the directional lighting produced.

The versatile Timo Sarpaneva from time to time directs his attention to metal as a material. His red and black enamel-on-cast-iron pots, some with removable teak handles, are manufactured by Rosenlew, and he has also designed an entire series of truly handsome door handles, made so the fittings do not show, and patented the technical method by which these can be mass-produced yet made to fit various thicknesses of doors.

Sweden

As in most other Swedish design, the tendency in metals and jewelry is toward a more formal version of modern-day simplicity. The forms are full of vitality and originality, yet there is a reserve, an economy of line, in line with or as a result of the industrialized nature of Swedish production in all fields of endeavor, and in harmony with the Swedes' somewhat more formal way of life in general. There are, of course, bold exceptions, for example, Erik Höglund at Boda, and certain well-known potters, but in general Swedish design reveals a delicacy approaching severity . . . not that it is any the less beautiful or charming for this particular factor.

Karl Edvin Wiwen-Nilsson (son of Anders Nilsson of Lund, Sweden, who was a court jeweler) was, among Swedish silversmiths, the first to cast off in the early twenties the yoke of earlier baroque, rococo, and classic styles. His characteristic style was angular, utilizing reflections to obtain special effects. Hemispheric shapes also had occasional appeal for him, and he preferred all surfaces smooth and shiny. He acquired his thorough knowledge of silver and his flawless craftsmanship as a boy in his father's workshop, and later through extensive study-travel. Typical of his meticulous work is a pentagonal silver box, entirely handcrafted, whose lid fits perfectly no matter which way it is put on. He is represented in many museums, has exhibited in many countries, and has gathered up numbers of medals and trophies. His individual approach to silver is evident also in his jewelry, in which his artistic restraint and precise craftsmanship show off the unusual stones he selects, as, for example, a white-gold pendant, ring, and bracelet set with exotic green Ceylon moonstones.

Wiwen-Nilsson led the way in Sweden, followed by his colleagues Erik Fleming at Atelier Borgila in Stockholm (a traditional stylist who was also head of the metal-work department at the School of Arts, Crafts and Design) and Jacob Ängman; then Sven-Arne Gillgren, Åke Strömdahl, with heavy support for artistic progress in all design fields from such authorities as Gregor Paulsson. Paulsson was a Swedish art historian associated with the Stockholm National Museum from 1913 to 1924, administrative director of the Society for Industrial Design, 1920 to 1934, chairman of its council from 1943 to 1950, professor at Uppsala University, 1934 to 1956, general secretary for the Stockholm Exposition of 1930, and the author of several books on design. He was one of only three men ever to be selected as an honorary member of the Swedish Society for Industrial Design.

Sven-Arne Gillgren, who succeeded Fleming at the School of Arts, Crafts, and Design, and followed Wiwen-Nilsson as artistic director of the Guldsmedsbolaget, was led into design for industrialized production through the 1917–20 crusade of the Swedish Society for Industrial Design to bring more beauty into the production of everyday articles. He was commissioned often for ecclesiastical work, at which he was expert both artistically and technically. His work is in over forty churches in Sweden. Gillgren is represented in numerous museums and collections in many countries and he accumulated many awards prior to his death in 1942. He favored undecorated, clean-lined forms in his hollowware and cutlery. In his jewelry, he worked largely with gold and precious stones.

Åke Strömdahl runs his own workshop and also contributes much to industrial design. Like Sigurd Persson and Wiwen-Nilsson, he learned his craft from his father, court jeweler Hugo S. Strömdahl. Åke Strömdahl's forms are softened and serene. Twenty years ahead of today's return to stones, leather, ropes of seed beads, and other natural materials for personal adornment, Strömdahl had already sought out new materials of this type. In 1955 he made a fascinating rope of beads, cut and polished from dozens of different stones native to Sweden. From natural stones, this master jeweler-goldsmith ventures readily into the design of the most costly diamond jewelry, and furthermore is expert at designing in plastics (for Skaraplast, Ltd.).

In the 1920's Sigurd Persson was growing up, and learning, in the silversmith workshop of his father, Fritiof Persson, of Halsingborg, Sweden. From these beginnings, Persson developed into perhaps the finest gold- and silversmith designer of Sweden. In the Chapel of Our Lady at Strängtäs Cathedral, Sweden, is an exquisite wall hanging designed by Sigurd Persson and Kaisa Melanton and woven in a threaded

Bracelet of gold with amethyst, designed in 1963 by Sigurd Persson of Sweden. [Courtesy Svenska Slöjdföreningen. Photo: Sune Sundahl]

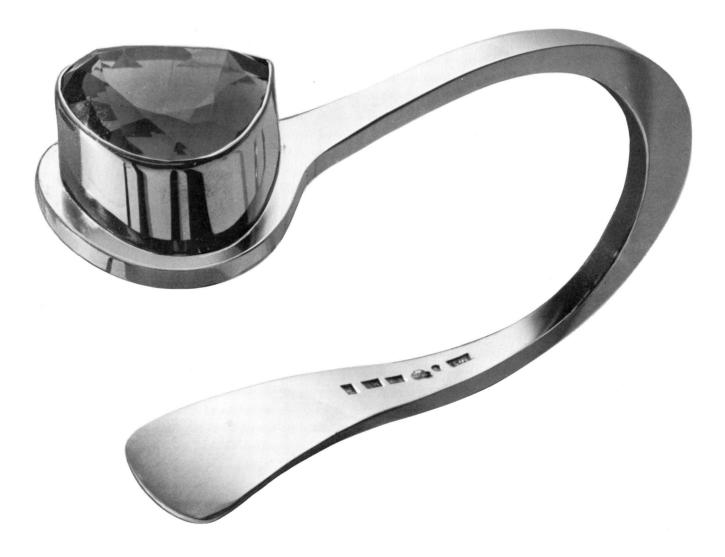

Another leading Swedish designer of
jewelry is Torun Bülow-Hübe, who
made this graceful necklace in
silver and crystal, 1960, and was
awarded the Medaglia d'Oro for it in
Milan that year. [Courtesy Svenska
Slöjdföreningen. Photo: Fotogramma,
Milan]

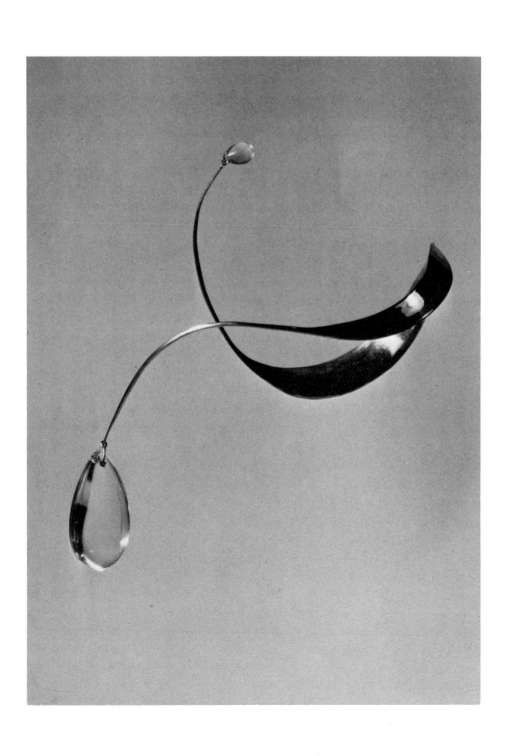

Coffee set in sterling, typical of the
clean formal lines of the artist Sigurd
Persson of Sweden. [Courtesy Svenska
Slöjdföreningen. Photo: Sune Sundahl]

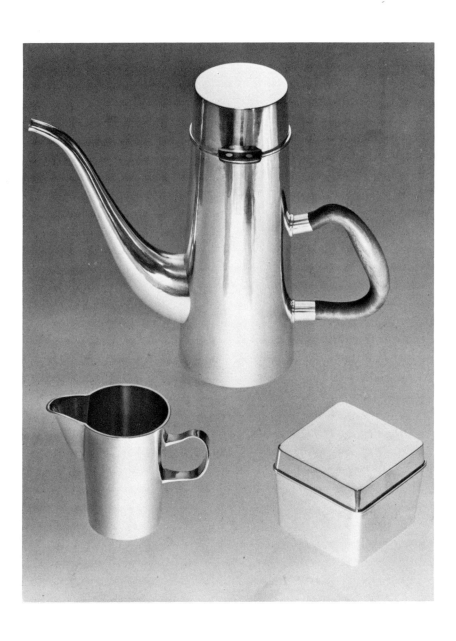

technique by Handarbetets Vänner in Stockholm. It is an abstract in delicate shades of silver-gray, blues, soft greens, and violets. Before it is a small, simple altar on which, perfectly set off by the wall hanging, stand the elegant sterling candlesticks and crucifix created by Sigurd Persson. The cross of silver frames the figure of Christ in red crystal—simple yet effective, even dramatic.

Persson is an expressive and impressive artist. Another of his altar crosses can be seen at the Adolf Fredrik Church in Stockholm. This one is flat, made of silver set with one enormous, specially cut, rock-crystal medallion. These objects must be considered in the realm of fine arts, as a sort of formal sculpture, yet Persson can as effectively turn his talents to glamorous and frivolous jewelry or enameled and stainless-steel cutlery, pots and pans, silver candelabra, or plastic and stainless tableware for Scandinavian Airlines (a prize awarded to him over three hundred other Scandinavian competitors), or metal garden furniture. Persson is a master artist-craftsman as much at home with design of exclusive jewelry or ecclesiastical objects as with sensible design for industrially produced articles in stainless steel, enamel, or plastic.

Outgrowing what he could learn in his father's shop, he traveled and studied in Italy, France, at Munich's Academy of Applied Art, then at Stockholm's State School of Arts, Crafts, and Design. For a while, as a lay brother, he studied at the monastery of St. Martin at Ligugé, France, with the monks, who are enamel-art specialists. He has been awarded the international "Golden Ring of Honor," the Diplome d'honneur at Milan in 1951, the Gregor Paulsson trophy, is represented in many museums, including the New York Museum of Modern Art, has written a book *Modern Swedish Silver,* and has contributed many articles to the press.

Persson's unique and perfectly crafted rings and bracelets are the kind which have personal appeal to fashionable women seeking exclusive and absolutely stunning pieces of jewelry. He is a true artisan and sculptor in metals and gems, a serious thinker in many dimensions who is a strong crusader for free creativity and good taste in estimating the real merit of all things in life, both material and aesthetic.

Torun Bülow-Hübe is a Swedish designer who loves using natural stones from beaches, quartz, or other semiprecious stones in combination with silver. One of her most noted pieces is a feminine necklet of silver, shaped to the neck contour and going only halfway around, then down from the left shoulder across toward the right. It is set with two "jewels" or crystals of graal glass made at Orrefors by Edvard Hald. Cleopatra would have loved it. The neck ring is hammered out in one piece, with enough spring to let it follow neck movements yet stay in place comfortably. This artist has worked and lived in France since 1958, and continues to have strong influence on jewelry design in Europe. She received a gold medal at the Milan Triennale in 1960, and that same year was awarded the Lunning Prize.

Inga-Britt Dahlquist belongs to a still-younger generation in Swedish jewelry design. She works with non-precious stones, and an interesting method of hers is combining silver with fossils from Gotland. She has her own studio in Malmö.

In the eighteenth century in Sweden, almost every town had its guild silversmiths, pewterers, and cabinetmakers, whereas the weavers, glass-workers, and potterers were scattered sparsely around the country. Not until the thirties did metal-work firms begin to seek out architects and designers for their production. World War years caused great hardship to gold- and silversmiths. On the other hand, the path was opened for stainless steel, which quickly earned its place as an acceptable material and was exploited for its many advantages without imitating silver or silver plate. An immeasurable contribution to advanced Swedish stainless-steel design has been that of Folke Arström. At the leading Swedish firm of Gense, Arström has acquired a thorough technical expertise with his material. His imaginative yet disciplined designs have attained both for him and for Gense a world reputation for design and quality, along with a gold medal at the Triennale of 1951, the Gregor Paulsson trophy in 1961, and many distinctions in America. Folke Arström began his career working in pewter and silver, but since 1940 he has kept to stainless steel designs for Gense, Ltd., at Eskilstuna, where he is chief designer. His most famous design is the cutlery pattern "Focus DeLuxe" in stainless steel with hard black nylon, a design that is softly shaped, partly for appearance but mainly as a result of functional considerations.

A colleague of Arström's at Gense is the younger designer Pierre Forsell, who is good at tackling form and function with a fresh, contemporary viewpoint. A most interesting utensil of his is a 3-in-1 fork in stainless with a black handle. Near-triangular in shape, the two-pronged "fork" offers a straight edge suitable for cutting, and a bowl or spoon effect for small foods, gravies, and sauces. It is meant for buffet supper use, when more than one eating utensil complicates matters. Forsell also began as a silversmith, but now devotes his attention entirely to stainless steel.

Eskilstuna, where the Gense firm is located, is a picturesque place to visit. Known as the "Town of Smiths," its history goes back to the early sixteenth century. In the year 1771, Eskilstuna became a Free Town, and the whole place was preplanned and laid out with blocks and streets at right angles. Single-story timber houses with high mansard roofs contributed to its neat village look. Many of the old seventeenth-century buildings have been carefully preserved in a part of the town now considered a cultural landmark, under the name of the "Rademacher Smithies." They stand as a living exhibition of the architecture and the industrial system of that time. Not only this charming town but the factory of Gense offers an interesting day to the visitor in Sweden.

Another worthwhile visit is to the Home Handicraft Association (Hantverket) on Hornsgatan in Stockholm. Hantverket has an exhibit and sales house for the best work of gifted young craftsmen. The group runs a huge lottery, with outstanding handcrafted items as prizes. There is a silver display included in the general exhibit, offering young silversmiths a chance to show their latest creations. All articles shown are unique items, carefully selected for their artistry and quality craftsmanship.

Iceland

Iceland has an outstanding modern-minded gold- and silversmith of considerable stature in the person of Jóhannes Jóhannesson, who is also one of Iceland's most talented painters.

"I would much rather paint than make jewelry," the artist frankly states, but this does not deter him from giving generously of his talents to the precious metals. His work is strong and vital in expression, largely free-form, emphasizing the use of silver threads arranged in volcanic-like little mountains with polished highlights against oxidized crevices. I wear a ring made by him almost constantly. It piques my imagination, seems to be right with everything, and draws many comments. It is like wearing a miniature sculpture. I study it often, and depending upon my own mood, I can see in its whorls of silver many and varied things . . . sometimes an impressionistic volcanic mound born of Iceland and its sagas, other times naked, slender human forms in distorted postures piled atop one another, and still others exotic surrealistic animals or kelp washed up into a curly heap upon a black-sanded Arctic shore. If this seems too much to see in a ring, be assured it is not. It is a mini abstract sculpture in silver to live with every day, always seeing something new. His paintings (many of them in the National Museum of Fine Art at Reykjavik) present the same challenge.

Johannesson makes more than rings, earrings, pendants, and brooches for ladies' adornment. There are masculine cuff links and a massive-handled letter opener, which seems perfect for the desk of a burly industrial tycoon. A magnificent barklike silver chalice he made in 1964 for a small country church communicates a regal-rustic feeling, and is studded most appropriately with two half-sphere, polished Icelandic opals. The impression is of vigorous dignity, manly Viking strength, and an unself-conscious provinciality appropriate to its purpose, location, and use. The spirit of all the old Icelandic traditions is present in this fine chalice interpreted in contemporary form and techniques. In Johannesson's work one is always reminded of the ancient jewelry of the Viking age, not as an imitation, or even an interpretation, but by some powerful artistic sense of form and effect communicated through the osmosis of time, forebears, and a volcanic island environment.

Jóhannes Jóhannesson, Iceland's leading designer in silver and gold, is also an outstanding painter. His painting comes first in his life, but he likes to work with silver when he can, and his interest in art and sculpture is demonstrated in his design forms in metal. (1) Pegasus silver sculpture, (2) Condiment set in silver. [Photos courtesy artist and Dr. Selma Jónsdottír, National Gallery of Iceland], (3) Ring in oxidized silver threadwork. [Photo: Kristján Magnússon], (4) Gold chain and pendant, with smoky topaz. [Photo: Myndin], (5) Early-1955 silver bracelet with a Viking feeling. [Photo: Andres Kolbeinsson]

1

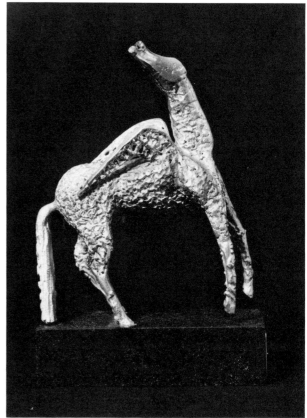

2

3

5

4

VIII. TROLLS, MOBILES, ETC.

Everybody knows you must have a troll for a friend if you want to have any good luck at all. Well, maybe you don't know that yet, but all Scandinavians do.

Norwegian, Swedish, and Danish trolls are mischievous but also very kind. Unfortunately, most of them are rather gnarled and ghoulish in appearance (perhaps with one tooth, or a huge warty nose), so unless you understand that they have soft and loving hearts, you are not inclined to make them your secret friends. Finnish trolls, however, are full of charm and wit; the second you look at them you just have to grin.

There are Moomin trolls and Fauni trolls from Finland, and they have made so many collector-friends they found it necessary to multiply like crazy and travel to all the other European countries, the United States, Canada, South Africa, Australia, and many other far-off lands. Some Fauni trolls send postcards home to Jarvenpää from such exotic addresses as Hawaii, Bermuda, Curaçao, Puerto Rico, Trinidad, St. Croix, El Salvador, and Thailand. The Fauni certainly do get around, and in many forms . . . as small doll figures, in movies, on television, and in comics, in storybooks, on children's clothing and decorating textiles, on wallpaper, as children's banks, and so on.

The Moomin and Fauni trolls are brought into being at Jarvenpää in a large, airy, two-story studio building where about a hundred maternal Finnish ladies work to the tune of wild-bird songs from the woods surrounding the atelier. The great towering pines in this picturesque forest are said by the trolls to have three magic existences, "the first reaching toward the pale blue sky, the second a reflection in the clear water, and the third as a long shadow in the golden Nordic sun." The women in the atelier know that the laws of trolldom require that no two trolls look exactly alike or they will cancel out each other's good-luck qualities. So they can be produced only by hand. They are individuals who require virgin forests, northern lights, and bright summer nights to maintain their power to bring good fortune. In ancient times, so the stories go, trolls were primitive, shy creatures whose origin was obscurely rooted in mythology, but nowadays they have become sophisticated in order to continue being lucky for people of the modern world.

The star of the Fauni tribe is Trott Tivvy, a serious troll who is burdened with a terrible inferiority complex. He is practical and intelligent, but believes himself to be so ugly that no one could really like him, so he seldom laughs. When Tivvy visited England, though, he discovered the British people had a great need for trolls as friends, and that they, in fact, found his ugliness quite charming. He was so happy he almost smiled. Now he's very prominent there for his starring roles in television advertising.

There was a rare occasion when Tivvy did burst into laughter, and that was when he met another troll called Hotlips, who was even uglier than himself; it really broke Tivvy up. Hotlips and Tivvy spend much time together, and have one strange characteristic in common— their shadows move to the sunny side of them when they are angry. Hotlips has a gift for cooking up wild schemes and inventing gadgets, all of which seem to end up as minor fiascos, but being charming and loquacious, he always manages to talk his way back into everyone's good

graces. Hotlips is also a television and movie star, but this has not given him a big head.

The trolls live in small forest villages of wood or stone huts with log roofs. Outside their villages are some strange beings called Lituskas, which are round from the front and flat from the side, and have huge eyes. Lituskas never sleep, eat, or make noise, but they're always there, alert and ready to protect the trolls from harm. They can reproduce at will when any danger threatens. Lituskas love children and make excellent pillows for young sleepyheads. Another friendly protector of the trolls is the Forest Brownie, a friend to all living beings. Usually he just meanders, philosophizing and contemplating life.

Then there are the Naksu trolls, gaily colored and always madly dashing around and playing busily, but only when the sun shines. They aren't much help with anything, since they never can remember for two seconds what it was that should be done. The Muksus are brightly colored, fuzzy creatures with long flying topknots. They are childish little things, and they, too, thrive only in sunny spots. There is a troll ghost, too. He's all hair and eyes. Ghost moves around only at night, but no one is afraid of him (which makes him sad and frustrated), because they know perfectly well he is really quite timid and mild. The "Troll with Seven Fingers" doesn't frighten anyone either, even though his prominent teeth make him fierce-looking. The trolls know that his main interest in life is merely to find and collect fertile, loamy soil. When he has gathered up a comfortable heap of it, he settles down on it and goes to sleep for two years and three minutes.

"Is there a troll hero?" I asked Helen Kuuskoski, who with her husband, Martti, established the atelier. She assured me there was, and then told me about Torvinokka.

Torvinokka is the trolls' poet laureate, much admired by all. In seeking inspiration for his poems, he has all sorts of adventures and emotional crises, as necessary for his calling. He stores his works in his large red snout, and at night, instead of ugly snoring sounds, he exhales lovely verses. Torvinokka has never become conceited. He spends most of his time in solitary creative anguish, for which his admirers have kindly built him a high stone tower where he can find seclusion to compose more verse. Here he shuts himself up and concentrates so hard he sometimes forgets to eat.

Torvinokka has a little adoring pal, Murri, who follows him around, and when Murri wants to contact the bard of Fauniland, he calls the Mökös, tiny round furry balls with tails. They wear helicopter hats and fly in packs or squadrons on their many helpful errands as messengers . . . perhaps to bring an emergency call to the Hip-Troll, for instance. Hip-Troll is really quite a talented magician, and is always willing and able to help out in a pinch, if you believe in him implicitly.

The Tattiainen troll and his wife (who look like mushrooms) live deep inside the forest where the moss is always very thick, and all they need to subsist is a few streaks of light seeping through the heavy branches above them. Pa is a peaceful, easygoing type, which is a good thing, since Ma keeps things more than lively. She adores and helps all her poor relations, and there are scads and *scads* of them.

Another romantic couple are Himmi and Hiski. Himmi is a little

gossipy, very hypersensitive, but also appealingly feminine. She has to be rather firm with Hiski, who is a little shiftless and a procrastinator as far as work is concerned. "Never do today what you can put off till tomorrow" is his motto. He much prefers to loll around, taking life easy and playing his guitar to shoo the blues away. Himm wears minis and has long straight scraggly locks, for she always likes to keep up with fashion.

There are other Faunis who complete the community. Some engage (now and then) in agriculture, compose music, play in the village orchestra, or perhaps just stand around and watch Hotlips goof up his latest invention, or stand in hushed silence in the evening, listening for the beautiful bass voice of the shy little Peetu, a small creature in a blue coat who hides in the treetops. There is also a sprightly little dog, Peki, whom the trolls found in the forest long ago.

All together, there are about forty different types of trolls, all of whom have many relatives. The only worrisome creatures in the lot are such as Edvard, a troll who visited the big city and took on airs, refusing ever after to wear anything but tails and a top hat. The trolls, finding this snobbery obnoxious, drove him off, so he is now a rather off-and-on-successful banker in the city. The only other threats are the Lättähattuma-tos, nasty little critters who forage on the trolls' farm produce, but the trolls have now developed secret repellents to drive them off.

The Moomin troll family, originated by Tove (and later Lars) Jansson, are an equally intriguing group, especially that old rake, Papa Moomin, who is forever meandering off from home and family to live it up in the bright lights of the city, armed with his beloved bottle of wine, a strong appreciation of beautiful young girl Moomins, and a zest for the sophisticated life.

Fauniland and the Fauni studio lie some twenty scenic miles northeast of Helsinki, about an hour's drive along good highway, then a turn over a little bridge and up a winding lane into an enchanted forest of silvery birch and dark, towering pines. It is a setting that is surely ideal for the adventures and pranks of the mysterious and lovable trolls.

Here, in 1952, an artist-actor named Martti Kuuskoski and his pretty blond wife, Helen, first became engaged in the business of turning these fey little creatures out into the world, making them take shape and come to life. The Kuuskoskis became devoted to the Fauni and kept discovering new ones. Their children often help select names for them and interpret their varied personalities and tales of adventure.

Helen Kuuskoski also had literary studies and training as an artist behind her when she and Martti began from scratch making the small Fauni figures entirely by hand. Helen, taking up the business part of the venture, crammed her shopping bag with trolls and personally canvassed on foot the nearby gas stations and small roadside shops to sell the initial output. So appealing and charming were the Fauni, they soon outgrew the rural market and leaped to international fame, capturing the imagination of the public, some travel associations, and many large department stores. Later they graduated to syndicated comic strips, cartoons, television, etc., until now they are Big Business.

Fauniland itself has grown from just the house of its owners and the big atelier to include an attractive cafeteria and an entire Fauni Village

and Labyrinth in the forest, all encompassed in the relaxing tranquillity of the majestic pine and birch forest—a setting so idyllic it is almost impossible to depart from this dreamy hideaway and return to a much too hurried world.

In 1956, the Fauni studio contracted for the manufacture and marketing rights of the already-famous Moomin trolls, featured in the strip cartoon drawn by Tove Jansson and distributed by the Associated Press. The Faunis, at that time less known than the Moomin, nonetheless soon managed to captivate an ever-growing number of international fans, for their personality and charm quickly stir the imaginations of young and old.

Martti and Helen Kuuskoski have said that, although the trolls are born of the woods, they are also born out of man's intellectual needs in a busy and often joyless world. They feel the trolls truly do bring luck, if by no other means than putting folks in a good mood so they can better cope with life's daily problems. Having made so many friends in the outside world, the Fauni family are now found on textiles, wallpapers, rugs, children's clothes and slippers, bibs, pillows, towels, table mats, and many other articles.

Of course, those who have stayed behind at Jarvenpää are busy playing host at the Fauniland Village. It is enchanting to call on the Fauni in their native haunts and let the years and the cares of life fall from one's slightly sagging shoulders for a time.

Mobiles, Etc.

There are many unique things for children from Nordic lands, where they are much loved and perhaps better understood than in some other parts of the world. Toys, like those of the Dane Kaj Bojesen (see Chapter IV), are often simple, wholly slanted toward the sense of touch and the imagination of the very young. Things for children to wear appeal equally to the child's eye and sense of touch, and there are many soft toys meant to be hugged. Denmark, in particular, offers a charming array of these things.

The Danish Christmas decorations and mobiles (largely devised of paper, thread, and bits of pine cone) are appealing to all ages. They collapse, fold up, pack away, and are lightweight. Hearts and flowers dominate the scene, and bright blue, yellow, and white are more prominent than red and green.

Children's bibs and wall hangings may have hungry baby birds printed or appliquéd on sturdy linen, or have pockets, in the form of a wagon, a cradle, a high chair, or a playpen, in which there is a removable, small stuffed doll, rabbit, or toy soldier to be played with. They are irresistible.

Mobiles are popular throughout Scandinavia, whether for children or adults, and most especially in Denmark. (The Danish word for "mobile" also means "restless.") In a romantic old half-timber house on the west coast of Fünen, Christian Flensted and his assistants make about forty different mobile models, with an annual output of well over 100,000, shipped to forty-eight countries around the world. There are two main groups, concrete and abstract, the former including shapes of fish, birds,

a
A gathering of trolls and their relatives. On the right Peki, the troll dog, and just below him a Lituska, who neither eats, sleeps, nor talks but protects the Faunis from harm by reproducing at will to guard the village. Front and center are Trott Tivvy and a girl Tivvy, with Edvard (in tails and top hat), and just behind them is Hotlips. The troll ghost is the white hairy creature with two big eyes, near the center, and the loving mushroom couple just in front of him are the Tattiainens. The fierce-looking, toothy black character in the back is the Troll with Seven Fingers, who naps for two years and three minutes at a time

b
Edvard welcomes a caller. Edvard, banished from the troll village because he has taken on airs, refuses to wear anything but tails and a top hat

c
Martti and Helen Kuuskoski, inspired designers of the Fauni, with their star Tivvy (Finnish name: Sumppi), who is now a television artist in England. Tivvy rarely smiles, for, though he is intelligent, he feels he is so ugly no one could really like him. Now that he's become so popular, he is beginning to grin occasionally

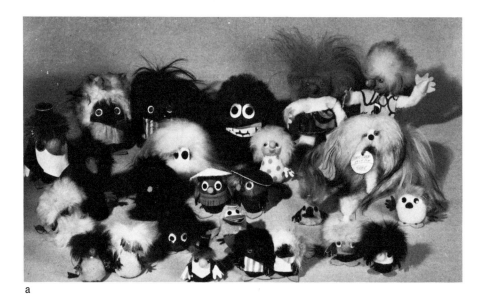

a

b

c

a
A small corner of the Fauni village
at Jarvenpää, Finland. Fauniland
can be visited in winter or summer,
and on Sundays some living trolls put
on a delightful show. There is now
a Fauniland near Stockholm, too, where
one can meet the trolls in their natural
environment and learn about their
intriguing way of life. The stone tower
in this scene is where Torvinokka,
poet laureate who stores his verses in
his nose, secludes himself when in a
creative mood
b
Like other famous characters, the Fauni
now appear in many forms on articles
for fun or use. All are made by Oy
Fauni, Ltd., Jarvenpää, Finland

a

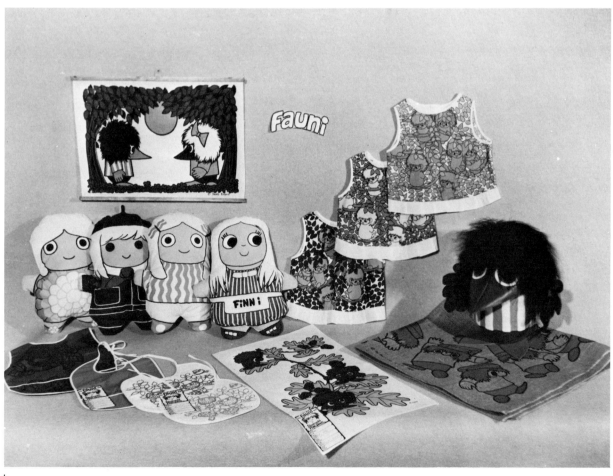

b

Toys by Kaj Bojesen of Denmark are evidence of his insight into children's needs

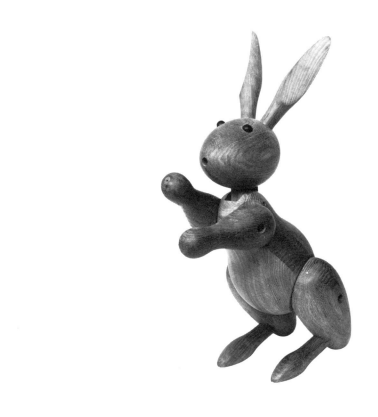

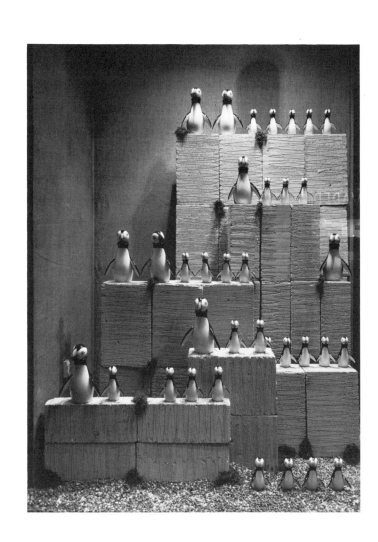

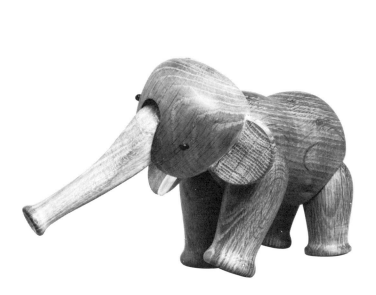

ships, and the like. The abstracts take many different non-figurative forms. If you think these are merely amusing things, consider that a British dentist hangs one over his chair to divert and calm his patients, and hospitals often use them for the same effect. They are tranquillizing and stimulating to the imagination, sometimes even slightly hypnotic. Other well-known Danish designers have tried their hand at mobiles, among them Anni and Bent Knudsen, and Kaj Bojesen.

Throughout the Scandinavian countries it is possible, in fact probable, that doll collectors young and old will run amok. There are dolls of every description, and many exquisitely hand-carved and authentically dressed down to the minutest detail, meant for fine collections and viewing. On the other hand, the sturdy, perfectly crafted toys of Kaj Bojesen are intended to be touched, chewed on, stacked, thrown, and otherwise played with and treasured by active children, designed only with them in mind and with a perfect understanding of their special needs.

I want to mention again the work of Kaija Aarikka, whose major design has to do with wooden beads combined with metal. From these spheres in dyed or painted colors and gilt, she fashions unique jewelry, candlesticks and candelabra dripping with linked beads and chains, or pincushions circled with beads. The candles she presents with her holders are the round or two-tone ones designed by Pi and Timo Sarpaneva in a rainbow of lush colors. Miss Aarikka is also designing huge rings in tune with today's fashion. They are of silver and either geometric in pattern and shape (domes, squares, or small circlets, etc.) or covered with little silver spheres in clusters.

Papers have not been ignored. The latest from Finland include disposable tablecloths, made of fire-resistant paper, reusable several times, and with refreshing and colorful designs. There is matching tableware, and the cost of these attractive and popular picnic supplies is low, in keeping with their purpose.

Perhaps the most noteworthy paper product developed has been the Eurostar award-winning (for packaging achievement) wrapping papers designed by Timo Sarpaneva. He first designed a printing method allowing many colors to be applied with a single run of the press. This method was applied to the cheapest possible paper stock, and one side was also plastic-coated. The beautiful panoramic colorings are visible on both sides. Thus, the paper is suitable for large stores to use, and available to them at an appropriate cost. The process has since been applied by Sarpaneva to fabrics made at the firm of Tampella, and the line is known as "Ambiente." There is also a line of writing paper using the same method and called by the same name. The shadings and tones of colors used swim together in a watery effect, and the textiles are ideal for decorating purposes, such as draperies and slipcovers.

In a sense Timo Sarpaneva's wrapping papers—their low cost, their versatility, their adaptability to other media—can be taken as an emblem of Scandinavian design, just as Sarpaneva himself, with his many achievements in many fields, exemplifies the Scandinavian designer, an artist always mindful of the use to which his work will be put. Of such is good design created—subtle coloring, good form, expert craftsman-ship, high standards of artistry, and that special touch of practicality that makes anything a lasting joy. The astonishing success of the Scandinavians in the applied arts can perhaps be attributed to their steadfast avoidance of the gaudy, the junky, the inferior. If it's from Scandinavia, you should be able to cherish it for its expected lifetime, and learn from it just what is the essence of good taste and common sense.

Three mobiles made by Christian Flensted of Denmark: (1) Waiting Fish, (2) Black Rhythm, (3) Satellite. The Flensted studio now exports well over 100,000 of these mobiles and more than thirty other designs to forty-eight countries around the world. The studio is located on the west coast of Fünen, and has turned a former cottage craft into a substantial business

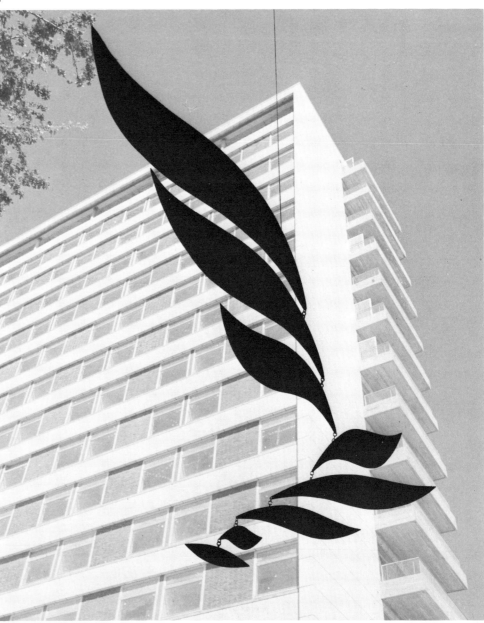

1

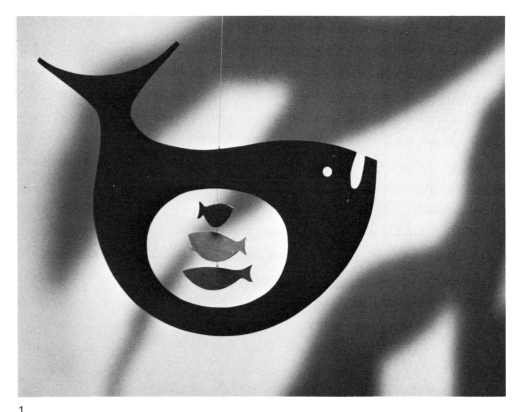

2

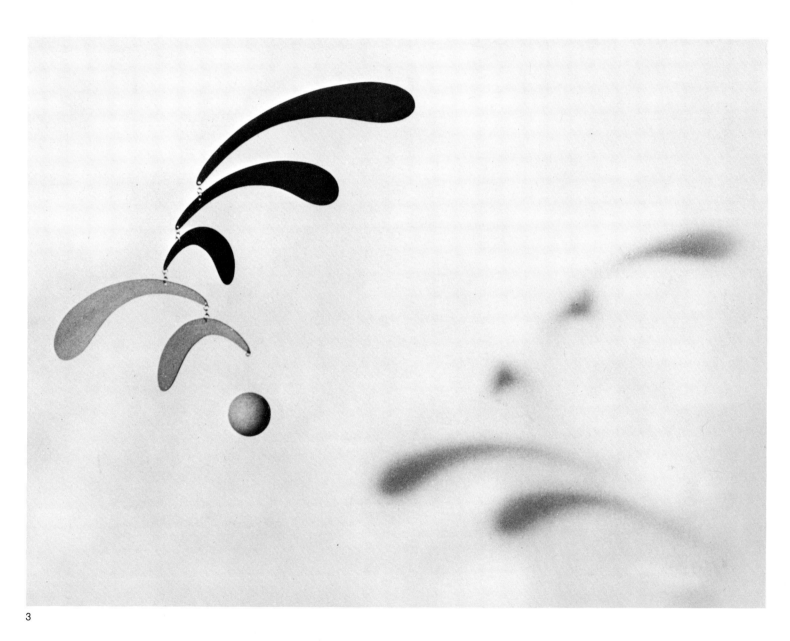

3

Two mobiles by the Danish designer
team of Anni and Bent Knudsen: (1)
Flying Dishes, and (2) Swans

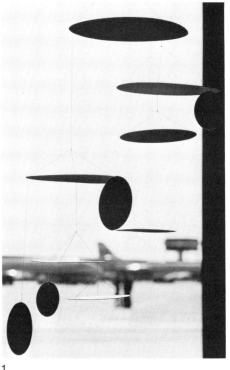

1

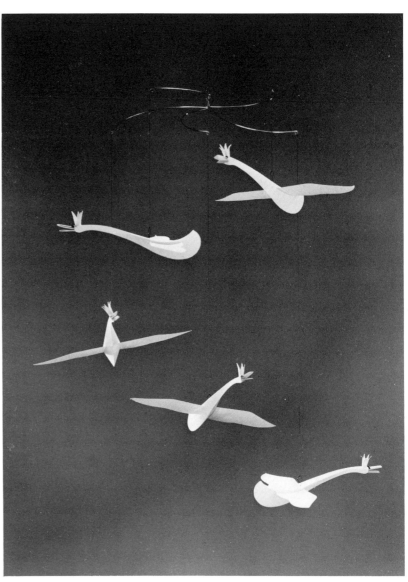

2

a
The mobile "Fish" by Kaj Bojesen is in a class by itself. Made of bamboo, the form, balance, and technical expertise involved verge upon sculptural effect
b
Handmade collectors' dolls, by Birthe Thage-Hansen of Denmark

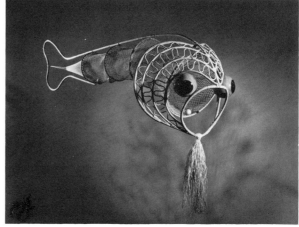

a

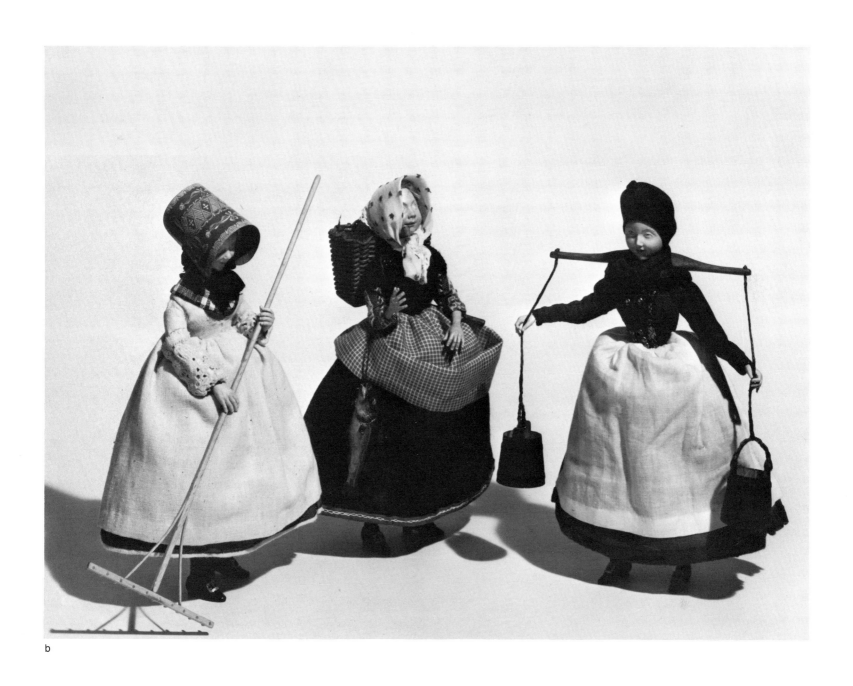

b

Bibliography

Aars, Ferdinand. *Norwegian Arts and Crafts and Industrial Design.* Oslo: Royal Norwegian Ministry of Foreign Affairs (not dated).

Abbey, Staton. *The Gold and Silver-Smith Handbook.* Princeton, N.J.: Van Nostrand Co., Inc., 1965.

Algård, Göran and Roland Romell. *Sweden Today.* Stockholm: Almqvist and Wiksell Förlag AB, 1970.

Andersson, Ingvar. *Introduction to Sweden.* Stockholm: Swedish Institute, 1961.

Askeland, Jan. *A Survey of Norwegian Painting.* Oslo: Royal Norwegian Ministry of Foreign Affairs, Office of Cultural Relations, 1963.

Barry, Joseph. *The House Beautiful Treasury of Contemporary American Houses.* New York: Hawthorn Books, Inc., 1958.

Bayerschmidt, C. F. and Erik J. Friis, eds. *Scandinavian Studies.* New York: American-Scandinavian Foundation and Seattle: University of Washington Press, 1965.

Bernier, Georges and Rosamond, eds. *The Best in European Decoration.* New York: Reynal & Co., 1963.

Bjerregaard, Kirsten, ed. *Design from Scandinavia.* Copenhagen: World Pictures (not dated).

——. *Design from Scandinavia, No. 3.* Copenhagen: World Pictures (not dated).

——. *Design from Scandinavia, No. 4.* Copenhagen: World Pictures (not dated).

Boe, Alf. *Porsgrund's Porcelain Works, Achievement and Production Through Eighty Years (Porsgrunds Porselaensfabrik, Bedrift og Produkjon Gjennom Åtti År).* Oslo: Porsgrunds Porselaensfabrik in commission with Johan Grundt Tanums Forlag, 1967.

——. *Tias Eckhoff.* Oslo: Porsgrunds Porselaensfabrik, reprinted from 1965 Yearbook for Kunstindustrimuseet, 1965.

Clark, Sidney. *All the Best in Scandinavia.* New York: Dodd, Mead & Co., 1949.

Cox, Warren E. *The Book of Pottery and Porcelain. Vol. I.* New York: Crown Publishers, 1963.

Davis, F. *Decorative Art.* New York: Viking Press, 1961.

de Mare, Eric. *Scandinavia.* London: Batsford, Ltd., 1952.

Denmark's Official Handbook. Copenhagen: Danish Ministry of Foreign Affairs, 1964.

Engle, Eloise and Lauri Paananen. *The Winter War—The Russo-Finnish Conflict, 1939-40.* New York: Charles Scribner's Sons, 1973.

Engle, Lyle, ed. *Scandinavia.* New York: Cornerstone Library, 1963.

Eric the Ruddy. *Veni Vidi Viking.* Oslo: Alb. Cammermeyers Forslag, 1963.

Faber, Tobias. *Arne Jacobson.* New York: Frederick A. Praeger, Inc., 1964.

Facts about Finland. Helsinki: Keskuskirjapaino and Otava Publishing Co., 1962, 1963.

Fodor, E. *Scandinavia.* New York: David McKay Co., 1963.

Franck, Klaus. *A Survey of International Designs.* New York: Frederick A. Praeger, Inc., 1961.

Frost, Kathleen and Rathbone Holme. *Decorative Art '56-'57.* London: Studio Ltd., 1957.

Haggar, Reginald C. *A Dictionary of Art Terms.* New York: Hawthorn Books, Inc.; Toronto: McClelland & Stewart Ltd.; London: George Rainbird Ltd., 1962.

Hald, Arthur. *Swedish Design.* Stockholm: The Swedish Institute, 1958.

Hannisdal, Ole Audf., ed. *Textile Forum, Jubilee Issue (Tekstil-forum, Jubileumsnummer).* Oslo: Tekstilfabrikkenes Konsulent og Opplysningskontor, 1963.

Hastrup, Thure. *History of Art Styles/Stylists (Stilarternernes Historie).* Copenhagen: Gyldendalske Boghandel Nordisk Forlag, 1943.

Hatje, Gerd and Ursula. *Design for Modern Living.* New York: Harry N. Abrams, Inc., 1962.

Hayward, Helena, ed. *World Furniture.* New York and Toronto: McGraw-Hill Book Co., 1965.

Hinshaw, David. *Heroic Finland.* New York: G. P. Putnam Sons, 1952.

Hård af Segerstad, Ulf. *Modern Finnish Design.* Denmark: F. E. Bording Ltd., 1968; England: George Weidenfeld and Nicholson Ltd., 1969.

——. *Modern Scandinavian Furniture.* Copenhagen: Gyldendalske Boghandel Nordisk Forlag, 1963.

——. *Scandinavian Design.* Stockholm: Nordisk Rotogravyr; Copenhagen: Gyldendalske Boghandel Nordisk Forlag, 1961.

Illustrated Library of the World and Its Peoples Encyclopedia (Scandinavia). New York: Greystone Press, 1965.

Janssen, Tove. *The Moomin Books.* London: Benn, 1960.

Jonsson, Hannes. *Iceland's Unique History and Culture.* Reykjavik: Information Division, Ministry of Foreign Affairs, Iceland Tourist Bureau and Solarfilma, 1964.

Karlsen, Arne, Bent Salicath, and Mogens Utzon-Frank, eds. *Contemporary Danish Design.* Copenhagen: Danish Society of Arts and Crafts and Industrial Design, 1960.

Karlsen, Arne and Anker Tiedemann. *Made in Denmark.* Copenhagen: Jul. Gjellerups Forlag, 1960.

Kaufmann, Edgar Jr., Erik Lassen, and Christian D. Reventlow. *Fifty Years of Danish Silver in the Georg Jensen Tradition.* Copenhagen: Schonberg, 1954.

Kjellberg, Reidar. *Thorbjorn Lie-Jorgensen.* Oslo: Dreyers Forlag for David-Andersen Solvsmed, 1961.

Kristoffersen, K., ed. *Norwegian Textile Times (Norsk Tekstil Tidende).* Special history for 150th textile trade anniversary. Bergen: Norsk Tekstil Teknisk Forbund, 1963.

Lassen, Erik, ed. *The Arts of Denmark.* Denmark: Danish Society of Arts and Crafts and Industrial Design, 1960.

Li Ch'iao p'ing. *The Chemical Arts of Old China.* Easton, Pa.: Journal of Chemical Education, 1948.

Markfelt, Barbro. *Swedish Handcraft Times (Svensk Slöjdtidning).* Stockholm: Sveriges Textillärares Riksförening, 1964.

Midgaard, John. *A Brief History of Norway.* Oslo: Office of Cultural Relations, Norwegian Ministry of Foreign Affairs, 1963.

Hanna Ryggen. Oslo: Office of Cultural Relations, Norwegian Ministry of Foreign Affairs, 1964.

Moody, Ella, ed. *Decorative Art 1962/3.* London: Longacres Press Ltd.; New York: Viking Press, 1963.

———. *Decorative Art 1965/6.* London: Studio Vista Ltd.; New York: Viking Press, Inc., 1965.

Nostetangen Design Book. Hand-drawn in 1763 at Nostetangen. Property of Arild Berg. Hadeland Glassworks, Jevnaker, Norway.

Nyborg, Anders, ed. *Suomi/Finland.* Copenhagen: Anders Nyborg A/S, 1963.

Ogrizek, Dore, ed. *Scandinavia.* New York: McGraw-Hill Book Co., 1952.

Polak, Ada Buch. *Old Norwegian Glass (Gammelt Norsk Glas).* Oslo: Gyldendal Norsk Forlag, 1953.

Read, Herbert. *A Concise History of Modern Sculpture.* New York: Frederick A. Praeger, Inc., 1964.

Rothery, Agnes. *Iceland—New World Outpost.* New York: Viking Press, 1948.

Saarikivi, Skari. *The Modern Sculpture of Finland.* Helsinki: Osakeyhtion Kirjapainossa Porvoossa, 1963.

Savage, George. *A Concise History of Interior Decorating.* New York: Grosset and Dunlap; London: Thames and Hudson, 1966.

Schjodt, Liv, ed. *Norwegian Applied Arts (Norsk Brukskunst).* Oslo: Landsforbundet Norsk Brukskunst, 1964.

Scott, Franklin D. *The United States and Scandinavia.* Cambridge, Mass.: Harvard University Press, 1950.

Sirelius, U. T. *The Ryijy Rugs of Finland, A Historical Study.* Helsinki: Otava Publishing Co., 1926.

Stagg, Frank Noel. *East Norway and Its Frontier.* London: George Allen & Unwin, Ltd., 1956.

———. *The Heart of Norway.* London: George Allen & Unwin, Ltd., 1953.

———. *North Norway.* London: George Allen & Unwin, Ltd., 1952.

———. *West Norway and Its Fiords.* London: George Allen & Unwin, Ltd., 1954.

Stavenow, Åke and Åke H. Huldt. *Design in Sweden.* Stockholm: AB Åetåtryck Åhlén & Åkerlunds Tryckerier, 1964.

Stavenow-Hidemark, Elisabet. *Swedish Art Nouveau (Svensk Jugend).* Stockholm: Nordiska Museum, 1964.

Strode, Hudson. *Denmark Is a Lovely Land.* New York: Harcourt, Brace & Co., 1951.

Toyne, S. M. *The Scandinavians in History.* London: Edward Arnold & Co., 1948.

Valen-Sendstad, Fartein. *The Sandvig Collections.* Gjovik, Norway: Maihaugen Open Air Museum, 1958.

Vincent, Jean Anne. *History of Art,* College Outline Series. New York, Barnes & Noble, Inc., 1962.

Wilson, H. W., ed. and compiler. *Industrial Arts Index/Applied Sciences and Technical Index.* New York: H. W. Wilson, 1957.

Zahle, Erik, ed. *A Treasury of Scandinavian Design.* New York: Golden Press; Denmark: Alfred G. Hassing Publishers, Ltd., 1961.

Zilliacus, Benedict. *Decorative Arts in Finland.* Helsinki: Werner Soderstrom/Osakeyhtion Kirjapainossa Porvoossa, 1963.

Booklets, Trade·Papers, Magazines, and Special Publications

Abrahamsen, Poul. *Royal Wedding—Setting and Background.* Copenhagen: Royal Danish Ministry of Foreign Affairs, 1967.

American-Scandinavian Review. New York: American-Scandinavian Foundation Quarterly, 1963 through spring 1975.

Aro, Pirkko. "Finnish Chinaware and Glassware Today." *Finnish Features.* Helsinki: Finnish Ministry of Foreign Affairs, 1961.

Art News (Nyttikonst). Stockholm: A. Hald and E. E. Skawonius, 1943.

Barry, Naomi. "The Shops of Europe." *Holiday,* November 1964.

Bonytt. "Plus Guide" issue, June 1961 and "Textiles" issue, September 1963. Oslo: Norwegian National Society of Arts and Crafts and Industrial Design.

Brown, Andrew H. "Sweden, Quiet Workshop for the World." *National Geographic.* April 1963, pp. 451–91.

Carring, Holger, ed. *Ceramics and Glass (Keramiikka ja Lasi).* Helsinki: Wärtsilä Arabia Oy, 1961–7.

Chandeliers (Kroner). Oslo: Hadeland Glassworks, 1962.

Danish Foreign Office Journals. Copenhagen: Royal Danish Ministry of Foreign Affairs, 1960–3.

Designed in Finland. Helsinki: Finnish Foreign Trade Association, 1961–75.

"Finland." British *House & Garden* special supplement. London: Condé Nast Publications Ltd. (not dated).

Finland. Special publication (with excerpts from *Green Gold and Granite* by Wendy Hall. London: Max Parrish, 1957). Washington, D.C.: Embassy of Finland, 1957.

Finland, Finns, and Finished Products. Helsinki: Finnish Foreign Trade Association, 1965.

Finlandia. Helsinki: Finnish Foreign Trade Association, 1969.

Finnish Art Industry. Helsinki: Ornamo, 1962.

Finnish Design at Jensen's. New York: Georg Jensen, Inc., 1964.

Gardner, Ralph R., ed. *Icelandic Arts and Crafts.* New York: Icelandic Arts and Crafts Shop, 1964.

Glass and Wine Culture (Glas og Vin Kultur). Oslo: Hadeland Glassworks, 1954.

Glass Is Our Material (Glas Er Vårt Material). Oslo: Hadeland Glassworks, 1961.

Gleaming Glass from K-I. Helsinki: Karhula-Iittala Glassworks, 1961.

Gordon, Elizabeth, ed., Marian Gough, feature ed. "The Scandinavian Look in U.S. Homes." Special issue of *House Beautiful.* Vol. 101, No. 7, July 1959.

Hadeland Crystal. Oslo: Hadeland Glassworks, 1960.

Hadeland of Norway. Oslo: Hadeland Glassworks, 1961–2.

Hadeland Tradition. Oslo: Hadeland Glassworks, 1961.

Hadeland's Art Glass (Hadeland's K-Glass). Oslo: Hadeland Glassworks, 1962.

Hamar, H. J. and H. Hannesson, eds. *Icelandic Review.* Reykjavik: 1965–70.

"Iittala's Glass of Fashion from the Mold of Form." *Made in Europe.* Frankfurt, West Germany (not dated).

Johannsen, Kai and Jorgen Benzon, eds. *Denmark Review*. Special issue for New York World's Fair. Copenhagen: Royal Danish Ministry for Foreign Affairs, 1964.

Karhula-Iittala Finnish Glass. Helsinki: Karhula-Iittala Glassworks, 1962.

Karin Björquist of Gustavsberg. New York: Georg Jensen, Inc., 1965.

Korpikaivo-Tamminen, Laura. *Ryijy-Rugs*. Helsinki: Taidekutomo Textile Studio, 1961, 1963.

Lee, Sarah Tomerlin, ed. with Marian Gough. "Scandinavia." Special issue of *House Beautiful*. Vol. 110, No. 1, January 1968.

Lindqvist, Lennärt, ed. *Form*. Stockholm: Svenska Slöjdföreningen, 1962–4.

Lönnroth, Inga Mari, ed. *Kontur*. Swedish design annual. Stockholm: Svenska Slöjdföreningen, 1965.

———. *Kontur 12*. Swedish design annual. Stockholm, Svenska Slöjdföreningen, 1964.

The Marimekko Story. Helsinki: Marimekko-Printex Oy, 1964.

Modern Homes (Moderne Hjem). Oslo: A. M. Hancke Forlag, 1963.

Moller, Svend Erik, Gunnar Bratvold, Lena Larsson, and Thomas Winding, eds. *Mobilia*. Special edition (No. 112) "Den Permanente." Snekkersten, Denmark: Gunnar Bratvold, publ., November 1964.

———. *Mobilia*. Snekkersten, Denmark: Gunnar Bratvold, No. 99, October 1963; No. 105, April 1964; No. 114, January 1965; No. 115, February 1965.

Norwegian National Folk Costumes (Norske Bunader). Oslo: Norsk Folkemuseet, 1963.

Per Krohg. Washington, D.C.: Embassy of Norway, 1954.

Pihlstrom, Bengt, ed. *Look at Finland*. Helsinki: Finnish Travel Association and Press Bureau of Finnish Foreign Ministry, 1965, 1966, 1970.

Ramskou, Thorkild. *Denmark's Olden Times (Danmarks Oldtid)*. Odense, Denmark: National Museum of Denmark, 1965.

Rasmus Meyer's Collection. Bergen, Norway: Municipal Art Museum, 1956.

Scandinavian Viewpoint. New York: Georg Jensen, Inc., 1964.

Shopping in Norway. Oslo: Norwegian Travel Association, 1962.

Silver and Enamel (Solv og Emalje). Oslo: David-Andersen Solvsmed, 1964.

Smith, Ray Winfield. "History Revealed in Ancient Glass." *National Geographic*. September 1964, pp. 346–69.

The Story of Boda and Erik Höglund. Boda, Sweden: Boda Glassworks, 1965.

The Story of Husfliden. Bergen, Norway: Husfliden, 1962.

Svedberg, Margit, ed. *Kontur 8*. Swedish design annual. Stockholm: Svenska Slöjdföreningen, 1959.

Tenera Faience. Copenhagen: Royal Copenhagen Porcelain Manufactory, 1964.

Traetteberg, Gunvor Ingstad. *Norsk Folk-Costumes*. Washington, D.C.: Norwegian Information Services, Embassy of Norway, 1964.

Virkkunen, Maggi. *Helsinki in a Shopping Bag*. Helsinki: Association of English-Speaking Wives, British Council, 1970.

"Wirkkala: Pioneer of Modern Finnish Design." *Finnish Features*. Helsinki: Finnish Ministry of Foreign Affairs, 1963.

Index